Reading Egyptian Art

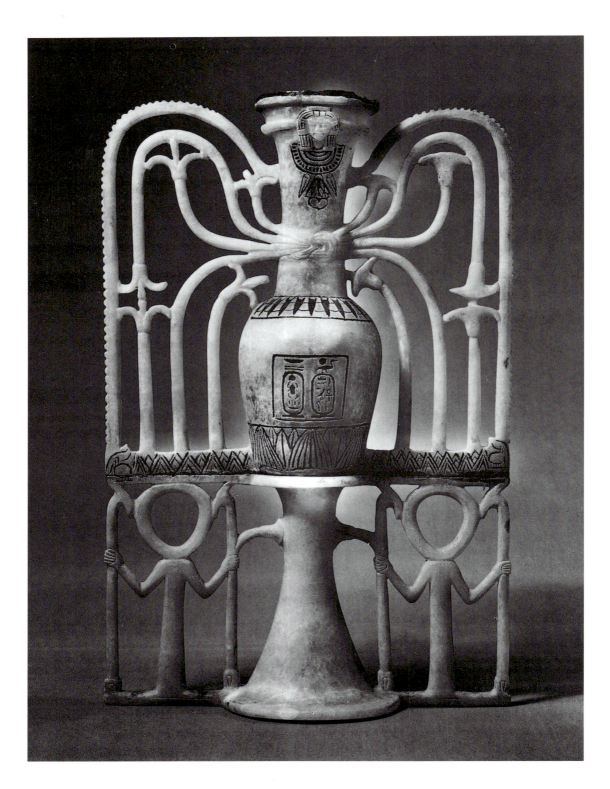

Richard H. Wilkinson

Reading Egyptian Art

A HIEROGLYPHIC GUIDE TO ANCIENT EGYPTIAN PAINTING AND SCULPTURE

With over 450 illustrations

For Anna

ACKNOWLEDGMENTS

A number of people have been of assistance in the production of this guide. Dr. John Baines, Professor of Egyptology at Oxford University, encouraged the book's writing by means of a number of suggestions at the planning stage, and discussions on the use of hieroglyphs in Egyptian art with Dr. Robert Bianchi also proved helpful. I am grateful to several colleagues who offered comments on sections of the text, and especially to Dr. Susan Hollis, who provided helpful suggestions in this regard. Dr. Otto Schaden was no less helpful in taking the time to locate several elusive representations. A number of scholars kindly assisted in checking museum accession numbers or other details, among them Drs. Harry Douwes, Rita Freed, Charles Jones, Catharine Roehrig and James Romano. The trustees of the Griffith Institute are thanked for allowing the reproduction in this work of Gardiner's sign list, while the hieroglyphs appearing in the text were produced by CompuGlyph software.

I am indebted to the many individuals who helped arrange photographic illustrations of objects in the collections listed below, and Mr Troy Sagrillo is to be especially thanked for his patience and care in producing the line drawings which accompany the text. Above all, I would like to thank my wife Anna for her encouragement and help in bringing this book to fruition in an already busy academic schedule.

PHOTOGRAPHIC CREDITS

Archive of Late Egyptian Art/Robert Bianchi: D27.3 British Museum, London: D18.4; D32.1; E1.3; G31.3; I3.4; W15.2; X2.2; Y8.4 Brooklyn Museum: B5.2; I12.5; O33.3; U6.4 Egyptian Museum, Cairo: M9.1; O18.2; O18.3; O23.2; S35.2; T10.3; V17.5 Eton College: E20,21.2 Graetz Inc./Kenneth Graetz: E10.3; K1.2; O20.3 KMT/Dennis Forbes: F34.3 Metropolitan Museum of Art, New York: Frontispiece; A13.1; A30.3; E25.2; G5.4; M20.3; V9.2 Museum of Fine Arts, Boston: A22.1; A26.1; B8.4; D1.3; D10.3; R13,14.1; R17.2 Museo Archeologico, Florence: O40.3 Kestner Museum, Hanover: G26.3 The Louvre, Paris: C10.1; E22.2; N5.2 University Museum, Philadelphia: A40.3; F24.1 Seattle Art Museum: G26.2; H5.2 Staatliche Museen, Berlin: B5.1; S34.1 Walters Art Gallery, Baltimore: E32.5
Other photographs by author.

On the cover: Ramesses I and a jackal-headed spirit, from the king's tomb at Thebes. Nineteenth Dynasty. Photo Richard H. Wilkinson.
Frontispiece: Alabaster vase composed of hieroglyphic forms, from the tomb of Tutankhamun, Thebes. Eighteenth Dynasty.

First published in the United States of America in 1992 by Thames & Hudson Inc., 500 Fifth Avenue, New York, New York 10110

thamesandhudsonusa.com

First paperback edition 1994
Reprinted 2003

Library of Congress Catalog Card Number 91-67312
ISBN 0-500-27751-6

Printed and bound in Slovenia by Mladinska Knjiga

CONTENTS

PREFACE p.8
 How To Use This Book

INTRODUCTION p.9
 History and Art of Egypt p.12

CATALOG OF HIEROGLYPHS pp.13–213
 Chronological Table

A MAN pp.15–31

A1	A8	A13	A17	A22	A26	A28	A30	A40
Seated Man	Praise	Bound Captive	Child	Statue	Summon	Rejoice	Adore	Seated God

B WOMAN pp.33–5

B5,6	B8
Woman Nursing Child	Mourning Woman

C ANTHROPOMORPHIC DEITIES pp.37–9

C10	C11
Maat	Heh

D PARTS OF THE HUMAN BODY pp.41–55

D1	D10	D18	D27	D28	D32	D39	D49
Head	Wedjat Eye	Ear	Breast	Ka	Embrace	Offer	Clenched Hand

E MAMMALS pp.57–73

E1,2	E4	E10	E13	E15,16,17	E20,21	E22,23	E25	E32
Bull	Divine Cow	Ram	Cat	Anubis Animal	Seth Animal	Lion	Hippopotamus	Baboon

F PARTS OF MAMMALS pp.75–81

F24	F34	F35	F36
Foreleg of Ox	Heart	Nefer	Union

G BIRDS pp.83–99

G5	G14	G24	G26	G31,32	G36	G39,40,41	G48	G53
Falcon	Vulture	Lapwing	Ibis	Heron	Swallow	Pintail Duck	Nest	Ba

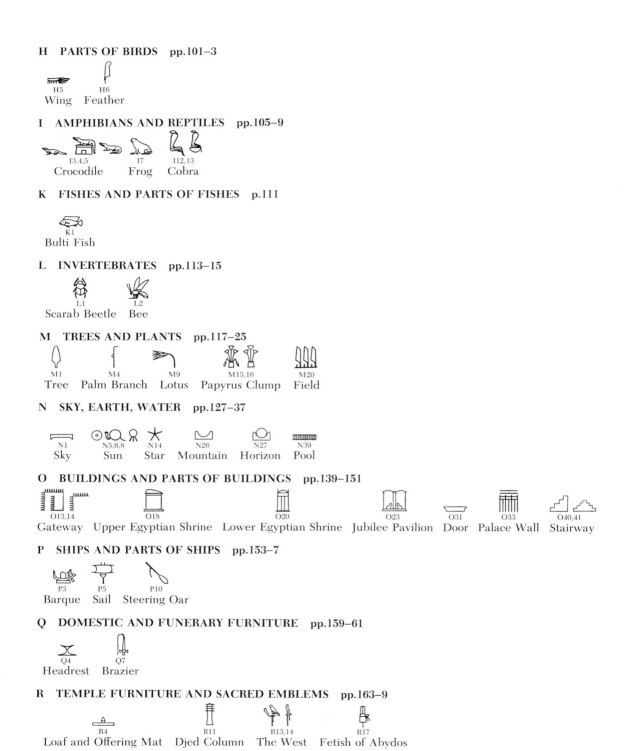

H PARTS OF BIRDS pp.101–3

H5
Wing

H6
Feather

I AMPHIBIANS AND REPTILES pp.105–9

I3,4,5
Crocodile

I7
Frog

I12,13
Cobra

K FISHES AND PARTS OF FISHES p.111

K1
Bulti Fish

L INVERTEBRATES pp.113–15

L1
Scarab Beetle

L2
Bee

M TREES AND PLANTS pp.117–25

M1
Tree

M4
Palm Branch

M9
Lotus

M15,16
Papyrus Clump

M20
Field

N SKY, EARTH, WATER pp.127–37

N1
Sky

N5,6,8
Sun

N14
Star

N26
Mountain

N27
Horizon

N39
Pool

O BUILDINGS AND PARTS OF BUILDINGS pp.139–151

O13,14
Gateway

O18
Upper Egyptian Shrine

O20
Lower Egyptian Shrine

O23
Jubilee Pavilion

O31
Door

O33
Palace Wall

O40,41
Stairway

P SHIPS AND PARTS OF SHIPS pp.153–7

P3
Barque

P5
Sail

P10
Steering Oar

Q DOMESTIC AND FUNERARY FURNITURE pp.159–61

Q4
Headrest

Q7
Brazier

R TEMPLE FURNITURE AND SACRED EMBLEMS pp.163–9

R4
Loaf and Offering Mat

R11
Djed Column

R13,14
The West

R17
Fetish of Abydos

S CROWNS, DRESS, STAVES pp.171–83

S12	S18	S27	S34	S35	S40	S42
Gold	Menit Necklace	Clothing	Ankh	Fan, Sunshade	Was Scepter	Sekhem Scepter

T WARFARE, HUNTING, BUTCHERY pp.185–9

T10	T18	T30
Bow	Follower Sign	Knife

U AGRICULTURE AND CRAFTS p.191

U6
Hoe

V ROPE, FIBER, BASKETS pp.193–201

V9	V10	V17	V30	V39
Shen Ring	Cartouche	Protection	Basket	Isis Knot

W VESSELS OF STONE AND EARTHENWARE pp.203–5

W3	W15
Alabaster Bowl	Water Jar

X LOAVES AND CAKES p.207

X2,3,7,8
Bread Loaf

Y WRITINGS, GAMES, MUSIC pp.209–13

Y3	Y5	Y8
Scribe's Outfit	Board Game	Sistrum

Gardiner's Sign List	p.214
Glossary	p.218
Further Reading	p.220
Locations of Illustrated Objects	p.222
Index	p.224

PREFACE

Ancient Egyptian art enjoys great popularity in the modern world and is appreciated by people from many walks of life, as well as by students of art history. Yet Egyptian artworks can often appear deceptively simple, and much can remain hidden from view without knowledge of the symbolic repertoire which was used by the ancient artists and craftsmen. Many Egyptian works of art were designed, in fact, to be "read" symbolically and to provide an underlying message which was an essential part of their composition. Colors, materials, numbers, and especially the forms of the written Egyptian hieroglyphs were all part of this symbolic language which, if it is learned, can open up Egyptian art to an understanding far beyond what is seen by the untrained eye. This book has been designed with this goal in mind – to allow the non-specialist to "read" the major hieroglyphs found in Egyptian painting and sculpture and to understand much of the symbolic content of Egyptian art which is usually only accessible to the trained Egyptologist.

How To Use This Book

The format of this book is based on the standard hieroglyphic index or "sign list" of Sir Alan Gardiner's *Egyptian Grammar* (Oxford, 3rd edn., 1982). Gardiner's list of hieroglyphs, reproduced here on pp. 214–17, is conveniently divided into twenty-six thematic categories – each assigned a letter of the alphabet – with individual signs being sequentially numbered within each group.

While the number of hieroglyphs employed in the writing of the Egyptian language was considerable (Gardiner's sign list contains some 750 signs – and is itself greatly abbreviated), only a fraction of these hieroglyphs were regularly used in the composition of two- and three-dimensional works of art. The one hundred hieroglyphs discussed in this book actually constitute the greater part of this specialized symbolic corpus. Each hieroglyph appears here in the order of its Gardiner designation, and the Egyptian name of the object depicted in the glyph is given in an English pronouncing version which is used throughout the text. References to other hieroglyphs which are discussed in this book are preceded by an asterisk (*).

The thematic arrangement of the text also allows the book to be used as a guide when studying and appreciating Egyptian art in museums and other collections. In using this book as a guide, a given symbol in an Egyptian artwork may be easily located thematically in the sign list by looking under the relevant category – humans, mammals, fish, etc. Hieroglyphs discussed in the text have been highlighted in the sign list.

RICHARD H. WILKINSON

INTRODUCTION

For centuries the art of ancient Egypt has stirred Western curiosity and imagination. Even before European scholars deciphered the long-forgotten hieroglyphic script, Egyptian paintings and inscriptions were copied and published, and artworks of every size were avidly obtained by museums and private collectors. This is not difficult to understand, for Egyptian art is as rich and captivating as any that has survived from the ancient world, and fortunately much has survived. The Egyptians filled their homes, temples and tombs with works of art – ranging from colossal statues to minuscule yet often finely wrought utensils, items of jewelry, and amuletic charms. But these works cannot be understood merely in terms of a desire for ornamentation and aesthetically pleasing compositions, for the role of representational art was closely interwoven with the religious beliefs of the ancient Egyptians and often the one cannot be understood without reference to the other. Even though many artworks were undeniably intended to be enjoyed and appreciated, we know that this was not always their primary purpose. The single unifying theme which is invariably found in Egyptian art is its symbolic message.

Through symbols the Egyptians sought to represent many of their religious beliefs and ideas about the nature of the cosmos. Symbolic objects and pictures were used in this way to make the transcendental and the unseen both immediate and understandable. Sometimes this symbolism would refer to the creation and origin of life on earth, sometimes to the mystery of its propagation and continuance. Symbols were also used for protection, to keep the Egyptian safe from evil influences in this life, and even beyond – for much Egyptian art has to do with the theme of life after death.

An understanding of the basic concerns of this ancient culture can help us to appreciate the art which has survived, but in many instances Egyptian artworks cannot be fully understood or appreciated without some knowledge of the specific symbols that were utilized in their composition. The Egyptian king, for example, may be represented in the form of a falcon, lion or bull, just as his attributes may be suggested by the portrayal of his throne, crown or scepter. By wearing different crowns the king could symbolize his rule over different areas of the country, or his great power and relationship with the gods. The two major regions of the country, Upper (southern) and Lower (northern) Egypt, were symbolized by various emblems such as the lotus and the papyrus, while her enemies were shown as the so-called "Nine Bows" – depicted as nine ethnically differentiated captives, or sometimes as literal war-bows. A simple offering scene showing a family of father, mother and son may represent a complex symbolic statement through the use of various symbols, gestures, and colors. Such a scene might associate the members of the family with important deities of Egyptian religion – perhaps Osiris, Isis and their son Horus – and through this association make a specific statement about the people and their place in the future life. It is only knowledge of this aspect of Egyptian art which can transform such a scene from the relatively meaningless to the richly detailed tapestry of symbols which the artist originally produced. Above all else, it is the Egyptian artist's use of the hieroglyphic signs of the written language which added this symbolic dimension to Egyptian art, and it is this use of hieroglyphs in representational contexts which is the theme of the present book.

The ancient Egyptians referred to the hieroglyphic signs by which their language was written as the *medu netcher*: "the god's words" – a meaning preserved in the word *hieroglyphs* which the Greeks coined for the carved Egyptian temple reliefs and inscriptions. The connection between these written signs and larger, representational images was always a

strong one. The Egyptians had developed written, cursive forms of their script at a very early time for mundane purposes such as the writing of letters and accounts, but the use of the pictorial hieroglyphic signs persisted throughout Egyptian history and was evident in ritual and representational settings long after the hieroglyphs had ceased to be used in everyday communication. Although the hieroglyphic script is extremely complex in many of its aspects, the basic principle it employed is easy to grasp. Essentially, signs were used in two ways – phonetically and ideographically. As phonograms or "sound signs," hieroglyphs could spell out words phonetically, so that the symbol ⬯ which represented the mouth ("r" in Egyptian) could be used to write the letter "r"; and the sign ⎵ which represented the arm ("a" in Egyptian) could be used for "a." The signs could also be used ideographically as "idea signs" to convey their original meaning, ⬯ for "mouth" and ⎵ for "arm," or for words associated with these ideas, such as "speak" or "give." Usually, words were written by means of a combination of these two uses of the signs so that the word "ra" or "sun," for example, was written ⬯⎵⊙ with the phonetic signs "r" + "a" followed by the sign for "sun" (⊙) to clarify the meaning of the word. An ideogram used in this way at the end of a word to define what kind of thing is being referred to is known as a "determinative" and allows different words written in the same way to be distinguished. Written with the determinative for a god (𓀀), for example, the word ra becomes ⬯⊙𓀀 "the sun god Ra," (or "Re" – the form used in this book).

Thus, all Egyptian hieroglyphic writing is made up of pictures, yet it is seldom realized that a great deal of Egyptian art is in turn heavily influenced by, and on many occasions made up of, hieroglyphic words and written signs. The extent to which this is true may be seen in the rather elaborate carved rock vase from the tomb of Tutankhamun which is shown in the frontispiece of this book. Upon examination, it may be seen that this vase is almost entirely composed of hieroglyphic signs placed together in such a way as to create a finished work full of symbolic meaning. The hieroglyphs which appear in the vase are as follows: the ankh (𓋹) sign for "life" – the crossbars of which

are here shown as arms grasping the signs beside them, the was (𓌀) sign for "dominion," the renpet (𓏤) sign for "years," the lily or sedge of Upper Egypt (𓇉), the papyrus of Lower Egypt (𓇑), and the basic form of the sema (𓄑) sign for "union." This work then, far from simply incorporating an ornate or intricately produced abstract design, contains a clear symbolic message which relates the underlying continuous support of the powers of life and dominion to the united kingdoms of Upper and Lower Egypt. Individual hieroglyphic signs were thus often the models for parts of or even whole works of art and complex compositions, and the interaction between writing and pictorial representation was an ever present reality. This is not to imply that all Egyptian art is hieroglyphic in nature, or that all hieroglyphs are used in Egyptian art, but it is probably not overstating the situation to say that the hieroglyphic signs do form the very basis of Egyptian iconography, which – just like the written inscriptions – is concerned with the practical function of making a clear and often specific symbolic statement. Thus, it was not coincidental that the Egyptians used the same word to refer to both their hieroglyphic writing and the drawing of their artworks, and it was often the scribe who accomplished – or at least designed – both. As one noted historian of Egyptian art has said, "... once a scribe had learnt to draw the full range of ideographic signs with requisite skill he had become ipso facto an artist, since the composition of his pictures is the assemblage of a number of ideograms with some interaction between them" (Cyril Aldred, Egyptian Art, 1980, p.17).

This interaction between the signs incorporated in Egyptian paintings or sculptures is important and may be seen by the trained eye to form the skeleton, as it were, of many compositions. The individual "ideographic" elements of Egyptian pictures must be "read" like the signs of an inscription, whether they are shown overtly, or as in other cases, more subtly, for the use of the hieroglyphic signs in Egyptian art occurs on two distinct levels. On the primary level the signs are used quite clearly in essentially their normal written forms, and in this kind of primary association artworks may contain or even be wholly composed of hieroglyphs. A classic example of this practice can be seen in

the statue of Ramesses II (see *A17), where the king is shown as a young child – the word for which is *mes* in Egyptian – sitting with his finger in his mouth in the exact gesture which is always shown in the hieroglyph for *mes* or child. On his head the king wears a sun (*ra*) disk, and with his left hand he holds a stylized *su* plant. Thus the statue not only physically represents the king, but also spells out his name – *Ra-mes-su* or Ramesses.

Egyptian art also uses hieroglyphs in another way, in what we might call a secondary level of association. At this secondary level, objects, people or even gestures may be represented so as to suggest the form of the hieroglyphic signs and thus spell out a symbolic message. The many statues in which the goddess Isis holds her son Horus or husband Osiris before her in such a way as to form with her arms the hieroglyph meaning "to embrace" (see *D32) are all examples of this secondary level of association. Often, the same composition will use hieroglyphic forms at both levels of involvement. In the vase of Tutankhamun described above, the flanking plants, *ankh*, and *was* signs are clearly distinguished at the primary level, but the central body of the vase does not have all the inherent details of the *sema* or "union" signs and these can only be seen at a secondary level. The presence of either – or both – of these uses of hieroglyphic forms must be looked for in attempting to understand the symbolic aspect of any Egyptian work of art.

Another aspect of the use of hieroglyphic forms is that of personification. The *ankh* signs with human arms in the same vase are examples of this, and the phenomenon is a common one in Egyptian art. Often, this device is used to identify hypostases – the personifications of ideas or non-human things – or to enrich the symbolic value of an object in some way (John Baines, *Fecundity Figures: Egyptian Personification and the Iconology of a Genre*, 1985). Examples of two kinds of personification will be found repeatedly in the following pages – "formal personification" and "emblematic personification." Formal personification involves human figures which are made to personify an object, place, or idea, such as "fire" (see *Q7, ill. 1), the river Nile (see *D27, ill. 1), or "the west" (see *R13, 14, ill. 4). These personifications are often represented with identifying hiero-

glyphs worn on their heads like elaborate crowns or headdresses – as in the examples just given – or depicted as figures whose heads are actually shown in the form of their hieroglyphic signs (see *R13, 14, ill. 3). In all cases, however, formal personification involves a human figure made to represent something. Conversely, emblematic personification relates to non-human objects or emblems, such as hieroglyphic signs, which are given human attributes – as in the case of the arms added to the *ankh* sign in the frontispiece vase. Both of these types of personification enabled the Egyptian artist to incorporate the use of hieroglyphs into representational contexts and to enhance the symbolic aspect of a given composition.

Study of the symbolism involved in the art of a given culture may proceed at a number of different levels, however. The artworks which are illustrated in this book are described in terms of their component hieroglyphic symbols, and interpretive comments are often given – but a complete investigation of the symbols themselves is not intended. Even at this limited degree of interpretation, we begin to enter the gray areas at the threshold of our knowledge of ancient Egyptian culture and religion, and there are many things which we only partially understand. Art historians are well aware of some of the dangers of symbolic interpretation and it is easy, for example, to superimpose our own ideas on those of the ancients or to draw conclusions about representational symbols from information gleaned from apparently related textual sources. Yet sometimes these are the only ways we have of dealing with a given symbol. Even when great care is taken, it must be remembered that symbols can be fluid things seeming almost to have lives of their own. As the products of human minds they certainly change in time, and find different expression in different contexts in the same period. The information presented in this book, then, is chosen not to attempt a full interpretation, but to act as a guide. Its purpose is to provide background which may be helpful and to supply a range of examples for each hieroglyph discussed, thus enabling the reader to see the hieroglyphic component when it appears in Egyptian works of art and to gain an initial understanding of its symbolism. It is through learning to "read" Egyptian art that we come to understand something of its rich

symbolic content and to see it in a way much closer to that in which the ancient Egyptians saw it themselves.

History and Art of Egypt

The civilization of pharaonic Egypt lasted for almost three thousand years – far longer than any other culture in the ancient world – and this fact gives an unmistakeable continuity to Egyptian culture and its art. It also demands a clear ordering of the flow of time, and as early as the third century BC, the High Priest Manetho of Heliopolis divided the history of Egypt into thirty successive royal dynasties based on earlier king lists and other records of his predecessors. These thirty dynasties plus the thirty-first which was later added, run from the putative beginnings of Egyptian history (often referred to as the unification of the "Two Lands" of Upper and Lower Egypt), to the Grecianized Ptolemaic dynasty of Manetho's own day. Although modern scholars debate the history of some of these dynasties (a few kings seem to have been contemporaneous), by and large they are clearly based on historical fact and the same system is used today.

But in the long cycle of history, the civilization of Egypt was far from static. More than once Egypt rose, flourished, declined and fell. Long before the rise of classical Greece, Egypt had already enjoyed at least three long periods of prosperity and centralized power. These times, now known as the Old (2649–2150 BC), Middle (2040–1640 BC), and New (1550–1070 BC) Kingdoms, eventually led to periods of decline or change known respectively as the First, Second, and Third Intermediate Periods. Brought about by gradual climatic, social or other causes these intermediate periods still saw the continuation of Egyptian civilization, often with the introduction of new ideas and concepts. Even the influx of foreign peoples like the Hyksos (whose entry into Egypt from the Near East roughly coincided with the end of the Middle Kingdom) did not altogether break Egypt's cultural traditions, and sooner or later native royal dynasties continued the long-established pattern.

These units of time, therefore – the dynasties, kingdoms and intermediate periods – are far from abstract labels. Although, for the people of ancient Egypt, time was measured mainly by the cyclic patterns of nature and myth (the agricultural seasons and the religious festivals which followed them), larger periods of time were carefully recorded. The annual inundation of the croplands which occurred when the Nile rose in flood provided the most dramatic marker of the progress of time, but beyond the seasonal cycle, the Egyptians measured time by the reign of each god-king, and by the periodic "renewal" of the world which each implied.

In Egyptian art, new styles may often be seen to have developed with new reigns, with new dynasties and with the arrival of new historical eras. Although the Greek philosopher Plato, in his day, suggested that Egyptian art had remained the same for thousands of years, modern scholars are increasingly aware of subtle diachronic changes as well as distinct periods and styles such as the Amarna Period of the late Eighteenth Dynasty and the Ramesside Period of the Nineteenth and Twentieth Dynasties. Perhaps more so than in any other culture, the art of ancient Egypt was forever changing as it stayed the same.

CHRONOLOGICAL TABLE

The dates in this chronological table are based on those given by Professor John Baines and Dr Jaromir Malek in their *Atlas of Ancient Egypt* (New York, 1984). Some dates are approximations.

LATE PREDYNASTIC PERIOD	(c. 3000 BC)

EARLY DYNASTIC (ARCHAIC) PERIOD	(2920–2649)
First Dynasty	2920–2770
Second Dynasty	2770–2649

OLD KINGDOM	(2649–2150)
Third Dynasty	2649–2575
Fourth Dynasty	2575–2465
Fifth Dynasty	2465–2323
Sixth Dynasty	2323–2150

FIRST INTERMEDIATE PERIOD	(2150–2040)
Seventh Dynasty	2150–2134
Eighth Dynasty	2150–2134
Ninth Dynasty	2134–2040
Tenth Dynasty	2134–2040

MIDDLE KINGDOM	(2040–1640)
Eleventh Dynasty	2040–1991
Twelfth Dynasty	1991–1783
Thirteenth Dynasty	1783–1640

SECOND INTERMEDIATE PERIOD	(1640–1550)
Fourteenth to Seventeenth Dynasties	1640–1550

NEW KINGDOM	(1550–1070)
Eighteenth Dynasty	1550–1307
Nineteenth Dynasty	1307–1196
Twentieth Dynasty	1196–1070

THIRD INTERMEDIATE PERIOD	(1070–712)
Twenty-first Dynasty	1070–945
Twenty-second Dynasty	945–712
Twenty-third Dynasty	828–712
Twenty-fourth Dynasty	724–712

LATE PERIOD	(712–332)
Twenty-fifth Dynasty (*Kushite*)	712–657
Twenty-sixth Dynasty (*Saite*)	664–525
Twenty-seventh Dynasty (*Persian*)	525–404
Twenty-eighth Dynasty	404–399
Twenty-ninth Dynasty	399–380
Thirtieth Dynasty	380–343
Thirty-first Dynasty (*Persian*)	343–332

GRECO-ROMAN PERIOD	(332-AD 395)
Macedonian Dynasty	332–304
Ptolemaic Dynasty	304–30
Roman Emperors	30 BC–AD 395

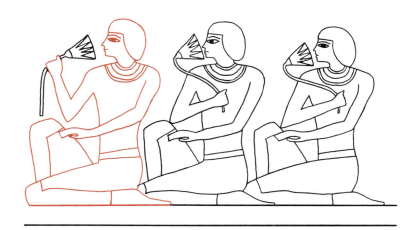

1 *Banquet scene, tomb of Menkheperreseneb, Thebes. Eighteenth Dynasty.*

2 *Statue of a scribe, from Saqqara. Fourth Dynasty.*

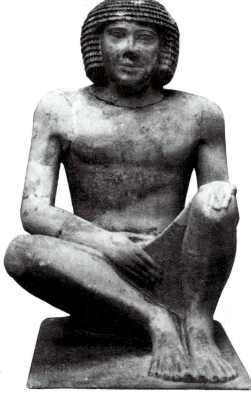

3 *Statue of Nyankhre, from Giza. Fifth Dynasty.*

In ancient Egyptian this hieroglyph served to represent the word *se*: "man," and also functioned as a determinative or "class indicator" in a wide range of words signifying human relationships and occupations, as well as personal names and pronouns. Slight variations in the positioning of the arms could be used for words indicating eating, drinking, or speaking (A2), giving praise, adoring (A4), etc. It is not surprising, therefore, that the hieroglyph appears – written large – in many Egyptian works of art where seated figures are represented. In **ill. 1**, for example, a banquet scene from an Eighteenth Dynasty tomb at Thebes shows guests seated with their legs in exactly the same position as is found in the written sign, and the posing of their arms is adjusted only to accommodate the festive lotus blossoms (°M9) they hold. The identical repetition of this same form in all but the first figure also underscores the hieroglyphic nature of the pose in this composition.

Interestingly, the exact positioning of the limbs as they are depicted in this hieroglyph is rather difficult to ascertain. It is fairly certain that the arms – which may look as though one is extended beyond the other because of the representational "twisting" of the torso – are merely held out over the folded legs. The positioning of the legs is more difficult to understand, however. While one knee appears to be raised, it is possible that this is the result of a convention employed by the Egyptian artist to show the far leg clearly. In other words, it is possible that what is depicted in this hieroglyph is simply the "seated scribe" stance of a man who sits cross-legged with both legs folded beneath him, flat against the ground (**ill. 2**). This pose is known in statuary from the Old Kingdom on, and as the ability to write was the mark of an educated and prestigious person, the pose was used to portray some of Egypt's most important men.

A much less common asymmetrical variety of this scribal pose depicts the seated man with one leg (usually the left) raised and the other resting flat on the ground, as in **ill. 3**. While this variant pose might seem to be closer to the appearance of the hieroglyph, its relative scarcity indicates that the basic cross-legged pose is actually what is represented by the written sign. In either case, the scribal basis of the "man" hieroglyph (we must remember that the sign was invented and used by scribes!) doubtless explains the positioning of the arms which are extended to hold a papyrus scroll above the lap. This is clear in wooden sculptures of scribes where the arms are held at waist height. In works of stone (as in ills. 2 and 3), however, the near impossibility of producing unsupported limbs meant that the arms were invariably shown at a lower level, resting on the figure's legs. While many variations exist in the two- and three-dimensional portrayals of seated figures, it is possible to see something of the basic form of the seated man hieroglyph in most of them.

se

A 1

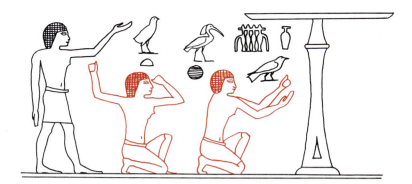

1 *Jubilation scene, mastaba of Heti, Giza. Fourth or Fifth Dynasty.*

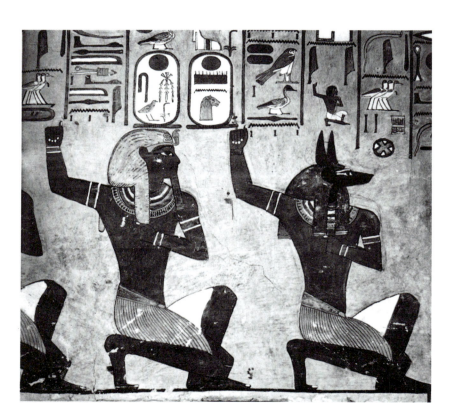

2 *(Above) Ramesses I with ancestral spirits from the king's tomb at Thebes. Nineteenth Dynasty.*

3 *(Right) Jubilating rekhyt bird, relief of Amenemhet I. Twelfth Dynasty.*

4 *(Far right) Jubilating was scepter, from relief of Djoser, Saqqara. Third Dynasty.*

This hieroglyph represents the culminating point in a sequence of ceremonial gestures which comprised the act of offering praise to a god. The "Recitation of the Glorifications," as this ritual was called, also carried the connotation of "jubilation" and "rejoicing." Careful analysis of Old Kingdom tomb paintings has enabled the reconstruction of the entire gesture sequence. First the worshipper knelt on one knee and extended one arm (with its hand held open) while holding the other arm (with closed fist) crooked back toward the body. As the recitation progressed the extended arm was drawn back and its hand closed. The worshipper then touched or struck his chest with alternating blows of his clenched fists. Different stages of this process are sometimes shown in the same representations – such as that from the Fourth or Fifth Dynasty mastaba of Heti at Giza (**ill. 1**). These scenes show that it was the final part of the ritual which is represented in the *henu* sign, with the hieroglyph serving as a kind of résumé of the whole gesture sequence.

henu

A 8

The use of this hieroglyphic form to depict the "praise" or "glorification" gesture is found in all periods of Egyptian art from the Old Kingdom on. The sacred ancestral "souls" of the Lower and Upper Egyptian cities of Pe (Buto) and Nekhen (Hierakonpolis) are often represented by hawk-headed and jackal-headed gods in the *henu* position as they salute the rising sun each dawn, or in other settings such as the scene of jubilation in the Nineteenth Dynasty tomb of Ramesses I (**ill. 2**). In this scene, which celebrates the rejuvenation of the king's *ba* (*G53) or soul, the written *henu* hieroglyph is visible in the inscription above the figure next to the king and is clearly mirrored in the larger figures of the representation. The figures are, in fact, simply hieroglyphs made large. In a similar representation from the Eighteenth Dynasty temple at Buhen in Nubia, the falcon-headed gods of Pe are accompanied by an inscription which states "May they give all life and power...[and] all stability which they have...," showing that the gesturing figures could sometimes be symbolic of divine gifts.

Occasionally, personified creatures of symbolic importance such as the *rekhyt* bird (*G24) or lapwing (**ill. 3**) and even personified hieroglyphs such as the *was* (*S40) scepter (**ill. 4**) are shown in the *henu* position. In the latter example, the forked base of the scepter is used to represent human legs, and the artist has added arms with which the *was* is made to form the gesture of praise. Such representations are clear examples of the secondary or indirect level in which hieroglyphic forms were used in ancient Egyptian art. At this level, objects other than those actually represented in the hieroglyphs are made to conform to the essential appearance of the signs in order to convey the same symbolic meaning or to add their own significance to that of the hieroglyph being imitated. Other examples of this same principle may be found in a number of the following signs.

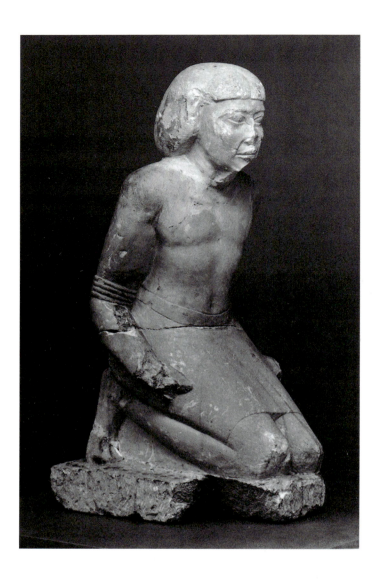

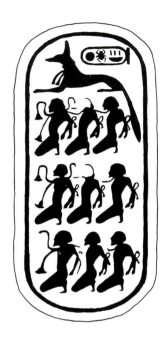

1 (Left) Statue of a bound captive, from Saqqara. Fifth or Sixth Dynasty.

2 (Above) Seal impression, tomb of Tutankhamun, Thebes. Eighteenth Dynasty.

3 (Below) Bound Asiatics and Africans on the footstool of Tutankhamun, from Thebes. Eighteenth Dynasty.

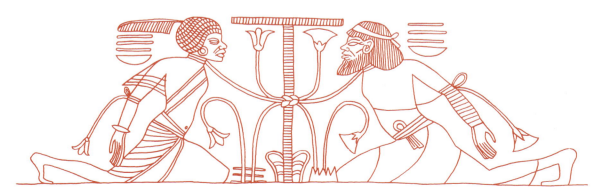

Shown as a kneeling prisoner with his arms tied behind him, the captive is depicted as harmless and in an attitude of submission – symbolically important aspects for those words such as *sebi*: "rebel," and *khefty*: "enemy," for which the sign was used as a determinative. In Egyptian art the hieroglyph is often directly transposed into larger two- or three-dimensional representations as an iconographic motif with the same symbolic intent. **Ill. 1** shows such a statue of a captive where the relationship between the form of the figure and the hieroglyph is immediately apparent. Large numbers of this type of figure depicting enemies of different ethnic or tribal groups were placed in Fifth and Sixth Dynasty funerary complexes in the area of Saqqara, but the fact that most of these sites were thoroughly ransacked in history precludes our fully understanding how the statues were originally set up and used in the funerary context.

The motif continues throughout most of the dynastic period of Egyptian history, however, with many variations in its form and symbolic placement. Small bound figures were sometimes used as playing pieces in the board game *senet* (*Y5) and in other games. **Ill. 3** shows some of the bound captives carved on the ceremonial footstool of Tutankhamun – where ethnically differentiated prisoners are held by rope-like plant tendrils issuing from the hieroglyph for "union" (*F36), which was used to symbolize the two united lands of Upper and Lower Egypt. On the right, Asian prisoners are bound with the papyrus of the north (*M15) and on the left, African prisoners are restrained by the sedge or lily of the south (M26). The presence of these bound enemies on the king's footstool, and hence beneath his feet, is of course a part of the overall symbolic statement, and other examples may be found carved along the bases of royal statues, inscriptions and thrones. The motif also appears in lists of captives inscribed on New Kingdom temple walls. There, the heads and arms of bound prisoners are often placed on rings which contain the names of the captive peoples, and three hieroglyphic forms – the bound prisoner, the fortified wall sign (O36), and the name ring or cartouche (*V10) – are fused into single iconographic units. Yet another place in which the bound captive motif appears may be seen in the seal impressions of the priests of the royal necropolis. Tombs in the Valley of the Kings were sealed with stamp seals such as that shown in **ill. 2** which bears the image of the necropolis god Anubis (*E15) guarding bound prisoners. These captives represent the "Nine Bows" (*T10) or traditional enemies of Egypt and here symbolize the forces of evil.

In some expressions of the motif the captives are shown prone, or their arms may be secured before them or tied above their heads. But the standard pose of the bound prisoner is reminiscent of that used in representations of the lapwing or *rekhyt* bird (*G24), where the bird's wings are held behind its back as a symbol of subject peoples. An inscription of Ramesses II at Medinet Habu which shows prisoners in this pose specifically states, in fact, that they were "pinioned like birds."

BOUND CAPTIVE

sebi

A 13

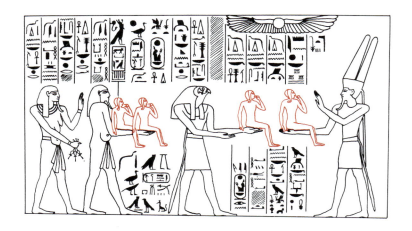

1 *Amenhotep III and his ka presented to Amun, Birth Room, Luxor Temple. Eighteenth Dynasty.*

2 *(Left) Faience plaque of young sun god, from Thebes. Twenty-third Dynasty.*

3 *(Below) Solar child in disk, Papyrus of Herytwebkhet A. Twenty-first Dynasty.*

4 *(Right) Statue of Ramesses II as a solar child, from Tanis. Nineteenth Dynasty.*

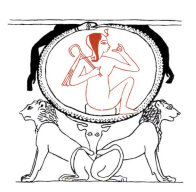

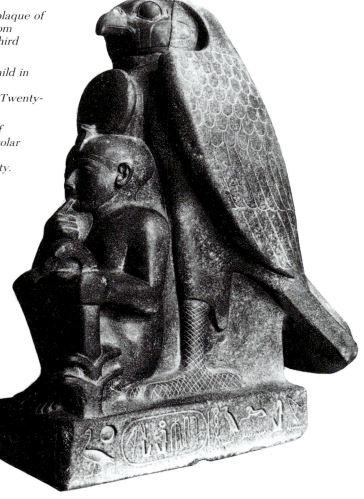

The Egyptian language had some seven words for "child," most of which signify different – though often overlapping – stages of development from the infant to the grown youth. All of these words share a common determinative sign, however: a nude child, sitting with index finger held to the mouth and wearing on his head the distinctive "side-lock" of youth. Depictions of the ram-headed god Khnum often show this deity forming the child and its *ka* (*D28), or double, on his potter's wheel in this exact pose. The hieroglyphic form is closely followed, in fact, in most cultic representations of children – as in **ill. 1** where the gods Horus, Hekau (Magic), and Hapi (the Nile), are shown presenting the young Amenhotep III and his *ka* to the great god Amun-Re in the temple at Luxor.

It is in this way that the young sun god Heru-pa-khered: "The Infant Horus" – whom the Greeks called Harpokrates – was portrayed, and whose finger- or thumb-sucking they misunderstood as a gesture of silence. Harpokrates, and a number of sun-child deities which were assimilated with him, symbolized the beginning of existence; and these gods are frequently represented sitting on a sacred lotus (*M9) which rises from the "lake" hieroglyph (*N39) symbolizing the primeval flood (**ill. 2**). A related and also common solar image depicts the sun child within the solar disk itself, as in **ill. 3**. Here, the young sun god rises between two lions (representing "yesterday" and "tomorrow,") posed in the shape of the horizon hieroglyph (*N27). The solar deity is received into the arms of Nut, the goddess of heaven, before sinking again into the west which is represented by a bovine skull (signifying the cow-goddess Hathor). The serpent holding its tail in its mouth in this composition forms the shape of the *shen* hieroglyph for "eternity" (*V9) and symbolizes the eternal renewal of the young sun god. Horus the child is also frequently the subject of works which show the seated goddess Isis holding the infant in a similar pose. Standing, he is represented on the carved plaques known as *cippi*, which were used for magical purposes connected with the healing of sickness caused by the bites and stings of noxious creatures.

Mes, one of the words for "child" and related concepts such as "beget" and "give birth," may be the basis of the biblical name Moses and is found in such Egyptian royal names as Thutmose (*Djhehuty-mes*: "Thoth bore Him") and Ramesses (*Ra-mes-su*: "Re bore him"). The form of the sign used as a determinative for *mes* allowed the sculptor of the famous statue of the young Ramesses II (**ill. 4**) to incorporate the hieroglyph into his composition. Here, crouching before the protective figure of a divine falcon, the king is shown as a child (*mes*) with the sun disk (*re*) on his head, and holding a sedge plant (used phonetically as *su*) at his side. The statue thus forms a triple-hieroglyph rebus spelling *Ra + mes + su*: a writing of the king's name. Although depicted as a child in this composition, the association of Ramesses with the infant sun god is clear.

mes

A 17

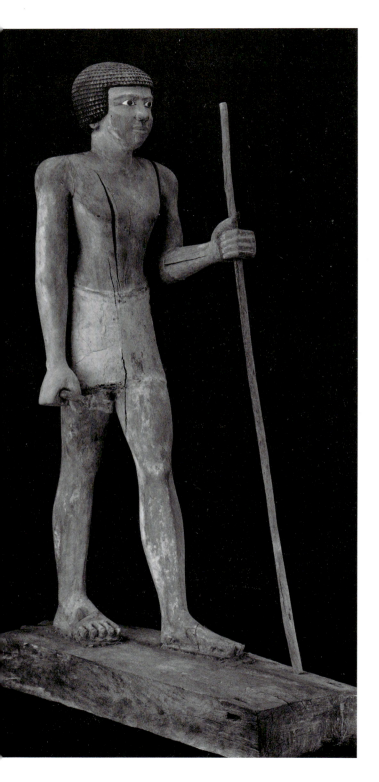

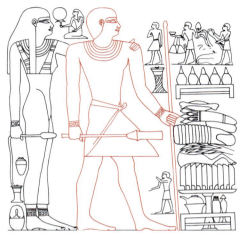

1 *(Left) Statue of Wepwawetemhat, from Asyut. First Intermediate Period.*

2 *(Above) Stele of Sa-Inheret, from Sheikh el-Farag. Twelfth Dynasty.*

3 *(Below) King with staff and cloth, tomb of Seti I, Thebes. Nineteenth Dynasty.*

The image of a man standing with one foot advanced, holding a staff in one hand and a scepter (*S42) in the other, was used as a determinative in written words such as *khenty*: "statue," and *tut*: "statue" or "image." It was in this way that noble and successful men were portrayed in the classic Egyptian tomb statue. The hieroglyph itself appears in Middle Kingdom times but statues were produced in this pose at least as early as the beginning of the Old Kingdom some seven hundred years earlier. **Ill.** 1 shows an example of the genre, the wooden statue of the man Wepwawetemhat from about 2100 BC; and although this work now lacks part of its original costume, every detail of the formal stance reflects the canonical tradition of a pose already established for hundreds of years by the time the statue was made.

khenty

A 22

The same pose is also found in painted and relief representations in funerary contexts from the beginning of the Old Kingdom. **Ill. 2** provides an interesting example of the motif from a Twelfth Dynasty tomb at Sheikh el-Farag in Upper Egypt. In this stele the tomb owner, Sa-Inheret, is shown in the standard two-dimensional representation of the "statue" pose, but the work is also a fine example of the way in which Egyptian artists do occasionally display an imaginative variation on such established themes. This charming adjunct to the symbolism of the piece is seen in the figure of the man's wife whose importance is shown not only by the similarity of their representations, but also by the lotus bud which she holds and which stands unnaturally erect in her hand. The natural limpness of the lotus may be seen in that part of the flower's stem hanging behind her hand and in the depiction of the flowers of the same species draped over the arm of the small offering bearer before the couple – but the stiffened lotus bud held by Sa-Inheret's wife is clearly meant to mirror the scepter carried by her husband, and thus to impart a measure of authority and prestige to her also. In the same way, the woman's embrace of her husband almost imitates his holding of his staff and the artist has thus been able to incorporate the essential elements of the statue pose effectively into the representation of the wife as well as that of the husband.

Just as the basic form of the statue might be produced with certain variations, variants of the hieroglyph also exist. The hieroglyphic figure may hold a kerchief instead of the scepter (**ill. 3**), for example, and the determinative for the word *iety*: "sovereign", shows the king in the same stance yet holding a mace or club in place of the scepter. While this royal form of the statue pose appeared no later than the private type (and may well have provided the origin of the latter), it enjoyed an even longer existence, continuing to the very end of Egypt's pharaonic period and appearing in combination with many long-established forms of royal representation even as late as Roman times.

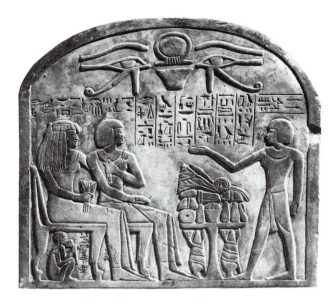

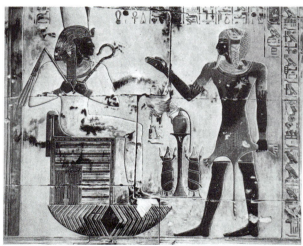

1 *Stele of the chief metalworker Ahmose. Eighteenth Dynasty.*

2 *Iunmutef priest, temple of Seti I, Abydos. Nineteenth Dynasty.*

3 *Emissaries before the king, temple of Ramesses II at Beit el-Wali. Nineteenth Dynasty.*

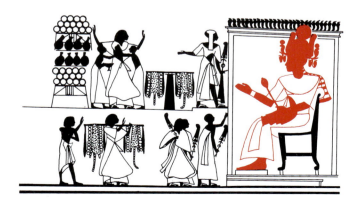

In written Egyptian, the figure of a man with one arm raised, beckoning or calling, is found in words such as *djewi*: "call," *nis* and *ash*: "summon," as well as in related words such as *sedjem-ash*: "servant" (literally, one who hears the call or summons). In large-scale representations, the gesture is found especially often in tomb paintings and funerary stelae where relatives are shown invoking or calling forth the spirit of the deceased, usually to accept offerings. This is seen in **ill. 1**, where the man Ahmose and his wife and family are depicted in the classic Egyptian offering scene on a limestone stele dating to the New Kingdom. Ahmose and his wife Werer sit before a table heaped with offerings, and before their eldest son Meny who calls forth their spirits to receive the gifts. Usually such scenes are without subtlety, though occasionally the respective members of the family may be identified with the underworld deity Osiris, his wife Isis, and their son Horus. The fact that the man and his wife are usually shown seated in such representations is also symbolic of the fact that they have now become *akhu* or "revered spirits" – just as the hieroglyph for this word (A51) is written with a seated person in virtually the same pose.

Temple reliefs include the summoning gesture in many depictions of religious rituals where a priest – or the king serving in a priestly function – makes an offering or serves a deity in some other way. This may be seen in **ill. 2** where an *Iunmutef* ("pillar of his mother") priest – who symbolized the eldest son of the divine or royal family and who cared for the deceased king – pronounces a censing formula before the image of Seti I. Statues of the king also appear to have been made showing the monarch reaching out in the summoning gesture, and these statues may well have been used in temple rituals in order to allow the king to invoke and attend to the gods without the necessity of his actual presence.

In secular contexts, the Egyptian king is shown in this same pose, summoning servants or accepting tribute, in many narrative relief scenes of the New Kingdom. In **ill. 3**, Ramesses II receives Nubian emissaries in this way. Sometimes – as in the upper register of this composition – the invocation gesture is also found in juxtaposition with the gesture signifying rejoicing (*A28). Scenes showing the reward of some favored official by the king are invariably produced in this way, with the king shown in the calling or summoning pose, and the honored person adopting the attitude of the gesture "to rejoice." Such scenes are prime examples of the influence of hieroglyphic forms upon Egyptian art. In all its instances, however, the "calling" or "invocation" gesture must be carefully distinguished from the normal gesture of greeting which is quite similar. In the greeting gesture, the hand is held with the palm toward the person being greeted, so that the artist renders it in profile with the thumb shown on the underside of the hand. In the gesture of summons or invocation, however, the arm is usually extended somewhat further, and the thumb is seen on top of the hand which is held vertically.

nis

A 26

1 *Khonsumes before the scale, Papyrus of Khonsumes B. Twenty-first Dynasty.*

2 *Rejoicing man, temple of Ramesses III, Medinet Habu. Twentieth Dynasty.*

3 *The high priest Amenhotep before a statue of Ramesses IX. Temple of Amun, Karnak. Twentieth Dynasty.*

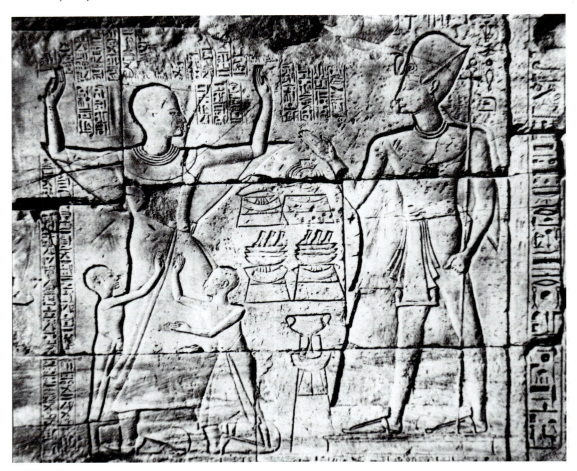

The positive and joyful side of the Egyptian personality is perhaps seen in the fact that the Egyptian language contained over ninety words for happiness, rejoicing, and exultation. Many deities were associated with joy and a number of animals, plants, and materials were symbolic of this emotion – the ape (*E32), the cow (*E4), and the lotus (*M9) being examples. In the human body joy was associated with the heart (which was believed to be the seat of emotion) and the nose, both of which could also act as symbols for rejoicing. In the written language, however, a man with both arms raised high in jubilation formed the determinative used for the writing of *hai*: "rejoice," and several other related words. In Egyptian art this same gesture is clearly seen in a number of scenes which show the deceased appearing in triumph after being found innocent at the weighing of his heart (*F34) in the afterlife Hall of Judgment. **Ill. 1** shows such a scene from a vignette in the Book of the Dead of Khonsumes where the man jubilates at the positive outcome of the test.

The gesture for rejoicing also appears in representations from secular contexts such as victory celebrations (**ill. 2**) or the royal investiture of an honored official – a motif which was especially popular in the tomb decoration of those so honored in the later dynasties of the New Kingdom. The relief carving of Amenhotep, the high priest of Amun, being rewarded with a golden collar at Karnak provides a good example of this motif (**ill. 3**). Here, the priest stands before a beckoning statue of Ramesses IX and is thus symbolically in the king's presence to receive the decoration. Attendants (who are shown on a smaller scale) adjust the priest's robes and the collar while Amenhotep lifts up his hands in the gesture of joy. Several art historians have referred to this scene as an "elaborate hieroglyph," as both the priest and the king (who stands in the position of the summoning gesture – *A26) mirror written hieroglyphs in their stances, and the scene provides an excellent example of the use of hieroglyphic forms in Egyptian art.

Not all raised arm figures connote joy, however. Because the hands were also lifted up in grief, this same determinative is found in the writing of one of the words for "to mourn" and in some representations of mourning (*B8). The two uses are, however, clearly discernible in context. In the same manner, representations which show the air god Shu – or other deities – supporting Nut, the goddess of the heavens, with upraised arms are certainly not directly associated with the concept of joy and signify only the simple act of holding the heavens aloft (see *C11). A somewhat similar hieroglyph which shows the figure of a man with both arms raised before his face (A30) depicts the attitude of giving praise, supplication, or respect; while the ithyphallic god Min and certain other deities are invariably represented holding one arm above their heads in what is probably a protective gesture.

hai

A 28

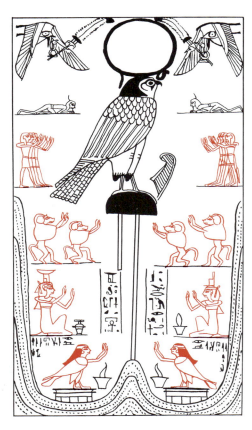

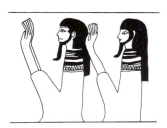

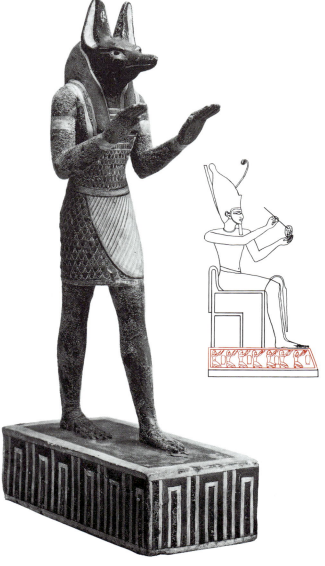

1 *(Above) Solar falcon adored, Papyrus of Anhai. Nineteenth Dynasty.*

2 *(Top right) Adoring gods, from Papyrus of Kenna. Nineteenth or Twentieth Dynasty.*

3 *(Right) Painted wooden statue of Anubis. Ptolemaic Period.*

4 *(Far right) Enthroned Amun-Re, Ramesseum, Thebes. Nineteenth Dynasty.*

The figure shown with outstretched and upraised arms in this hieroglyph represents the pose of worship and adoration adopted by the Egyptians. In the written language the hieroglyph was used as a determinative in such words as *iau*: "praise," *dua*: "adore," *suash*: "extol," and *ter*: "to show respect," so the gesture's range of meaning is perfectly clear to us. Because the gesture was made before all images of the gods as well as by people approaching the king, it is frequently found in religious scenes and in certain works of art representing subjects, captives, and tribute bearers in the royal court.

In painted scenes, figures adopting this pose are often shown in exactly the same manner as in the hieroglyph – apparently with one arm held further forward than the other. But this is a result of the artistic convention used by the Egyptians, which shows the upper torso turned toward the viewer although the rest of the body is shown in profile. The stance is, however, accurately portrayed in three-dimensional sculpture, as may be seen by comparing the following examples. An illustrated papyrus in the British Museum (**ill. 1**) shows the solar falcon of the west (°R13) being adored by different groups of figures – men, gods, baboons (°E32), goddesses and *ba* (°G53) or soul birds. The pose is frequently seen in illustrations of symbolic animals – baboons, for example – and where necessary, such creatures as the *ba* birds are depicted with human arms in order that they might accomplish the gesture of adoration. The positioning of the arms of the goddesses Isis and Nephthys in this illustration is particularly like that found in the hieroglyph, and this pose is usual for adoring human figures. The Ptolemaic painted wooden statue of Anubis in New York's Metropolitan Museum of Art (**ill. 3**) illustrates the actual position of the arms in this gesture. Along with **ill. 2**, it also reiterates the fact that even gods could adopt this pose before deities greater than themselves, as may be seen in many representations of ancillary deities before Osiris or before some manifestation of the sun god – for all practical purposes, the two most important deities in Egyptian culture.

In the context of praise and adoration directed toward the king, the gesture is seen in both narrative and symbolic scenes. Not only do we find figures standing or kneeling (A4) before the king in narrative expressions of this pose, but adoring figures are also frequently depicted on the base of the throne or dais upon which the king is seated, or upon his footstool or other area of similar significance (**ill. 4** – in this case the throne of the god Amun). These emblematic figures may consist of rows of bound captives (°A13) in which the arms of the leading figures are left free to offer praise. Alternatively, the figures may represent subjects – frequently shown in the form of pinioned lapwings or *rekhyt* birds (°G24), which are depicted with arms for the same purpose of expressing adoration.

ADORE

dua

A 30

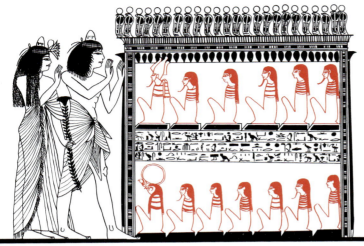

1 *(Top left) Seated gods, tomb of Sennedjem, Thebes. Nineteenth Dynasty.*

2 *(Above) Deceased in solar barque, Papyrus of Gautsushshenu. Twenty-first Dynasty.*

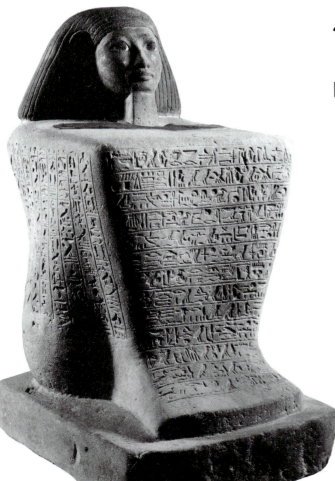

3 *Block statue of Satepihu, from Abydos. Eighteenth Dynasty.*

This sign belongs to a large class of hieroglyphs depicting seated deities and humans – in the latter case, usually revered persons. The form represents a direct profile view of a figure sitting with knees bent and feet drawn back toward the body. The essential characteristic, however, is the mummy-like nature of the tightly wrapped body, and as a result the arms and hands are not usually shown. Variant forms include the range of anthropomorphic deities which may be represented in this manner (C1-10) and a number of human figures such as the seated king (A42-6) and the "foreigner" holding a feather, throwing stick, or knife (A47-9). According to Egyptian convention, male deities were usually differentiated by the addition of a curved beard.

Examples of the direct transposition of this hieroglyphic form to representational – especially funerary – contexts are common. A scene in the Nineteenth Dynasty tomb of Sennedjem at Thebes (**ill. 1**) is typical. Here the owner of the tomb and his wife approach a shrine-like structure in which a number of deities are seated. The deified nature of the figures is apparent in the hieroglyphic form in which they are represented and is also seen in the plinths – in the shape of the *maat* sign (*C10) – upon which the figures of gods are often set. Seated gods of this type also occur frequently in the vignettes of most copies of the Book of the Dead. They are the members of the divine tribunal which oversees the judgment of the deceased and are sometimes depicted with various anthropomorphic and zoomorphic faces – and in some cases, with hieroglyphic heads representing the personifications of qualities or elements such as "fire" (*Q7) or "truth" (*H6).

The deceased may also be shown in this same wrapped, seated pose in various afterlife scenes, and examples where the person accompanies the god Re in the solar barque (*P3) in this form are not infrequent. **Ill. 2** is one such example from the Twenty-first Dynasty papyrus of the Lady Gautsushshenu in which the scale and pose of the deceased woman and the god are virtually identical. Gautsushshenu has even been given a crook and flail in this representation as further indicators of her divinity. Although not usually considered in this context, many of the so-called "block" statues of private Egyptian statuary actually embody the essential characteristics of this hieroglyph in three dimensions (**ill. 3**). Such statues were produced for afterlife use and the presentation of the deceased as a revered person may well be a major part of their purpose. A block statue in the Archaeological Museum of Florence which shows the deceased seated in this manner on a staircase (*O40) underscores this possibility. The staircase may represent the dais upon which Osiris – with whom the deceased is identified – sits, or alternatively it may refer to the primeval hill of creation. Either interpretation accords the deceased the status of a revered person for whom the seated god pose is perfectly apropos.

netcher

A 40

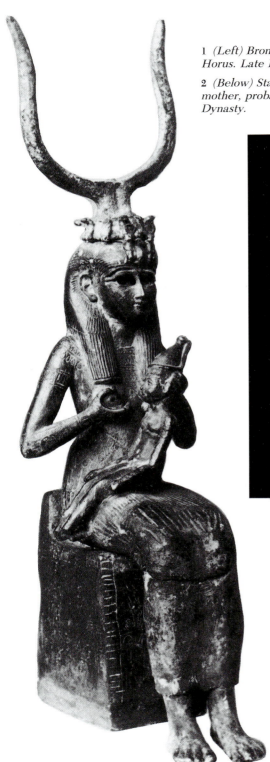

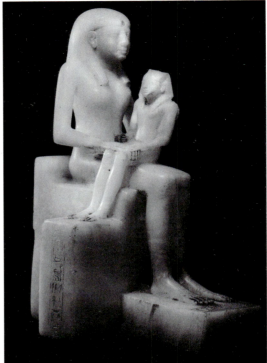

1 *(Left) Bronze statuette of Isis and Horus. Late Period.*

2 *(Below) Statuette of Pepy II and his mother, probably from Saqqara. Sixth Dynasty.*

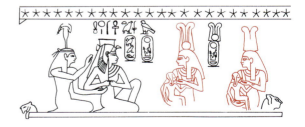

3 *Amenhotep III and his ka nursed by goddesses, Birth Room of Luxor Temple. Eighteenth Dynasty.*

Two closely related hieroglyphs – and a number of variants of each – may be described under this heading. While Gardiner's sign list shows both a seated woman with a child on her lap (B6) as well as a kneeling woman with a baby at her breast (B5), many variations of the woman's posture occur. The woman may, in fact, be shown standing, seated, or kneeling, and the child may or may not be held to the breast, yet the essential concept is the same; and any of the existing variants may be found written in the hieroglyphic script as determinatives for such words as *menat*: "nurse," "foster mother," or *renen*: "nurse," "rear."

In Egyptian artworks this motif occurs with the same degree of variety of expression, yet the subjects are usually limited to the figures of the goddess Isis and her son Horus, or – by extension of the myth – to Isis and the king as Horus. Thus the goddess Isis is represented as the *mut-netcher* or "mother of god" (a title which, with the advent of Christianity, was later transferred to the Virgin Mary) holding the infant Horus to her breast in countless Egyptian statues and amulets (ill. 1). The motif of the Egyptian king being nursed by a goddess is also an old one, and one which was commonly represented on the walls of the royal cult temples. One of the earliest examples is that of King Unas, who is shown nursing at the breast of an unidentified goddess in a relief from his mortuary temple at Saqqara. The scene becomes very popular in the later New Kingdom and is often associated with the coronation ceremonies and with what may have been an actual ritual aimed at the rejuvenation of the king's *ka* (see *D28). In addition to Isis, a number of other goddesses may be shown as the nursing mother of the king, and representations of Hathor – who is sometimes portrayed as a cow (*E4) as well as in the form of a human woman – are especially common in this maternal role.

The king may also be shown held by or nursing at the breast of his actual mother, as in ill. 2 which shows an alabaster statue of Pepy II – as a miniature adult and wearing his kingly regalia – seated on the lap of his mother, Queen Ankhnesmeryre. Here, the queen clearly fulfills the role of the maternal goddess, a fusion which may be found in a number of other representations (see *D27); but in other instances the royal mother takes a more subsidiary part in the representation of the nursing of the king. This may be seen in one of the scenes from Luxor Temple where Mutemwia, the mother of Amenhotep III, merely watches as the young king and his *ka* are nursed by a number of goddesses after his birth (ill. 3). Variants of this type of scene are commonly found on the walls of the *mammissi* or "birth rooms" of later Egyptian temples, where episodes from the divinely initiated birth of the king were recorded up through the Roman Period. Portrayed alone, representations of royal and divine children (*A17) may signify the concepts of creation, rebirth, and the eternal nature of the solar cycle.

WOMAN NURSING CHILD

menat

B 5,6

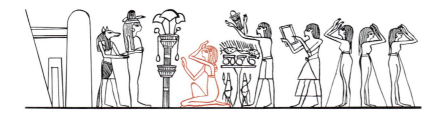

1 *(Top) Funerary vignette, Papyrus of Nesitanebtashru. Twenty-first Dynasty.*

2 *(Above) Mourners, tomb of Ramose, Thebes. Eighteenth Dynasty.*

3 *(Below) Mourners, Papyrus of Ani. Nineteenth Dynasty.*

4 *(Right) Statuette of mourning Isis. Twenty-sixth Dynasty.*

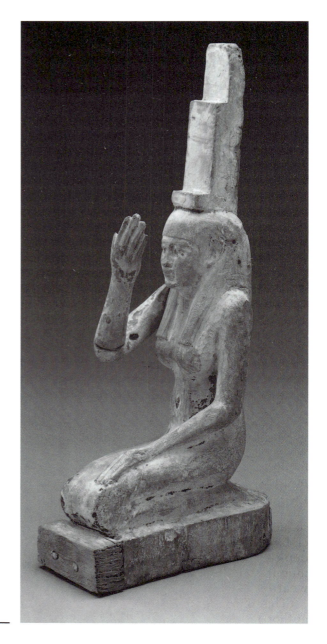

Mourning the dead was traditionally the role of women in ancient Egypt and mourners appear in almost all representations of funerary rituals. A bereaved wife, or a close relative of a dead woman, is often shown crouching before the mummy of the deceased while a group of professional mourners or other women of the family stand or sit, lamenting, a little way off (**ill. 1**). The sorrowing woman before the mummy and the other mourners are usually depicted with one hand raised to their heads in an expressive gesture which can symbolize the act of covering the face or throwing dust upon the head as a sign of sorrow. This gesture is seen in the group of mourners from the tomb of Ramose at Thebes (**ill. 2**) and is exactly that found in the written determinative used in the hieroglyphic word *iakbyt*: "mourning woman," and in some of the dozen or so other Egyptian words for mourning and mourners.

The hieroglyphic nature of many representations of mourners may be seen in the way in which the stance of the different women often appears to be virtually identical – as is the case in ill. 2. The hieroglyph itself shows a crouching woman with one hand raised before her face and often delineates, in a simple fashion, the mourner's unkempt or disarranged hair. Although the written determinative is too small to show any but these essential details, larger representations such as that shown in **ill. 3** frequently include teardrops or lines on the women's faces and also show the mourners' clothes to be torn or pulled open to reveal the breasts which were beaten with loud cries – a manner of mourning still practiced in many areas of the Near East.

The archetypal image of mourning in Egyptian culture was that of the goddess Isis and her sister Nephthys mourning for Osiris, and the two deities are frequently depicted mourning, respectively, at the feet and head of the mummiform god. As a natural corollary of this motif, the two sisters are frequently shown kneeling on the ends of Egyptian coffins and sarcophagi, mourning for the deceased who symbolically became an "Osiris" at the time of death. Many statuettes also exist which depict the two goddesses kneeling in the hieroglyphic pose. The example shown in **ill. 4** is a wooden figure of Isis in the Boston Museum of Fine Arts which shows the goddess wearing on her head the sign of the throne (*iset*) which spells her name. Pairs of statues such as these were often made to be positioned at their respective ends of the sarcophagus. Because of the wailing cries of mourning women, the two sister goddesses are often termed the *djerity* or "two kites" (birds of prey which sometimes frequent the area of the necropolis with loud piercing cries). In some representations Isis and Nephthys are, in fact, depicted as hawk-like kites stationed at the head and feet of the mummy and identified only by the hieroglyphic signs which they wear on their heads.

(This hieroglyph has been added to Gardiner's sign list by the author.)

iakbyt

B 8

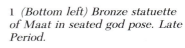

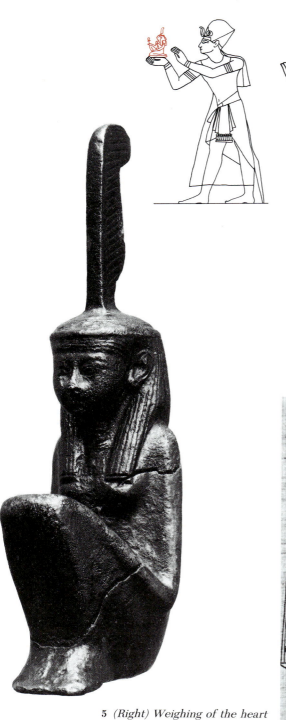

1 *(Bottom left) Bronze statuette of Maat in seated god pose. Late Period.*

2 *(Center left) King presenting Maat, temple of Seti I, Abydos. Nineteenth Dynasty.*

3 *(Left) Image of Maat, Temple of Ramesses II, Abu Simbel. Nineteenth Dynasty.*

4 *(Below) Maat in solar barque with Re, Papyrus of Nespakayshuty. Twenty-first Dynasty.*

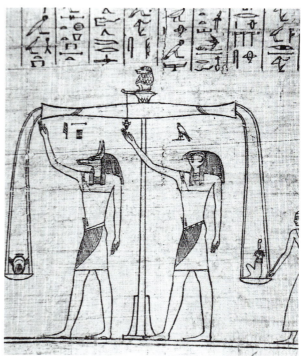

5 *(Right) Weighing of the heart vignette, Papyrus of Ankhwahibre. Late Period.*

The goddess Maat personified the idea of order which was fundamental to the Egyptian worldview and which formed the basis of the Egyptians' concepts of law, justice and truth. The hieroglyph shows the goddess seated, with knees drawn up in the manner in which deities (*A40) were represented, and with the tall ostrich feather (*H6) which was her symbol upon her head. She appears in this hieroglyphic form in many statuettes (as in **ill. 1**) and amuletic pendants and in a number of other representational contexts.

As the personification of world order, Maat embodied one of the chief responsibilities of the Egyptian king – to re-establish and maintain the original order and security of the cosmos; and the goddess is therefore often depicted in scenes where the king symbolically "offers" her as a supremely important gift to the gods (**ill. 2**). Such scenes show the king holding a small image of Maat in his cupped hand, usually in her basic hieroglyphic form, yet occasionally with small, symbolically important variations. This is especially true of the monuments of those Ramesside kings whose names included that of the goddess and who therefore had a special identification with her. In the facade of the great rock-cut temple at Abu Simbel, for example, Ramesses II is shown offering Maat on either side of a large image of the god Re who holds *user-* and *maat-*headed staffs in his hands and thus forms a huge rebus of the king's throne name: *User-maat-re*. Not only does this central image of the god reflect the king's name, but each tiny image of Maat which the king offers (**ill. 3**) also may be seen to hold an *user* staff and to be crowned with a sun (*re*) disk, and thus to spell out the royal name. This association with the sun is also a mythological one, however, for as the "daughter of Re," Maat is often shown accompanying the sun god in his solar barque (**ill. 4**) – sometimes as two identical goddesses, the *Maaty*, in the barques of the morning and evening sun.

The goddess was also intimately connected with the Egyptian notion of truth and justice, and judges were regarded as priests of Maat in the fulfillment of their roles. In the weighing of the heart of the deceased which constituted the afterlife judgment, the heart (*F34) was believed to be weighed against the feather of Maat, and most illustrated copies of the Book of the Dead include a vignette which shows this judgment, with one pan of the balance scale containing the image of the *maat* feather or the goddess herself (**ill. 5**). Often the image of Maat may also surmount the central beam of the scale, or appear nearby. Another symbol of *maat* is found in the narrow hieroglyphic sign which resembles a straight rule or measure (Aa11). The concept of "straightness" which this represents is seen literally in the word *maut* which can signify the shaft of a spear, a staff, stalk, or rays of light, and figuratively in *maa*: true, just, and right. The symbol thus formed the plinth upon which statues and other representations of deities were placed.

MAAT

maat

C 10

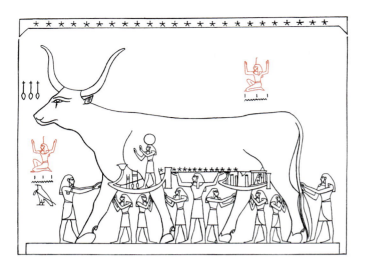

1 *Cow of Heaven supported by Heh deities, tomb of Seti I, Thebes. Nineteenth Dynasty.*

2 *Ceremonial chair back, tomb of Tutankhamun, Thebes. Eighteenth Dynasty.*

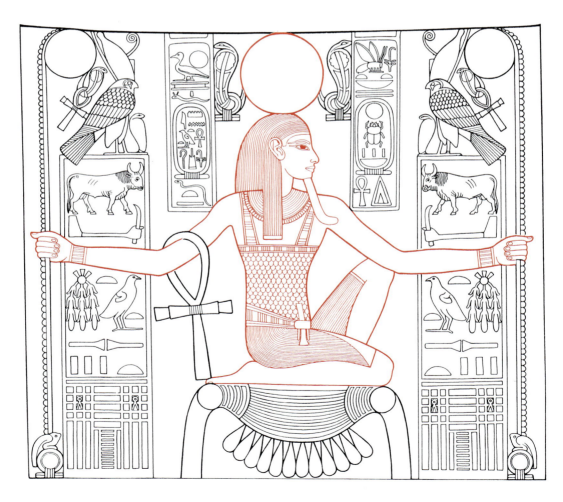

The name Heh subsumes a number of separate mythological beings, yet the symbolism of these deities is seldom blurred in the representations found in Egyptian art. According to Hermopolitan legend, Heh was one of the primeval deities who existed along with the gods Nun ("water"), Kek ("darkness"), and Amun (perhaps "void") before the world began. These gods are mentioned together in the Middle Kingdom Coffin Texts; and in later representations, Heh and his female counterpart Hehet are shown first in human form and later as a frog (°I7) and snake-headed human respectively. In another myth, the magical Heh deities were created to help hold the sky aloft when the celestial cow (°E4) rose with the sun god Re on her back to become the sky. When the cow trembled because of the great height, Re created eight Heh deities to support her. He placed two of these gods at each of the cow's legs and Shu, the god of the air, was also commanded to stand beneath the body of the cow to support her and to protect the Heh deities. **Ill. 1** illustrates this myth, though in this representation the god Re travels across the sky in his solar barque (°P3) rather than riding on the cow's back. The belly of the cow is thus adorned with stars, and a second barque below her udder represents either the moon or the evening boat of the sun. The Heh deities are shown supporting the cow's legs, and the hieroglyph written above the back of the cow and again below her face is the *heh* glyph referring to these gods.

Perhaps most importantly, Heh was the personification of eternity. Because of the linguistic meaning of the word *heh* – a million or very great number – Heh was often associated with the concept of great lengths of time (perhaps as a result of the common expression *heh-em-renput*: "a million years"), and the iconography of the deity usually reveals this association. The god is often shown wearing the palm branch (°M4), which was the sign for "year," on his head or holding two of these notched branches in his hands. He is shown in this manner from Middle Kingdom times. On the back of the carved ceremonial chair of Tutankhamun (ill. **2**), and on many other treasures from that king's tomb, the god of eternity is shown in the classic hieroglyphic pose, kneeling on the sign for "gold" (°S12) or on the "festival" sign while grasping his year-marked branches. In this particular example the god also has an *ankh* sign (°S34) slung over his arm, and each palm branch ends with a small tadpole (°I7) – representing 100,000 – seated on a *shen* sign (°V9) signifying infinity. The meaning of the whole group is, therefore, the wish that the years of the king's life might amount to "100,000 times infinity."

Because of this kind of usage the figure of the god Heh was a favorite motif frequently represented on the personal effects of the Egyptian kings – especially in the New Kingdom – and his image may be found as a decorative element in a wide range of contexts.

HEH

Heh

C 11

1 *(Far left) Detail of Narmer Palette, from Hierakonpolis. Early Dynastic Period.*

2 *(Near left) Head of the goddess Meskhenet on birth brick, Papyrus of Ani. Nineteenth Dynasty.*

3 *(Below) Heads of four sons of Horus on model canopic jars. Third Intermediate Period.*

4 *(Bottom) Four human heads on serpent's back. Third funerary shrine of Tutankhamun, Thebes. Eighteenth Dynasty.*

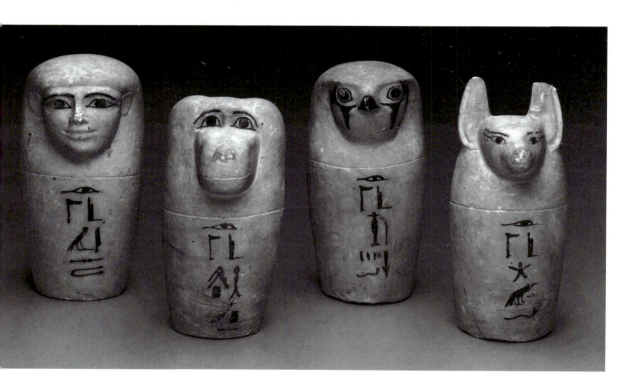

Because the head signified the whole being, this part of the body may be shown independently in Egyptian art and writing to represent a person, god or animal. The inhabitants of Lower Egypt are thus represented by a head attached to the hieroglyph for "land" on the Narmer Palette (which celebrates a military victory of the First Dynasty king Narmer, and may record events which took place close to the original unification of Egypt – ill. 1, and see *M15). In this same way the head of a god or goddess is sometimes shown attached to an object related to the nature of that particular deity. Meskhenet, the goddess associated with childbirth, for example, is frequently shown in the form of a woman's head attached to a brick of the type Egyptian women crouched upon when giving birth (ill. 2). Meskhenet was also believed to appear at the time of an individual's death – perhaps to preside over "birth" into the afterlife – and the goddess is sometimes depicted in this way in vignettes from the Book of the Dead.

In a similar manner, the heads of the four sons of Horus who guarded the internal organs of the deceased are portrayed on the lids of the so-called canopic jars in which these organs were embalmed (ill. 3). Although they are occasionally shown as full mummified figures, from the end of the New Kingdom these four gods are usually represented by their heads only: Imsety (guarding the liver), with the head of a human; Hapy (guarding the lungs), with the head of a baboon; Duamutef (guarding the stomach), with a dog's or jackal's head; and Qebesenuef (guardian of the intestines), with the head of a hawk. In some periods, however, the four heads are not differentiated and the gods may be represented by four identical human heads – as in ill. 4, where they are fused with the body of a protective serpent.

Conversely, the opposite principle is also common in Egyptian art, and the heads of deities may be replaced by their hieroglyphic signs – as when gods of the underworld are shown with fire signs (*Q7) in place of their heads, or the head of the goddess Maat is replaced by her symbol, the feather (*H6). Malevolent beings may be depicted as headless figures in order to render them harmless magically, just as certain hieroglyphs – such as the signs for scorpions and snakes – were often mutilated or rendered incompletely in written texts for the same reason.

As the part of the being which held individual human appearance, it was important that the head be preserved for the afterlife survival of the complete person. This may have led to the Old Kingdom practice of placing a carved stone "reserve" head in the tomb with the deceased. Even though the areas surrounding the face are often only roughly delineated in these works, reserve heads usually show a high degree of care in the portrayal of the facial features. The mummy mask which appeared in New Kingdom times may also have originated in this same desire to preserve the head and thus the appearance of the deceased.

HEAD

tep

D 1

1 *(Near left) Solar eye pectoral, tomb of Tutankhamun, Thebes. Eighteenth Dynasty.*

2 *(Far left) Detail, lunar eye pectoral, tomb of Tutankhamun, Thebes. Eighteenth Dynasty.*

3 *(Center, below left) Detail, coffin of Menkabu, from Farshut. First Intermediate Period.*

4 *(Center, below right) Personified wedjat eye, tomb of Pashedu, Deir el-Medina. Nineteenth Dynasty.*

5 *(Bottom) Ramesses X presenting wedjat eyes, tomb of Ramesses X, Thebes. Twentieth Dynasty.*

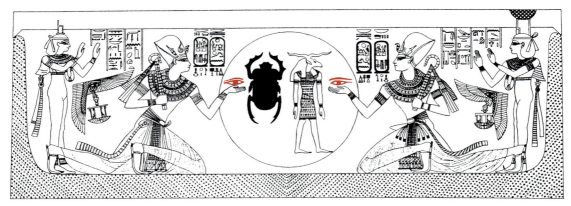

From very early times in Egypt the sun and the moon were regarded as the eyes of the great falcon (°G5) god Horus, though the two eyes eventually became differentiated – with the left eye (the "Eye of Horus") often being regarded as the symbol of the moon and the right eye (the "Eye of Re") being that of the sun. An ornate pectoral, or chest ornament, among the treasures of Tutankhamun depicts the right or solar eye (**ill. 1**), while another depicts the left eye beneath a lunar orb (**ill. 2**). A mythological story which tells how the Eye of Horus was damaged and then healed reflects the waning and waxing of the moon, and the name *wedjat* given to this symbol would seem to mean "the whole or restored one." The composition of the symbol itself is not completely understood, however, though it seems to represent a human or falcon eye (depending on the individual representation) above the distinctive cheek marking of the falcon. The stylized, spiral "tear line" below the eye is somewhat like that found on the face of the cheetah – which was also associated with the heavens in early Egyptian mythology by virtue of the star-like pattern of its coat.

Despite the uncertainties surrounding the origin and significance of the sacred eye symbol, its use in Egyptian iconography is widespread and relatively clear. Above all, the eye was a protective device, and this is seen in the countless representations of the *wedjat* which are found in amulets and jewelry and on the protective plaques which were placed over the embalming incision on mummies. This protective aspect is probably at least part of the significance of the two eyes which were commonly painted on the left side of coffins during the First Intermediate Period and Middle Kingdom (**ill. 3**). Although the mummy was often placed on its left side in these coffins, suggesting that the eyes may have served as a "window" onto the world for the deceased, a protective function also seems likely. In the same way, the Horus eyes painted on the bows of boats both protected the vessels and "saw" the way ahead. More directly, in New Kingdom representations the sacred eye is often depicted with wings (°H5), hovering behind kings and gods as an emblem of overshadowing protective force.

Because of its mythological origins the sacred eye could also function as a symbol of offerings. The restored eye which was presented by Horus to his father became an archetype of the act of offering and an offering itself. Variations on this theme appear frequently in the art of the later New Kingdom – as in **ill. 4** where a personified eye presents incense as the deceased kneels before the throne of Osiris, and **ill. 5**, which shows twin figures of Ramesses X holding the *wedjat* symbol in his cupped hand as he approaches a disk containing the deities of the rising and setting sun. As sacred solar animals, baboons (°E32) are also frequently shown presenting *wedjat* eyes to the rising sun; and in Greco-Roman times the god Nefertem – who was associated with the lotus and with offerings – was also frequently depicted holding the Eye of Horus in one hand.

WEDJAT EYE

wedjat

D 10

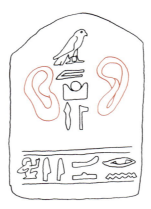
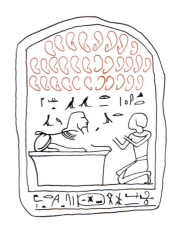

1–3 *(Above) Ear-stelae, from Giza and Memphis. New Kingdom.*

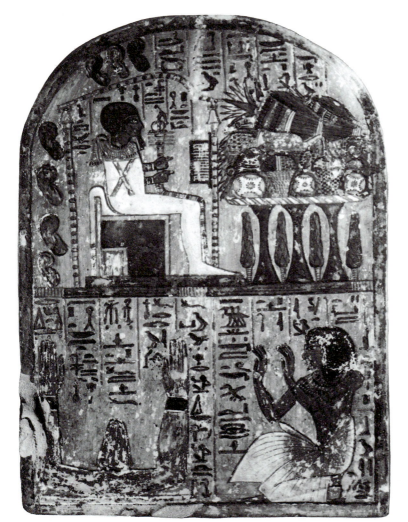

4 *Stele of Penbuy, from Deir el-Medina. Nineteenth Dynasty.*

5 *Ear amulet. New Kingdom or Late Period.*

Although the ear of the ox (F21) was used as the determinative for "hearing" and related words, the human ear was used for the word *mesedjer*: "ear," and in representational contexts related to hearing. Symbolic ears appear in mortuary paintings and in temple reliefs, but the most common occurrence of this sign is on the class of votive "ear-stelae." These stelae were usually carved with fairly summary inscriptions and with one or more pairs of ears. **Ills. 1-3** show typical examples, including one found by W. Flinders Petrie at Memphis (**ill. 3**) inscribed with twenty-two pairs of ears on its face. Early Egyptological works proposed that these stelae were requests for the healing of deafness, but the fact that comparable stelae showing other body parts do not exist immediately precludes such a possibility. The stelae were, in fact, simply dedicated to certain gods in appreciation for answered prayers or for present requests. A number of deities are described as "great of hearing" or "of hearing ears," and the god Ptah was given these epithets especially. The example in **ill. 4** – the ear stele of Penbuy in the British Museum – is dedicated to that god. In this stele, Ptah of the hearing ear is shown enthroned before a richly decked offering table with the ears symbolic of his listening role surrounding the kiosk in which he sits. Other deities sometimes described as "hearing gods" include Amun, Serapis, Horus, Thoth, and Isis.

The ears depicted on these stelae and in other contexts are only occasionally shown pierced and earrings seem to have had somewhat restricted use in ancient Egypt. Ear ornaments were probably introduced from western Asia by the Semitic Hyksos people, as only a very small number of Egyptian examples are thought to date before New Kingdom times. Initially earrings seem to have been worn almost exclusively by women, and pierced ears do not appear on the mummies of kings until Thutmose IV (*c.*1400-1390 BC), though some few private instances of the male use of earrings are known to predate this monarch's reign. At least in royal usage, it would also seem that the actual wearing of ear ornaments by males was mainly confined to young princes, and that these ornaments may have been discarded in adulthood. In the second half of the New Kingdom, representations of gods also show pierced ears, but male deities are normally not shown wearing ear ornaments. The occasional appearance of pierced ears on ear-stelae must be understood in this context, and it is doubtful that any special symbolism was involved. Given the popularity of the ear-stele, it does seem somewhat strange that the ear does not appear more frequently in other contexts (though it occasionally appears as an amulet – as in **ill. 5**), but this kind of selective use of a specific hieroglyphic symbol is not necessarily out of character for Egyptian modes of representation – where tradition must be understood to play just as great a role in the placement and use of iconographic images as it does in the development of their forms.

EAR

mesedjer

D 18

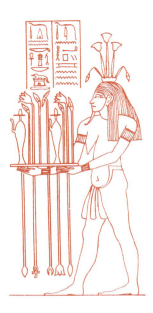

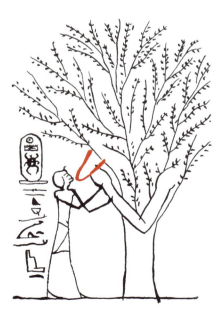

1 *(Left) Nile god with offerings, temple of Suchos and Haoris at Kom Ombo. Greco-Roman Period.*

2 *(Bottom left) Thutmose III suckled by tree goddess, tomb of Thutmose III, Thebes. Eighteenth Dynasty.*

3 *(Below) Situla held by Isis. Detail of statue from Ras el-Soda. Greco-Roman Period.*

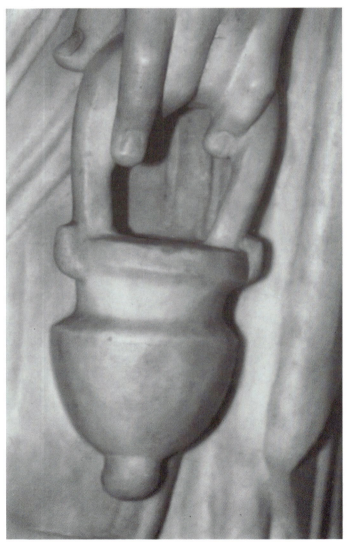

The manner in which the female breast is depicted in this hieroglyph doubtless originated in a desire to avoid confusion with the *re* sign used to signify the sun (N5). But iconographically the hanging form probably also carries the connotation of fecundity, for figures shown with pendent breasts are usually symbolic ones representative of maternal or natural abundance. Representations of Hapi, the god of the Nile inundation, for example, all show this deity as a man with the beard of the gods yet with heavy, pendulous breasts. Usually this god, and the other fecundity figures who are subsumed under his name, are shown crowned with papyrus stems and frequently, as in **ill. 1**, holding offerings of water and flowers or other items signifying the abundance which he provided. This motif is particularly common in architectural decoration, and may be found along the bases of walls and columns in virtually all temples of the Greco-Roman Period.

In a similar manner, Taweret – the protective goddess associated with pregnancy and childbirth – is represented as a hippopotamus (°E25) who stands on her hind legs in upright human position with pendent human breasts rather than with the udder of the hippopotamus. Here again, the representation of the breast in this form is clearly symbolic of the goddess' role and may be contrasted with actual representations of nursing mothers who, like Isis with her son Horus (°B6), are not usually depicted with pendent breasts. This symbolic use of the hieroglyphic form of the breast may be seen in a representation in the tomb of Thutmose III (**ill. 2**). Here, the king is shown being suckled by a goddess in the form of a sycamore tree. In the original painting, the trunk of the tree (representing the goddess' torso), the pendent breast, and the arm which supports it are painted red, while the branches and leaves are in green to help clarify the image. The inscription behind the king reads "Menkhepere [the throne name of Thutmose], nursed by his mother Isis." As this king's own mother's name was in fact Isis, the image of the nursing tree here applies to both his human and divine mothers.

In the latter part of the first millennium BC, the *situla*, a distinctly Egyptian vessel used in certain religious contexts, became assimilated into this imagery. It has been pointed out, in fact, that one of the Egyptian words for *situla* could be used as another word for "breast." The *situla* was used to hold water or milk for offerings and, as a frequent attribute of Isis, it could associate the goddess (through water) with the Nilitic rites of Osiris and (through milk) with her maternal role as the mother of Horus. Thus, in the very fine statue of Isis from Ras el-Soda in the Greco-Roman Museum at Alexandria (**ill. 3**), the goddess holds in her left hand (the traditional side of nursing) a *situla* made in exactly the form of the *menedj* hieroglyph – the pendent breast. The association of the breast with the concept of fecundity, and with the person of Isis, is here complete.

BREAST

menedj

D 27

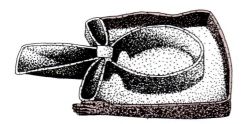

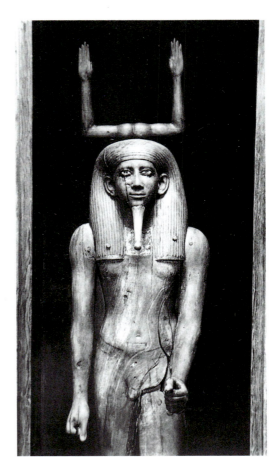

1 *Slate palette or dish. Early Dynastic Period.*

2 *Ka statue of Hor Auibre, from Dashur. Thirteenth Dynasty.*

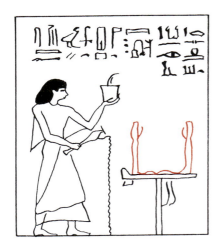

3 *Deceased before ka emblem, funerary papyrus. New Kingdom.*

4 *Coronation scene on fallen obelisk of Hatshepsut, temple of Amun, Karnak. Eighteenth Dynasty.*

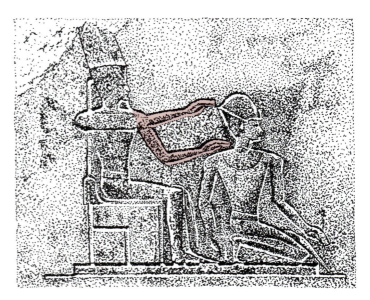

ka

D 28

While this common hieroglyph clearly represents two extended arms, the exact orientation of the arms – whether they are to be understood as reaching upward or forward – and the meaning of the gesture intended in the sign is far from clear. While some scholars have seen the gesture as one of embrace (as in the sign *D32), others see the gesture as one of praise, prayer or even self-defense. The concept behind the sign is no less elusive, and while the word *ka* is usually translated as "soul" or "spirit," the *ka* was much more than this. In ancient times the *ka* may have indicated male potency, and in all periods it is used as a term for the creative and sustaining power of life. The *ka* was thus an aspect of the human being which came into existence when the individual was born, and many representations show the ram-headed god Khnum fashioning the *ka* on his potter's wheel – as a double or twin of the individual child. To "go to one's *ka*" meant "to die," however, as the *ka* continued to live on after the body died; and the priests who served in the funerary cult were called *hemu-ka* or "ka servants." Model houses were built as funerary residences for the *ka*, and it is possible that some of the subsidiary pyramids built during the Old Kingdom served this same purpose on a much larger scale. Importantly, the *ka* needed continuing nourishment in order to survive and offerings of food and drink were made to it. Eventually, the offerings themselves began to be regarded as being imbued with the *ka*'s life-power, and the plural *kau* was used to mean "food-offerings."

This broad diversity in the meaning of the term *ka* is responsible for a wide variety of uses of the sign. The *ka* hieroglyph sometimes appears on offering tables (*R4) in place of representations of actual offerings, and in its basic sense of "life-power," the sign may appear in apposition with the *ankh* (*S34) or some other sign – as in the Early Dynastic slate palette in the Metropolitan Museum of Art (**ill. 1**). As representative of the king's double it surmounts the wooden statue of the Thirteenth Dynasty monarch Hor Auibre (**ill. 2**) and is frequently found, emblematically, supporting the *serekh* (*O33) in which the king's "Horus" name (see *O33) was written, and in funerary contexts (**ill. 3**). At a secondary level of association, the Egyptian artist frequently positioned the arms of his subjects in such a way as to form the *ka* sign when this sign was relevant to the symbolic content of the composition. In coronation scenes, for example, the sign is often formed by the overlapping arms of the deity who invests the king – thus providing the symbolic giving of "life-power" as well as the crown itself. This use is seen in the investiture of Hatshepsut depicted on her obelisk at Karnak and in the nearly identical coronation relief from the fallen obelisk of Thutmose III at the same location (**ill. 4**).

The *ka* was an aspect of gods as well as humans and the name Egypt is probably derived, through Greek, from the ancient name for the capital city Memphis: *Hut-ka-Pteh,* or "House of the *ka* of Ptah."

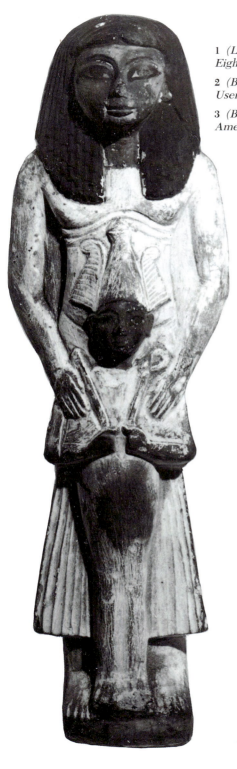

1 (Left) Statuette of Nebre with Osiris effigy. Eighteenth Dynasty.

2 (Below) Rising sun embracing earth, Papyrus of Userhet. Eighteenth Dynasty.

3 (Bottom) Ramesses III and Ptah-Tatenen, tomb of Amenherkhepeshef, Thebes. Twentieth Dynasty.

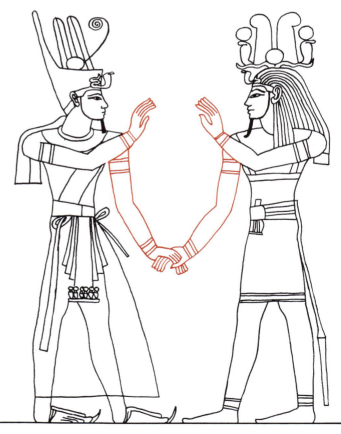

This hieroglyph – representing two arms reaching out in an embrace – was used as a determinative in words such as *ienek*: "enclose," and *hepet*: "embrace" or "hold." With these meanings, the sign is frequently found in texts and inscriptions where the king is said to have a special relationship with the gods. In the Pyramid Texts, for example, the intimate relationship between the king and a protective deity is often expressed in terms of the god's or goddess' embrace: "Nut has fallen upon her son, namely you, that she may protect you; she enfolds you, she embraces you, she lifts you up, for you are the eldest of her children" (Spell 1629). As a result of this concept, from the Old Kingdom on the goddess Nut is frequently depicted on the inside of the lids of coffins and sarcophagi receiving the deceased into her embracing arms.

hepet

D 32

In other representational contexts the form of the hieroglyph is also frequently incorporated in three-dimensional works where the idea of embracing is involved. It is especially common in statuettes showing Isis and her husband Osiris or son Horus in which the goddess extends her arms to embrace the figure standing before her. In the votive statuette of Nebre in the British Museum (**ill. 1**), the scribe holds an effigy of Osiris before him in exactly this manner, and comparison of the position of Nebre's arms with the *hepet* sign reveals the conscious utilization of the hieroglyphic form. From at least Middle Kingdom times, the identical pose is also used in statuary of private family groups where a parent (usually the father) holds a child before him. In such works the parent's hands are often turned inward toward the child in the exact form of the hieroglyph – as opposed to being shown in profile, as are the hands of other members of the group.

In more symbolic contexts this hieroglyph is used in representations of the rising sun where the twin peaks of the horizon (*N27) are depicted as the breasts of a reclining goddess whose upraised arms support and embrace the solar disk. Rather more unusual is the British Museum papyrus vignette shown in **ill. 2**, where the artist has portrayed the solar disk itself as reaching out and embracing the earth. In New Kingdom works the "embrace" sign also seems to have been occasionally used at a secondary level of association where it is formed by the interlocking arms of persons shown facing each other. In the tomb of Prince Amenherkhepeshef in the Valley of the Queens, a number of scenes depict Ramesses III greeting deities such as Imsety, Isis, and Ptah-Tatenen. In each of these scenes the king and the deity face each other, hand in hand, while they raise their free hands to greet one another (**ill. 3**). The shape formed by the interlocking arms and hands of the two figures in these representations is exactly that of the sign "to embrace" – although inverted – and it is possible that this was intended as part of the symbolic content of such scenes which aim to depict the close relationship between the king and the gods.

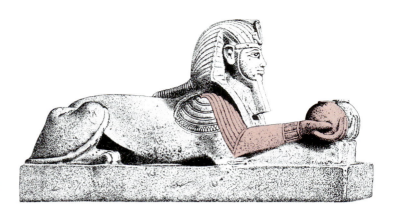

1 *Faience sphinx of Amenhotep III. Eighteenth Dynasty.*

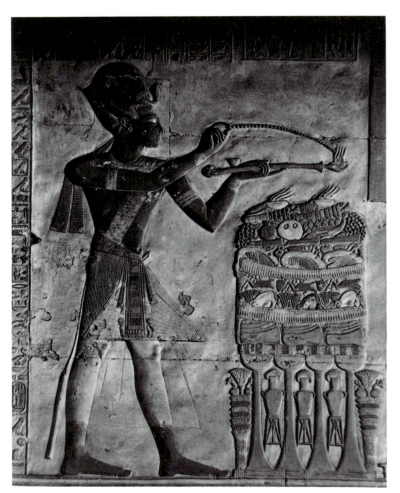

2 *King with censer arm, temple of Seti I, Abydos. Nineteenth Dynasty.*

3 *Arm-shaped "offering" spoon. Twelfth Dynasty.*

The arm and hand – whether clenched (*D49) or open (D46) – are represented in a range of different hieroglyphs, and the hand itself may be shown holding a number of objects of various significance. While the forms of many of these signs may be found in Egyptian art, the "offering" arm is the sign most frequently transposed into representational contexts. The hieroglyph was used to signify the presentation of a libation offering to the gods and represents a stylized forearm with the hand holding an offering bowl. The sign functioned as the determinative for words such as *henek*: "to present," and *derep*: "to offer," and is related in type to the very common hieroglyph D37 which shows an arm and hand holding a stylized loaf of bread (*X2), and which was used in words such as *di* or *redi*: "to give."

The motif of a pious king presenting an offering before one of the gods was a favorite one in royal Egyptian art, and many monarchs were portrayed in this way from Middle Kingdom times on. In the reliefs and statuary showing this gesture, the king holds an identical bowl in each hand – one for each of the two parts of the kingdom – and usually the bowls are said to be filled with wine or milk, or simply cool water. In virtually all representational examples the king does not hold the offering out at arm's length, but the upper arms are kept parallel to the body and only the forearms are extended – in exactly the position of the hieroglyph. The same gesture is seen in the small sphinx of Amenhotep III which is shown in **ill. 1**. In this example, the normally fully leonine body of the sphinx has been given human hands in order to hold the offering jars which it presents in the form of the offering sign.

Another use of the offering arm is found in the design of censers which were frequently made in this same form. The objects consisted of a handle – usually about the length of the human forearm – with a hand at one end which held a bowl in which incense was burned. A small box was often attached to the upper surface of the "arm" to hold the pellets of incense burned in the bowl (**ill. 2**). Various elaborations were made upon this basic design, and here, as is frequently the case in other examples, the "elbow" of the censer has been shaped as the head of a falcon-like deity, and the "wrist" area is expanded into a decorative papyrus umbel (M13) – both elements symbolic of solar and offering concepts. It is presumed that the use of censer arms such as these was intended both to avoid having to hold the heated incense bowl, and also as a means of presenting the incense without touching or approaching the presence of the deity too closely. Spoons made for ceremonial and perhaps everyday use were also occasionally made in essentially the form of the offering glyph – as in the example in **ill. 3** which dates to the Middle Kingdom. While many functional objects such as batons, percussion instruments and flail handles represent the simple arm, it is likely that such spoons often implied the specific concept of "offering."

OFFER

derep

D 39

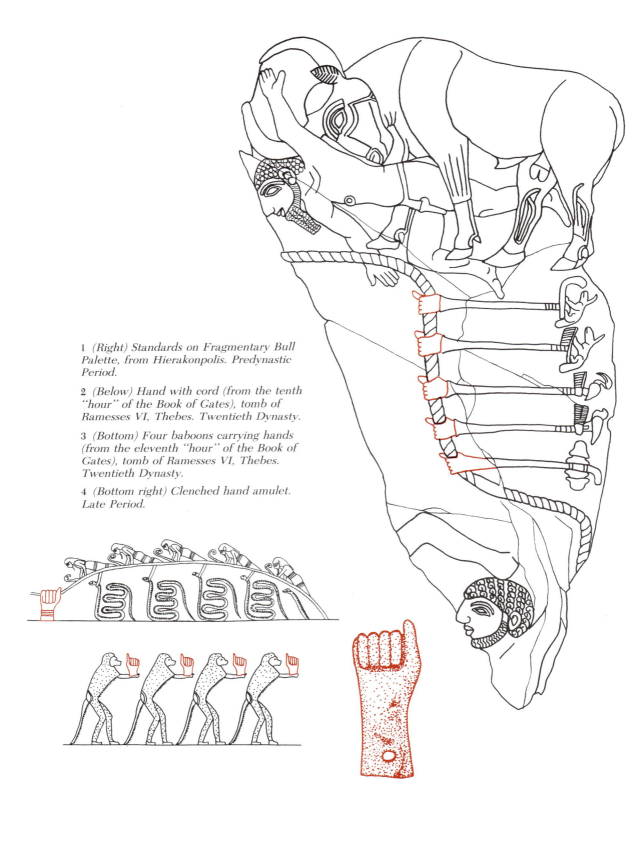

1 *(Right) Standards on Fragmentary Bull Palette, from Hierakonpolis. Predynastic Period.*

2 *(Below) Hand with cord (from the tenth "hour" of the Book of Gates), tomb of Ramesses VI, Thebes. Twentieth Dynasty.*

3 *(Bottom) Four baboons carrying hands (from the eleventh "hour" of the Book of Gates), tomb of Ramesses VI, Thebes. Twentieth Dynasty.*

4 *(Bottom right) Clenched hand amulet. Late Period.*

The hand was used not only to express concepts related to taking and holding, but also as a symbol of action itself, and therefore of creation and of latent creative power. According to Egyptian myth, Atum – the Heliopolitan deity of primeval chaos – created the first beings by copulating with his own hand. In this myth, the god's hand personified the female principle inherent within him, and from the union the divine pair Shu ("air") and Tefnut ("moisture") arose. This myth is found in the Pyramid Texts (Spell 1248), and it finds representational expression on decorated coffins of the First Intermediate Period which depicted the image of the divine couple "Atum and his [clenched] hand." The exact nature of the symbolism is seen in the fact that in the New Kingdom the title "God's hand" was applied to the wife of Amun – the queen or princess who would bear the heir to the throne.

A number of hieroglyphs depict the human hand in different poses and from different angles (D46-9). The clenched hand was used to write not only the word "fist," but also, and more importantly, related concepts such as *khefa*: "grasp," and *amem*: "seize." The hieroglyphic form appears with these meanings in representational art from very early times and is seen on the predynastic "Fragmentary Bull Palette" (**ill. 1**) where divine standards terminate in clenched hands which grasp a rope restraining the enemies of the king. This device of giving hands and sometimes arms to inanimate or non-human objects persisted throughout the centuries of Egyptian art; and thousands of years after the construction of the Fragmentary Bull Palette, we may find a similar image appearing in a cryptic illustration from the tenth "hour" of the New Kingdom Book of Gates (**ill. 2**) – where a clenched hand grasps a cord to which deities and serpents are attached. The hand was held clenched as a fist in the performance of the so-called "*henu*-gesture" of praise and rejoicing (*A8), and this particular gesture may lie behind certain representations where clenched hands appear in contexts having to do with praise and adoration. An example may be seen in the four baboons (*E32) depicted in **ill. 3**, where the animals carry clenched fists in illustration of the written statement "It is they who announce Re in the Eastern Horizon of Heaven. They announce this god who has created them with their arms...," from the eleventh "hour" of the Book of Gates. Here then, as elsewhere, the apes praise the sun as the dawn commences.

Finally, the form of the clenched hand – often with its forearm – was used decoratively to "hold" the suspended elements on whisks and flails, and it also appears independently as an amulet from the First Dynasty onwards (**ill. 4**). While these amulets may have had a protective function or perhaps reflected the imagery of the hand of Atum – and thus signified creation and rebirth – their exact nature is not fully understood.

CLENCHED HAND

khefa

D 49

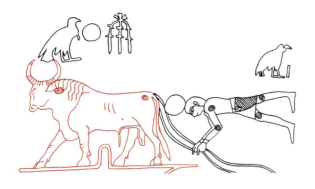

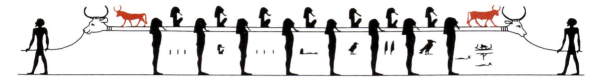

1 (Left) Northern constellation, astronomical ceiling of tomb of Seti I, Thebes. Nineteenth Dynasty.

2 (Below) Earth barque (from the third "hour" of the Book of Gates), sarcophagus of Seti I. Nineteenth Dynasty.

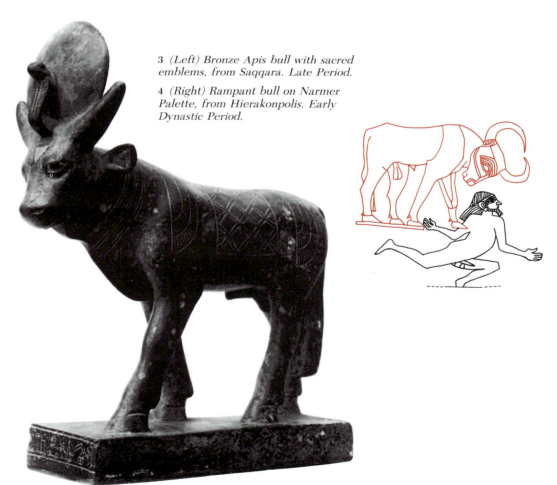

3 (Left) Bronze Apis bull with sacred emblems, from Saqqara. Late Period.

4 (Right) Rampant bull on Narmer Palette, from Hierakonpolis. Early Dynastic Period.

The bull was regularly represented in two hieroglyphic forms in Egyptian writing, in docile and rampant stances. In its normal, docile stance, the bull is shown standing with head erect, and in this form the animal was associated with the sun and with various astral entities. As a cosmic animal, the powerful bovine appears as the "Bull of Re" in the Pyramid Texts; and the sun, the moon and the constellation of Ursa Major (**ill. 1**) were all associated with the bull in some way. The young bull calf (E3) also occurs as a symbol of the rising sun and is frequently illustrated in scenes from the Book of the Dead where the animal is shown emerging from between the twin sycamore trees (*M1) of the horizon. In Chapter 148 of the Book of the Dead, seven cows (*E4) and their attendant bull seem to represent the sustaining powers of the universe (see *P10); and in the third "hour" of the underworld Book of Gates, the figures of bulls surmount a beam to which the barque of the sun god is attached (**ill. 2**). Selected bulls were worshipped as representing the cosmically important Atum (the Mnevis bull of Heliopolis), Ptah (the Apis bull of Memphis), and Montu (the Buchis bull of Thebes). All of these sacred animals were represented in Egyptian art with their special identifying markings and attributes (**ill. 3**).

As a potent source of procreative life, the image of the bull could also represent the primeval waters or the inundation of the Nile and certainly had important fertility connotations. The Egyptian king was also identified with the bull, and many New Kingdom monarchs bore epithets such as "mighty bull" or "bull of Horus." The ruler of the Two Lands is rarely directly depicted as a bull in Egyptian iconography during this later period, however, and it is in the earlier dynasties of Egyptian history, and in its rampant form, that the animal served as a primary representational emblem of the king. In its rampant stance (E2) the enraged bull is shown with head lowered and horns proffered to an adversary, and while this hieroglyphic form was occasionally used in writing the word *ka*: "bull," it more usually formed the determinative in the more specific *sema*: "fighting bull." It is in this way that the bull is depicted on the predynastic "Fragmentary Bull Palette" in the Louvre, and on the obverse of the Narmer Palette (**ill. 4**, and see *D1), both of which show the king as a raging bull overthrowing his enemies. In these representations the identification of the king with the powerful animal is complete; the king *is* a great wild bull just as he is Horus, and is also shown as the manifestation of that falcon god on the reverse of the Narmer Palette. The rampant form of the bull also appears in less specific representational contexts in the earliest period, however. A macehead of Narmer now in Oxford's Ashmolean Museum, for example, shows the bull in this same rampant hieroglyphic profile, but in a representational grouping which does not include the figures of enemies.

BULL

ka

E 1,2

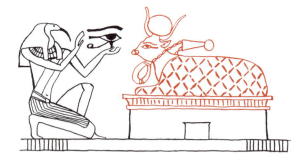

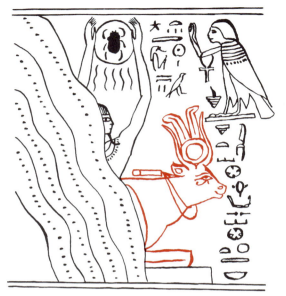

1 *(Above) Thoth offering wedjat eye to divine cow, Papyrus of Hunefer. Nineteenth Dynasty.*

2 *(Right) Cow emerging from mountainside, Papyrus of Tabaktnetkhonsu. Twenty-first Dynasty.*

3 *Mekhweret, tomb of Irynefer, Thebes. Nineteenth Dynasty.*

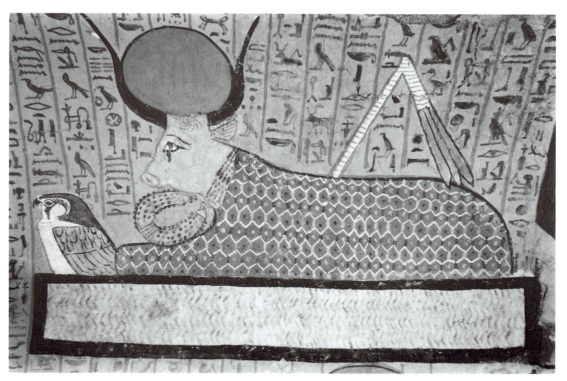

The cow was regarded as the sacred animal of several female deities and was mythologically associated with both heaven and the underworld. Nut, the goddess of heaven, was often depicted as the cow who rose with the sun god Re on her back to become the sky – supported by Shu, the air, who held up her belly, and the magical Heh deities (°C11) who steadied her four legs. The great cow-faced goddess Hathor (who also functioned as a goddess of heaven and of the necropolis) was worshipped in bovine form, and cows sacred to her were kept at her temple in Dendera. In later times, Isis also shared this association with the cow and, like Hathor, she too is often portrayed with the horns of a cow surmounting her head. Because of its association with the mother-goddess figures, the cow also played a limited yet important role in royal iconography. The great cow was the symbolic mother of the king – who was in turn the *kamutef* or "bull of his mother." The young king was also suckled by the divine cow, a motif which is represented in the Eighteenth Dynasty statue of Amenhotep II drinking from the udder of the Hathor cow from the shrine of the goddess at Deir el-Bahari, and also in a similar relief in the temple of Dendera. In these works the divine cow is both mother-goddess and heavenly deity (quatrefoil markings on the cow's hide represent the stars), as well as the goddess of the necropolis – a complex of mythological ideas summed up in a single iconographic image.

In the specific form depicted in the hieroglyph, the divine cow is Hesat or Mekhweret meaning "the great flood," the celestial cow of the First Time who rose from the primeval waters. The cow is usually depicted with the facial markings of the *wedjat* eye (°D10); and in the seventeenth chapter of the Book of the Dead, as well as in mythological stories, she is specifically called the "Eye of Re" (**ill. 1**). In the tomb of Irynefer, however, as in a number of funerary papyri, the divine cow is used to illustrate Chapter 71 of the Book of the Dead, the "coming forth by day," which relates to the coming forth of the deceased into the afterlife, in the same way that Mekhweret came forth from the waters when there was no life. This association with afterlife beliefs is also expressed in the many representations of Hathor depicted in bovine form (**ill. 2**) emerging from the side of a mountain which represents the necropolis, and in the fact that the Hesat cow was held to be the mother of the mortuary god Anubis (°E15,16) as well as of the sacred Apis bull (°E1,2). The Iseum, the burial place of the cows which bore the Apis bulls, was located at Saqqara. In the Nineteenth Dynasty tomb of Irynefer at Thebes (**ill. 3**), she is characteristically shown lying in a robe with a stylized quatrefoil design, with a flagellum above her back and a *menit* (°S18) necklace and collar around her neck. As is often the case, Hesat sits above the representation of a pond or lake (°N39) symbolizing the primeval waters and wears between her horns the sun disk with which she is also associated.

DIVINE COW

hesat

E 4

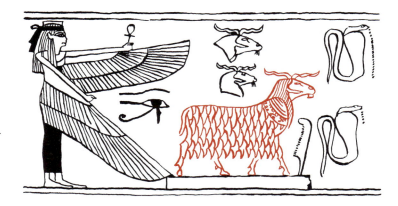

1 *Divine ram on pedestal, Papyrus of Khonsurenep. Twenty-first Dynasty.*

2 *Four crowned rams (from the eighth "hour" of the Book of That Which Is in the Underworld), tomb of Seti I. Nineteenth Dynasty.*

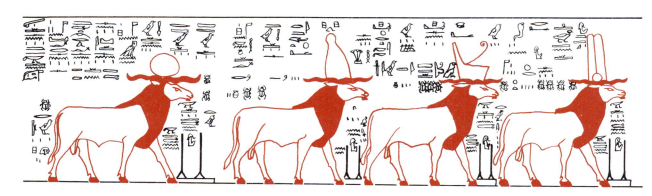

3 *Ram of Amun, limestone fragment from the Valley of the Kings. Nineteenth to Twentieth Dynasty.*

Although sheep, like fish, were thought to be ritually unclean and were not eaten by sanctified persons or offered to the dead, they were undoubtedly used in the diet of many people as it is known that large flocks were maintained in all periods. Led by their ram, sheep were used for treading in the seed sown in mud left by the inundation of the Nile and perhaps because of this association as well as the more obvious amorous nature of the ram, the animal was a common symbol of fertility. Ram gods appear to have been worshipped from the earliest times; Herishef of Herakleoplis, the ram god of Mendes, and above all, Khnum – the great ram deity worshipped at Esna and elswhere – were the most important of these deities. Animals sacred to these gods were embalmed in their major cult centers, and representations of such mummified rams are known from as early as the First Dynasty. From relatively early times the ram became associated with solar imagery, and in the New Kingdom the supreme god Amun also took the form of a ram.

Rams of two different species are found in Egyptian art, however, and these must be differentiated in order to understand the deity to which each alludes. The first species of sheep to be reared in Egypt was *Ovis longipes*, whose ram is recognized by its heavy build and long, horizontally undulating horns. This is the species which is depicted in representations of the earlier ram gods such as Khnum, and in solar images. **Ill. 1** shows a representation of *Ovis longipes* as a divine ram from the funerary papyrus of Khonsurenep. This long-coated ram is drawn in essentially the form of the hieroglyphic sign, but standing on a plinth which bears the feather (*H6) of truth, and surrounded by various signs including the heads of two more rams of the same species. In the Book of That Which Is in the Underworld, the ancient earth god Tatenen is shown in the form of four crowned divine rams, which reflect the hieroglyph in the same way (**ill. 2**). The iconography of the solar ram is particularly varied, and the deity is rarely shown in its fully zoomorphic form, but as the head alone within the sun disk or as a ram-headed man, falcon (*G5), or scarab (*L1), all these variants representing the sun in the evening and nightly aspects of its daily cycle. The ram of this species could also be associated with Osiris, and in the Middle Kingdom the ram of Mendes was specifically called the *ba* (*G53) or soul of that god – perhaps also as a play on the animal's onomatopoeic name.

Longipes was later supplanted, however, by the curved-horned *Ovis platyra*, and it is this animal which is shown in representations of the god Amun. In **ill. 3**, a painted limestone fragment in the Cairo Museum, the species is depicted with its down-curved horns and slighter build – noticeably leaner than the species *longipes* which is represented in the hieroglyphs above it. The prone position of the Amun ram is also iconographically characteristic, and it is in this pose that the god is depicted in the alleys of ram-headed cryosphinxes at Karnak and Luxor.

RAM

ba

E 10

1 *Cat destroying Apophis by sacred persea tree, tomb of Sennedjem, Thebes. Nineteenth Dynasty.*

2 *Bronze figure of cat with solar symbols. Late Period.*

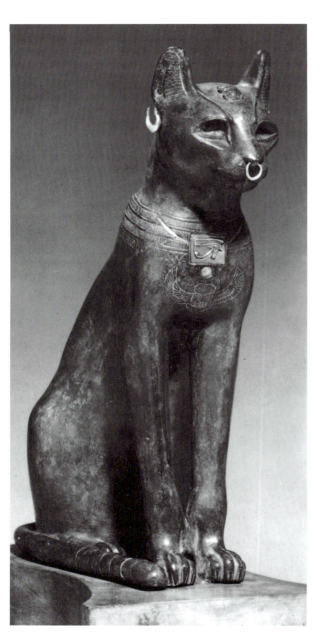

3 *Favorite cat beneath chair, back of chair of Princess Sitamun, from Thebes. Eighteenth Dynasty.*

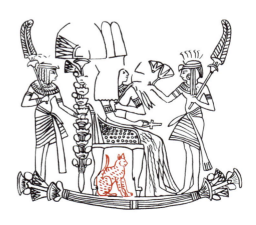

The domestic cat appears relatively late in Egyptian history and is to be differentiated from the short-tailed wild cat which lived in the papyrus thickets of the Delta. It is the wild cat which undoubtedly provided the original image for the "Great Cat of Heliopolis," which in the New Kingdom appears as an animal sacred to the sun god and which protects the rising sun from the serpent Apophis in the Book of the Dead and other mythological works. However, the animal which is portrayed in representations of these stories is the domestic cat which appears in Egypt in the Eleventh Dynasty and is common from the Middle Kingdom onwards. The origin of this domesticated species is unknown, its onomatopoeic Egyptian name *miu* providing no linguistic clue to the animal's original home, though this was probably somewhere in the Near East. Many vignettes illustrating the seventeenth chapter of the Book of the Dead show the rather long-eared, long-tailed domestic cat squatting on its haunches with its tail curled around its leg in the hieroglyphic pose. Often the animal is depicted holding a knife (*T30) in its paw as it destroys the serpent which threatens the cosmic tree (*M1) – an ancient symbol of the rising sun (**ill. 1**); and cat-headed deities appear in representations of the Book of That Which Is in the Underworld where they destroy malevolent beings in a similar manner.

The goddess Bastet, who seems to have been a leonine deity originally, soon became equated with the cat and was frequently portrayed as a woman with a kindly feline head. During the later periods, hundreds of bronze effigies were dedicated to Bastet in her temple at Bubastis and mummies of actual cats were also buried in multiple thousands at this same site. The bronze images depict the goddess in her anthropomorphic form (holding ritual items such as the sistrum – *Y8) or in the zoomorphic form of the hieroglyph, as in **ill. 2**. As a solar animal, figures of the cat often bear images related to the sun god in their incised decoration – such as the winged scarab which adorns the chest of the cat in this instance, and the scarab beetle which is depicted atop the animal's head. The she-cat was specifically equated with the concept of the "solar eye," and many examples are also decorated with a chest ornament in the form of the sacred *wedjat* symbol (*D10).

Because the domestic cat played an important practical role in ancient Egyptian households – as a deterrent to rats, mice and snakes – and was also trained for use in hunting in the papyrus marshes, it is frequently depicted in New Kingdom tomb paintings showing everyday activities. Sometimes the feline of the house is shown seated beneath the chair of the tomb owner (as in **ill. 3**) – a convention which singled an animal out as a favorite pet – but in most of these representational examples the pose of the animal is that of the hieroglyph. In fact, depictions which show the cat in any other position (other than satirical drawings of cats and mice in human roles) are relatively rare.

CAT

miu

E 13

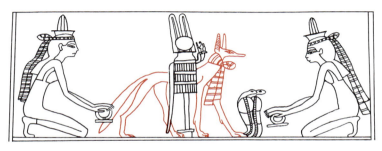

1 *Anubis with Fetish of Osiris, Papyrus of Nestanebettawy. Twenty-first Dynasty.*

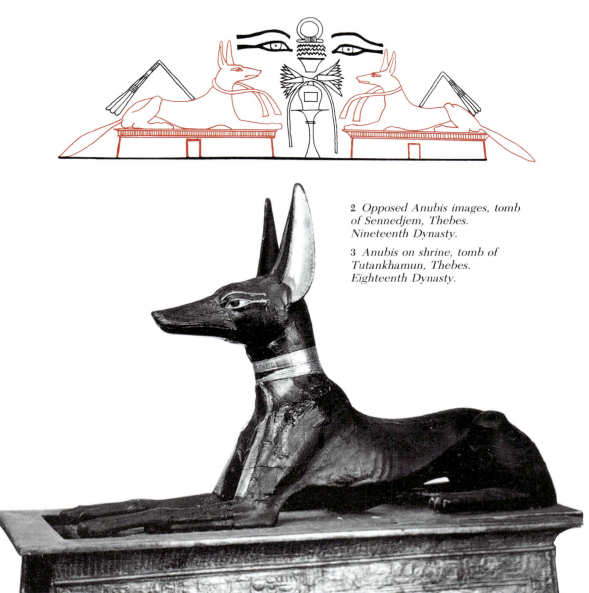

2 *Opposed Anubis images, tomb of Sennedjem, Thebes. Nineteenth Dynasty.*

3 *Anubis on shrine, tomb of Tutankhamun, Thebes. Eighteenth Dynasty.*

Anubis was the chief god of the dead before the rise of Osiris. The exact species of canid representing Anubis is a source of perennial disagreement, and while later linguistic usage indicates that the god's emblem was regarded as a dog, the representational evidence seems to show an animal closer to the jackal. While it is possible, therefore, that the Anubis animal was either a wild dog or jackal – or even a hybrid variety – what is clear is that the god was embodied by a canid which haunted the cemeteries of the desert's edge and which was associated with the necropolis from the earliest times. Prayers addressed to him were carved on the walls of the oldest mastabas, and he is mentioned in the Pyramid Texts in contexts which reveal his ancient protective role (e.g. Pyr. 659). The god was early assimilated into the cult of Osiris, however, and according to legend it was he who wrapped the body of the deceased husband of Isis. As both the patron of embalmers and the executive assistant of the Osirian Underworld, the god was known by his epithets "He of the funerary wrappings," "Foremost of the divine [mortuary] booth," and "Lord of the hallowed land" (the necropolis). Anubis gained great popularity in the New Kingdom as may be seen in his almost ubiquitous presence in private tomb paintings and in the vignettes of funerary papyri. In these representations the god is often shown as a canid-headed human, leading the deceased into the presence of Osiris and assisting in the ceremony of the weighing of the heart (*F34). Other representations depict priests dressed as Anubis in jackal-headed masks who receive the mummy of the deceased in the funerary ceremonies.

Apart from these anthropomorphized images where the god or his priest appears as a canid-headed human, Anubis is portrayed as a dog or jackal in the pose of his hieroglyphic signs. In these forms, standing (E17) or recumbent, Anubis is represented on many mummies and coffins, and in the vignettes of funerary papyri (ill. 1), as well as on amuletic plaques and other protective and decorative works. Usually the animal is shown with one or more of the Osirian attributes – such as the *sekhem* scepter (*S42), the crook (S38) or the flail (S45), and with a ceremonial tie around his neck. The god is also shown (as in the variant hieroglyph E16) in the same pose lying on a shrine or on a mastaba-shaped pedestal symbolic of the tomb which he guards. The example in ill. 2 is from the tomb of Sennedjem at Thebes where two such images face each other in a compositional format which was popular in many New Kingdom private tombs. In ill. 3 the same motif is seen in a three-dimensional example from the tomb of Tutankhamun. This fine image of the god is made of black varnished wood with gilded details, claws of silver, and piercing eyes of alabaster and obsidian. The animal rests upon a gilded chest in the form of the shrine depicted in the hieroglyph and was found, guardian-like, at the entrance to the room called the "treasury" by the tomb's excavators.

Ienpu

E 15,16,17

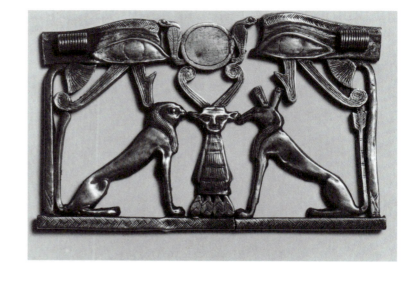

1 *(Top left) Serekh of
Khasekhemwy, from a seal.
Second Dynasty.*

2 *(Above) Horus and Seth
pectoral, perhaps from Dahshur.
Twelfth Dynasty.*

3 *(Far left) Seth standard, on
lintel of Sesostris III from Naq
el-Madamud. Twelfth Dynasty.*

4 *Seth animal protecting a king.
Nineteenth to Twentieth
Dynasty.*

The god Seth seems originally to have been a desert god who early came to represent the forces of disturbance and confusion in the world. According to the ancient Egyptians' dualistic view of the cosmos, Seth was therefore placed in juxtaposition with Horus, the god who ruled the land with order and stability. Already in the Pyramid Texts Seth is held to be the murderer of Osiris and the opponent of Horus in what appears to be a developed mythological cycle. The position of the god was not entirely inimical, however, as Seth was also held to be cunning and of great strength, and in the Second Dynasty, the figure of the deity appears on the *serekh* or "Horus" names (see *O33) of Peribsen and Khasekhemwy (**ill.** 1). By the Middle Kingdom Seth was assimilated into solar theology as the god who stood in the bow of the sun god's barque (*P3) to repel the cosmic serpent Apophis. In the Hyksos Period he seems to have risen to considerable popularity, and in the Nineteenth and Twentieth Dynasties the god became important as the patron deity of the Ramesside kings. But evidence for Seth declines after the Twentieth Dynasty, and his role as god of the desert and foreign lands led to his association in the later periods with Egypt's hated foreign overlords. By the Twenty-fifth Dynasty, veneration of Seth had virtually ended, and representations of the god were often changed into the form of more acceptable deities of similar appearance such as Thoth.

The iconography of Seth shows an interesting development, and while the god was later represented in anthropomorphic form as an animal-headed deity, he was originally depicted as an animal with a curved head, tall square-topped ears, and erect arrow-like tail. The exact species represented by the Seth animal has never been determined, however, and while suggestions have ranged from the ardvaark, jackal, antelope, okapi, pig, and ass, it is just as possible that the animal was a fabulous creature like the griffon. The earliest clear example of the Seth animal appears on the "Scorpion Macehead" (see *S35), where it is shown as an emblem mounted on processional standards. Here, the creature is depicted standing, as in ill. 1, though later representations prefer to show it in a seated or crouching stance. The Twelfth Dynasty pectoral, or chest ornament, shown in **ill. 2** depicts the Seth animal in what became a standard representational form – here, in juxtaposition with Horus as emblems of the Two Kingdoms – and the roughly contemporaneous monument of Sesostris (**ill. 3**) depicts the animal in the same crouching pose. Although Horus is sometimes described as being in the form of a hieracosphinx in this pectoral, the pose and details of the falcon-headed god are clearly made to mirror the form of the Seth animal – showing the iconographic, as well as cultural, importance of Seth in this period. The close association between Seth and the rulers of the Ramesside dynasties is seen in **ill. 4**, where the crouching god overshadows and protects the king in exactly the same manner in which other monarchs were portrayed beneath the figure of the Horus falcon.

Setekh

E 20,21

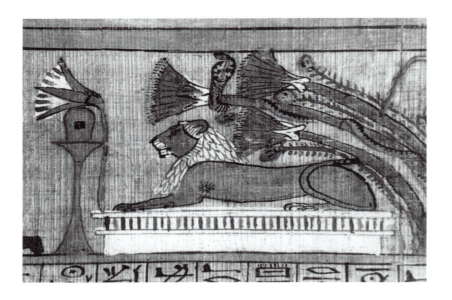

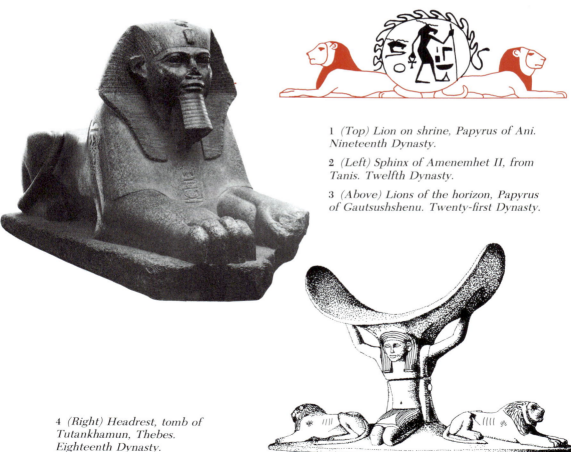

1 *(Top) Lion on shrine, Papyrus of Ani. Nineteenth Dynasty.*

2 *(Left) Sphinx of Amenemhet II, from Tanis. Twelfth Dynasty.*

3 *(Above) Lions of the horizon, Papyrus of Gautsushshenu. Twenty-first Dynasty.*

4 *(Right) Headrest, tomb of Tutankhamun, Thebes. Eighteenth Dynasty.*

In the hieroglyphic script, separate signs were used to depict the lion – standing, as *mai* (E22), and recumbent, as *ru* (E23) – though iconographically either of the two forms may represent the major aspects of the lion's symbolic role as a protective sentinel or as a solar animal. In the former aspect the lion's characteristics made it a potent symbol of defense. Door bolts might have lion heads carved on them in order to strengthen their protective function, and lion-headed gargoyles were used as waterspouts on the roofs of Egyptian temples to divert and subdue the power of storms. Largely because of this symbolism, chairs, thrones, and beds were commonly carved in the form of protective standing lions.

The crouching or recumbent form of the lion also served a defensive role, as may be seen in funerary paintings (**ill. 1**) and sculptures, and was also closely tied to the animal's solar significance. Under the name *Hor-em-akhet* the god Horus assumed leonine form as the deity of the appearing sun, and although the identification of this god with the human-headed sphinx is a late one, it is possible that this composite animal originally had solar significance. The great Sphinx of Giza may thus represent its builder, Chephren, as the sun god, as well as being a guardian of the king's necropolis. As a manifestation of the king, the recumbent sphinx was also occasionally given human forearms and hands to fit an offering context (*D39), and frequently the whole head of the animal is that of the king wearing the royal *afnet* or *nemes* headdress which closely resembled the shape of the leonine mane – as in the red granite sphinx of Amenemhet II (**ill. 2**). From at least the Fifth Dynasty on, and especially during the time of Egypt's New Kingdom expansion, the king is also depicted as a heraldic, rampant form of the sphinx, aggressively treading down his routed enemies.

At the cosmic level, the god Aker was an ancient lion-deity who guarded the gates of the horizon (*N27) through which the sun entered and left the world each day. The Aker lion was therefore represented as a strip of land with a lion's head at each end, though often the two aspects of the god were represented separately as two lions back to back (sometimes labelled *sef* and *duau*: "yesterday" and "tomorrow") and bearing the image of the solar disk. They are shown this way in **ill. 3**, from a vignette in a Twenty-first Dynasty papyrus copy of the Book of That Which Is in the Underworld. Three-dimensional Egyptian artworks may also use this motif of opposed reclining lions, and the headrest of Tutankhamun (**ill. 4**) shows the two lions in this way, flanking the figure of Shu, the god of the air. Here, Shu supports the headrest (*Q4) from which the king's head would rise from sleep – symbolizing the rising sun itself. The recumbent lions serve an apotropaic function by protecting the sleeper and are also tied into the solar imagery of the lion by mirroring the form of the horizon hieroglyph.

LION

mai, ru

E 22,23

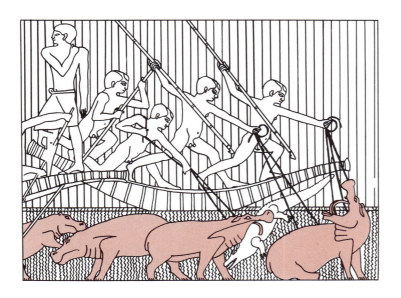

1 *Hippopotamus hunting scene, tomb of Ti, Saqqara. Fifth Dynasty.*

2 *Faience hippopotamus, from Meir. Twelfth Dynasty.*

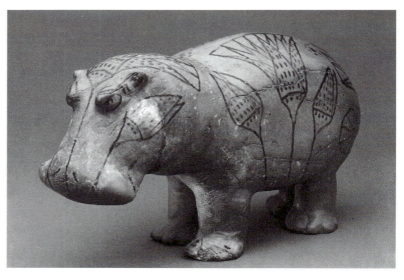

3 *Head of funerary bed, tomb of Tutankhamun, Thebes. Eighteenth Dynasty.*

Feared more because of its voracious appetite than because of any antipathy toward humans, the hippopotamus stole and trampled the Egyptians' crops and was viewed as a manifestation of disorder – and therefore of evil – from early times. Hippopotamus hunting-scenes are commonly represented in the mastaba tombs of Old Kingdom nobles (ill. 1), and these depictions seem to be at least partly aimed at preserving order in the afterlife environment of the deceased. Even the charming blue glazed faience animals commonly found in Middle Kingdom tombs may have had a similar purpose and are certainly more than merely decorative, though many examples – such as the animal shown in ill. 2 – are carefully decorated with the flowers, plants and birds of the hippopotamus' natural environment. Perhaps the superimposition of such decoration was intended to help keep the animal magically in its proper place! Although these representations might display a certain ambivalence toward the animal, in the later periods the hippopotamus was directly equated with malevolent beings such as the god Seth (*E20). Depicted on the walls of the Ptolemaic temple of Edfu, the so-called "Horus Myth" tells how Horus of Behdet (Edfu) fought in the barque of Re against the sun god's enemies – who are shown in the form of crocodiles and hippopotami. In another narrative, Horus the son of Isis fights the evil Seth who appears as a red hippopotamus. Even the composite Ammit, the fearsome "devourer of hearts" which lurked in the judgment hall of the afterlife, was depicted as having the jaws of a crocodile and the rear legs of the hippopotamus.

Yet despite this considerable animus against the giant herbivore, the hippopotamus – like the crocodile (*I3) – had a more positive side. The mother animal was held in awe as a great protector of its young, and the goddesses Isis, Hathor, and Nut, who functioned in the rebirth of the deceased, could all appear in hippopotamine form. In the astronomical tomb paintings of the New Kingdom, for example, one of the northern circumpolar constellations depicts Isis as a powerful hippopotamus who restrains the foreleg (*F24) of Seth. The hippopotamus could also function as a symbol of fertility and is best known in this role in the guise of Taweret ("the great one") or Opet (meaning "harem"), the hippopotamus goddess of pregnancy, who is depicted standing on her hind legs in human fashion and usually resting a paw upon a large *sa* or "protection" sign (*V17). The Ammit or hippopotamine-headed funerary bed found in the tomb of Tutankhamun (ill. 3) was perhaps meant to convey this same imagery of protection and rebirth – like the matching Hathor cow bed from the same tomb. The iconography of the hippopotamus is, therefore, not entirely consistent. Whereas those animals depicted as standing on their hind legs are almost always meant to show the hippopotamus in its more positive aspect, hippopotami standing on all four legs are usually inimical – though the funerary bed and certain other works might provide exceptions to this general rule.

HIPPOPOTAMUS

deb

E 25

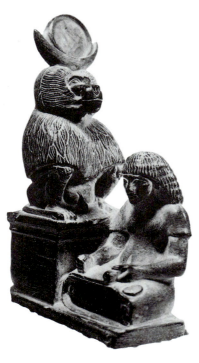

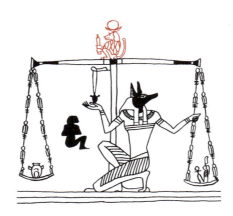

1 *(Left) Scribe with baboon of Thoth on a shrine, from Amarna. Eighteenth Dynasty.*

2 *(Above) Weighing of heart scene, Papyrus of the musician of Amun, Nany. Twenty-first Dynasty.*

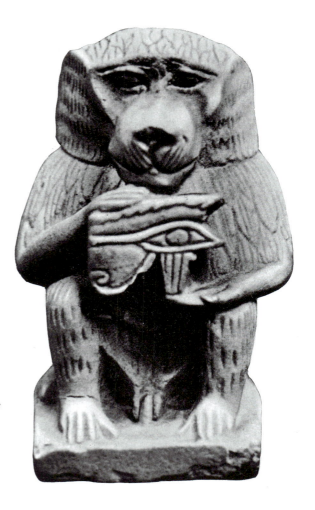

3 *Scene from the first "hour" of the underworld, tomb of Seti I, Thebes. Nineteenth Dynasty.*

4 *Baboons by the Lake of Fire, Papyrus of Ani. Nineteenth Dynasty.*

5 *(Right) Faience baboon with wedjat eye. Twenty-sixth Dynasty.*

The baboon (*Papio hamadryas*) appears in many contexts in Egyptian art from very early times. A baboon god is known to have been worshipped from as early as the Archaic Period and the baboon deity *Baba* may be the origin of our own name for this animal. Interestingly, however, the animal is infrequently represented in the exact pose of the hieroglyph shown by Gardiner – standing on all four feet – but is usually depicted in a more characteristic pose, squatting on its haunches or standing, with arms raised, on its hind legs. The seated form of the animal depicted here is found as a hieroglyph in many written words and is by far the most common form found in representational contexts.

In the Old Kingdom the baboon became associated with Thoth, the god of writing and patron of the scribal arts. As a sacred animal of this deity, the baboon is frequently represented sitting on the head or shoulders of scribes, as though directing them. Alternatively, the scribe may be represented as seated before the animal – as in the Eighteenth Dynasty statuette in the Cairo Museum (**ill. 1**), where the squatting scribe is evidently subservient to his Thothic patron. Because Thoth was the deity who presided over all forms of measurement, baboons are also to be understood as fulfilling variant aspects of this same role when they appear above the outlets of water clocks and when they are seated on or before the scales which weighed the heart of the deceased in the judgment of the dead (**ill. 2**). Baboons guard the first gate of the underworld in the Book of That Which Is in the Underworld (**ill. 3**); and in Chapter 155 of the Book of the Dead baboons are also said to sit at the four corners of the Underworld Lake of Fire (*Q7). This connection with the underworld is depicted in funerary papyri (**ill. 4**) and even in small models found in some of the royal tombs of the New Kingdom; and Hapi, the baboon-headed deity who was one of the four sons of Horus (see *D1), is represented on one of the so-called canopic jars which held the mummified organs of the deceased.

Because Thoth seems originally to have been a god of the moon, baboons are frequently represented with the lunar crescent or disk upon their heads. More common, however, is the relationship of the baboon with the sun. Perhaps because of their screeching at daybreak or because of their practice of warming themselves in the early morning sun, the ancient Egyptians believed the baboon greeted or worshipped the rising solar orb. This association with the sun is expressed in several ways: the animals are depicted with forepaws raised in an attitude of worship (A30) on the pedestals of a number of obelisks (which served as symbols of the sun) and on the eastern facades of certain architectural structures. Baboons are also frequently shown holding a *wedjat* eye (*D10) as a symbol of the solar orb (**ill. 5**) or seated with the sun god Re in the solar barque (*P3). In some late examples the association is such that a baboon may even be shown within the sun disk in the manner normally reserved for some manifestation of the sun god himself.

BABOON

ian

E 32

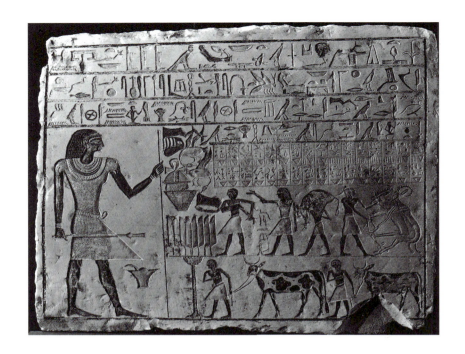

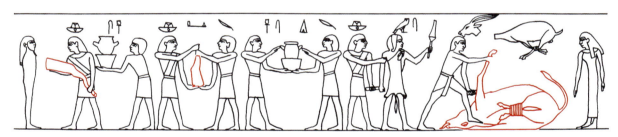

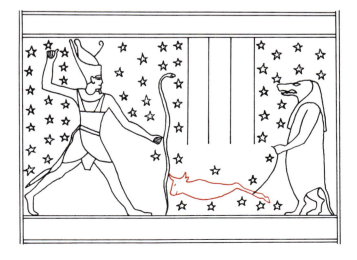

1 (Top) Offering stele of
Nefersefekhi, from Naga ed-Der.
First Intermediate Period.

2 (Above) Opening of the mouth
scene, tomb of Pedamenopet,
Thebes. Twenty-fifth or Twenty-
sixth Dynasty.

3 (Right) Relief showing stellar
constellations, temple of Isis,
Philae. Ptolemaic Period.

The word *khepesh* had a number of meanings in the Egyptian language, but all of these were associated in some way with the shape or symbolism of the ox's foreleg. This choice cut of meat is almost invariably included in mortuary offering scenes where it appears in lists of offerings, is also represented with different kinds of foods on the offering table (see also *M20), or is held and presented alone as a select gift to the deceased. In the painted limestone stele shown in **ill. 1**, we find an example of this genre which shows all three of these forms of representation. While the foreleg appears as a written hieroglyph toward the right of the third register of the inscription, another *khepesh* is placed on top of the heaped offerings before the face of the deceased, and a third is held by the leading figure presenting offerings. Comparison of these occurrences shows that the written hieroglyphic sign was simply transposed into the other representational settings.

Because the foreleg was also used to denote the "strong [human] arm," it appears as a symbol of royal and divine strength. The *khepesh* glyph may be used with this connotation, rather than simply as an "offering," on the standard of the Second Nome (province) of Lower Egypt. Perhaps as a result of its symbolic connotation of power, the foreleg was also used in the magical rituals associated with the "opening of the mouth" ceremony which was performed before statues when they were erected and before the mummy of the deceased as it was placed in the tomb. Representations of this ceremony show the *khepesh* being presented before the face of the statue or mummy for what was probably a symbolic transfer of power. In the example in **ill. 2**, the foreleg is shown being cut from the sacrificed animal in the presence of the officiating *sem* priest and carried to the mummy before which it is presented. In a similar way, by reference to the shape of the foreleg, the *khepesh* could denote the curved Egyptian sickle sword or scimitar. In scenes where the god Amun presents the pharaoh with such a sword, the god is manifestly giving the gift of "power" along with the weapon itself.

Finally, by virtue of its shape alone, the foreleg also represented the constellation of Ursa Major – the Big Dipper – which was called *Meskhetiu* by the Egyptians, but often referred to simply as "The Foreleg." In mythology this constellation was explained as the leg of Seth (*E20) which was torn out and hurled into the heavens by the god Horus, an archetypal mythic action which is also seen in the Babylonian Epic of Gilgamesh (col. v, l. 161), where the foreleg of the "Bull of Heaven" is torn out and hurled at Ishtar, the Mesopotamian Queen of Heaven. The constellation Ursa Major is always represented as a *khepesh* foreleg in Middle Kingdom Egyptian astronomical paintings, but from the New Kingdom on it may also be shown as a stylized bull, or even as a bull-headed foreleg, as in the representation from Philae shown in **ill. 3**.

FORELEG OF OX

khepesh

F 24

1 *(Above) The deceased's heart being weighed, Papyrus of Ani. Nineteenth Dynasty.*

2 *(Right) Heart pectoral with protective goddesses Isis and Nephthys. Nineteenth to Twentieth Dynasty.*

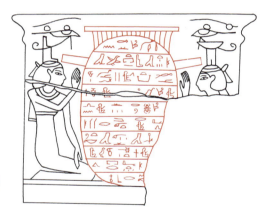

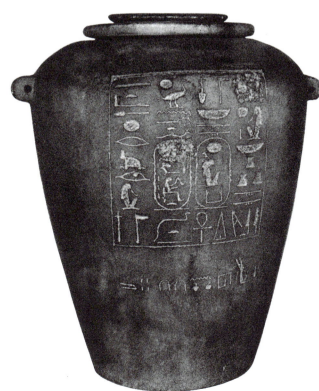

3 *(Left) Heart-shaped jar with inscription of Hatshepsut, from Thebes. Eighteenth Dynasty.*

4 *(Below) Au-ieb amulet, from the jewelry of Khnumet. Twelfth Dynasty.*

According to the ancient theology prevailing at the Egyptian city of Memphis, the primeval god Ptah conceived the universe in his heart before bringing it forth by his word, for in the view of the ancient Egyptian the heart was the seat of thought and emotion and even of life itself. As the heart was regarded as the center of life, it was said of the deceased that his heart had "departed," and the heart was often equated with a person's very being. For this reason the heart was the only organ that was not removed from the body in the mummification process.

It was the heart that was weighed against the feather of truth (*H6) in the afterlife judgment before the throne of Osiris, and this important event is illustrated in the vignettes found in many copies of the Book of the Dead – which contained specific spells to protect the heart of the deceased and to ensure favorable judgment. The vignettes usually show the deceased's heart being weighed (**ill. 1**) while the mythical Ammit or "devourer" which destroyed the hearts of those found guilty waits at the side. In preparation for this judgment, special amulets such as the heart scarab (*L1) were wrapped with the mummy in the area of the heart, and these were often inscribed with multiple spells from Chapter 30 of the Book of the Dead, which aimed at covering all the angles from which the heart might inadvertently betray its owner through an unfavorable utterance: "Oh my heart...Do not stand as a witness against me. Do not contradict me with the judges. Do not act against me with the gods. Do not be my enemy in the presence of the guardian of the balance [Anubis – *E15]...Do not make my name to stink to the gods who made mankind. Do not tell lies about me in the presence of the great god...." These amulets were made in the shape of the heart-shaped glyph with its top and side projections (which represent the veinal and arterial connections to the heart) or in a more simplified near-oval form. A damaged amuletic pectoral pendant in the Boston Museum of Fine Arts (**ill. 2**) shows Isis and Nephthys protecting an inscribed heart symbolic of the heart of Osiris with whom the deceased was identified. Here, both representational form and verbal inscription enter into the symbolic content of the amulet.

Because the heart "held," as it were, the individual's life, and the form of the written sign was also reminiscent of a vase or jar, many actual containers were made to mimic the shape of the heart sign (**ill. 3**). The heart glyph was also frequently incorporated in the design of items of jewelry, sometimes with simple religious significance and in other cases as part of a more complex verbal-symbolic statement. The word "heart" appears in many terms and expressions in ancient Egyptian – for example, a close friend was termed *ak-ieb*: "one who has entered the heart" – and verbal groups such as these often form the basis of jewelry design. In this way the small necklace pendant in **ill. 4** shows the heart in the group *au-ieb*: "joy," and another common group reads *ieb-netcheru-hetep*, "the heart of the gods is satisfied" (see *R4).

HEART

ieb

F 34

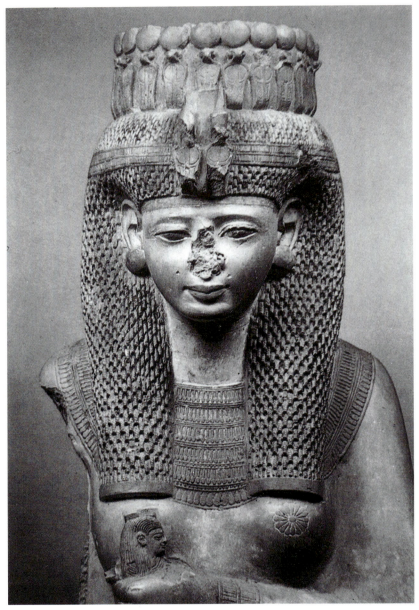

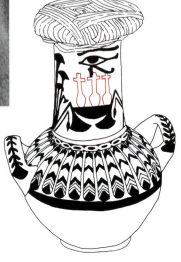

1 *A queen of Ramesses II, perhaps Meryetamun,
from Thebes. Twentieth Dynasty.*

2 *Nefer-shaped vase, tomb of Kha, Deir el-Medina.
Eighteenth Dynasty.*

The term *nefer* was well loved and much used by the ancient Egyptians. It appears with a dozen different meanings in Egyptian literature – all of them positive – and was incorporated into many personal names, including those of the celebrated Nefertiti and Nefertari, consorts of the pharaohs Akhenaten and Ramesses II (Ramesses the Great) respectively. The origin of the hieroglyph is a complex one. Although the *nefer* sign is sometimes described as a stylized "stomach and windpipe," the developed hieroglyph is actually a composite of the heart and trachea, of the same type as the "union" hieroglyph (°F36) which consists of lungs and trachea. Originally the upper part of the sign may have represented the esophagus – as the striations characteristic of the windpipe only appear in the hieroglyph after the Old Kingdom – but the lower part of the sign is clearly representative of the heart, as the internal markings found from earliest times on this part of the sign closely follow the form of the musculature of a sheep's heart. Examples dating to the Early Dynastic and Old Kingdom Periods often show a double pair of lateral projections at the top of the sign, though this feature is simplified to a single line in later examples. This rather complex development of the *nefer* sign underlies the wide variety of forms found in examples of the hieroglyph, but the sign is almost always clearly recognizable and used with clear significance.

While not as common in Egyptian art as some of the major amuletic hieroglyphic signs, the *nefer* hieroglyph was nevertheless widely represented, and had important meanings. Used emblematically, the sign is usually translated "goodness" or "beauty," but it can also carry the meaning of happiness, good fortune, youth, and other related ideas. The *nefer* sign was used in the production of small stone and faience amulets and in the design of amuletic and decorative jewelry such as the collar seen in **ill. 1**. This work, the celebrated statue of Meryetamun, the eldest daughter of Ramesses II and Nefertari, shows the princess wearing a wide collar (S11) consisting of five rows of *nefer* hieroglyphs – here undoubtedly meant to suggest beauty and youth. Another application of the hieroglyph is found in the use of its form in the shape of vases and jars. The example in **ill. 2** from the Eighteenth Dynasty tomb of Kha at Deir el-Medina is not atypical of a common class of New Kingdom high-necked vases, but the extra-wide rim and other details show that the *nefer* sign is being emulated in this example. Painted *nefer* signs do, in fact, surmount a *neb* basket (°V30) on the neck of the vessel, heightening the visual association of the vase with the form of the hieroglyphic sign.

The White Crown (S1) which symbolized the kingship of the land of Upper Egypt was sometimes called "The Nefer" or "The White Nefer," and this crown may be drawn in such a way as to suggest the *nefer* hieroglyph in some representations.

nefer

F 35

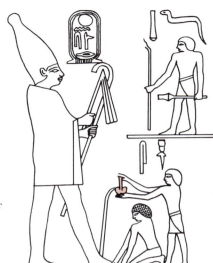

1 *(Right) Royal jubilee scene, sun temple of Niuserre at Abu Gurab. Fifth Dynasty.*

2 *(Far right) Sema-tawy motif on a throne statue of Mycerinus, from Giza. Fourth Dynasty.*

3 *(Below) Ramesses III on union sign, temple of Ramesses III, Medinet Habu. Twentieth Dynasty.*

4 *(Below right) Ornate alabaster vase, tomb of Tutankhamun, Thebes. Eighteenth Dynasty.*

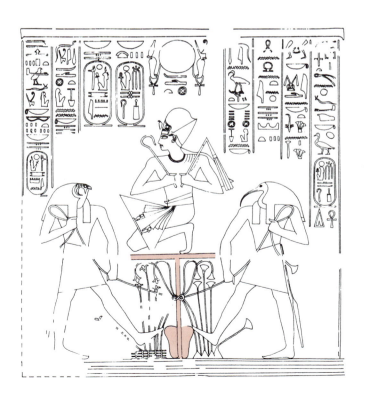

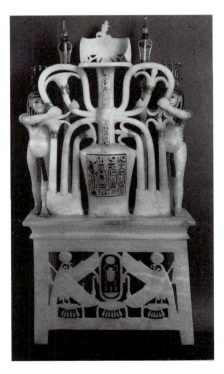

The *sema* hieroglyph represents two lungs attached to the trachea, an anatomical unit which provided a natural symbol for the concept of the unification of equal parts, and particularly, the unification of the two kingdoms of Upper and Lower Egypt. The union of the Two Lands stood behind much of the ritual and ideology of Egyptian kingship, and the *sema* hieroglyph is found in a wide range of contexts which underscored the king's uniting rule. The unadorned symbol of unity appears, for example, in the shape of the vessel used for the ritual foot-washing of the king in a representation of the jubilee festival (°O23) of the Fifth Dynasty monarch Niuserre (**ill. 1**). The basic form of the *sema* sign is elaborated from an early date, however, and in this more complex form it stands between the heraldic lily (M26) and papyrus (°M15) plants of the Two Kingdoms, the group thus actually spelling out the concept of *sema-tawy*, or "Union of the Two Lands." This developed emblem is found carved on the sides of royal thrones from the Fourth Dynasty where it appears on statues of Chephren, Mycerinus (**ill. 2**), and other monarchs.

Other heraldic elements were also added to this emblematic unit – usually fecundity figures representing the Upper and Lower Nile, or the juxtaposed figures of the gods Horus and Seth (or the latter's substitute Thoth) as symbols of Upper and Lower Egypt. These flanking deities may be found grouped with the central *sema* element in a number of ways: seated, kneeling, or standing – often with one foot placed on some part of the union sign to give them leverage as they tightly knot the heraldic plants together. The composition may be surmounted by the image of the king or by the cartouche (°V10) containing his name, showing the role of the king in presiding over the unity of the Two Lands. **Ill. 3** shows a relief representation of this theme depicting Ramesses III, and a calcite vase from the tomb of Tutankhamun (**ill. 4**) also provides an elaborate three-dimensional expression of the fully developed motif. Although in this latter piece the vase's stopper with its surmounting figure of the king is missing, the outstretched wings of the protective vulture (°G14) indicate where the royal image was originally placed. One further important variant of this developed theme occurs in the New Kingdom. In this form, rather than being held by Egyptian gods, the tendrils of the Upper and Lower Egyptian heraldic plants are shown binding foreign captives (°A13) who kneel on either side of the composition.

Although the *sema* motif reflected the royal prerogative of union, the sign was used increasingly in the later periods in funerary contexts which aimed at the association of the deceased with royal figures – or even the deceased's becoming a royal being in the afterlife. Thus, the union sign appears alongside the standard amuletic hieroglyphs on Late Period coffins, and in at least one papyrus the *sema* sign is depicted on the dais upon which Osiris – with whom the deceased was directly associated – sits enthroned.

sema

F 36

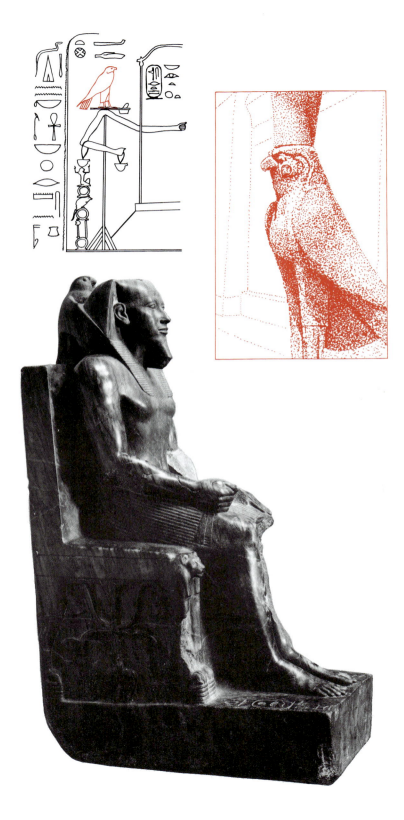

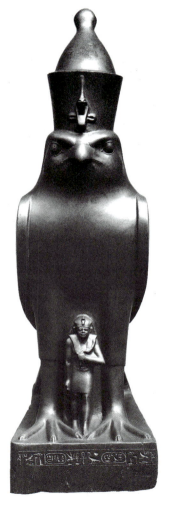

1 *(Far left) Falcon standard on lintel of Sesostris III, from Naq el-Madamud. Twelfth Dynasty.*

2 *(Left) Colossal statue of Horus falcon, Temple of Horus at Edfu. Ptolemaic Period.*

3 *(Left) Statue of the enthroned Chephren, from Giza. Fourth Dynasty.*

4 *(Above) Statue of Nectanebo II, from Heliopolis. Thirtieth Dynasty.*

From the earliest times the falcon (*Falco peregrinus* and related species) seems to have been worshipped as a cosmic deity whose body represented the heavens and whose eyes were the sun and moon. This was the god Horus whose name meant "he who is distant" or "he who is above," and who gained universal veneration even before the founding of Egypt's first dynasties. But the falcon also came to represent a number of other important deities, and in Old Kingdom times the image of this bird served as the determinative for the generic word "god." With certain attributes the falcon was specifically associated with different deities: with a sun disk atop its head – the sun god Re; with two tall feathers – the Theban god Montu; mummified – the mortuary god Sokaris; and with double crown – Horus the son of Isis; as well as many others. The goddess Hathor was sometimes associated with the image of a female falcon, and the bird often appears perched on a plumed pole as a symbol of the west (°R13) and hence of the necropolis. Isis and Nephthys are sometimes shown as two kites – similar in appearance though not identical to the true falcon.

Because of the large number of deities associated with the falcon, the range of identificational possibilities is often quite wide; yet most frequently, depictions of the bird in its simple hieroglyphic form without added attributes represent the god Horus and the king's relationship with that deity (**ill. 1**). The bird appears in this way atop the Horus *serekh* (°O33) and "Golden Horus" (see °S12) names of the king; in falcon-shaped statues such as the colossal example in the Temple of Horus at Edfu (**ill. 2**); and in many statues of the king sitting or standing in the god's protection. The relative status of the god and king are sometimes evident in these latter compositions – as when we compare the Cairo Museum statue of the seated king Chephren who is guarded by a small falcon perched behind his head (**ill. 3**), with that which shows the diminutive figure of King Nectanebo II protected by a hugely overshadowing Horus falcon from some 2200 years later (**ill. 4**). Although the symbolism of these compositions is nearly identical, the stress placed on the figures of the god and the king is dramatically different. The falcon also served as a symbol of the king himself, however, and this concept finds frequent expression in Egyptian literature – beginning with the Pyramid Texts, where the king ascends to heaven as a falcon – and in art, where the king is associated with the noble raptor from very early times. In the Late Period, mummy-shaped coffins and even the masks of the mummies themselves were sometimes given falcon-shaped heads in expression of this concept.

The human *ba* (°G53), or soul, was frequently represented in the form of a falcon with a man's or woman's head; and the "Eye of Horus" (°D10), with its distinctive markings taken from the face of this bird, is another image based on the falcon which is found throughout Egyptian art.

FALCON

bik

G 5

1 (Right) Emblematic vulture on stone vase of Khasekhem, from Hierakonpolis. Second Dynasty.

2 (Below) Nekhbet and Wadjet, barque shrine of Sesostris I, Karnak. Twelfth Dynasty.

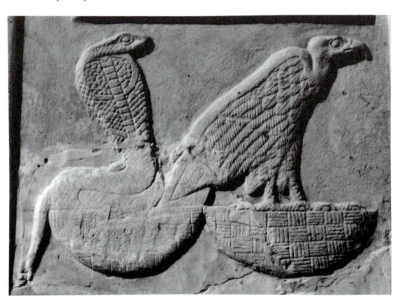

3 (Above) Double vulture amulet of princess Khnumet, from Dahshur. Twelfth Dynasty.

4 (Right) Falcon, vulture and ibis, pylon of temple of Khonsu, Karnak. Ptolemaic Period.

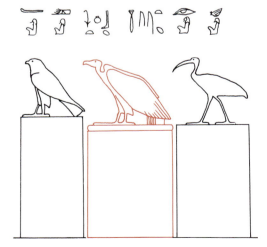

At least five different species of vulture were known in ancient Egypt – including the so-called "Egyptian vulture" (*Neophron percnopterus*) which was used as the letter "a" in the hieroglyphic script (G1). A more massive bird resembling the griffon vulture (*Gyps fulvus*) appears in the hieroglyph G14, and in most representations in Egyptian art, however. This vulture was associated with a number of female deities, and especially Nekhbet of the town of El-Kab in Upper Egypt. When El-Kab rose to prominence at an early date, Nekhbet took on the role of national goddess of Upper Egypt and the vulture thus became a heraldic creature – as is seen in the grouping found on a stone vase of the Second Dynasty king Khasekhem (**ill. 1**). Here, the vulture goddess stands on a *shen* ring (*V9) containing the word for "rebels," while she grasps the sign for "unity" (*F36) as though offering it to the king's "Horus" name (*O33) which is written before her. Nekhbet was also depicted in juxtaposition with the uraeus serpent (*I12) of Buto in Lower Egypt, the two creatures serving as symbols of the Two Lands and of the divine kingship which united them (**ill. 2**). The vulture again appears with the serpent in the *nebty* or "Two Ladies" name of the king – one of the five formal names adopted by each pharaoh at his accession – and in the images sometimes placed together on his brow. Because of this parallel role of the uraeus serpent and the vulture, the two deities could become assimilated to each other's imagery and sometimes appear as two royal serpents or two vultures shown together (**ill. 3**).

The vulture was also the symbol of the goddess Mut who was worshipped in human form as the consort of Amun at Thebes, but who is also frequently depicted in bird form. The Egyptian word *mwt*, written with the vulture hieroglyph, means "mother"; and beginning in the Late Period, the bird also served as a symbol of the female principle – often in apposition to the scarab (*L1) which signified the male principle. The vulture thus came to represent a number of important female deities such as Isis and Hathor (as well as being used in general representations of unspecified goddesses – **ill. 4**), and the combined images of the vulture and the scarab could represent the androgynous goddess Neith and the creator-god Ptah, in whom both sexes were united.

Probably no other creature is depicted in so many different formal poses in Egyptian art, but of these poses, four are certainly the most important. The vulture is shown standing, not only in its basic, hieroglyphic form (as an amulet or in other contexts), but also with wings outstretched to protect figures or symbols (in amuletic jewelry and larger representations). The bird is also depicted flying, and may be shown both in profile (as when it guards the king) and viewed from underneath (as on the roofs of temples and shrines). While it is not always possible to decide which deity is represented by the vulture on the basis of these iconographic details alone, a flying vulture usually represents the goddess Nekhbet.

VULTURE

neret

G 14

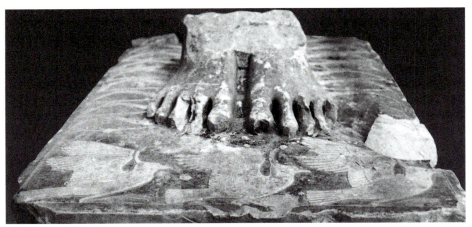

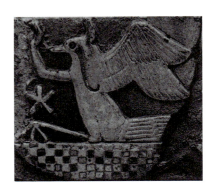

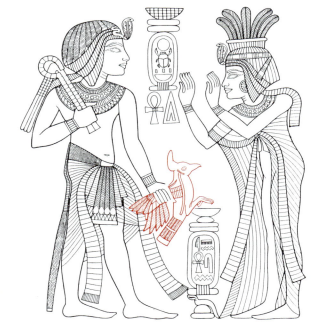

1 (Top) Lapwings on broken statue base of Djoser, from Saqqara. Third Dynasty.

2 (Above) Tile with rekhyt bird, temple of Ramesses III, Medinet Habu. Twentieth Dynasty.

3 (Above right) Personified rekhyt, temple of Ramesses III, Medinet Habu. Twentieth Dynasty.

4 King holding lapwing, small gilt shrine, tomb of Tutankhamun, Thebes. Eighteenth Dynasty.

The Lapwing (*Vanellus vanellus*) appears in Egyptian art from very early times. On the "Scorpion Macehead" from Hierakonpolis (*c.* 3000 BC – see *S35), the bird (which may be recognized by its distinctive head-crest) is already used with symbolic significance, apparently representing captured peoples of Lower Egypt. On the base of the statue of the Third Dynasty king Djoser, the lapwing motif appears in a more developed form, identical to that of the hieroglyph (**ill. 1**). In this work the feet of the king are placed solidly upon graphic representations of the "Nine Bows" (*T10) which symbolized Egypt's foreign enemies, while before his feet a row of lapwings represent the subject peoples of the king's own land. Although the king does not place his feet directly upon them, it may be seen that the wings of the birds are twisted one over the other at the joint – rendering them helpless and unable to fly. Captured birds are often shown pinioned in this manner in paintings of bird catchers, and the symbolic significance of this kind of control of the king's subjects is forcefully clear.

By New Kingdom times, however, the lapwing motif often finds a more positive mode of expression. The image of pinioned birds is often transferred to the enemies of Egypt (*A13), and from the Eighteenth Dynasty onward, the lapwing is found in temple reliefs and on glazed tiles used to decorate the walls of royal palaces. In these representations the bird is often shown in the same pose, but with the arms of a human in the act of giving praise (*A30). The bird is typically shown seated in an upright position upon a decorated basket with a five-pointed star before its breast as in **ill. 2**. Here, the lapwing is part of a symbolic statement: the bird itself signifies the people of Egypt, the basket is the *neb* hieroglyph (*V30) for "all," and the star (*N14) represents the verb *dua*: "to give praise." The whole rebus thus spells out the message "All the people give praise." Occasionally, the bird is replaced by an anthropomorphic personification in which a human figure is shown with the wings and head-crest of the lapwing (**ill. 3**), but the symbolism remains the same. In temple reliefs, the lapwing motif was used as a decorative band running around the bases of walls and columns – with the birds usually set on either side of a cartouche (*V10), indicating that the object of their praise was the king. In palace decoration, however, the inlaid tiles or plaques with this motif may usually have been affixed so as to face thrones, doorways, or areas along processional paths – in order to direct their symbolic message of praise toward the king himself. On the small gilt shrine of Tutankhamun (**ill. 4**), the king is shown with the emblems of his office holding a lapwing before him. The bird directs its praise toward the cartouche of his queen, the "Mistress of the Two Lands," Ankhesenamun, while the queen herself is shown raising her hands in adoration of the king. The composition thus embodies a complete iconographic cycle: under the king's rule the people praise the queen, and the queen praises the king.

LAPWING

rekhyt

G 24

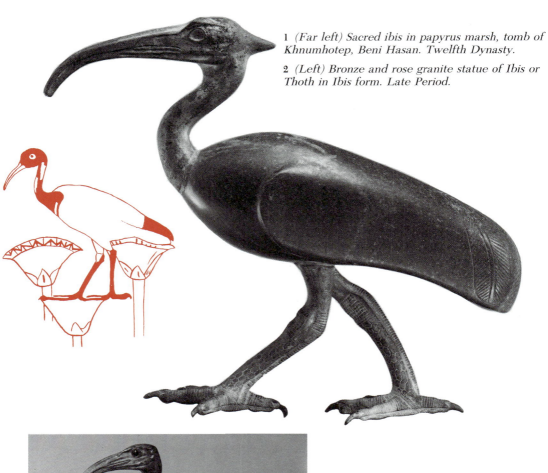

1 *(Far left) Sacred ibis in papyrus marsh, tomb of Khnumhotep, Beni Hasan. Twelfth Dynasty.*

2 *(Left) Bronze and rose granite statue of Ibis or Thoth in Ibis form. Late Period.*

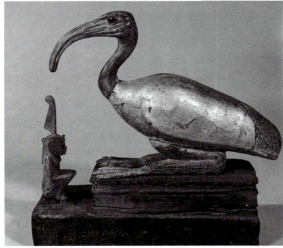

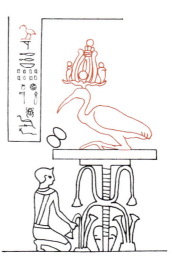

3 *(Above) Ibis and Maat statue, from Tuna el-Gebel. Late Period.*

4 *(Right) Ibis on union sign, from the sanctuary of the temple of Hibis. Late Period.*

Known to the ancient Egyptians by the name *heb(i)* – the origin of the Greek name *ibis* – the sacred ibis (*Threskiornis aethiopicus*) appears in Egyptian art in representations of marsh and river scenes (**ill. 1**), and also in symbolic contexts as the bird identified with Thoth, the god of the moon and patron deity of scribes and writing. At Hermopolis, the main cult center of Thoth, ibis were mummified in honor of the god. Many thousands of such embalmed birds have been found there, as well as in the vast underground catacombs at Saqqara and at other sites where ibis were dedicated by pilgrims in the later Saite and Ptolemaic Periods.

Not only was Thoth portrayed with the head of an ibis in many representations, but the bird itself was also frequently depicted to signify the god. Thus many statues were made in the shape of the ibis for cultic purposes, and these frequently follow the hieroglyphic form. Usually the body was constructed of painted wood, alabaster, or some other light-colored stone and the head, legs and pinion feathers of the bird were made of darker material in order to reflect the coloration of this particular species. **Ill. 2** shows a fine example from the Late Period where the body of the ibis was carved from a block of rose granite to which the head and legs of molded bronze were added. Here, the sculptor has closely followed the pose of the striding bird as it is depicted in the hieroglyph, but an alternative pose also appears which depicts the ibis squatting with its forelegs flat on the ground in the same manner as one of the hieroglyphs used to represent the heron (°G32).

Statues of the bird in this position sometimes show the ibis alone, but are frequently associated with the goddess of truth and justice, Maat (°C10), who may be shown as a miniature figure seated before the bird as in **ill. 3**. In this example, the body of the ibis is of gilded wood and the dark wing feathers of the bird are of inset bronze, as are the head and legs. The figure of Maat is shown wearing her characteristic feather (°H6), and it may not be coincidental that the carefully arranged space between the bird and the goddess in this statue – as in many others – also reflects the shape of the feather of truth. In addition to its close connection with Thoth and Maat, the ibis was also associated with the gods Ptah and Osiris, as well as with the deified Imhotep and the goddesses Hathor and Nephthys. Thus the bird may appear with any of these deities (or their symbolic attributes) in representational contexts (**ill. 4**).

While the sacred ibis is distinguished by its white plumage and dark head, legs and pinion feathers, the crested or hermit ibis (*Geronticus eremita*) is recognized by its characteristic ruff of head feathers. This species is seen in the hieroglyph G25 and appears as a determinative in the word *akh* used to signify "glorious" and "the transfigured spirit" of the deceased. The bird also appears occasionally in Egyptian art, especially as a decorative element on Fourth and Fifth Dynasty funerary diadems.

IBIS

heb

G 26

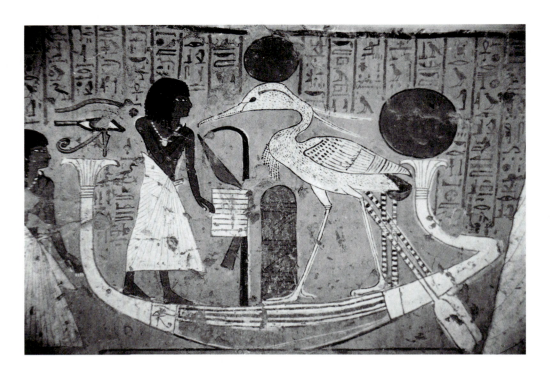

1 *Phoenix in solar barque, tomb of Irynefer, Thebes. Nineteenth Dynasty.*

2 *Phoenix perched on ben-ben or pyramidion, Papyrus of Nakht. Eighteenth or Nineteenth Dynasty.*

3 *Heron standard, lintel of Sesostris III, from Naq el-Madamud. Twelfth Dynasty.*

4 *(Below right) Osirian heron, tomb of Inherkhau, Thebes. Twentieth Dynasty.*

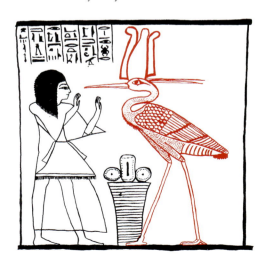

The gray heron (*Ardea cinerea*) is recognized by its long straight bill and double head plumes, as well as the tuft of neck feathers which also appears in most representations. In the hieroglyphic script the bird occurs in two distinct signs: standing upright in a striding stance (G31), and also sitting, crouched on its characteristic perch (G32). Both of these hieroglyphic forms occur in larger representations – the former in naturalistic or symbolic scenes, and the latter usually with solar and afterlife connotations. The heron is thus frequently found in marsh scenes, and as an object of adoration in tomb paintings and the vignettes of funerary papyri – as in the scene from the Nineteenth Dynasty tomb of Irynefer (**ill. 1**). In this painting Irynefer is shown standing in a pose of respect before a large phoenix in a sacred barque (*P3). The solar connotations of the image are evident in the use of the sun disk on the heron's head, and on the stern post of the boat, for the phoenix was believed to represent the *ba* (*G53) or soul of the sun god, and in the Late Period the hieroglyph of the bird was used to represent this deity directly.

As a symbol of the sun, the heron was the sacred bird of Heliopolis which became the legendary phoenix of the Greeks. Doubtless as a result of its association with the setting and rising sun, the phoenix was regarded as lord of the royal jubilee (*O23) of rejuvenation which was enacted after thirty years of the king's rule. This association led in turn to the Greek tradition of the phoenix renewing itself, from its own ashes, at regular intervals many years apart. Like the sun, the heron rose from the primeval waters and its Egyptian name, *benu*, was probably derived from the word *weben*: to "rise" or "shine." The stately wading bird was also associated with the Nile inundation; standing alone on isolated rocks or patches of high ground in the midst of the waters, the heron fittingly represented the first life to appear on the primeval mound which rose from the watery chaos of the original creation. This mound was probably the origin of the *ben-ben*, the pyramidal or cone-shaped sacred stone of Heliopolis with which the phoenix was associated, and which was depicted in the hieroglyph of the perched heron. This sign was used as a determinative in the word *bahi*: "to be inundated," and in many representations (**ill. 2**) as a symbol of rebirth.

Like the ibis (*G26), the heron was also considered a manifestation of the resurrected Osiris, and the bird is often shown perched on his sacred willow tree (*M1). In **ill. 4** the Twentieth Dynasty architect Inherkhau is shown worshipping a phoenix which wears the double plumed Atef crown (S8) usually worn by Osiris. The bird is further associated with the underworld deity in the hieroglyphic inscription above Inherkhau's head. In astronomical paintings the heron may represent *Dja*: "the Crosser" – the Egyptians' name for the planet Venus, and in other contexts the bird is also occasionally used as a symbol of Upper Egypt (**ill. 3**).

HERON

benu

G 31,32

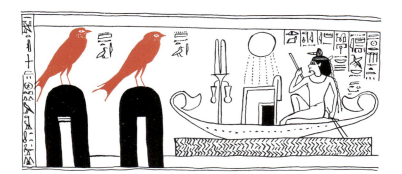

1 *Swallows on mounds, Papyrus of Panebenkemetnakht. Twenty-first Dynasty.*

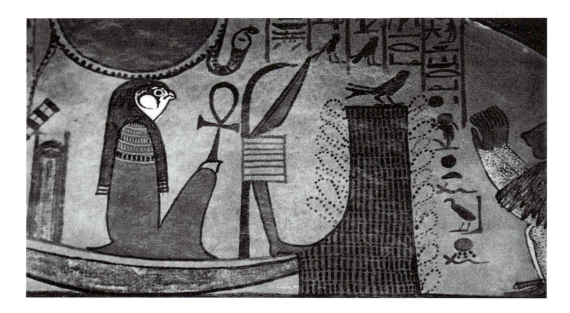

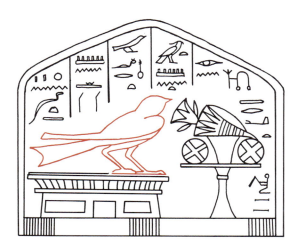

2 *Swallow on prow of solar barque, tomb of Sennedjem, Thebes. Nineteenth Dynasty.*

3 *Swallow deity, limestone stele from Deir el-Medina. Nineteenth Dynasty.*

Although it is not possible to define the exact species represented in this hieroglyph, it is clear that a swallow or martin of the family *Hirundinidae* is what is indicated. Several species of this family are common in Egypt, and while many ancient painted examples resemble the house martin (*Delichon urbica*), variation in the coloring of other examples indicates that Egyptian artists may well have used different species as models, and the generic term "swallow" may therefore be safer than any more specific appellation.

The hieroglyph was used to indicate the word *wer*: "great" (as opposed to the common sparrow which was used to write *nedjes*: "small," *bin*: "bad," and related words), and in the Old Kingdom, swallows were identified with the stars – and thus, in all probability, with the transfigured souls of the deceased. In the Pyramid Texts (Spell 1216), the king declares, "I have gone to the great island in the midst of the Field of Offerings on which the swallow gods alight; the swallows are the imperishable stars." And in the New Kingdom, Chapter 86 of the Book of the Dead specifically informs the deceased on "making the transformation into a swallow." In symbolic representational contexts then, the bird often signifies the soul of the deceased which is given the power to change itself into any form it wishes – especially into avian forms such as the hawk and the swallow – which might go forth from the grave and join in the daily cycle of light and life. This is often illustrated in the vignettes of the sacred funerary books. In the Late Period example shown in **ill. 1**, two swallows are depicted sitting upon conical structures which are undoubtedly meant to represent funerary mounds. Open doors give access to these mounds, allowing the soul to come and go at will – and the deceased appears, in fact, in this same composition where he is shown paddling a boat which holds a throne and the image of the sun.

The swallow also appears in representations of the solar barque of Re which frequently show the bird sitting on the boat's prow (**ill. 2**) as the sun passes through the underworld. In these instances, however, the swallow seems to represent not the soul of the deceased, but a kind of "day greeting" bird who announced the dawn and the sun's approach; the same imagery is also found in Egyptian literature, where the swallow proclaims the dawn in love poems of the New Kingdom. The reddish facial and body coloration of the common swallow (*Hirundo rustica*) may well have suggested an association with the sun, and the bird is, in fact, directly represented as a solar symbol in a small amuletic bracelet from the tomb of Tutankhamun which shows a swallow bearing a sun disk on its rump. Thus the swallow was itself a minor deity and is represented as such on the Nineteenth Dynasty stele from the Theban necropolis shown in **ill. 3**.

According to Plutarch's version of Egyptian mythology, the goddess Isis took the form of a swallow when she lamented the death of her husband Osiris.

SWALLOW

menet

G 36

1 *(Right) Ivory comb, from Hierakonpolis. Predynastic Period.*

2 *(Left) Domesticated pintail ducks, from the mastaba of Ti, Saqqara. Fifth Dynasty.*

3 *Wild fowling scene, tomb of the scribe Horemheb, Thebes. Eighteenth Dynasty.*

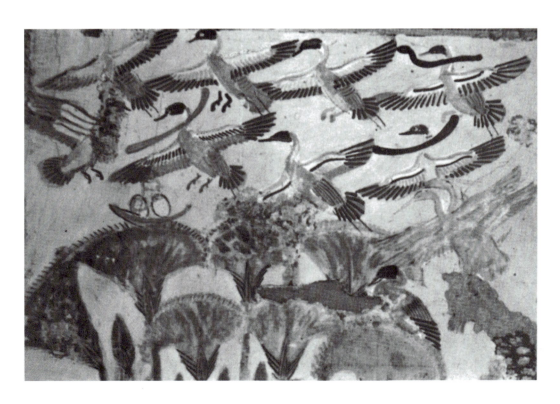

As one of the most common species of waterfowl in ancient Egypt, the Pintail Duck (*Anas acuta*) was depicted in three different hieroglyphs – standing (G39), and flying (G40, 41) – all three signs being used as indefinite determinatives for waterfowl and even birds in general. Despite this generic use, the duck held special symbolic significance and was a popular decorative element at all periods. The flying duck (more precisely, the hieroglyphs G40 and G41 depict a duck in the act of taking flight) appears on ivory combs (**ill. 1**) and as a pottery design from predynastic times. The species was domesticated at an early date and while standing birds are often depicted in household scenes (**ill. 2**), in representations of river, marsh, or lake settings the motif of wild flying ducks is ubiquitous from the Old Kingdom on. Often, whole flocks of ducks are depicted in a uniform hieroglyphic manner – with little if any variation of pose – as may be seen in **ill. 3**. In instances such as this the hieroglyphic pose clearly takes precedence over modern concepts of naturalism, and the power of the habitual written form of the sign is manifest. Yet this need not imply an automaton-like attitude on the part of the Egyptian artist. While swarms of bees (*L2) are also depicted as composite groups of identical hieroglyphic signs, the fact that non-flocking birds are never depicted in this manner suggests that the repetition of the standard pose evoked the idea of a flock or swarm of flying creatures and thus reinforced the artist's intended visual statement.

The symbol of the duck, however, seems to have had two quite distinct meanings, as the bird functions in contexts where both the suppression of evil and the evocation of fertility and rebirth are concerned. As a symbol of the wild marshes which were considered the refuge of evil spirits, the duck was itself identified with such pernicious elements. Thus the heads of ducks which often adorn the legs of seats and footstools are perhaps intended to show the suppression of the spirits symbolized by these creatures. On the other hand, the wild duck seems to have had erotic connotations for the ancient Egyptians, and while the nature of this symbolic aspect is not fully understood, the very common type of "cosmetic spoon" which consists of a swimming duck held by a naked or near-naked girl (who forms the handle of the spoon) may provide an example of this use – as may tomb paintings showing the deceased and his wife hunting ducks together in which the woman holds a small duck between her breasts. Often, the imagery seems purposefully oblique, yet it is possible that it was simply the very great number of ducks which inhabited the marshes and banks of the Nile that formed the basis of this connotation of fecundity. The duck could also be a symbol of rebirth, as when the Pyramid Texts speak of the king flying to heaven in the form of a falcon (*G5) or a duck (Spell 461). Earrings from the tomb of Tutankhamun which fuse the head of a duck with the body of a falcon (see *V9) may possibly symbolize this same concept.

PINTAIL DUCK

set

G 39,40,41

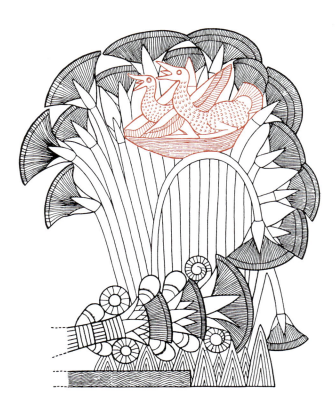

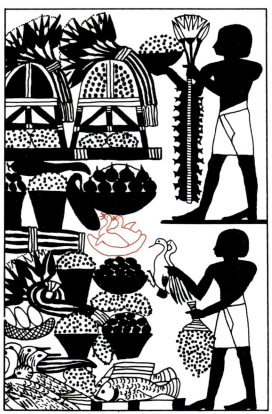

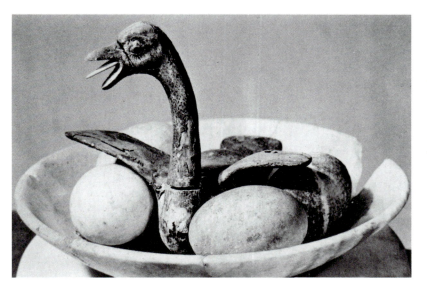

1 *(Above left) Marsh scene, small gilt shrine of Tutankhamun, Thebes. Eighteenth Dynasty.*

2 *(Above right) Offering scene with nests, tomb of Nakht, Thebes. Eighteenth Dynasty.*

3 *(Left) Lid of alabaster jar, tomb of Tutankhamun, Thebes. Eighteenth Dynasty.*

This hieroglyph, which was used as a determinative in the word *sesh*: "nest" and as an ideogram in words such as *tau*: "nestling," is often found written large in painted and relief representations of marsh scenes (**ill. 1**), and occasionally in offering scenes as well. The sign depicts several – usually three – ducklings, or perhaps goslings (G47), crouching in a crescent-shaped nest. Sometimes eggs are shown in the nest instead of the nestlings. In the Eighteenth Dynasty tomb of Nakht at Thebes (**ill. 2**), nests with both birds and eggs appear in a painted register depicting a variety of food offerings – ranging from heaped baskets of food to birds and fish. At the center of the register, with one wing up and one down (to be understood as being outstretched) two ducklings sit in their nest, or in a nest-like bowl, in the characteristic pose of the hieroglyph. As it is unlikely that young birds would actually be presented in their nest in this manner, the artist has clearly used the nest hieroglyph as an independent unit transposed into the composition. Below and to the left of this central nest, three eggs are also shown presented in a nest-like basket identified by its cross-hatched weave. The angle at which the eggs are depicted is exactly that at which the egg hieroglyph (H8) is drawn, and once again we see the direct utilization of hieroglyphic forms in the large-scale representation.

The egg, and by extension the nestling duck or goose, was symbolic of beginnings, and of the origin of the primeval world itself. According to one Egyptian myth, the first god came into being from the egg of a goose deity – "the Great Cackler" – probably representative of Amun or of the earth god Geb. The goose was the emblem of Geb and his daughter Isis is herself sometimes referred to as the "Egg of the Goose." Representations also show the creator god Ptah fashioning the first egg on a potter's wheel in the same way that the ram-headed Khnum is often depicted fashioning human beings. The egg and the hatchling could thus have cosmic and religious significance, and the ancient Egyptian certainly viewed them both as symbols of a new afterlife. Egg-shaped amulets were placed in tombs of the later periods as symbols of rebirth, and the lid of an alabaster jar found in the tomb of Tutankhamun (**ill. 3**) combines the symbolism of egg and nestling and is probably to be understood in this way. The lid is carved to form a shallow bowl representing a nest with four eggs and a nestling crouching in characteristic pose with outstretched wings and gaping mouth. Although the exact composition is somewhat different from that of the hieroglyph, this lid is clearly a variation within the recognizable range of the form of the nest sign.

The offspring of the goose (used hieroglyphically as *sa*: "son" and *sat*: "daughter") was also used to symbolize the children of the royal family, and a finger ring of Ramesses IV in the Louvre depicting a small gosling has this significance.

NEST

sesh

G 48

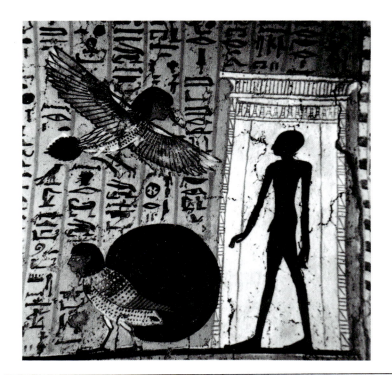

1 *Ba birds and shadow, tomb of Irynefer, Thebes. Nineteenth Dynasty.*

2 *Ba birds towing solar barque, Papyrus of Djedkhonsuiuesankh. Twenty-first Dynasty.*

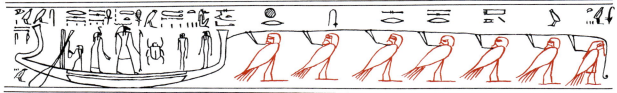

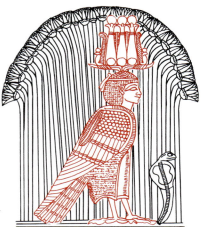

3 *The god Mandulis as a ba bird, temple of Kalabsha. Greco-Roman Period.*

Although the word *ba* (plural *bau*) is usually translated as "soul" or "spirit," the specific components or expressions of the human being as understood in Egyptian thought are notoriously difficult to define, and the word "soul" is frequently inadequate, if not wrong. The word *ba* is probably usually better rendered as "spiritual manifestation" and can only be understood fully according to context. In the earliest texts various anonymous gods are described as *bau* and as time progresses a *ba* could be the manifestation of any god. The word could also apply to the king, and by the end of the Old Kingdom the concept of the *ba* began to be applied to all people. In the following centuries the word took on the meaning of the personification of the vital forces – both physical and psychic – of the deceased.

If it cannot be well translated, the meaning behind the fully developed concept of the *ba* can at least be described. For the ancient Egyptian of New Kingdom and later times, the *ba* was a spiritual aspect of the human being which survived – or came into being – at death, and which was imbued with the fullness of a person's individuality. This is seen in the hieroglyphic sign used to portray the *ba* in writing and in the frequently depicted funerary scenes which show it as a human-headed (i.e., individualized) being, with the body of a bird – usually a falcon (°G5). This *ba* bird is often shown in tomb paintings and in the vignettes of funerary papyri hovering over the mummy of the deceased or entering and leaving the tomb at will. **Ill. 1** shows the *ba* of Irynefer, together with his shadow (another part of the Egyptian's concept of the self) from this person's Ramesside tomb at Thebes.

The independent nature of the *ba*'s existence meant that animals could be thought of as representing the *bau* of deities. At Heliopolis the phoenix (see °G31) was thus regarded as the *ba* of Re, and at Memphis the Apis bull (°E1) was venerated as the *ba* of Ptah or Osiris. The flexibility of the concept is seen in the fact that one god could be referred to as the *ba* of another, as when Osiris himself is called the "*ba* of Re." Because the *ba* could also represent anonymous gods or powers, *ba* birds are sometimes shown in various mythical contexts – greeting the sun or accompanying it in its heavenly barque (°P3). In some illustrations of the Book of the Dead, *ba* birds are shown towing the barque of the sun on its nightly journey through the underworld (**ill. 2**). Such human-headed *ba* birds may represent divinities, whether or not they are shown with the curved beards of gods (**ill. 3**).

The Jabiru – or Saddlebill Stork, *Ephippiorhynchus senegalensis* (G29) – was also used to represent the divine *ba*; and this species is frequently depicted in a monogrammatic group of three birds or as three rejoicing figures (°A8), representing the anciently deified kings of the cities of Pe (Buto) and Nekhen (Hierakonpolis), and elsewhere.

BA

ba

G 53

1 (Left) Votive stele of
Wedjarenes, from Thebes.
Twenty-sixth Dynasty.

2 (Above) Emblems on
ivory comb of King Djet,
from Abydos. First
Dynasty.

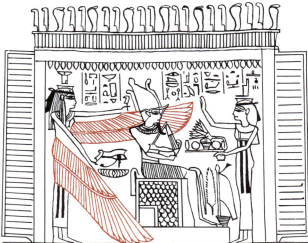

3 Osiris enthroned, Papyrus of
Khonsurenep. Twenty-first Dynasty.

According to a very ancient Egyptian conception of the cosmos, the heavens were the wings of a great falcon (°G5) whose eyes were the sun and moon, and whose speckled underside was the starry sky. This deity was the falcon-shaped god Horus, and the conception of the heavens as his wings may be seen in the First Dynasty tomb of King Djet (**ill. 2**) where the wings are attached to the solar barque (°P3) on which the falcon rides. Beginning in the Fifth Dynasty and concurrent with the rise in importance of the solar cult, a sun disk (°N5) was placed between the two wings which then became attributes of the sun god Re. The winged disk could still be associated with Horus, however, especially under the name of Behdety, the god of the southern city of Edfu and as the composite deity Re-Herakhty. In the later periods the image of the winged sun disk occurs universally as a protective symbol above the entrance doors of temples and their inner rooms, and also along the central axis of the temple roof as a symbol of the daily procession of the sun. Winged disks also appear on round-topped votive stelae of the Saite and Late Periods which were erected along processional ways as well as in shrines and tombs. **Ill.** 1 shows such a stele of a Twenty-sixth Dynasty temple officiant. On the left, this stele shows the deceased worshipping the figure of the creator god Atum and on the right, the falcon-headed Re-Herakhty. The setting imitates a shrine in its Hathor-headed columns (see °Y8) and facade – including the winged sun disk above the entrance. At the top of the stele, a larger winged sun disk also appears and is identified in the hieroglyphs as "the great god, lord of heaven, he of variegated plumage...Behdety." The curved upper section of Late Period stelae in which this motif appears was doubtless symbolically associated with the arch of the heavens – as may be seen in stelae where the sky (°N1) hieroglyph is placed in the same area, or the sun god Re-Herakhty is shown in his solar barque. The winged sun disk was so universally present in such works in the later periods of Egypt's history that it spread to a number of cultures influenced by Egyptian civilization to reappear as an important emblem in Hittite and Persian art and elsewhere. It is possible that the image is even echoed verbally in the poetic Hebrew phrase "the sun of righteousness shall arise with healing in his wings," found in the biblical book of Malachi.

Wings are also shown as attributes of a number of deities, usually in a protective context, as when they appear on apotropaic images of the god Bes, on the protective *wedjat* eye (°D10), or on goddesses associated with the funerary cult such as Isis and Nephthys (**ill. 3**). Along with Selket and Neith, these two goddessess were positioned at the sides or corners of royal sarcophagi of the Eighteenth Dynasty with their winged arms outstretched to protect the body of the king on all sides. In a similar way, the encircling wings found on royal coffins of the New Kingdom clearly symbolize the winged embrace of a protective goddess.

WING

djeneh

H 5

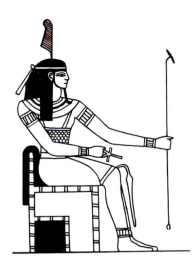

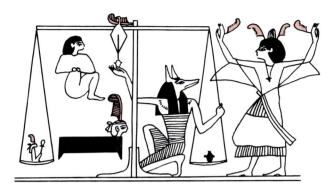

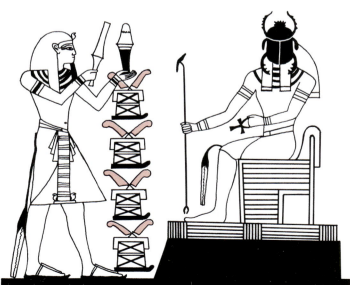

1 *(Top left) The god Shu, tomb of Ramesses III, Thebes. Twenty-first Dynasty.*

2 *(Top right) Weighing of the heart, Papyrus of Khonsumes B. Twenty-first Dynasty.*

3 *(Above) Divine judges of the afterlife, Papyrus of Dirpu. Twenty-first Dynasty.*

4 *(Left) The king presenting meret chests, tomb of Ramesses I, Thebes. Nineteenth Dynasty.*

The feather represented in this hieroglyph is a tall ostrich plume which bends over at its tip from its own weight. This curved upper portion is characteristic and serves to distinguish the sign from the reed-leaf (*M20) which is similar. The feather appears in several contexts in Egyptian art. Because of its phonetic value, the feather was used in writing the name of the air god Shu, and thus became an emblem of that deity. Often the god is depicted wearing the tall feather on his head as the sign of his identity (**ill. 1**), and the plume was also worn on a standard on the head of the goddess of the west (*R13). Occasionally, too, the earth god Geb may be depicted in a "costume" of feathers (see *P3) representing the air which covers him.

Most commonly, however, the feather appears as the sign of the goddess of truth and order, Maat (*C10) – surmounting the head of the goddess as in the previous cases, or independently as her emblem. Thus the feather is often shown as a symbol of truth weighed against the heart (*F34) of the deceased in funerary judgment scenes. In these scenes the feather may be represented not only on one of the pans of the scale, but also (as in **ill. 2**) in the form of the arm upon which the pointer of the scale is suspended. This illustration from the Twenty-first Dynasty papyrus of Khonsumes also shows another use of the feather symbol, in that feathers – doubtless representing *maat* – are held by the deceased and also worn on either side of the perfume cone atop his wig. These feathers are probably depicted to suggest the successful resolution of the judgment and the right character of the deceased. Although a single feather is more usual in the headdress of Maat, the goddess herself is sometimes depicted wearing two or more feathers in this same way. The deities which constituted the divine tribunal of the afterlife were traditionally depicted as seated figures (*A40) holding feathers as symbols of their office – as in **ill. 3**, where several of these gods also wear the feather upon their heads, and in one case a feather even functions as the head of the god himself.

Most other iconographic uses of the feather are also related to Maat. Ostrich feathers which appear as spouts on *nemset* vessels (small jars which were used in ritual offering contexts such as the "opening of the mouth" ceremony performed before statues and the mummy of the deceased) were associated with the goddess of truth in a number of ways, as were the feathers which appear with uraei (*I12) in friezes placed on shrines and tomb walls.

On the other hand, the significance of the four feathers worn on the heads of the men who erect the ceremonial mast or pole in the feast of the god Min is not fully understood, nor is the origin of the four feathers which characteristically adorn the *meret* chests (which seem to be related to the presentation of linen in certain ritual contexts) in the New Kingdom and later periods (**ill. 4**), though in these instances the four feathers seem to relate to the four cardinal points.

FEATHER

shut

H 6

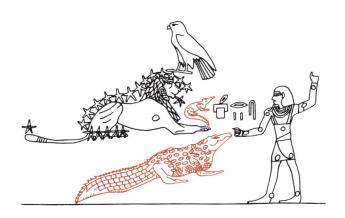

1 *Crocodile toy with moveable jaw. Late Period.*

2 *Constellations, astronomical ceiling, tomb of Seti I, Thebes. Nineteenth Dynasty.*

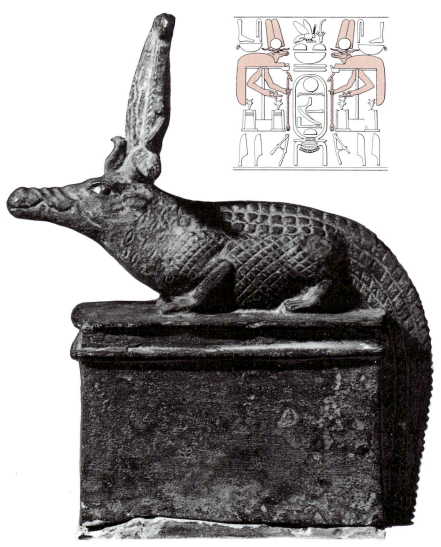

3 *Sebek standard, inscription of Amenemhet III, Krokodilopolis. Twelfth Dynasty.*

4 *Bronze crocodile with solar headdress on shrine. Greco-Roman Period.*

For the ancient Egyptian the crocodile (*Crocodilus niloticus*) was a creature of dual personality. As a common and dangerous animal which frequented much of his environment, the large reptile was easily viewed as a symbol of cosmic disorder and therefore of Seth (°E20), the enemy of the gods. The hieroglyph was used not only in the name of the crocodile *meseh*, but also as the determinative in words such as *seken*: "lust after," and *akhem*: "aggression." The gaping jaws of the animal were expressive of this aspect of its nature and are rendered in the child's toy shown in **ill. 1**, which is constructed so that the animal's mouth could be snapped shut by means of a string. In the same way, the mythical Ammit – fearsome devourer of the hearts of the wicked in the Judgment Hall of the afterlife – was represented as a composite creature with the body of a lion and the head and jaws of a crocodile. The Egyptians even saw the image of the crocodile being speared by a hero in one of the constellations of the northern sky, a motif which appears in a number of New Kingdom astronomical tomb paintings (**ill. 2**).

On the other hand, it was true that the crocodile emerged from the waters like the sun god himself; that facing east it basked in the early morning sun as though paying homage to the deity, and that it attacked the fish which were commonly viewed as the sun's enemies according to Egyptian mythological thinking. The creature was therefore worshipped in many localities, and a number of crocodile cults arose from the time of the Middle Kingdom. The most important of these was the cult of Sebek or Sobek which flourished at Krokodilopolis in the Faiyum, Silsileh, Ombos, Gebelein, and elsewhere. The worship of this powerful reptilian deity continued down into Greco-Roman times when half of the temple of Kom Ombo was dedicated to him under his Greek name Suchos. In Egyptian writing and in iconographic representations, the god is distinguished by his semi-mummiform shape or by the fact that his image is placed upon a shrine (I4). This is the manner in which Sebek appears on the inscription of the Middle Kingdom monarch Amenemhet III from Krokodilopolis (**ill. 3**). Here the figure of Sebek is depicted before the name of the king as a cult image with a headdress of horns, sun disk and feathers, and with human arms in which he holds the *was* (°S40) and *ankh* (°S34) signs. The god is shown on a standard which rises from the hieroglyph for the shrine of Krokodilopolis – so that the whole emblem expands upon the basic hieroglyph of the god upon his shrine to read "Sebek of Krokodilopolis (gives) life and power." This same hieroglyphic image of the crocodile deity upon his shrine is also found in many small statues and amulets from later periods, such as the bronze icon in **ill. 4** which dates to about 200 BC. Shown with an inward curved tail (I5), the crocodile was used to write words such as *sak*: "collect" or "gather together," and this hieroglyphic form is also found in representations such as the small constellation depicted in ill. 2.

meseh

I 3,4,5

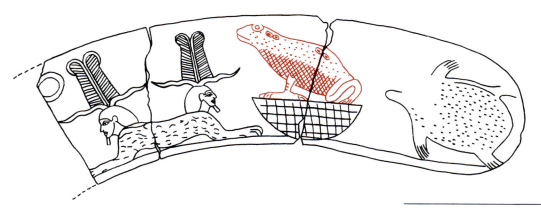

1 *Protective frog on basket, ivory magical knife.*
Middle Kingdom.

2 *(Right) The frog goddess Heket overseeing the birth*
of Horus, temple of Hibis. Late Period.

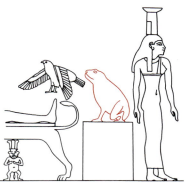

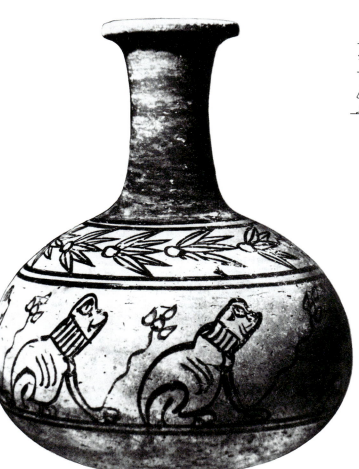

3 *(Left) Ceramic bottle with frog*
figures, from Semna. Greco-Roman
Period.

4 *(Below) Nile fecundity figure,*
Osiris chapel, temple of Isis, Philae.
Roman Period.

The frog is common in Egypt and was known by various names, one of the most frequently used in late New Kingdom times being the onomatopoeic *kerer*, representing the animal's croaking call. Because of its prodigious reproductive capacity the frog was a symbol of creation, fertility, birth, and regeneration. As an underworld animal it was associated with the forces which initially brought life into being. The four male gods of the primeval group of eight gods or Ogdoad who ruled before the creation of the world and were honored at Hermopolis – Heh (infinite space), Kek (darkness), Nun (water), and Amun (void) – were thus frog-headed.

Most important, however, the frog was sacred to Heket, the goddess of childbirth who was venerated as the female complement of the creator-god Khnum. While some representations depict this goddess as a frog-headed woman assisting her husband as he fashioned the child and its *ka* (see °D28) on his potter's wheel, usually Heket is represented in the zoomorphic form of the hieroglyph. In the Middle Kingdom she – or her symbol – was depicted on magical "knives" (**ill. 1**) which are believed to have been placed on the wombs of pregnant women, or upon their newborn children for their protection. The numerous images of frogs found in the Temple of Khenti-Amentiu at Abydos are thought to have served as votive offerings to Heket, and a relief of Seti I at this same site shows the king presenting offerings to her zoomorphic image which is set in an ornate shrine. The goddess appears in a similar manner in a Late Period representation of one of the legends of Osiris (**ill. 2**) in which Isis becomes pregnant by her husband as she hovers above him in the form of a hawk. In this representation Heket oversees the event in her role as goddess of pregnancy and birth. The frog was also associated with the Nile god Hapi and late representations depict the animal as a source of fecundity symbolized by the waters of the Nile – which are shown flowing from both the god and animal (**ill. 4**).

Like the mature animal, the swarming tadpole (*hefner*) was a symbol of abundance and was represented in the hieroglyphic script (I8) as the symbol for 100,000. Usually the diminutive amphibian is depicted sitting on the *shen* or "eternity" sign (°V9) at the end of the notched palm branch (°M4) signifying "years," as a symbol of the long reign conferred upon the king by the gods. The tadpole also appears independently with the significance of regeneration – a concept with which the frog was closely associated – and small stone or faience images of tadpoles and frogs were included as amulets in the wrappings of many mummies. In the later dynasties of the New Kingdom the frog hieroglyph was used to write the ritual expression *wekhem ankh*: "repeating life," and because it was connotive of rebirth, the frog, like the fish (°K1), was later adopted by the Christianized Egyptians as a symbol of the resurrection. The animal thus appears as an ornamental motif on decorated vases (**ill. 3**), lamps, and other items, late into the Christian period.

FROG

kerer

I 7

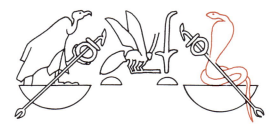

1 *Carved hieroglyphs, barque shrine of Sesostris I, Karnak. Twelfth Dynasty.*

2 *Seti I granted life, shrine of the temple of Seti I at Abydos. Nineteenth Dynasty.*

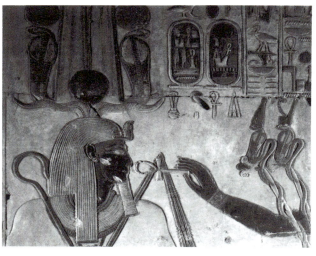

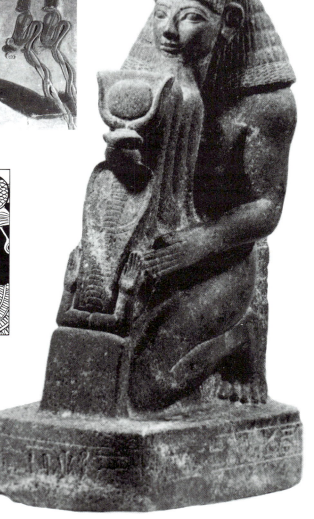

3 *(Above left) Fire-spitting serpent, tomb of Montuherkhepeshef, Thebes. Twentieth Dynasty.*

4 *(Above right) Serpent ear ornament, tomb of Nefertari, Deir el-Medina. Nineteenth Dynasty.*

5 *(Right) Maat-ka-re rebus statue of Senenmut, from Thebes. Eighteenth Dynasty.*

The Greek word from which "uraeus" is derived may have originated in the Egyptian expression "she who rears up," as the uraeus represents the rearing cobra (*Naja haje*) with its characteristic dilated hood. This species was associated from very early times with the sun, with the kingdom of Lower Egypt, with the person of the king, and with a number of deities. As the sacred creature of the goddess Wadjet in the Delta city of Buto, the cobra became an emblem of Lower Egypt (**ill. 1**) and appears with the Upper Egyptian vulture (*G14) Nekhbet in the king's *nebty* or "Two Ladies" title. Sometimes two uraei are depicted as a pair wearing the red and white crowns as symbols of the Two Lands (**ill. 2**). Standing alone, or alongside the head of the vulture goddess, the uraeus also appears on the diadem worn on the king's forehead and on crowns from the Middle Kingdom onwards, as in ill. 2. Even before this time, the cobra was held to represent the fiery "eye" of the sun god Re, and twin uraei had begun to be represented on either side of the solar disk (*N6).

A gilded wooden cobra inscribed with the name *netcher-ankh*, or "living god," which was found in the tomb of Tutankhamun is representative of this creature's associations with the underworld. Similar serpents are known from representations on painted wooden coffins from the end of the Middle Kingdom, and from examples appearing in illustrations of the New Kingdom Book of That Which Is in the Underworld and the Book of Gates. In these funerary works the uraeus is frequently depicted spitting fire (**ill. 3**), and two such creatures guard the gates (*O13) of each "hour" of the underworld. In certain Late Period funerary papyri uraei are also shown towing the barque (*P3) of the sun god through the underworld, and the creature's protective role is evident in all these examples.

Apart from these symbolic connotations and the general decorative use of the uraeus – as seen in **ill. 4** – uraei could also represent specific deities. Many of these serpents bear the sign (V26) of the Delta goddess Neith at the center of their dilated hoods (as in ill. 2), though this aspect need not associate the cobra directly with that deity. The uraeus was also associated with the goddess Maat (*C10), the daughter of Re, as well as with Re himself. In the statue of Hatshepsut's minister Senenmut (**ill. 5**), the uraeus with its solar disk forms part of a rebus spelling out the queen's throne name: *Maat-ka-re*. The uraeus was also called *weret hekau*: "The Great Enchantress," who could be represented as a human-headed goddess with the body of the cobra. This deity is mentioned ten times in the inscriptions on the shrine of Tutankhamun and also appears as the pendant of a necklace found in his treasures which shows her nursing a small figure of the king.

The resting cobra (I10) is also found in Egyptian art works, and in the decoration of certain objects such as the sistrum (*Y8), but its symbolism in this form remains the same.

COBRA

iaret

I 12,13

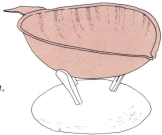

1 *Bulti-shaped bronze lamp, tomb of Kha, Deir el-Medina. Eighteenth Dynasty.*

2 *Schist bulti palette, from Thebes. New Kingdom.*

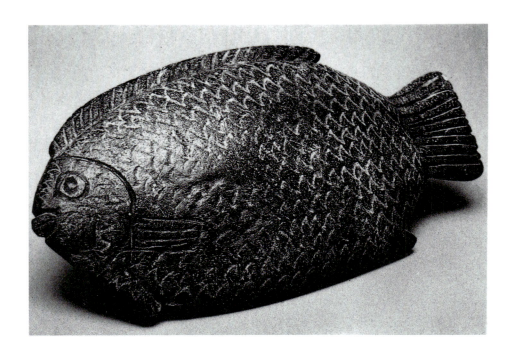

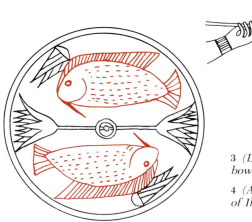

3 *(Left) Bulti with lotus blossoms, faience bowl, from Thebes. Eighteenth Dynasty.*

4 *(Above) Speared bulti and perch, tomb of Ibi at Deir el-Gebrawi. Sixth Dynasty.*

Although fish were viewed as ritually unclean and were disallowed as offerings to the king, to priests, or to the transfigured dead, they were nevertheless used for food by most people and are often represented in Egyptian art. Certain fish were highly symbolic, and the *ienet* fish (*Tilapia nilotica* – the chromis or bulti) held special symbolic significance and was frequently depicted from predynastic times in the form of slate palettes, pottery models and other items. The characteristic rounded shape and long dorsal fin of this species make it immediately recognizable in even the most stylized and summary representations – such as the fascinating example in **ill. 1**. This artifact, an Eighteenth Dynasty lamp, was carefully made to conform to the outline of the bulti. Although the spout of the lamp – which forms the line of the fish's mouth – and the projecting tail fin are the only details which are clearly rendered, the identity of the fish is unmistakeable and is further hinted at in the upper rim which outlines the dorsal fin, and in the rounded fullness of the lamp's body. This conscious use of the bulti form as a lamp is probably more than simply decorative, however. The body of the bulti is often of a bright reddish coloration and probably because of this and its rounded shape, the fish symbolically represented the sun and was especially fitting for the form of a lamp.

Because the bulti incubates and hatches its eggs in its mouth – from which the young may be seen to emerge – this fish also symbolized the concept of rebirth. For according to some aspects of Egyptian mythology, the spirit of the deceased was believed to rise from the waters of the afterlife as the sun had risen from the primeval lake. Thus, the body of the slate unguent palette representing a bulti (**ill. 2**) is carved not with scales, but with the waved lines used in the hieroglyph for water (N35). But because these lines are shown *vertically* in representations of bodies of water (°N39), this bulti may be meant to be understood as swimming *upwards*, toward the surface of the symbolic rebirth.

In the New Kingdom, bulti were often depicted along with lotus blossoms (another symbol of the sun, and of rebirth – °M9) on the inside surfaces of bowls such as the example shown in **ill. 3**. In this way the bowl, when filled with water or wine, is made to represent a pond or pool. In this instance the bulti may be shown swimming with lotus blossoms in their jaws to heighten their symbolic association with the sun. A final symbolic significance for this fish is seen in the many New Kingdom tomb paintings which depict the deceased hunting and fishing in the marshes. Such scenes frequently show the bulti speared with another fish, the nile perch (*Perca nilotica*), on the two tines of the bident used to catch fish (**ill. 4**). The differing natural habitats of these two species have led scholars to realize that the two fish are probably placed together to represent the produce of the united Upper Egypt (the perch) and Lower Egypt (the bulti).

BULTI FISH

ienet

K 1

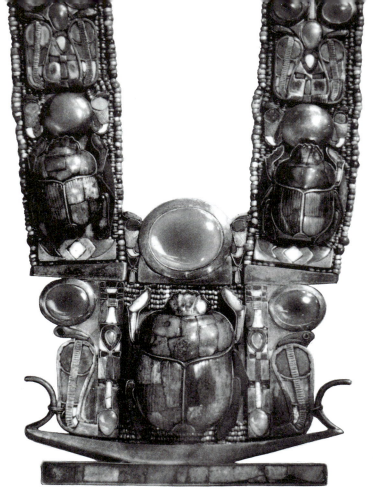

1 *Scarab pectoral, tomb of Tutankhamun, Thebes. Eighteenth Dynasty.*

2 *Osiris-Khepri scarab, tomb of Petosiris at Hermopolis. Greco-Roman Period.*

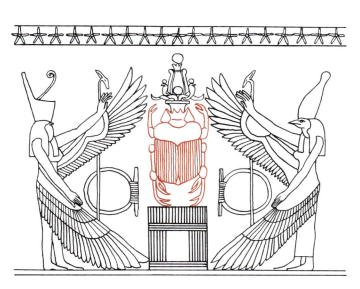

Several species of scarab or dung beetle are found in Egypt, but the large sacred scarab (*Scarabaeus sacer*) is the species most commonly represented in ancient Egyptian art. This beetle is known for its habit of rolling balls of animal dung along the ground before depositing them in underground tunnels as a source of food for its larvae. Because the young beetles seemed to emerge spontaneously from these tunnels, the Egyptians worshipped the scarab under the name Khepri: "he who came forth" or "he who came into being." Thus the beetle was equated with the creator god Atum from early times. The ray-like crenations of the the scarab beetle's head and the insect's habit of pushing a ball of dung before it also suggested solar symbolism; and the god Khepri was believed to roll the solar disk across the sky in exactly the same manner. This notion is often reflected in representations of the scarab on Egyptian artifacts, especially those made for kings whose names included both the *kheper* hieroglyph and the sun god Re, as may be seen in various items from the treasures of Tutankhamun (one of whose names – the so-called prenomen – was Neb*kheper*ure). By a coincidence of the conventions of Egyptian writing, this name of the king was written so that the scarab appears to be pushing the sun sign before it, and the scarabs depicted on Tutankhamun's *ankh*-shaped mirror case (°S34), the double cartouche case, and a number of bracelets, pectorals, or chest ornaments (ill. 1), and other items from the king's tomb all depict the scarab-solar motif in a kind of visual punning on the king's name. The scarab may also be depicted pushing the disk of the moon, or the left "Eye of Horus" (°D10) which represented it.

Scarabs of stone or faience ranged from the stylized to the highly naturalistic and were made in millions in ancient Egypt as stamp seals and as amulets. In the former case they were engraved with the name or design of the owner, and in the latter, often engraved with the image of a god or the name of some great king (especially one whose throne name included the *kheper* sign, such as Thutmose III – "Menkheperre," or Amenhotep II – "Aakheperure"). The undersides of larger scarabs were used for the historical commemorative announcements issued by Amenhotep III who also erected a great granite scarab on a plinth before the sacred lake at Karnak. Such large-scale representations of the scarab are known in the contexts of several temples and tombs. In the Hellenistic Period tomb of Petosiris at Hermopolis, a large scarab beetle is shown as Osiris-Khepri crowned on a pedestal between the flanking goddesses of Upper and Lower Egypt (ill. 2). Finally, from the New Kingdom on, the heart (°F34) of the deceased which was left in the mummy was assisted by a so-called "heart scarab." This heart scarab was meant to be weighed against the feather (°H6) of truth in the final judgment and was often inscribed with part of Chapter 30 of the Book of the Dead, which included the words "Oh my heart...Do not stand as a witness against me."

SCARAB BEETLE

kheper

L 1

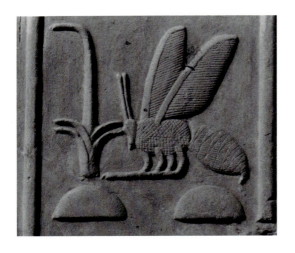

1 *Nesu-bit title of Sesostris I, barque shrine, temple of Amun, Karnak. Twelfth Dynasty.*

2 *(Top right) Mutilated bit hieroglyph, temple of Ramesses III, Medinet Habu. Twentieth Dynasty.*

3 *(Right) Apicultural scene showing hives and the collection of honey, tomb of Pabesa, Thebes. Twenty-sixth Dynasty.*

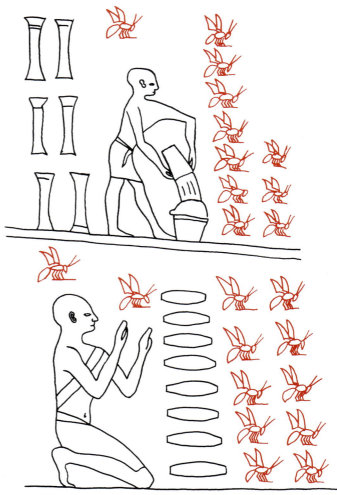

Like many other animals and insects, the bee was accorded a measure of solar significance, and according to one myth this insect was created when the god Re wept and his tears fell to earth in the form of bees. Besides this connection with the sun god, the bee was associated with a number of other deities – especially Amun, Min and Neith, the temple of Neith at Sais being called the *per-bit* or "house of the bee." The bee also had important royal significance from very early times as the emblem of the Lower Egyptian Kingdom. While the exact origin of this association is not fully understood, it is reflected in the *nesu-bit* or "He of the sedge and the bee" name of the king's titulary (**ill. 1**) where the creature stands next to the heraldic plant of Upper Egypt (M23). This connection with the royal ideology led to the name *bit* being used as a name for the Red Crown of Lower Egypt, and also for the king as monarch of that region.

The bee also played a small but important part in Egyptian society. Apiculture seems to have been fairly widely practiced in many periods, as honey was commonly used in food and in the preparation of medical compounds, unguents, and many other substances. Bees were kept in long hollow tubes with narrowed ends which functioned as hives, and the honey (also called *bit* but with the determinative of a honey pot) was collected by means of fumigation. Several representations exist showing the various aspects of bee-keeping and the collection and processing of honey. The Fifth Dynasty "Chamber of the Seasons" in the Sun Temple of Niuserre at Abu Gurab contains the earliest of these representations, and others are known from Eighteenth and Nineteenth Dynasty tombs, especially those of Amenhotep (the major domo of Hatshepsut) and the vizier Rekhmire in Thebes, as well as the Twenty-sixth Dynasty tomb of the high official Pabesa (**ill. 3**). In this last instance, the bees are depicted swarming round their tubular hives, and in the upper register they appear again while a man pours the collected honey into a mold or some other receptacle. The use of hieroglyphic elements is seldom more noticeable in Egyptian art than in these and similar representations. Numerous identically posed insects – the repeated hieroglyphic *bit* sign – constitute the "swarms" of bees, and although the representation may seem rather mechanical by modern standards, an effective image of the swarm is nevertheless achieved.

Despite the bee's positive associations and beneficial uses it was still a stinging insect, and because of this fact its representations – just as in the written hieroglyphs – often show the systematic omission of the insect's head in order to render the image harmless (**ill. 2**). Apart from this aspect, the bee was a fitting symbol of the fecund bounty of the natural world, and in the Book of Gates it is said that when the sun god enters the first "circle" of the eighth "hour" of the underworld, the gods Tem, Khepri and Shu – who symbolize this quality in one way or another – answer the great Re in a voice which resembles the humming of many bees.

BEE

bit

L 2

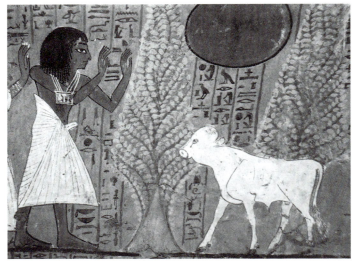

1 Syrians hiding among trees, relief of
Seti I, temple of Amun, Karnak.
Nineteenth Dynasty.

2 Bull calf between trees of the horizon,
tomb of Irynefer, Thebes. Nineteenth
Dynasty.

3 (Right) Tree bestowing gifts, stele of
Niai. Eighteenth to Twentieth Dynasty.

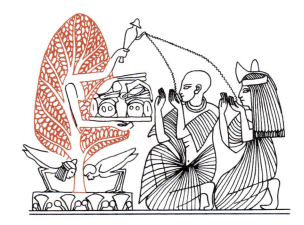

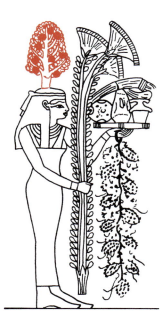

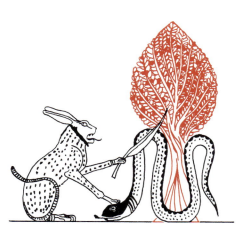

4 (Far left) Tree goddess, tomb
of Nakht, Thebes. Eighteenth
Dynasty.

5 (Left) Cat, serpent, and solar
tree, tomb of Inherkhau, Thebes.
Twentieth Dynasty.

Although the hieroglyph written to signify "tree" probably represented the sycamore (*nehet*), several types of trees appear in Egyptian mythology and art, the names of which were all written with the same hieroglyphic determinative. In paintings and relief sculpture, trees are often depicted by this generic sign, the hieroglyph being simply transposed into the larger representational context – as in the example shown in **ill. 1**.

The sycamore itself was a tree of particular mythical significance. According to Chapter 109 of the Book of the Dead, twin "sycamores of turquoise" were believed to stand at the eastern gate of heaven from which the sun god Re emerged each day, and these same two trees sometimes appear in New Kingdom tomb paintings with a young bull calf emerging between them as a symbol of the sun (**ill. 2**). While the cosmic tree could thus take on a male aspect as a form of the solar god Re-Herakhty, the sycamore was especially regarded as a manifestation of the goddesses Nut, Isis, and Hathor – who was given the epithet "Lady of the Sycamore." Many representations show the arms of Hathor or Nut reaching out from a tree of this species to offer the deceased food and water, as in **ill 3**. Here, the deceased couple kneel before a sycamore while the two arms of the goddess proffer a stream of water and a tray laden with offerings, thus symbolically supplying all their needs. Formal (fully anthropomorphic) personifications of tree goddesses are also known (**ill. 4**). As a result of this significance sycamore trees were often planted near tombs and models of the leaves of the tree were used as funerary amulets. Burial in the wooden coffin could also be used as a return into the womb of the mother tree goddess.

The *ished*, a fruit-bearing deciduous species – probably the *Persea* – also had solar significance and was protected from the serpent Apophis by the great cat (*E13) of Heliopolis (**ill. 5**). A sacred *ished* was grown in Heliopolis from Old Kingdom times, and later in Memphis and Edfu as well. On the ceiling of one of the chapels of the Temple of Dendera twin *isheds* are depicted on the tops of the two peaks of the horizon hieroglyph (*N27) showing their cosmic role, like the sycamore, in association with the rising sun. In the Eighteenth Dynasty the motif of a divine *ished* upon which the king's name and the years of his reign were inscribed by the gods appeared, a motif which became especially popular in Ramesside times. The willow (*tcheret*) was also particularly important in iconographic symbolism. This tree was sacred to Osiris as it was a willow which sheltered his body after he was killed, and in which the god's soul often sat as a bird. Many towns had tombs where a part of the dismembered Osiris was believed to be buried and these all had willow groves associated with them. A festival called "raising the willow" was held each year which assured that the fields and trees of the land would flourish. The tree could thus function in Egyptian art as a symbol of life, fecundity, and rebirth, as well as an emblem of a number of deities.

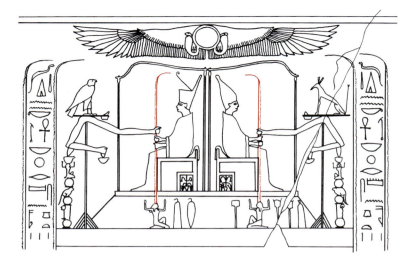

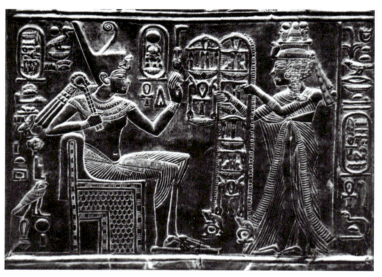

1 *Palm branches presented to the king, lintel of Sesostris III, from Naq el-Madamud. Twelfth Dynasty.*

2 *Ankhesenamen with palm branches, small gold shrine of Tutankhamun, from Thebes. Eighteenth Dynasty.*

3 *Gods with palm branches and renpet signs, third funerary shrine of Tutankhamun, from Thebes. Eighteenth Dynasty.*

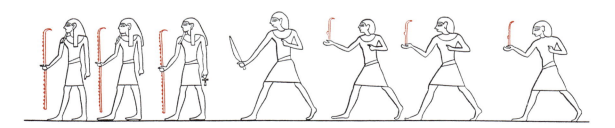

A branch of the date palm (*Phoenix dactylifera*), stripped of its leaves and notched annually, appears to have been used as the standard method of recording years in ancient Egypt from the most distant times. The Egyptian word for "records" or "annals" is thus *genut* from *genu*: "a branch," and the palm branch hieroglyph was used in such words as *renpet*: "year" and *ter*: "time" or "season," from Old Kingdom times. The sign also appears in large-scale representations from an early date, and by the Middle Kingdom its use was established in several fairly common iconographic motifs.

Because the sign implied "years" and "length of time," it was especially fitting in contexts concerning the rule of the king and his coronation and *sed*, or jubilee (*O23) festivals. In the Twelfth Dynasty relief of the *sed* festival of Sesostris (**ill. 1**), the king is shown enthroned as the king of Lower and Upper Egypt and is presented with notched palm branches by partially personified emblems of the Two Lands – the Horus falcon (*G5) and the Seth animal (*E20) respectively. Behind both of these emblems pairs of large *renpet* signs are shown which not only visually frame the composition, but also reinforce the symbolic content of the scene. In this instance, the whole scene is of course symbolically treated, but that such palm branches were actually presented to the Egyptian king at his accession and jubilees seems more than likely. As time progressed, a number of other symbols were affixed to the palm branch in many of its representations, and later New Kingdom works such as the scene from the small gilt statue shrine of Tutankhamun (**ill. 2**) show the notched branches with tadpole ("100,000" – see *I7) and *shen* ("eternity" – *V9) signs at their bases, and with pendent groups of hieroglyphs reading "jubilee festivals" and "all life and power" (*S34 , *S40). The symbol for "year" or "time" was thus elaborated with these concepts so that the whole formed a promise from the gods for a long reign of "hundreds of thousands of years of life and power with many jubilees."

Fittingly, the palm branch was the symbol of the god Heh (*C11), the personification of eternity, and this deity is often depicted with the *renpet* sign worn on his head and with notched palm branches grasped in each hand. As a symbol of time, the palm branch is also occasionally found in other, more cryptic representations; and in illustrations of the second "hour" of the Book of That Which Is in the Underworld, for example, the figures of three gods appear, perhaps running to acclaim the sun god (and thus by association, the king) with *renpet* signs in their hands (**ill. 3**). These three deities are given the names "The Opener of Time," "The Guardian of Time," and "The Carrier," and show not only the importance of the control of time for the deceased king's successful entry into eternity, but also – as in the examples seen above – the often inseparable relationship between the written hieroglyph and the symbolic pictorial element in Egyptian art.

PALM BRANCH

renpet

M 4

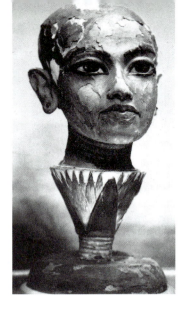

1 *Tutankhamun as Nefertem, from the king's tomb, Thebes. Eighteenth Dynasty.*

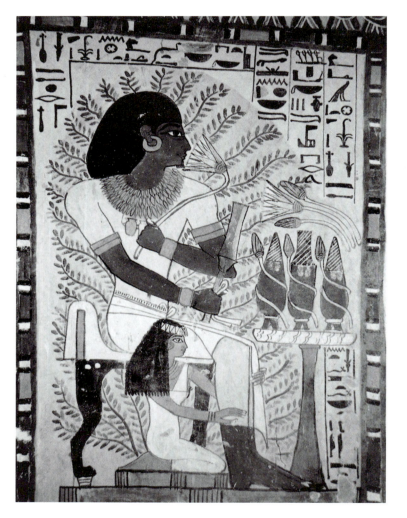

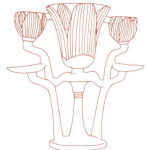

2 *(Above) The deceased with lotus and offerings, tomb of Sennefer, Thebes. Eighteenth Dynasty.*

3 *Lotus-shaped lamp, tomb of Tutankhamun, Thebes. Eighteenth Dynasty.*

Two species of lotus or water lily were indigenous to Egypt, the white *Nymphaea lotus*, and the blue *Nymphaea cerulea*. The first is recognized by its rounded buds and petals and the second by its more pointed buds and narrow petals. A third, unrelated species, the red or pink lotus *Nelumbo nucifera*, was introduced from Persia in the Late Period. While both the white and blue lotus are represented in classical Egyptian art and the red lotus frequently appears on Hellenistic monuments, the sacred blue lotus is the most commonly depicted species and it is this flower which is represented in the hieroglyph.

Because the water lily closes at night and sinks underwater – to rise and open again at dawn – it was a natural symbol of the sun and of creation. According to Hermopolitan myth it was a giant lotus which first rose from the primeval waters and from which the sun itself rose. The concept of the young sun god appearing as a child (*A17) on a lotus is described in Chapter 15 of the Book of the Dead, and was frequently represented in Egyptian art, with the god Nefertem, "Lord of Perfumes," who represented the fragrant lotus, being assimilated into this imagery. As a symbol of rebirth the lotus was also closely associated with the imagery of the funerary cult – the four sons of Horus (see *D1) are sometimes shown on the flower which rises from a pool (*N39) before the throne of Osiris, and Chapter 81 of the Book of the Dead contains the spells for "transforming oneself into a lotus" and thus into the reality of resurrection. The small wooden portrait bust of Tutankhamun (**ill. 1**) represents these concepts in showing the young king's head rising from a blue lotus blossom to a renewed life.

As the most beautiful of Egyptian flowers, the lotus also appears in countless offering scenes (**ill. 2**) and in most New Kingdom tomb paintings of banquets – where the flower is often depicted placed upon wine jars and its extract may have been used in wine for its mildly narcotic qualities. In the same period, the lotus was used representationally as a symbol of Upper Egypt (see *M15), and the flower was also a favorite subject for the design of bowls, goblets, and other items – such as the alabaster lamp of Tutankhamun (**ill. 3**) which represents a lotus plant with its leaves (M12), flowers (M9), and buds (M10) growing from the bed of a pond.

Careful attention to natural detail – bordering on the observance of an iconographic convention – may be seen in the orientation of the lotus flower in its representations. In instances where the flower is intended to be understood as growing in its aquatic habitat (as in the capitals of temple columns and in scenes symbolic of creation and rebirth), the lotus is shown in its floating, upright position. As a purely decorative element (pectorals, or chest ornaments, architectural friezes, etc.) the flower is usually shown inverted, and in scenes showing the actual use of the lotus in banquets and offerings it is depicted – as in the hieroglyph – with the flower head hanging to the side under its own weight.

LOTUS

seshen

M 9

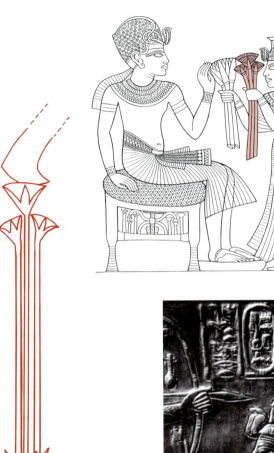

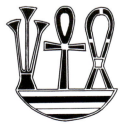

1 *(Far left) Papyrus clump supporting the sky. Detail, stele of Tentperet. Late Period.*

2 *(Left) Ankhesenamen offering papyrus and lotus to Tutankhamun, small gilt shrine of Tutankhamun, from Thebes. Eighteenth Dynasty.*

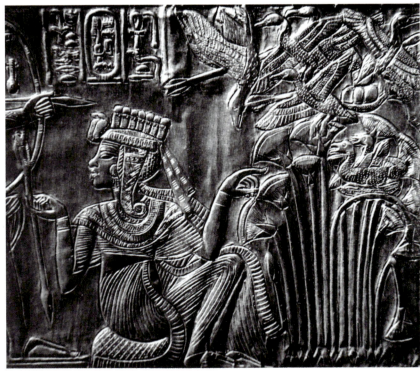

3 *(Above) Papyrus stand with wild birds, small gilt shrine of Tutankhamun, from Thebes. Eighteenth Dynasty.*

4 *(Left) Amulet, from the jewelry of Khnumit, Dahshur. Twelfth Dynasty.*

In the marshes and river borders of ancient Egypt and especially throughout the Delta, the tall papyrus plant (*Cyperus papyrus*) flourished in great stands and thickets. The papyrus was thus a natural symbol of life itself, and the hieroglyph M13 – which shows a single stem and umbel of the plant – was used as an amulet, and as a symbol for "green," and for concepts such as "flourish," "joy," and "youth." Because the plant was a symbol of the primeval marsh from which all life emerged, and papyrus "pillars" were also said to hold up the sky (**ill. 1**), the papyriform columns of the Egyptian temple may be seen to reflect the double symbolism of these ideas. The papyrus was also associated with several deities, and representations of Hathor, Bastet, Neith, and other goddesses often carry a papyriform staff as an attribute. Hathor, as a goddess of heaven and the necropolis, sometimes appears as a cow with a papyrus umbel between her horns as a symbol of the sun or of the papyrus marshes of the west, and the *ukh* staff (R16) – a papyrus stem crowned with two feathers – was an important fetish associated with the cult of this goddess.

A growing clump (M15,16) of three papyrus stems served as determinative in the word *idhu*: "swamp," and also in the word *Mehu* or *Ta-Mehu*: "Land of the Papyrus," which was used to denote the kingdom of Lower Egypt. As early as the beginning of the Dynastic Period the sign is found on the Narmer Palette (see *D1), where a papyrus clump grows out of the elongated *ta* sign (N17) signifying "land" – to which is attached the head of a subjugated rebel surmounted by the royal falcon (*G5) – a group clearly spelling out the message of Upper Egyptian control of the Delta in a compositional unit consisting purely of fused hieroglyphic signs. As an emblem of Lower Egypt, the *mehyt* hieroglyph was often paired with the heraldic plant of Upper Egypt (M26), and in New Kingdom times it appears with the lotus (*M9) in the same manner (**ill. 2**). In naturalistic scenes, the papyrus clump signifies the marshland environment in its meaning of "swamp," in countless wildfowling scenes (**ill. 3**), and in the rank lushness of private and royal gardens in scenes such as that of Tutankhamun hunting ducks with his wife Ankhesenamun on the small gilt shrine from that king's tomb (see *G48). Such compositions usually show the use of what is essentially a representative single papyrus clump. Despite the multiplicity of stems and added details – such as the nests of wild birds – the image of the papyrus clump remains essentially hieroglyphic in nature as opposed to a papyrus-filled "background."

A final meaning associated with the *mehyt* hieroglyph is seen in its linguistic usage for the word "around" or "behind," and in representational expressions of this concept. The hieroglyph is frequently used with the *sa* sign of protection (*V17) in the formulaic phrase "All life and protection are around [the king]," and this very common inscriptional formula may sometimes be found as an amuletic group with an independent representational existence of its own (**ill. 4**).

PAPYRUS CLUMP

mehyt

M 15,16

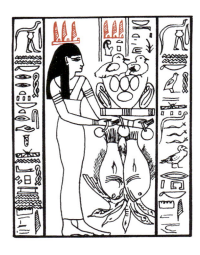

1 *Personified Sekhet, temple of Amenhotep III, Wadi el-Sebu'a. Eighteenth Dynasty.*

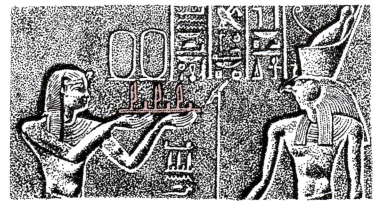

2 *King presenting fields of offerings, "Satrap Stele," from Buto. Ptolemaic Period.*

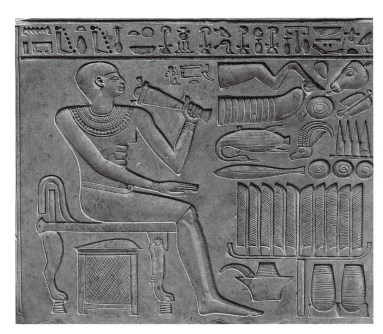

3 *Deceased before offerings with symbolic reeds, stele of the noble Maat. Eleventh Dynasty.*

Egyptian art uses this hieroglyph almost entirely in an emblematic way, as a symbol of "that which is produced by the fields." Linguistically, *sekhet* is used of marshland, fields and countryside, and in derivatives such as *sekhty*: "peasant;" but in iconographic contexts the sign is usually interchangeable with the *hetep* or offering sign (°R4) and its connotations. Just as the produce of the fields supplied offerings to the gods and to the deceased, so the field itself could be used as a symbol of offerings. Sekhet is thus sometimes personified as a goddess bearing offerings, as in reliefs from the temple of Amenhotep III at Wadi el-Sebu'a (**ill. 1**), where she appears in company with male fecundity figures (see °D27). Here, the personified Sekhet carries an offering mat laden with ducks, goslings, eggs, and bulti fish – produce of the marshes which she represents. The goddess wears the *sekhet* sign upon her head, and is named in the accompanying inscription which states that she brings *hu djefau*, "food and provisions" for the god.

The *sekhet* hieroglyph was also used in other symbolic ways. A stele of the early Greco-Roman Period shows the ruler Ptolemy, son of Lagos, presenting the sign for "field" (**ill. 2**) to the god Harendotes ("Horus, protector of his father"), a form of the god Horus. The motif is based on earlier examples, and the classical inscription before the king directly links the giving of offerings of the fields to his own hope of receiving the gift of life. In private monuments the hieroglyphic sign sometimes appears in a similiar manner. In **ill. 3**, the Eleventh Dynasty offering stele of the noble Maat in the Metropolitan Museum of Art shows the deceased before an offering table with various offerings: a foreleg (°F24) and ribs of beef, a duck and various other goods heaped above the conical half-loaves of bread traditionally shown on such offering tables (°X2). But the half-loaves are in fact quite clearly reeds – which approximate the shape of the required offering, but also suggest a much fuller range of "offerings of the field."

The concept of the field also found expression in various afterlife beliefs. In the Book of That Which Is in the Underworld, the sun god Re is said to distribute "fields of offerings" to the underworld's inhabitants on his nightly journey. In Chapter 145 of the Book of the Dead, the domain of Osiris is called the "Field of Reeds" or *Iaru*, and according to Osirian doctrine, the deceased was believed to work and live in these fields. Working in and harvesting the bountiful crops of the "Fields of the West," as they were also called, is a common theme as well for the vignettes illustrating Chapter 109 of this same work – which expresses the hope of an abundant afterlife. In the Book of That Which Is in the Underworld and the Book of Gates, the divisions of the underworld are sometimes called "fields," and these divisions were illustrated on the walls of many tombs of the kings of the New Kingdom. The *sekhet* hieroglyph itself, however, is rarely used in the composition of the vignettes or the tomb paintings, which tend to be more naturalistic in the portrayal of these concepts.

FIELD

sekhet

M 20

1 *(Left) Pet, ta, was frame representing heaven, earth, and the pillars of the sky in New Kingdom temple reliefs.*

2 *(Below) The sky goddess Nut, Papyrus of Nesitanebashru. Twenty-first Dynasty.*

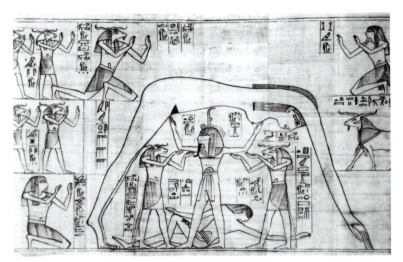

3 *(Left) The king upholding the sky, Altar of Taharqa, Gebel Barkal. Twenty-fifth Dynasty.*

4 *(Below left) Sky hieroglyph with falcon's head, Papyrus of Padiamun. Twenty-first Dynasty.*

The sky hieroglyph represents the heavens as a physical ceiling which drops at the edges just as the sky appears to reach down to the earth's horizon. The sign was frequently used at the top of walls, door frames, and gateways to symbolize the overarching heavens, and it is thus often shown studded with stars – not only as part of its specific visual significance, but also as part of an extensive effort to mirror the cosmos in architectural features. The curved top of the funerary stele also suggested the arch of the heavens to the Egyptians, as we see from the winged solar disk and the sky hieroglyph which so often decorate this area of these stelae. In temple reliefs and in many other artworks, the sign was also used as part of a kind of frame placed around individual compositions. In this framing device, the sky glyph is placed above the composition to represent the heavens, and the *ta* or earth glyph (N16) is placed beneath as a baseline, the two often being connected by a *was* scepter (°S40) at each side symbolizing the supernatural poles – or deities – which held up the sky (**ill. 1**).

The vault of the heavens was personified by the sky goddess Nut who is often depicted in a pose resembling the sky glyph as she arches over Shu, the god of the air, and Geb, the god of the earth (**ill. 2**). In these representations the arms and legs of the goddess reach down to the horizon, but she is also supported by various attendant deities who help to uphold her and who are symbolized by the *was* scepters in the geometric framing device. In religious representations of the New Kingdom and Late Periods, the king is also frequently shown supporting the sky hieroglyph with his upraised arms – symbolically supporting the heavens and thus the cosmic order and the gods themselves. This motif is expressed in reliefs found on temple walls, on shrines and on altars – such as the Altar of Taharqa (**ill. 3**) from the Temple of Amun at Gebel Barkal. Here, four figures of the king – reminiscent of the Heh (°C11) deities which support Nut, but here probably representing the cardinal points – hold aloft a star-studded emblem of the heavens. Variants of this theme show kings holding aloft sky signs upon which a divine barque (°P3), solar disk (°N5), or some other emblem of the sun is placed. Sometimes, as in the Altar of Atlanersa (*c.* 653-643 BC) in the Boston Museum of Fine Arts, the king stands upon the hieroglyphic sign representing the "Union of the Two Lands" (°F36) as he supports the sky: a complex iconographic statement which encompasses the whole of the king's role as ruler of men and supporter of the gods.

In the Late Period, the sky hieroglyph also appears in representations with the inverted head of a solar falcon (°G5) descending from it as a symbol of the radiant sun (**ill. 4**); or the figure of a god with outstretched arms is shown in the same manner, lowering the solar disk to the horizon or receiving it into the sky.

SKY

pet

N 1

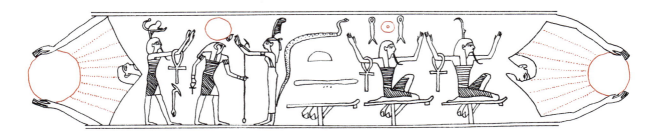

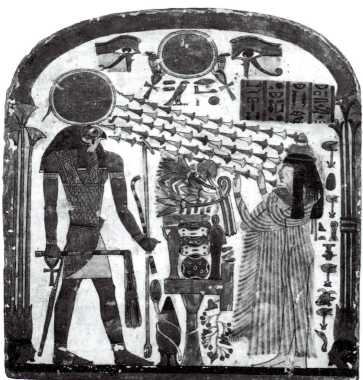

1 *Sun god in cycle of eternity. Papyrus of Khonsumes B. Twenty-first Dynasty.*

2 *Sun disk with floral rays, stele of Tentperet. Late Period.*

3 *(Bottom left) Atum and Khepri in solar disk, Papyrus of Bakenmut. Twenty-first Dynasty.*

4 *Aten disk with rays and hands, tomb of Ay, Amarna. Eighteenth Dynasty.*

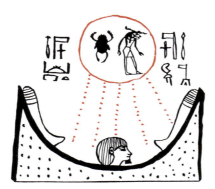

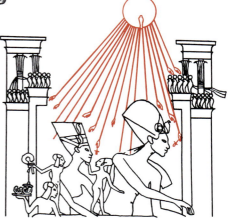

The sun was the most important element in Egyptian religion throughout most of Egypt's history and many of the major Egyptian gods were solar deities. For this reason the solar disk is one of the most frequently used symbols in Egyptian art, and one which is manifested in a number of forms. The sun seems to have been revered first as Horus, then as Re (and the combined Horus-Re) and later as Amun-Re, with all these gods being worshipped in the later periods. As the sun represented the "eye" (°D10) of the sky god Horus and also of the god Re, it is often shown as a disk on the head of a falcon (°G5), or alone, as a winged disk (°H5). But many other deities were also identified with the sun; and its appearance in the morning, at midday and in the evening was linked respectively with the winged beetle (°L1) Khepri, the great god Re, and the ram-headed god Khnum. In the Late Period, a different form was associated with each hour of the day, and the sun was represented in twelve ways ranging from a child in the first hour to an arrow-shooting monkey in the seventh (the hottest hour) and an old man (often with a ram's head) in the last. Other animals associated with the sun and used to represent it in many periods include the snake, lion, sphinx and griffon, and among plants, the lotus and sycamore.

A number of hieroglyphs were used to represent the sun in Egyptian writing, the most important being the simple sun disk (N5), the disk with uraeus (N6), and the disk with rays emanating from it (N8). All these forms appear in Egyptian art works, sometimes within the same composition – as in **ill. 1** where the sun is shown as a radiant disk being raised by the goddess of the sunrise (looking upwards) and lowered at the other end of the day (looking down) at sunset. Between these extremes the sun god Re is shown as a falcon-headed deity – with the sun disk and uraeus upon his head – being assisted by the figures of Magic, who stands behind him, and Maat (°C10) before him. The passage through the day also contains the hieroglyphs for "Everlastingness," "Forever," and "Eternity" set on standards. The sun is thus shown travelling through all time as it proceeds on its daily journey – in a representation which fuses picture and written word into a single pictorial statement. In a similar manner, in **ill. 3**, the radiant sun disk contains within itself the images of the scarab beetle and the ram as symbols of morning and evening as it rises above the horizon (°N27).

Ill. 2 shows part of a funerary stele where Re-Herakhty (Horus-Re) illuminates the Lady Tentperet with divine rays as in the hieroglyph N8, but here the rays are in the form of flowers. Between them Horus-Behdety (Horus of Edfu – the winged sun disk) is shown in a late representational form, flanked by uraei. Under the reign of Amenhotep IV (Akhenaten), the sun was also worshipped as the Aten whose rays are depicted as arms proffering *ankh* signs (°S34) to the king and his family (**ill. 4**). This semi-personification is also a variant of the sun disk with its rays.

SUN

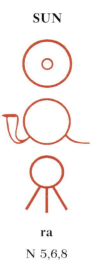

ra

N 5,6,8

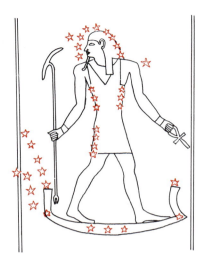

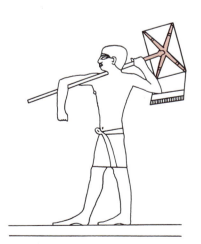

1 *Stellar deity, tomb of Pedamenopet, Thebes. Twenty-fifth or Twenty-sixth Dynasty.*

2 *(Right) The goddess Nut, lid of sarcophagus of Psusennes, from Tanis. Twenty-first Dynasty.*

3 *Seba sun shade, tomb of Ti, Saqqara. Fifth Dynasty.*

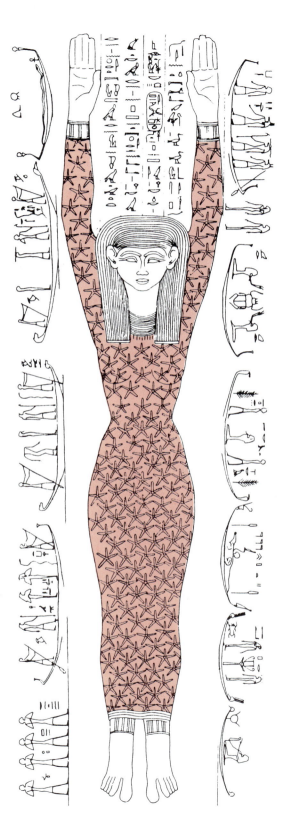

The timeless and constant nature of the stars played an important part in the development of the Egyptian calendar and in various afterlife beliefs. Because they never set, the northern circumpolar stars were especially important and were known as the "imperishable ones." Many of the brighter stars were named, and the night sky was divided into a number of defined constellations in thirty-six sections, or "decans," having ten days each. Paintings of stellar deities and constellations were made on the ceilings of many temples and tombs (ill. 1) because every Egyptian temple functioned as a complex model of the whole cosmos and because the stars were intimately connected with the Egyptian concept of immortality – they were not only the inhabitants of the heavens, but also of the *duat* (N13), the underworld realm of the dead through which the sun passed each night. The Egyptians believed that one aspect of the deceased person, the *ba* (*G53), might ascend to continue living as one of the myriad stars of heaven, but as "followers of Osiris" the stars could also represent souls in the underworld. The stars were thus connected to afterlife beliefs in two ways, and while those which decorated the roofs of tomb chambers and the lids of coffins symbolized the cosmic home which the *ba* would enter, many texts make clear the relationship of the stars to the underworld afterlife as well.

The iconography of the stellar image can be quite varied. While Egyptian star charts and decan tables make use of dots, circles and other figures as well as five-pointed stars, ceilings and other areas with more formal decorative schemes usually used the five-pointed star represented by the hieroglyphic sign, though the brightest stars are sometimes depicted as circles – like miniature sun disks. The five-pointed star hieroglyph was also frequently used in Egyptian art to adorn representations of the sky hieroglyph (*N1) and the body of the personified sky goddess Nut (ill. 2). In a similar manner, the bodies of divine cows representing Hathor in her function of cosmic goddess are often adorned with a trefoil design which approximates the natural spotting of the cows' hides but which also suggests a star-like pattern.

The widespread use of lapis lazuli in Egyptian artworks was not only due to the Egyptians' predilection for this precious stone, but also because its deep blue color – flecked with naturally occurring golden speckles – was a natural symbol of the star-filled sky. The use of the mineral in certain pieces of jewelry and other minor artworks may therefore be significant from a symbolic perspective which is based on the importance of the stars.

Occasionally, the star hieroglyph also appears at a secondary level of association in contexts where unrelated objects are produced in this form by virtue of their natural shape. An example of this is seen in the construction of sun shades (ill. 3) of a type called *seba* by the Egyptians, as their handle and supporting frame suggested the shape of the star hieroglyph.

STAR

seba

N 14

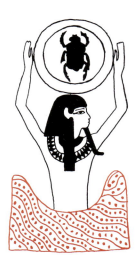

1 *Sun rising above the horizon mountain, anonymous sarcophagus. Twenty-first Dynasty.*

2 *Fetish of Abydos on mountain-shaped base, from Abydos. Nineteenth Dynasty.*

3 *(Below) Harvest scene with "mountains" of grain, tomb of Menna, Thebes. Eighteenth Dynasty. (After a copy by N. de G. Davies.)*

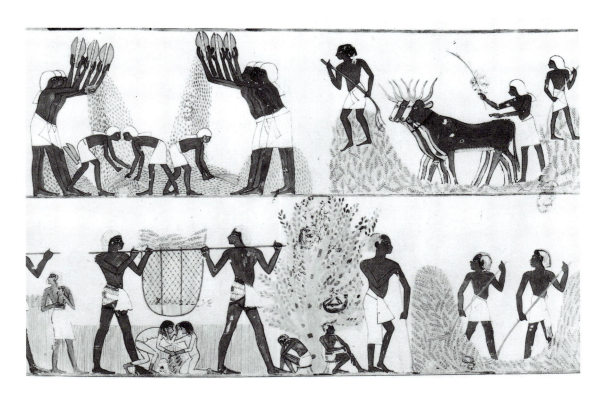

The hieroglyphic sign for "mountain" showed two rounded hills or peaks with a valley or strip of earth between them. While this sign could depict two individual peaks in any mountain range, it approximated the mountain ranges which rose on either side of the Nile valley, and also had a deeper cosmic significance. The Egyptians visualized a universal mountain split into a western peak (*Manu*) and an eastern peak (*Bakhu*) which served as the supports for heaven. The ends of this great earth mountain were guarded by lion deities (°E23) who protected the rising and setting sun and were sometimes portrayed as part of the cosmic mountain itself. The connection with the solar cycle is seen in the closely related *akhet* sign (°N27) which shows the sun rising above the mountain horizon, and in representations such as **ill. 1**, where the figure of a god lifts the solar disk above the mountain sign.

Because the Egyptian necropolis was usually located in the mountainous wasteland bordering the cultivation, the mountain was also closely related to the concept of the tomb and the afterlife. It may be in this context that the sacred symbol of Abydos (°R17) is to be interpreted, where the plumed cult symbol stands on a pole which is set upon the mountain sign (**ill. 2**). Texts referring to the mortuary deity Anubis (°E15) as "He who is upon his mountain," and the frequent representations showing the cow (°E4) goddess Hathor emerging from a mountain side (in the form of the hieroglyph N29 – which is one half of the mountain sign) as "Mistress of the Necropolis" are also manifestations of this symbolic aspect of the mountain.

The hieroglyph also appears in more mundane contexts at a secondary level of association. Because the mountain hieroglyph was divided into two peaks, the concept of a "hill" or "heap" of some substance such as grain is often expressed representationally by means of the mountain sign. The tomb of Menna at Thebes shows various scenes connected with the harvesting of the grain crop in which this principle is used (**ill. 3**). The cut grain is raked into large heaps, then threshed by oxen which are driven over it. After the grain is winnowed to remove the chaff, the final crop is carefully measured and recorded by scribes. At every stage in this process the artist represents the heaps of grain in the form of the mountain glyph to convey not only the shape of the heaps themselves, but also the concept of their large size.

The slightly different hieroglyph N25 – which shows a range of three peaks – was also used as a determinative in writing words relating to the desert and cemetery areas, as well as for quarries and foreign countries. Iconographically, however, the three-peak "mountain" is used almost exclusively with the sense of "foreign land," while the twin-peaked mountain is the form usually used in representations with cosmic and afterlife significance.

MOUNTAIN

djew

N 26

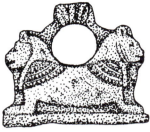

1 *Akhet amulet of the horizon. New Kingdom or Late Period.*

2 *(Left) Aker amulet with the lions of yesterday and tomorrow. New Kingdom.*

3 *Sphinx Stele of Thutmose IV with "horizon" composition, Giza. Eighteenth Dynasty.*

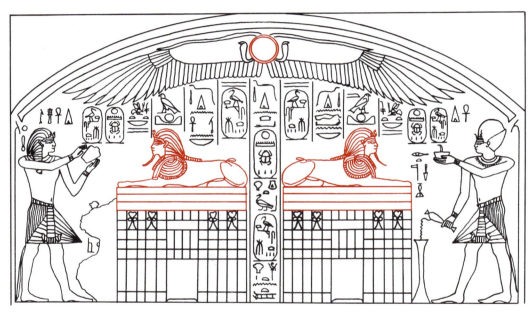

4 *Goddess of Horizon, tomb of Sennedjem, Thebes. Nineteenth Dynasty.*

5 *Metalworker with charcoal fire, tomb of Puimre, Thebes. Eighteenth Dynasty.*

The hieroglyphic sign for "horizon" shows the two peaks of the mountain glyph (°N26) with the solar disk appearing between them on the horizon from which the sun emerged or disappeared, as in the simple amulet in **ill. 1**. The horizon thus embraced the idea of both sunrise and sunset and was protected from early times by the *aker*, a double lion (°E23) deity who guarded both ends of the day. This double deity was represented in a number of ways, often as a long narrow tract of land with a human, or more usually leonine, head at each end – as in the more elaborate amulet in **ill. 2**. In this instance the opposed lions have clearly been made to mirror the shape of the mountain-glyph, with the circular space between them representing the sun in the image of the horizon. In the New Kingdom, Hor-em-akhet ("Horus in the Horizon") was the god of the rising and setting sun and is variously represented as a child, a falcon, or more commonly, as the leonine sphinx. The Great Sphinx of Giza thus came to be viewed as a literal "Horus in the Horizon" as it lay between the twin peaks of the giant *akhet* formed by the pyramids of Cheops and Chephren. In the relief scene carved on the famous "Sphinx Stele" at Giza (**ill. 3**), Thutmose IV is shown making offerings to twin sphinxes which represent the two aspects of the same god – Horus in the Horizon (whose name appears above the animals' heads). Because these sphinxes are placed back to back with the winged sun disk above and between them, this whole composition can be seen to be a complex elaboration of the horizon hieroglyph.

Other allusions to the horizon sign are frequently found in Egyptian art. The curved headrest (°Q4), for example, could imitate the *akhet* in its form and symbolism, for the sleeper's head rose from it like the sun from the horizon. Sometimes in two-dimensional representations the Egyptian artist would represent the mountains of the *akhet* as the two breasts of a reclining goddess who holds the sun aloft (**ill. 4**). In other instances the form of the hieroglyph was used not to suggest the rising sun, but as a visual metaphor referring to the related concepts of fire and heat. In the drawing of a metalworker blowing on the fire which he uses as a forge (**ill. 5**), the raised lip of the fire pit is shown in sectional profile with the heaped charcoal fire in its depression appearing just as the glowing sun between the two peaks of the horizon. The hieroglyph was also applied in architectural forms, and because the Egyptian temple was theoretically aligned on an east-west axis, the two towers which flanked its entrance may well have signified the two peaks of the horizon between which the sun rose. In an inscription at Edfu the pylon towers are, in fact, specifically referred to as the goddesses Isis and Nephthys "...who raise up the sun god who shines on the horizon." The statue of the sun god was thus sometimes displayed to the people from the terrace between the towers, and the term for this "appearance" – *khaai* – was the same as that used for the rising of the sun over the horizon.

akhet

N 27

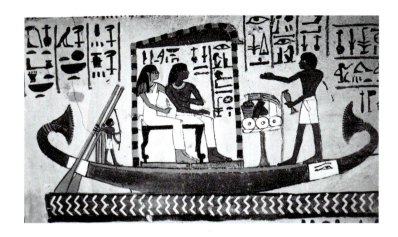

1 *Symbolic pilgrimage to Abydos scene, tomb of Sennefer, Thebes. Eighteenth Dynasty.*

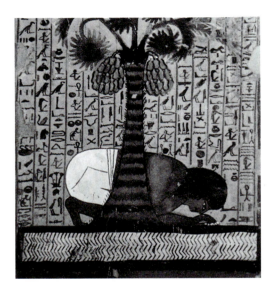

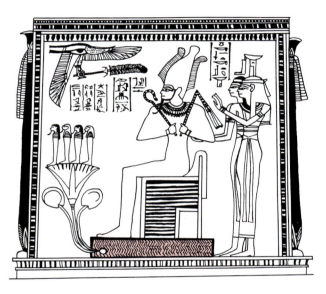

2 *Pool scene, tomb of Pashedu, Deir el-Medina. Nineteenth Dynasty.*

3 *Pool before Osiris, Papyrus of Hunefer. Nineteenth Dynasty.*

4 *Underworld Lake of Fire, Papyrus of Neskhonsu. Twenty-first Dynasty.*

The hieroglyphic sign used to denote a lake, pool, or other body of water may be written as a simple rectangle (N37), a rectangle with added lines to indicate the sloping sides of the pool (N38), or – most frequently – a rectangle crossed by vertical wave lines indicating water (N39 – **ill. 1**). The fact that these wave lines are usually drawn on a vertical axis is interesting, because the normal hieroglyphic sign used in the writing of "water," and as a determinative for words signifying bodies of water, always shows stacked horizontal wave lines (N35). This stacking of the water or wave lines would seem more in accordance with the usual canons of Egyptian art which used the principle of stacking rather than diminishing size to indicate distance – an approach consistent with the fact that to the human eye, the distant horizon does appear higher than the foreground. Nevertheless, in the pool hieroglyph and in paintings and relief sculptures where the hieroglyph is simply enlarged, the Egyptians invariably portrayed bodies of water by means of equally spaced vertical wave lines, and it is possible that this vertical wave pattern was preferred because it seems to heighten the sense of distance conveyed in the representation.

As in the myths of many of the cultures of the ancient world, water was the primeval matter from which the Egyptian believed all things arose; and the pool could thus signify the primeval waters of the First Time. The divine cow (°E4) Hesat or Mekhweret (meaning "Great Flood") is thus frequently depicted sitting on the pool hieroglyph to represent the original watery chaos from which all life emerged. The young sun god – in the form of a child (°A17) – is also depicted rising from the pool hieroglyph in many representations with this same symbolic meaning.

The pool also had strong afterlife connotations. Because a pool of water was to be greatly desired in Egypt's desert climate, tomb paintings often show the deceased drinking from a pool in the afterlife. **Ill. 2** shows such a scene from the tomb of Pashedu at Deir el-Medina, Thebes. Pashedu kneels by a fruit-laden palm tree – another symbol of afterlife sustenance – to refresh himself in his pool. Scenes of this type are often accompanied by inscriptions such as that found in the tomb of the scribe Amenemhet: "May you walk according to your desire on the beautiful edge of your pool...may your heart be satisfied with water from the cistern which you have made – for ever and ever." The four sons of Horus (see °D1) are also frequently depicted upon a lotus blossom which rises from a pool before the throne of Osiris in the underworld (**ill. 3**). On the other hand, the Egyptian conception of the afterlife also included the concept of a "lake of fire" which destroyed the wicked (Book of the Dead, Chapter 63). **Ill. 4** shows such a scene from the Papyrus of Neskhonsu, in which the dreaded lake is surrounded by fire signs (°Q7) and guarded by baboons (°E32).

she

N 39

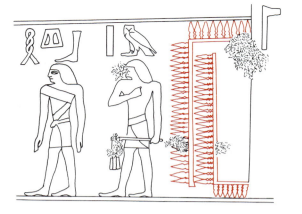

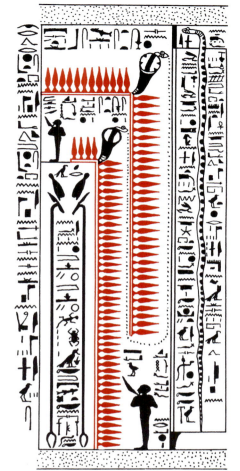

1 *Gate of jubilee court, temple of Niuserre at Abu Gurab. Fifth Dynasty.*

2 *Underworld gate, sarcophagus of Seti I, from Thebes. Nineteenth Dynasty.*

3 *Guardians of the underworld gates, tomb of Sennedjem, Deir el-Medina. Nineteenth Dynasty.*

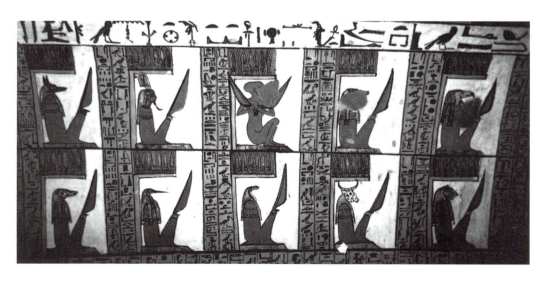

The walls and entrance gateway of some kind of enclosure are depicted in plan in this hieroglyph with a decorative *chevaux de frise* or battlement shown atop the walls according to the composite or "twisted" perspective used in many Egyptian architectural drawings. The use of this written hieroglyph to depict a gateway representationally is seen in the jubilee scene of Niuserre (**ill. 1**), where the king is shown performing ceremonial rituals connected with the *sed* festival (see °O23) in an open court before a high gateway. The "battlements" atop the walls in this hieroglyph represent rows of the *kheker* sign (Aa30) which was used to write the word "decoration" or "ornament," and it is the use of this element which distinguishes the gateway hieroglyph from the form of the simple reed shelter used by herdsmen in the fields (O4). Rows of *kheker* hieroglyphs are found painted along the tops of the walls of many New Kingdom royal tombs, signifying both the protective nature of the walls and the fact that the tomb was a gateway into the underworld.

sebkhet

O 13,14

Gateways were thus highly symbolic and could serve as thresholds as well as barriers in both textual and representational expressions of Egyptian mythology. As a threshold, the "Gate of Heaven" could refer to the shrine of a god or to the temple itself, and because the lord of the temple was often depicted on the temple gates, the entrance gateway became a place of worship where common people would present their prayers. The entrance pylons of temples also symbolized the gate of the eastern horizon (°N27) through which the sun entered the world each day, just as a second, western gate admitted the sun into the underworld and was thus symbolic of death. Those who were at the point of death were said, in fact, to "stand at the gate of the Horizon." In the Pyramid Texts, the most ancient of Egypt's religious writings, the king himself is said to pass over this threshold with the words " O...Gateway of the Abyss, I have come to you, let this (gate) be opened to me" (Pyr. 272).

In the later developments of Egyptian mythology, each of the twelve "hours" of the underworld was also separated by a door (°O31) or gate through which the deceased must pass. This is seen in many of the vignettes from the New Kingdom Book of the Dead and the Book of the Gates (**ill. 2**), which details the passage of the king in the barque of the sun god as it makes its nightly journey through the underworld. From the end of the Old Kingdom, the gates of the Underworld were believed to be guarded by serpents or demons – often armed with knives (°T30) and stationed to bar entrance to any who were unfit (**ill. 3**). The deceased needed to know the names of the gates and their component parts as well as the names of their guardians in order to pass through these portals, and this information was often carefully recorded in tomb inscriptions and funerary papyri. The importance of the underworld portals may be seen in Chapter 125 of the Book of the Dead where the secret, magical names of every part of the gateway are given.

1 *Shrine of Ptah, from a relief at Deir el-Bahari. New Kingdom.*

2 *Small gilt shrine of Tutankhamun, from Thebes. Eighteenth Dynasty.*

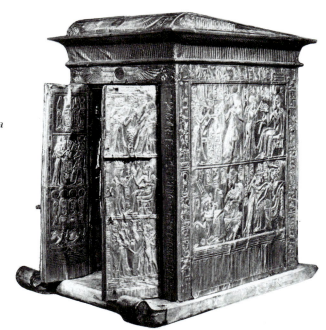

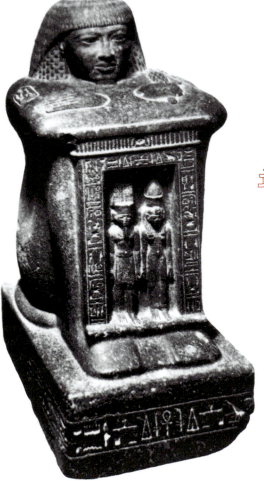

3 *(Left) Block statue of the vizier Khay, from Karnak. Nineteenth Dynasty.*

4 *(Above) Shrine-shaped coffin, Papyrus of Ani. Nineteenth Dynasty.*

5 *(Right) Shrine-shaped chests, tomb of Ramose, Thebes. Eighteenth Dynasty.*

Early in the history of Egyptian civilization, the vulture goddess Nekhbet was worshipped at the southern site of El Kab (ancient Nekheb) where she had a pavilion-like shrine which is shown in a number of predynastic representations. When El Kab's neighboring town of Hierakonpolis rose to prominence as the royal residence of the kings of Upper Egypt, Nekhbet assumed the position of national goddess for the whole area, and her shrine, which was known as the *Per-wer* (meaning "Great House"), became an emblem representative of the entire southern region (i.e. Upper Egypt). In a similar manner, the shrine of the important Lower Egyptian goddess Wadjet came, in time, to represent the northern half of Egypt (see *O20), and after the unification of the country the local shrines of these two goddesses were used together as a symbol of the "Two Lands." By the Third Dynasty, for example, dummy shrines of each type are found along the sides of the festival court of the Pyramid of Djoser at Saqqara where they symbolized the role played by all the gods of Egypt in affirming the king's reign.

Eventually, in a somewhat simplified form, the Upper Egyptian shrine became the *kar* (O18), with its sloping roof and cavetto cornice – the type of portable shrine which housed the image of the god in temples throughout Egypt (**ill. 1**). Usually this shrine was kept in its own room at the rear of the god's house, though it might be taken from there for religious processions and rituals. Shrines of this type sometimes showed figures of the king with upraised arms supporting the hieroglyph for "heaven" (*N1) directly beneath the canopy in order to symbolize royal service to the god. Each day a priest would open the doors (*O31) of the shrine with the words, "The gates of heaven are opened...," before tending to the needs of the god by bathing, dressing, and placing food before the image. In the Middle and New Kingdom periods, the shrines in which royal funerary statues were placed – such as the small gilt shrine of Tutankhamun (**ill. 2**) – were made in the form of the Upper Egyptian shrine, symbolizing the divine status of the deceased king. Coffins were also made to mimic the shape of the *kar* – as in the example found in the Papyrus of Ani (**ill. 4**); and chests made to hold canopic jars and other funerary items were made in this same form from the Middle Kingdom on (**ill. 5**).

The front view of the developed Upper Egyptian shrine or *kar* (which is seen in the hieroglyph O21) is often found in representations pairing the shrines of the Two Kingdoms in order that a symmetrical frontal view of both structures might be presented. This frontal view of the Upper Egyptian shrine is also found whenever the shrine is represented on three-dimensional objects – on ritual sistra (*Y8) or rattles, and sistrum-shaped columns, as well as in statuary showing the presentation of small votive shrines to the gods. The example in **ill. 3** fuses the form of the block statue (*A40) with that of the shrine, and thus stresses the pious attitude of the deceased through the presence of the shrine.

UPPER EGYPTIAN SHRINE

Per-wer, kar

O 18

1 *Fourth funerary shrine of Tutankhamun, from Thebes. Eighteenth Dynasty.*

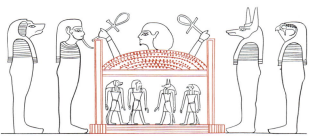

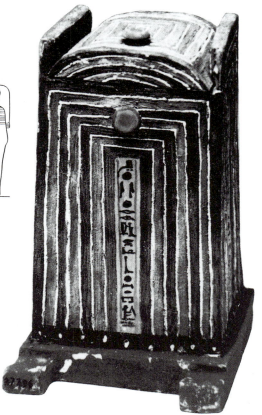

2 *Coffin with four sons of Horus, Papyrus of Ani. Nineteenth Dynasty.*

3 *Ushabty box, tomb of Sennedjem, Thebes. Nineteenth Dynasty.*

4 *Shrines of the third "hour" of the underworld, sarcophagus of Seti I, from Thebes. Nineteenth Dynasty.*

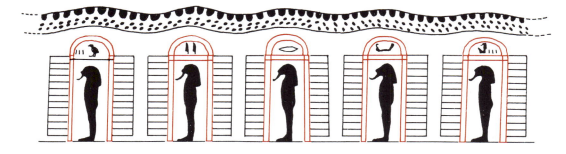

A predynastic shrine known as the *Per-nu* or *Per-neser* ("House of Flame") was located at the site of Buto, the Delta home of the serpent goddess Wadjet (*I12). Like the Upper Egyptian shrine (*O18) of Hierakonpolis, the *Per-nu* seems eventually to have come to represent all the local shrines in its area when the goddess Wadjet rose to regional importance as the tutelary goddess of kings of northern Egypt. After the unification of the country the *Per-nu* thus began to function as a symbol of the whole region of Lower Egypt alongside the Upper Egyptian shrine, and the forms of both shrines may be found, together, as in the massive Step Pyramid complex built by Djoser at Saqqara – where they clearly represent each of the "Two Lands" of Egypt.

The *Per-nu* or Lower Egyptian shrine is differentiated from its counterpart by its arched roof and high side posts; and while the Upper Egyptian shrine was usually represented in profile, the *Per-nu* is always shown in frontal view, as these views present the most characteristic depictions of the respective structures. Independently, the form of the Lower Egyptian shrine was used in a wide range of contexts. Royal sarcophagi patterned after the *Per-nu* are known from several Old Kingdom Dynasties, and the mastaba tomb of the Fifth Dynasty monarch Shepseskaf seems to have been constructed in this shape. In the New Kingdom a number of sarcophagi of the later Eighteenth Dynasty (Akhenaten – Horemheb) take this form, and the innermost of the four funerary shrines of Tutankhamun is also built in the shape of the *Per-nu* (**ill. 1**). Many coffins and sarcophagi were made in this shape throughout the later periods (**ill. 2**), and this practice seems to have been directly connected with the veneration of Osiris. At the Temple of Hibis, for example, the coffin of Osiris is shown in the form of the Lower Egyptian shrine. Probably as a result of this Osiride association, a particularly common manifestation of the form of the *Per-nu* was in the *ushabty* cases made to hold the small "answerer" figures intended to do any work which the deceased might be called upon to accomplish in the afterlife (see *U6). Such cases are often depicted beneath the funerary bier in tomb paintings, and a number of them have survived. The Nineteenth Dynasty example from the tomb of Sennedjem at Thebes (**ill. 3**) is placed on a small sled of the type used to transport the actual shrines which housed the images of the gods.

The *Per-nu* form of the shrine is also found in illustrations of shrines of the gods in the Book of the Dead and other funerary works that were recorded on papyri and painted on the walls of New Kingdom tombs. In the third "hour" of the underworld as it is shown in the Book of Gates, a row of twelve such shrines is shown with opened doors to reveal the gods which inhabit them (**ill. 4**). A huge protective serpent lies along the length of this row of shrines emphasizing the importance of these "holy gods of the underworld."

LOWER EGYPTIAN
SHRINE

Per-nu

O 20

1 (Below) Throne pavilion on Narmer Macehead, from Hierakonpolis. Early Dynastic Period.

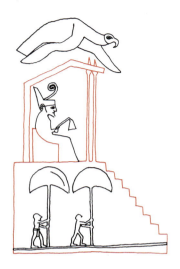

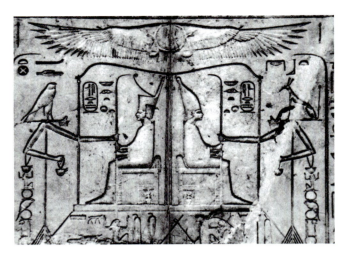

2 (Above) Heb-sed pavilions of Sesostris III, lintel from Nag el-Madamud. Twelfth Dynasty.

3 (Below) Jubilee scene of Ramesses II, temple of Amun, Karnak. Nineteenth Dynasty.

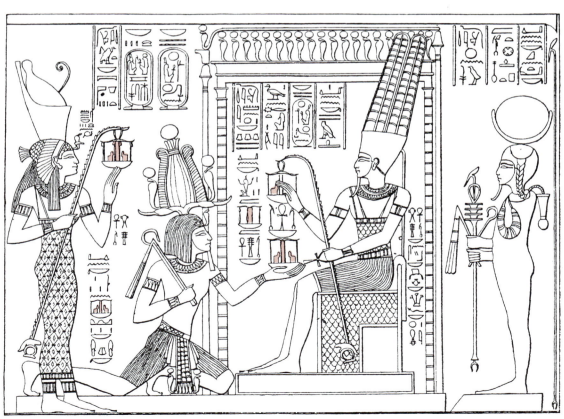

The *heb-sed,* or "jubilee festival," consisted of a series of rituals of royal renewal which seem to have originated at the very beginnings of Egyptian history. The king's jubilee was supposedly celebrated for the first time thirty years after his accession, and thereafter at much shorter intervals. Rather than a simple commemoration of the king's accession, however, the festival was clearly designed to renew the monarch's power and to rejuvenate his rule over the Two Lands. While some scholars have speculated that the festival may thus have developed as an alternative to a predynastic practice of regicide – the ritual slaying of the aged king – the origins of the *heb-sed* remain obscure.

In the Historical Period, the high point of the festival was reached when the king's rule over the Two Kingdoms was reestablished by his enthronement in a special pavilion similar to that depicted in **ill. 1**, representing Lower Egypt (in which the monarch wore the flat-based Red Crown of the northern kingdom), and in another, similar, pavilion representing Upper Egypt (in which he wore the pointed White Crown of the south). The hieroglyph representing the festival signifies this climactic point in the ceremonies by depicting the two thrones set in their respective pavilions. This jubilee sign is directly mirrored in the summary representation of the *sed* festival of Sesostris III (**ill. 2**) in which this king is depicted twice in the short robe characteristic of the ceremony. Sesostris grasps the signs for "many years" (*M4) which are offered to him by standards representing Upper Egypt (the Horus falcon – *G5), and Lower Egypt (the Seth animal – *E20). The year signs terminate in figures of Heh (*C11), the god of eternity, which support with their upraised arms the podium on which the two pavilions rest. An actual jubilee shrine of Sesostris I similar in form to the one depicted here has been reconstructed at Karnak from the limestone blocks which had been reused in a later pylon of the temple of Amun.

Often the *sed* hieroglyph is written directly upon the bowl-like *heb* glyph (*W3) which signifies a feast or festival, and which probably represented the kind of alabaster bowl used in rites of purification in such festivals. In **ill. 3**, Ramesses II is shown in a jubilee scene from the walls of the temple of Karnak where the god Amun-Re presents the king with multiple *heb-sed* signs suspended from the notched palm branch signifying "years." The inscription before Amun reads "...I give you millions of festivals with life, stability, and power," while the god's consort Mut also proffers a *heb-sed* sign with the words "I give you years of *sed* festivals with all lands beneath your feet." This motif occurs a number of times in Egyptian art of late New Kingdom times and may be found with many variations. Sometimes the goddess Mut is represented as a flying vulture (*G14) hovering over the king with a *heb-sed* sign held in her claws (see *W3), and sometimes the jubilee signs are depicted hung upon the *ished* or tree (*M1) of life upon which the years of the king's reign were written.

JUBILEE PAVILION

sed

O 23

1 *Construction of bronze doors, tomb of Rekhmire, Thebes. Eighteenth Dynasty.*

2 *Fourth "hour" of the Book of That Which Is in the Underworld, tomb of Thutmose III, Thebes. Eighteenth Dynasty.*

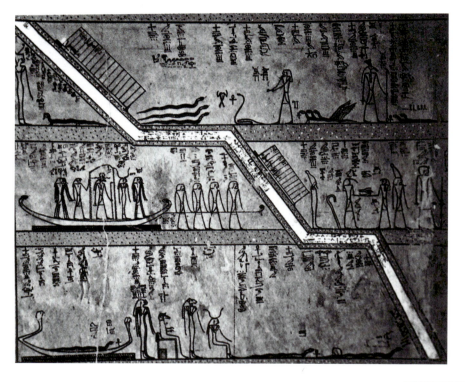

3 *Doors of heaven, tomb of Sennedjem, Thebes. Nineteenth Dynasty.*

The representation of a door – usually lying on its side rather than in upright position, and with the pins on which it turned projecting from each end – was used by the Egyptians to write the word "door" and also as a determinative in related words such as *wen*: "open." The horizontal representation is seen in **ill. 1**, where workers are shown casting bronze doors. When depicted in its normal upright position in large-scale representations, the door is usually shown in the same hieroglyphic form with the hinge-pins being clearly delineated rather than hidden in the sockets in which they turned. Like gateways, doors were symbolic thresholds as well as barriers; they could signify transition as well as protection and are seen with both these meanings in ancient Egyptian paintings and reliefs. As the thresholds of other worlds or states, doors are commonly shown in representations of the shrines (*O18) of gods, and the ritual act of opening these doors was symbolic of the opening of the gates of heaven itself. In the underworld, the hours of the night were divided by gates which may be shown as doors in the vignettes of funerary papyri and in tomb paintings. In the Tomb of Thutmose III, for example, the depiction of the fourth "hour" of the underworld shows doors opened on a descending passage which runs down through the registers in which the deities of the nether regions are shown (**ill. 2**). This seems to represent the threshold of the beginning of the deepest part of the underworld through which the deceased king, like the sun, must pass.

In the tomb of Sennedjem at Deir el-Medina, a ceiling painting shows the owner of the tomb approaching two doors set between the sign of the horizon (*N27) below, and the sign of the sky or heavens (*N1) above (**ill. 3**). Here, the doors clearly form the threshold of heaven through which Sennedjem hopes to pass into the afterlife. Symbolic significance was thus almost certainly attributed to the actual doors of temples and tombs, and in a similar manner, inscriptions at the entrance to the burial chambers in the pyramids of the Fifth and Sixth Dynasties frequently allude to the "Gate of Nut," the goddess of heaven. As symbolic barriers, doors also appear in certain other contexts – such as the passages of some of the painted and inscribed Egyptian tombs of the later New Kingdom. In the rock-cut tomb of the Ramesside prince Montuhir-khepeshef, for example, behind the area in which the first actual door was placed, the strong black forms of two huge doors are painted upon the walls. On the jambs of these symbolic portals, the figures of venomously spitting cobras are drawn – in order to strengthen further the protective nature of the painted doors, and to deter those who might attempt to pass them, and to breach the tomb. When the doors of tombs are shown open in the vignettes of funerary papyri, it is to represent symbolically the fact that the spirit of the deceased has free access to the buried body, and that the spirit *ba* (*G53) may come and go as it pleases.

DOOR

aa

O 31

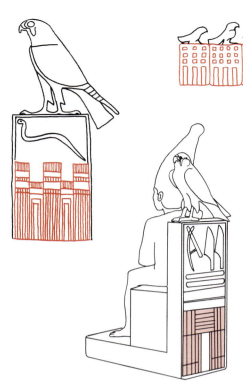

1 *(Far left) Funerary stele of Djet, from Abydos. First Dynasty.*

2 *(Above) Serekh bracelet, tomb of Djer, Abydos. First Dynasty.*

3 *(Left) Alabaster statuette of Pepy I. Sixth Dynasty.*

4 *(Below) Detail, coffin of Khnumnakhte, from Meir. Twelfth Dynasty.*

5 *(Below right) Serekh standard of Ramesses II, temple of Amun, Karnak. Nineteenth Dynasty.*

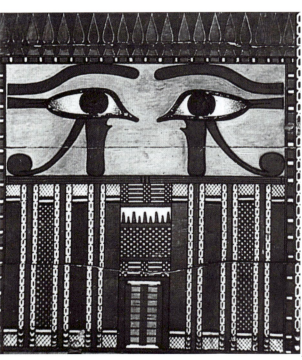

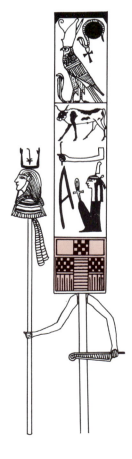

While the royal titulary of the Egyptian king consisted in later times of five full names or titles, in the earliest periods the chief or sole royal title was the so-called "Horus" name. The *serekh* hieroglyph was the device within which this name was written. It consisted of a rectangular "frame" with a section of recessed niche walling drawn at the bottom, and usually with the falcon (*G5) symbol of the god Horus perched on the top. The type of niched or panelled walling represented in the lowest section of the *serekh* is known to have been used in early Egyptian architecture and is also found decorating the sides of early royal coffins, indicating that the sarcophagus was thought of as the eternal house or palace of the king. The sides and top of the "frame" of the *serekh* may, therefore, also represent walls seen in plan – the whole device probably signifying the walls of the royal palace or the city in which the king dwelt as the incarnation of the god Horus.

The use of the *serekh* hieroglyph in Egyptian art and ornamentation begins at a very early date. In the burial stele of the First Dynasty king Djet (**ill. 1**), the *serekh* is used as the sole decoration of a memorial or offering stone on which the king's name is written with the sign of a serpent (Egyptian *djet*); and in the gold and turquoise bracelet from the same period found by W. F. Petrie at Abydos (**ill. 2**), some twenty-seven *serekhs* are linked together to form a decorative arm-band. Interestingly, the somewhat stylized falcons in this bracelet are shown in alternating crouching and erect forms. As earlier examples of the *serekh* show the falcon only in the lower, crouching position, this work seems to have been made at a time of iconographic transition.

In **ill. 3** – the Brooklyn Museum's alabaster statuette of Pepy I – we have, however, an example of the use of the *serekh* at a more sophisticated secondary level of association. Here, it is incorporated into the rectangular back of the king's throne (the word *serekh* could also mean "throne"), and the Horus falcon which stands on top of the device guards the pharaoh in the same manner in which a protective falcon was placed on the back of the throne of the earlier Fourth Dynasty king Chephren in his famous statue in the Cairo Museum (see *G5). In the Pepy sculpture, however, rather than facing toward the king, the Horus falcon is positioned at a right angle to him in order to maintain its proper alignment as a component part of the *serekh*.

The palace facade is also found as a decorative device in a number of other contexts. It appears, for example, on coffins from the Middle Kingdom (**ill. 4**); and in the later New Kingdom, the *serekh* is frequently shown in the form of a standard in association with the monarch's *ka* (*D28) or spirit double. **Ill. 5** shows such a standard containing the "Horus" name of Ramesses II, "Mighty Bull, beloved of Maat," partly personified with arms which hold the feather of truth and an emblem of the king's *ka*.

PALACE WALL

serekh

O 33

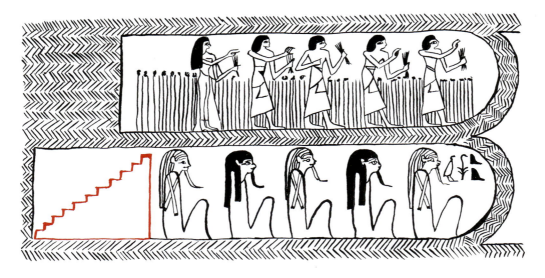

1 *Stair in underworld, Papyrus of Taukherit. Twentieth Dynasty.*

2 *Underworld stairs, funerary papyrus. Nineteenth Dynasty.*

3 *(Below) Deceased seated on symbolic staircase. Late Period.*

4 *(Below right) Osiris enthroned on staircase, Papyrus of Padiamun. Twenty-first Dynasty.*

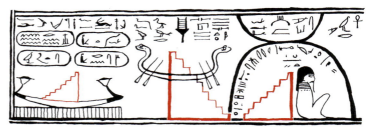

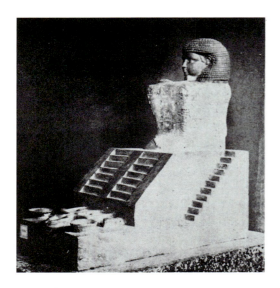

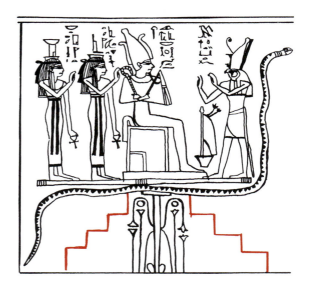

Stairs, like doors (°O31) and gateways (°O13), provide transitions from one area to another, and symbolically between one state and the next. From the earliest dynasties Egyptian tomb design incorporated a stairway which led down from the surface to the tomb itself. Both symbolically and in actual fact stairs could thus represent the interface between life and death, between the world of the living and the underworld. In Egyptian art this concept is frequently seen in vignettes from the Book of the Dead and other mortuary representations. **Ill.** 1 shows an example from the Twenty-first Dynasty Book of the Dead of the Lady Taukherit where a stairway appears in the lowest register with various deities symbolizing the inhabitants of the depths of the underworld. The stair leads up to the registers above in which agricultural scenes symbolize the abundant *Iaru* fields (°M20) of the afterlife.

rued

O 40,41

Ill. 2 shows a similar though rather more complex scene from an earlier example of the Book of the Dead. Here, the stairway glyph appears several times, once in conjunction with a underworld deity, and twice more with boats associated with the underworld. Despite their variations, such scenes all illustrate a section of Chapter 110 in the Book of the Dead. This chapter gives the spell "...for the descent to the judgment hall of Osiris and the veneration of the divinities who rule the underworld. Of the going-in and coming-out of the underworld, for a sojourn in the *Iaru* fields." Here, the staircase clearly provides the interface between the two areas or aspects of the afterlife.

This association with the underworld and with the concept of resurrection is also seen in Late Period depictions of the deceased seated on a flight of steps (**ill. 3**) and of Osiris enthroned upon a single or double staircase (O41) similar to that which was used by the king in the royal jubilee or *sed* festival (°O23). In **ill. 4**, the god sits atop such a stair which is decorated with the *sema-tawy* or "Union of the Two Lands" motif (°F36), and various elements of divine and royal iconography are, in fact, often fused together in such Late Period representations.

Stairs could also represent the mound of earth which rose from the primeval ocean at the beginning of creation, as well as the concepts of resurrection from the grave and ascension into the heavens. It is possible that the Third Dynasty Step Pyramid of Djoser at Saqqara incorporates either or even both aspects of this symbolism, though lack of written evidence precludes any certainty. Certainly the steps found before altars, between different sections of temples, and also at the entrances of temples had symbolic importance and were often given specific names. At Abydos, for example, the entrance before the Osiris Temple was called "Great Stair of the Lord of Abydos," and it is easy to suspect that the ancient Egyptians saw many levels of interaction between such areas and the symbolic nature and function of stairways.

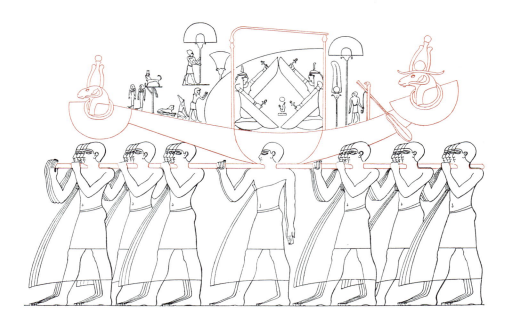

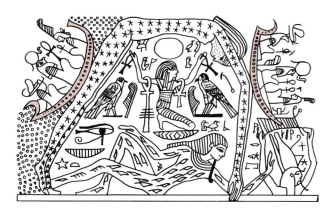

1 *The god's barque in procession, temple of Amun, Karnak. Eighteenth to Nineteenth Dynasty.*

2 *Solar barques on figure of Nut, funerary papyrus. New Kingdom.*

3 *Solar barque in the underworld, Papyrus of Herytwebkhet B. Twenty-first Dynasty.*

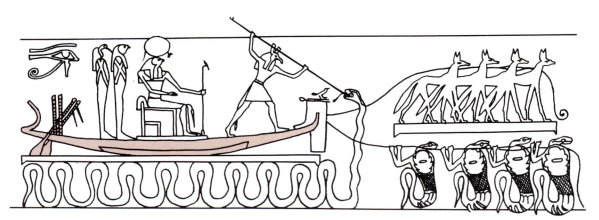

Navigation of the Nile and of the lakes and coastal waters of Egypt goes back to the earliest times, and papyrus boats with cabins and rear-mounted steering oars (°P10) were used from the Predynastic Period on. Such boats were used for travel as well as for fishing and trade, and constituted the primary method of transportation at all times. Not surprisingly, therefore, the Egyptians usually envisaged the gods – and especially the sun god in his various forms – as travelling in such boats, and the ceremonial barques used for cultic purposes reflected this belief. A shrine which held the god's image stood where the cabin was usually located, and the head of the deity set upon a collar (S11) often surmounted the prow and stern of the boat. Placed in such a barque, the image of the god was carried on the shoulders of the priests when the deity was taken from the temple in sacred processions or journeys (**ill. 1**).

Mythologically, the sun god Re possessed two barques, *Mandjet* and *Mesektet* – the boats of morning and evening. They are frequently depicted upon the sky hieroglyph (°N1), a lake hieroglyph (°N39) representing the celestial sea, or crossing the arched body of the sky goddess Nut (**ill. 2**). Representations of the barques show great variation in detail; and the sun god may be depicted as a falcon (°G5), a scarab beetle (°L1), a ram (°E10), or as an anthropomorphic deity with the head of one of these creatures. Alternatively, the sun may be represented by an actual disk (°N5), or as the "Eye of Re" (°D10), though the falcon-headed human form is perhaps the most common in all periods. Usually the sun god is accompanied by several other deities such as Thoth, Hathor, or Maat, or – in funerary depictions – by a figure representing the deceased (see °A40), and sometimes these attendants are implied by the presence of the "follower" sign (°T18). Tomb paintings and vignettes from the funerary books usually show the solar barque being pulled, barge-like, by various gods manifested as men or as jackals (°E15), uraei (°I12), or *ba* birds (°G53) in its nightly journey through the underworld. In **ill. 3**, for example, the solar boat is towed in this way while the figure of Seth (°E20) is shown fending off the giant serpent Apophis which attempts to destroy the sun each night. Although this boat is shown travelling across the sky hieroglyph, it is the "sky" of the underworld which is intended, and the swallow (°G36) perched on the boat's bow is the creature which will announce the sun's arrival at the dawn.

In many periods it was customary to include small model barques in tombs or to depict them on tomb stelae to represent the deceased person's actual or intended pilgrimage to the holy site of Abydos. Although the "solar boats" which have been found in association with royal tombs from several early dynasties may well reflect the desire of the deceased king to join the sun god in his journey across the sky, their compass orientation is not always east-west, and it is possible that some of these boats also represent the ritual voyage to an early site of pilgrimage.

BARQUE

wia

P 3

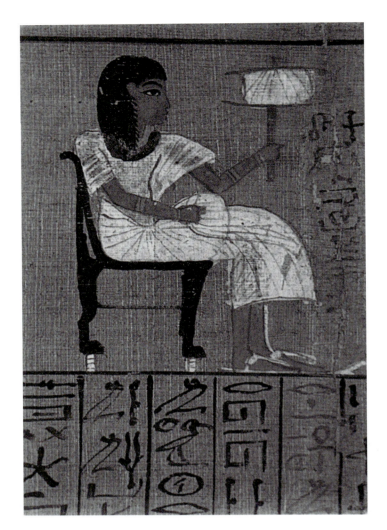

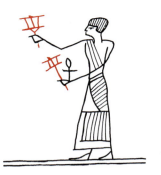

1 (Left) Seated deceased holding a sail, Papyrus of Nakht. Eighteenth to Nineteenth Dynasty.

2 (Above) Deceased holding sails and ankh sign, papyrus of Horemheb. Ptolemaic Period.

3 Atum with sail, Papyrus of Padiamunnebnesutawy. Ptolemaic Period.

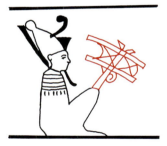

4 Deceased sailing in cosmic boat, Papyrus of Nakht. Eighteenth to Nineteenth Dynasty.

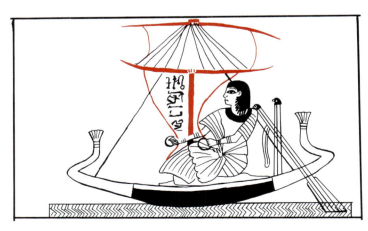

The ancient Egyptian craft which sailed the Nile were able to use the force of the river's current in travelling northward (downstream) and the force of the prevailing winds which blew to the south when heading upstream. Riverboats are thus usually depicted with a fixed mast (P6), and are often shown under sail. In the Egyptian script, however, the sail hieroglyph was used not only as a determinative in words such as *hetau*: "sail," and *nefu*: "ship's captain" or "skipper," but also in words connoting the winds – and by direct association, with the concept of "breath." This latter use in the word *tchau*: "breath" gave the hieroglyph a symbolic usage which is frequently found in vignettes illustrating various spells from the funerary Book of the Dead.

Ill. 1 shows the scribe Nakht seated on a lion-footed chair in a common representational pose for the depiction of the deceased (A51), but instead of holding the flail of authority which is usual in this pose, Nakht holds a mast with unfurled sail in illustration of Book of the Dead, Spell 38A – a spell "for living by air in the realm of the dead." Clearly, the sail here represents the breath of life which is to be accessible to the deceased; and in **ill. 2**, a simple thumbnail sketch from the papyrus of the Ptolemaic Period priest Horemheb, the dead man is in fact shown holding a sail in each hand as well as an *ankh* or "life" sign (*S34), which together spell out the idea of "breath" and "life" or "breath of life."

A variation on this same theme is seen in Book of the Dead vignettes illustrating other spells designed for "breathing air" or "giving breath in the realm of the dead." These representations show the deceased holding the breath-symbolizing sail as he or she stands before the god Shu, Osiris, Atum, or some other deity. Frequently, a table loaded with offerings stands between the deceased and the god, and the reciprocal giving of offerings to the deity and breath to the deceased seems to be implied. Spell 55 declares "I am Shu (the god of air) who draws the air...to the limits of the sky, to the limits of the earth...and air is given to those youths who open my mouth...;" and in Spell 56 the deceased requests "O Atum, give me the sweet breath which is in your nostrils." Sometimes, in fact, it is the deity who holds the sail before the worshipping deceased as a token of the gift of breath (**ill. 3**). The offering formula found on countless tomb stelae often includes "the sweet breath of life" among the gifts of sustenance to be given to the deceased.

Finally, the hieroglyphic sail may be seen in a number of illustrations of the boat by which the deceased must cross the celestial river, which was often equated by the Egyptians with the Milky Way. Spell 99 of the Book of the Dead is concerned with this cosmic journey and vignettes such as that shown in **ill. 4** from the papyrus of Nakht illustrate the spell. The boat of the deceased is propelled on its journey by the magically swelling sail which not only empowers the craft, but also carries the symbolic connotation of breath and life for the journey through the beyond.

SAIL

hetau

P 5

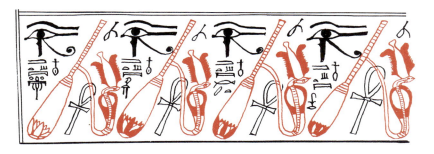

1 *Four steering oars and eyes, Papyrus of Nestanebettawy. Twenty-first Dynasty.*

2 *Bovines and oars, tomb of Nefertari, Deir el-Medina. Nineteenth Dynasty.*

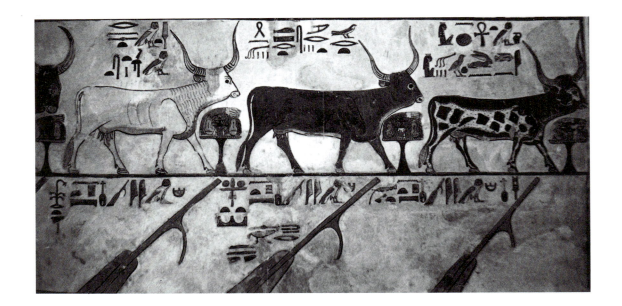

3 *Hide-patterned steering oars, Papyrus of Tentdiumut. Twenty-first Dynasty.*

The steering oar is readily distinguished from the simple *hepet* oar (P8) by its oblique angle of representation, its relatively larger paddle, and by the steering bar attached to its handle. The hieroglyphic sign representing this oar was used as a determinative in several words connected with the oar itself and with its direct derivatives – such as *hemy*: "steersman" – but in iconographic usage the steering oar takes on a distinct, if not fully understood, symbolic meaning.

Usually the *hemu* appears in groups of four identical oars in representational contexts, and these oars are frequently placed in association with magical eyes, bovines, uraei and other symbols in mythological papyri, and in tomb paintings illustrating Chapter 148 of the Book of the Dead. Certain copies of the Book of the Dead and other papyri of the Late Period do interpret the four oars as having to do with the four corners of the heavens. In the Twenty-first Dynasty Papyrus of Nestanebettawy (**ill. 1**), for example, the oars are specifically labelled "Beautiful rudder of the Southern Sky / Beautiful rudder of the Northern Sky / Beautiful rudder of the Western sky / Beautiful rudder of the Eastern Sky," and although the order of their listing may vary, this is the standard inscription which appears in other vignettes and paintings. Yet the origin and precise meaning of the cosmic significance of these four steering oars remains unknown. Probably they represent the guiding powers of the universe, but this meaning is nowhere explained in the texts themselves. In ill. 1 the oars may be seen to be decorated with lotus (*M9) flowers at their tips and with uraei which spring from their steering bars. They are also clearly in association with the four *wedjat* eyes (*D10) above them, thus making their connection with solar symbolism clear on three separate counts.

In those instances where the oars appear in conjunction with bovines – seven cows and a bull (*E1) – it seems probable that the essential concept being expressed has to do with the supernatural direction of the sustaining powers of the cosmos, as these bovines are specifically said to provide sustenance for the deceased in the Book of the Dead. **Ill. 2** shows an example of this association of the oars and bovines from the tomb of Nefertari at Deir el-Medina, and **ill. 3** shows an occurrence of the oars in which solar and bovine images are commingled. In this vignette from the Papyrus of Tentdiumut, the oars not only appear with various solar symbols such as uraei, but they are also themselves spotted and ringed to imitate the hides of bovines. The different symbolic images are so fused in this example as to leave little doubt that the steering oars must be understood in terms of the sustaining powers of the universe, represented by the cows and their bull. Yet once again the specific manner in which the four symbolic oars interacted with this principle of afterlife sustenance remains unclear.

hemu

P 10

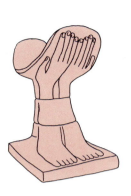

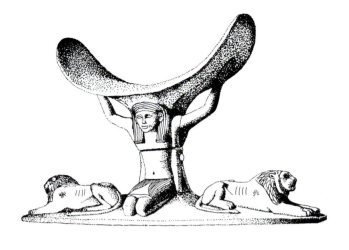

1 *Headrest supported by symbolic hands and feet. Eighteenth Dynasty.*

2 *Headrest, tomb of Tutankhamun, Thebes. Eighteenth Dynasty.*

3 *Djed, Isis knot, heart, and headrest symbols, Papyrus of Ani. Nineteenth Dynasty.*

4 *Headrest-like barque and stream motif, Papyrus of Anhai. Twentieth Dynasty.*

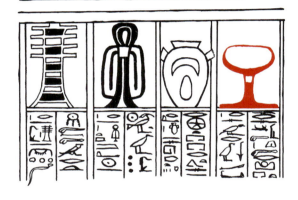

The Egyptian headrest was probably used from at least the beginning of the Old Kingdom to support the head of a person in sleep. Usually, the rest consisted of a curved upper section which cupped the head, mounted on a central supporting pillar set on a flattened base (the base usually being wider than the top from the New Kingdom onwards). The supportive function of the headrest was sometimes symbolically emphasized by painting or carving hands under the upper section and even feet on the base, as in **ill. 1** which represents an example in the Cairo Museum. Although it is sometimes argued that these headrests were not used in everyday life, their presence in representations and in the excavated huts of workmen indicate that they were not restricted to mortuary settings. Nevertheless, many headrests were undoubtedly produced or adopted for funerary use, as is indicated by their inscriptions which may include the owner's name and epithets such as *maa kheru*: "justified," and *wekhem-ankh*: "repeating life," both terms being the functional equivalent of "deceased." Headrests used in life and in funerary contexts were frequently inscribed with protective spells and decorated with the figures of apotropaic deities such as Bes or Taweret (*E25), as were the beds upon which they were used.

Symbolically, the headrest was closely associated with solar imagery for it held the head which, like the sun, was lowered in the evening and rose again in the day. The twin-lion headrest from the tomb of Tutankhamun (**ill. 2**) develops this imagery to the full by showing the two lions (*E23) which guarded the sun's passage – back to back in the form of the horizon hieroglyph (*N27). The solar lions here flank the air god Shu who supported with his upraised arms (*C11) the sky and the setting and rising sun. This connection between the sun and the head of the sleeper had special significance for the concept of the resurrection to the afterlife, and during the last millennium of pharaonic Egyptian history small round papyri known as *hypocephali* which contained spells to encourage a dull "star" to shine anew, were placed between the head of the deceased and the funerary headrest. Given these connotations, it is natural that the headrest should also appear in representations found in funerary contexts. The *weres* is, in fact, quite frequently found as an independent amulet with afterlife significance – as in **ill. 3** where it is placed alongside *djed* (*R11), Isis knot (*V39), and heart (*F34) amulets in the Nineteenth Dynasty Book of the Dead of the scribe Ani. The form of the headrest is even occasionally incorporated into other objects with which it is symbolically connected. In one of the vignettes of the Twentieth Dynasty Papyrus of Anhai (**ill. 4**), this copy of the Book of the Dead depicts a barque (*P3) on a stand-like vertical strip of water which together are perhaps intended to form the exact shape of a headrest. The shading of the central part of the barque distinguishes this section from the other parts of the boat and provides visual identification of the incorporated image.

weres

Q 4

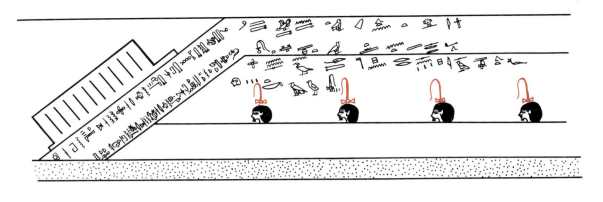

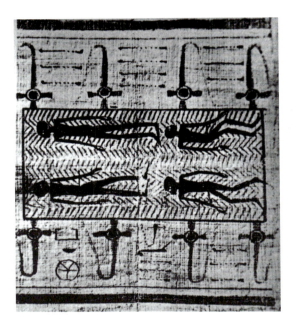

1 *Fire spirits from the fifth "hour" of the Book of That Which Is in the Underworld, tomb of Seti I, Thebes. Nineteenth Dynasty.*

2 *Lake of Fire with bodies of the damned, Papyrus of Bakenmut. Twenty-first Dynasty.*

3 *Fire signs on ivory magical knife. Twelfth Dynasty.*

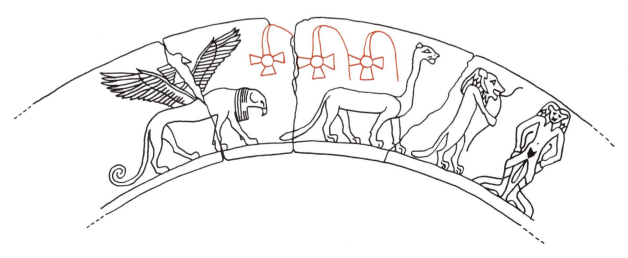

This rather interesting hieroglyph, often termed the "fire sign," depicts a brazier or lamp on a stand from which the stylized representation of a flame emerges. The hieroglyph functioned as the determinative in virtually all words concerning the different aspects of heat – such as *khet*: "fire," *sedjet*: "flame," *ta*: "hot," and *seref*: "temperature," as well as related words such as *abu* and *teka*: "torch" or "candle." Fire was regarded as a mysterious and potent entity in many early cultures so it is hardly surprising that the element figures quite prominently in Egyptian religious beliefs, and that the hieroglyphic form is frequently found in Egyptian art.

Because fire appears to have a life of its own, it may represent life itself – as when the Egyptian king kindled a new flame in his *sed* (°O23) or jubilee festival. Living fire was embodied in the sun and in its emblem the "fire-spitting" uraeus (°I12). Heliopolis, the great city of the solar cult, could be represented by the fire sign; and a pair of the signs formed the name of the mythical "Island of Fire" which was the birthplace of the sun god and was probably used as a metaphor for the dawn.

Beyond this solar imagery, fire was also an important element in the Egyptian concept of the underworld, often in ways strikingly similar to the medieval Christian conception of hell. According to the Coffin Texts and other works, the underworld contained fiery rivers and lakes as well as fire demons (identified by fire signs on their heads) which threatened the wicked (**ill. 1**). Representations of the fiery lakes of the fifth "hour" of the Amduat depict them in the form of the standard pool or lake hieroglyph (°N39) but with flame-red "water" lines, and surrounded on all four sides by fire signs which not only identify the blazing nature of the lakes, but also feed them through the graphic "dripping" of their flames (**ill. 2**). In a similar manner, in a scene from the funerary Book of Gates, the damned are subjected to the fiery breath of a huge serpent, Amemet, and this and other mythological serpents are often depicted in the vignettes of Late Period funerary papyri – bearing fire signs to identify them. However, the flames of the underworld were not necessarily to be feared by the righteous who might drink from the lake of fire and be refreshed, or change themselves into shooting flames to destroy their demonic enemies. Because all symbols are essentially ambivalent, fire was also a natural symbol of protection. The hieroglyph appears in protective contexts (**ill. 3**), and apotropaic deities such as Taweret – the hippopotamus (°E25) goddess of pregnancy – may be shown bearing torches to repel evil.

The somewhat similar hieroglyph R7 depicts an incense bowl or lamp with a flame rising from it and this sign is sometimes shown at the sides of the Lake of Fire – or in some other contexts – as a virtual substitute for the fire sign. This hieroglyph also appears as an amulet used to aid the deceased.

BRAZIER

khet

Q 7

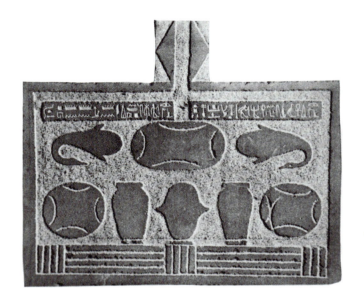

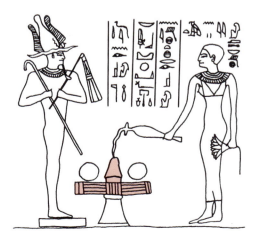

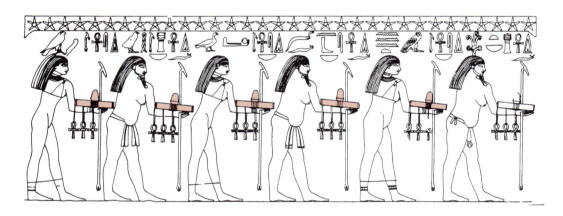

1 (Top left) Offering table, from the temple of Amun, Karnak. Ptolemaic Period.

2 (Top right) Sculptors carving offering table, tomb of Rekhmire, Thebes. Eighteenth Dynasty.

3 (Above) Figures bearing offering mats, mortuary temple of Sahure, Abusir. Fifth Dynasty.

4 (Left) Deceased offering to Osiris, stele of Tany. Late Period.

5 (Right) "The heart of the gods is satisfied" amulet, Middle Kingdom.

From prehistoric times offerings were made to the gods and to deceased persons on small mats of woven reeds. The *hetep* hieroglyph shows a loaf of bread (°X2) placed as an offering on such a mat, and this sign was used as an ideogram in words such as "offering" and "altar." Even when the simple mat was replaced by more permanent altars of stone at the beginning of the Old Kingdom, the altar often had the offering mat hieroglyph carved on the top, or was itself made in the form of the offering sign – with a projection at the front representing the bread loaf. **Ill. 1** shows such an offering table from the Ptolemaic Period in which both ideas are present. The woven mat and its bread loaf are clearly delineated on the table's surface along with a selection of other offerings consisting of jars of water, ducks, and flat loaves, all symmetrically arranged. Channels cut into the tops of tables such as this were intended to receive libations poured from ceremonial vessels (°W15) which are themselves often carved on the table's surface along with the representations of food offerings and written offering lists.

The offering formulae employed in the funerary cult and often inscribed on offering tables usually began with the phrase *Hetep di nesu*: "An offering which the king grants…," denoting the concept of requisite royal license. The formulae then continue to name important deities such as Osiris and Anubis, through whom the king's grant would be administered, and to list choice offerings – such as "bread, beer, oxen, fowl, unguent and clothing" – which were believed to be supplied magically by the ritual inscription even if they were not actually present. The second feature of the developed stone offering table is also seen in ill. 1 – the stylized bread loaf which is represented as a flattened extension projecting from the front side of the table. The shallow groove cut through the middle of this stylized "loaf" was made to channel the libations poured upon the table's surface. In **ill. 2**, sculptors are shown finishing a large stone altar of this type in a scene from the tomb of Rekhmire at Thebes. In this scene the bread loaf projection appears to stand vertically above the surface of the altar because it has been represented in the two-dimensional form of the *hetep* hieroglyph.

As a symbol of offering and plenty, the *hetep* sign is also sometimes shown being carried by "Nile" or fecundity figures in processional rows on the lower registers of temple walls, such as in the reliefs shown in **ill. 3** from the Fifth Dynasty Temple of Sahure at Abusir. As might be expected, the *hetep* sign often appears in representations of altars where the central bread loaf is shown on a plane of view different from that of surrounding loaves and other offerings (**ill. 4**). Because the word *hetep* could signify the concept of "rest," "peace," or "satisfaction," the sign also appears in the design of jewelry and other small items made to convey such messages as "The heart of the gods is satisfied" (**ill. 5**).

LOAF AND OFFERING MAT

hetep

R 4

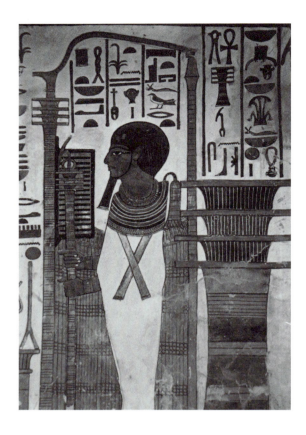

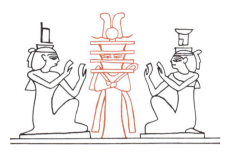

1 (Left) Ptah in shrine, tomb of Nefertari, Thebes. Nineteenth Dynasty.

2 (Above) Osiriform djed, Papyrus of Padiamun. Twenty-first Dynasty.

3 (Below) Personfied djed, temple of Seti I, Abydos. Nineteenth Dynasty.

4 (Right) Seti I erecting djed pillar, temple of Seti I, Abydos. Nineteenth Dynasty.

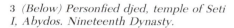

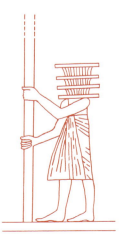

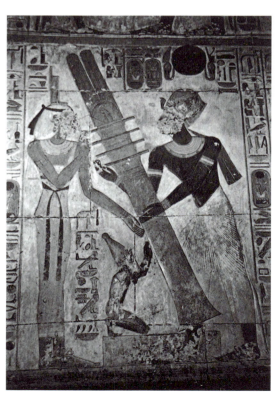

While the origin of this hieroglyph is uncertain, the sign may be a stylized representation of a pole around which sheaves of grain were tied or perhaps a rendering of the human backbone – and hence the use of the sign to connote "stability." It is known, however, that the *djed* was associated from Old Kingdom times with the chief Memphite god of creation, Ptah, who was himself termed the "Noble *Djed.*" Thus in the tomb of Nefertari at Deir el-Medina, Ptah is shown standing in a shrine-like kiosk with a large *djed* column behind him (**ill. 1**). The capital of the forward support of the kiosk takes the shape of a *djed* pillar in this composition, and the characteristic staff held by the god also combines the *djed* with the *ankh* (*S34) and *was* (*S40) signs. Finally, it may be noted that the written *djed* sign also appears in the hieroglyphic inscription "All protection, life, stability, dominion and health...are behind him" at the rear of the god's shrine.

Through a process of assimilation and syncretism, the god Ptah was eventually equated with the underworld deities Sokar and Osiris, and by the beginning of the New Kingdom, the *djed* was widely used as a symbol of Osiris and seems to have been regarded as representative of that deity's backbone. New Kingdom coffins, therefore, frequently have a *djed* pillar painted on the bottom where the backbone of the deceased would rest, in this way identifying the person with Osiris and acting as a symbolic source of "stability." The *djed* was commonly produced as an amulet of stability and regenerative power and is also given a degree of personification in some representational contexts as an emblem of Osiris. The sign is thus frequently depicted with eyes and with arms grasping a crook and flail or other attributes of the god of the underworld (**ill. 2**).

In relief scenes, and in decorated objects, the *djed* was one of the most frequently used hieroglyphic signs, either alone or in conjunction with the *ankh* and *was* signs, or with the *tiet* – the so-called "Isis knot" (*V39). The *djed* also had particular associations with Egyptian concepts of royalty. In the temple of Seti I at Abydos, personified *djed* signs are shown in the kind of heavy pleated clothing worn by royal figures (**ill. 3**), possibly as representative of the king himself. The royal ritual of "Raising the *djed* pillar" was also performed as a culminating act in the rituals for the deceased king and at the new king's jubilee festival. By means of ropes and with the assistance of priests, the king erected a large *djed* pillar in a symbolic act which may have represented both the rebirth of the deceased monarch and the establishment of stability for his own reign and for the cosmos itself. A painted wall relief from the temple of Seti I at Abydos (**ill. 4**) shows the king erecting the pillar in this ritual with the assistance of Isis – for the raising of the *djed* pillar also symbolized the ultimate victory of Osiris over his enemy Seth.

DJED COLUMN

djed

R 11

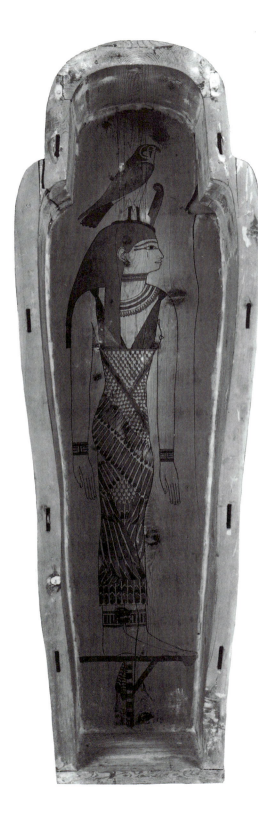

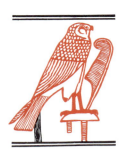

1 (Left) Goddess of the West, coffin of Nesmutaatneru, from Deir el-Bahri. Twenty-fifth Dynasty.

2 (Above) Falcon on "west" sign, Papyrus of Khonsumes A. Twenty-first Dynasty.

3 (Below) Imenet-headed goddess, Papyrus of Imenet. Twenty-first Dynasty.

4 (Below right) Osiris embraced by "west" sign, temple of Ramesses III at Medinet Habu. Twentieth Dynasty.

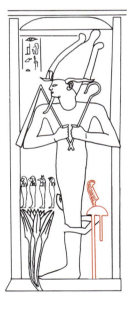

The hieroglyph representing the west occurs in two forms, as a standard upon which a falcon (*G5) and a feather (*H6) are placed (R13 – as in **ills. 1** and **2**), or in a simplified form with the round-topped pole surmounted by a feather alone (R14 – as in **ills. 3** and **4**). As representative of Amentet, the land of the west where the sun set and where the deceased found afterlife, the hieroglyph was particularly important and may even partake of imagery associated with the rising sun. In the Nineteenth Dynasty Papyrus of Anhai, the sign is shown in its full form as the solar falcon on a plumed pole (see *A30), and because the image is there associated with the adoration frequently accorded the rising sun, this vignette is sometimes said to represent the dawn. The fact that the falcon sits atop the *imenet* sign shows, however, that what is probably intended is the sun setting in the west. Similar examples are frequently found in other vignettes from the Book of the Dead. In the Papyrus of Hunefer in the British Museum, for instance, the *imenet* hieroglyph is used in its full form with figures of the deceased. There, the emblem is shown mounted on the sign for the two peaks of the mountain (*N26) of the horizon (*N27) and is flanked on the right and left by the hieroglyphs for food and drink. The whole complex thus signifies the provision which is supplied for Hunefer in the afterlife.

The *imenet* hieroglyph also appears in a wide range of representations in various degrees of personification. Late Period coffins such as that of the lady Nesmutaatneru in the Boston Museum of Fine Arts (**ill. 1**) sometimes show the west as the goddess who receives the deceased, and occasionally the level of personification is such that the *imenet* sign is shown in the place of the head, surmounting the body of the goddess (**ill. 3**). In other scenes, the goddess is simply represented by the hieroglyphic *imenet* sign with arms attached. In **ill. 4**, the mummified Osiris is shown embraced in his shrine by the personified West in exactly the same manner that the god is usually shown being embraced by Isis or by Isis and Nephthys. Because the deceased Egyptian was directly identified with Osiris (he is usually spoken of as "the Osiris X" in funerary inscriptions), the text accompanying such examples usually gives an assurance to the deceased to the effect "...the perfect West: her arms will receive you." In this way the goddess played a parallel role to that of the sky goddess Nut who accepted the deceased into her arms from the Old Kingdom on.

Because the goddess of the West originally developed as an aspect of the goddess Hathor, the two are sometimes shown side by side. Female deities personifying both the west and the east (R16) are also often depicted together – kneeling on either side of the sun disk as it sits on the horizon and thus portraying the two ends of the day.

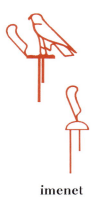

imenet

R 13,14

1 *(Left) Reconstruction of the fetish of Abydos. (After H.E. Winlock.)*

2 *(Below left) Fetish on coffin of Nesmutaatneru, from Deir el-Bahri. Twenty-fifth Dynasty.*

3 *(Below right) Horus and Isis with fetish of Osiris, sarcophagus of Pameshem. Twenty-first Dynasty.*

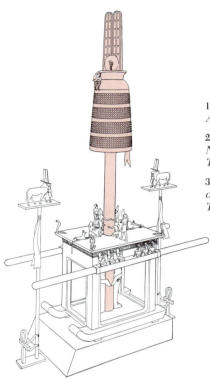

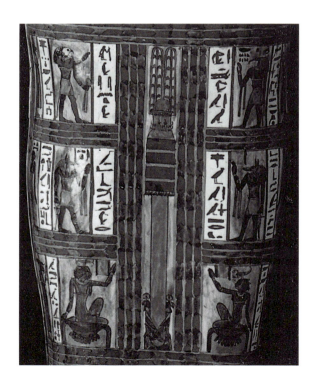

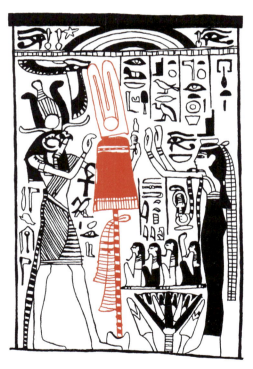

The Eighth Upper Egyptian Nome (province), with its local capital at Thinis, had as its sign from very early times a mound-shaped object surmounted by two feathers. This sign probably represented the primordial hill which rose from the waters of creation – as the Egyptian's name for the nome, *ta-wer*: "Eldest Land," might suggest. The growth of the religion of Osiris – which was centered at Abydos in the same area – seems to have been responsible for the reinterpretation of the sign as a reliquary for the head of the god which was supposed to reside at Abydos. Thus, the originally simple, mound-like sign became a much more complex emblem with many attributes associated with the cult of the god of the underworld. **Ill. 1** shows a reconstruction of the developed fetish as it probably looked, based on representations in the Temple of Seti I at Abydos and elsewhere. The emblem surmounts a tall pole and is mounted on a portable stand which could be carried in processions. Here, as in most representations, the fetish is adorned not only with sun disk and plumes, but also with uraei and headbands, and the ribbons associated with these fillets. These elements of the developed cult symbol were all intended to suggest its character as the "head" of the deity.

Representationally the emblem is found in a great many contexts, though usually these are of a funerary nature, as would be expected. In vignettes from the Book of the Dead, it appears in illustrations of Chapter 138, which gives a spell for "…the entry of the deceased into Abydos," and the sign is frequently found as an amulet wrapped with the mummy and in compositions painted on coffins and on the cartonnage cases of the mummy itself. **Ill. 2** shows an example of the emblem on the lid of the cartonnage inner coffin of the Twenty-fifth Dynasty Lady Nesmutaatneru, now in the Boston Museum of Fine Arts. The sign is placed between the panels of the composition which follow the length of the legs, and there is a phallic suggestive-ness – both here and in a number of similar examples – which may have been a conscious reference to Osirian fertility and rebirth.

In other instances the *ta-wer* is represented in scenes which allude to the concept of rebirth in terms of more traditional symbolism. On the inner sarcophagus of Pameshem in the Cairo Museum (**ill. 3**), the fetish of Osiris is depicted between the figures of the god's son Horus and wife Isis, and before a lotus (°M9) blossom which bears the seated figures (°A40) of the four gods known as the sons of Horus (see °D1). The fetish is set in a stand made in the shape of the mountain hieroglyph (°N26) – which also occurs in the writing of "Osiris, Lord of Abydos," above the fetish itself. All these symbols are directly connected with the concept of rebirth, and it is clear that the *ta-wer* sign functioned as a symbol not only of Osiris and his literal earthly domain, but also of the underworld realm of the god and the hope of the afterlife.

FETISH OF ABYDOS

Ta-wer

R 17

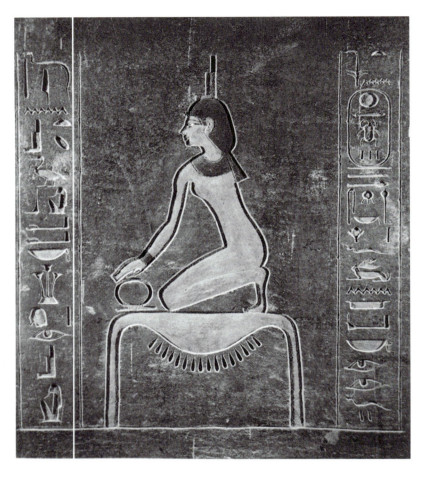

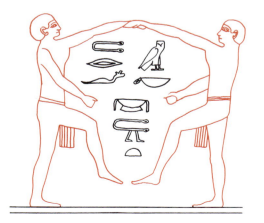

1 *(Top left) Divine falcon on gold sign, bed canopy of Hetepheres, Giza. Fourth Dynasty.*

2 *(Above) Isis on gold sign, sarcophagus of Amenhotep II, from Thebes. Eighteenth Dynasty.*

3 *(Left) Ritual dancers in "gold" position, tomb of Iy-Mery, Giza. Fifth Dynasty.*

The gold sign represents a collar (*nebyt*) of that metal which is differentiated from other collars by the beads which are delineated on its lower edge and by its hanging ends. Actually, the written sign was used as a determinative in words for a number of precious metals, including silver (*hedj*), and in words having to do with casting and finishing metals. Iconographically, however, it is always gold which is referred to by the use of the sign.

nebu

S 12

Gold was regarded as a divine and imperishable metal, and one naturally related to the brilliance of the sun. This solar symbolism of the metal was manifested in a number of ways. The goddess Hathor bore the epithet "The Gold;" the sun god Re was called "The Mountain of Gold;" and the sign appears early in the Old Kingdom in the "Golden Horus" title of the king (**ill. 1**), which probably associated the monarch with Horus or some other god in a solar function. By New Kingdom times the royal burial chamber was called the "House of Gold," and the solar and afterlife connotations of the sign are often present in its use in representational contexts. In this way, the sisters Isis and Nephthys are often shown kneeling on *nebu* signs at each end of coffins and sarcophagi – as in the carved and painted example from the sarcophagus of Amenhotep II (**ill. 2**). On the fourth shrine of Tutankhamun and in some other representations, the deities Neith and Selket also kneel on gold signs. In such instances, although the sign functions graphically as a kind of stylized footstool for the goddesses (small footstools were, indeed, sometimes made to mimic this shape), the gold sign also lends its connotations of afterlife immutability and doubtless also functions as a symbol of the king's divine nature (see *V10).

On the other hand, the gold sign, like the *heb* or festival hieroglyph (*W3), eventually became a decorative sign with little real meaning attached to it. By the Late Period, in fact, although the two signs are not in any way related, the gold sign was used in exactly the same contexts as the festival sign and the two images seem to be quite interchangeable, with deities and deceased persons being depicted on either sign. A convention of sorts arose in that seated figures were often shown on the *heb* hieroglyph, whereas standing figures were usually placed on the gold sign; yet works do occur in which the two signs alternate quite indiscriminately.

A particularly interesting example of the way in which the ancient Egyptians saw the forms of their hieroglyphic script in the shape or positioning of various objects may be seen in regard to the gold sign. The ritual dances which accompanied the Egyptian funerary proceedings included a "step" in which the position of the bodies of two dancers imitated this sign. In the representation of this movement found in the Old Kingdom tomb of Iy-Mery (**ill. 3**), the inscription between the dancers specifically states, "Behold the gold movement of the *tcheref* dance."

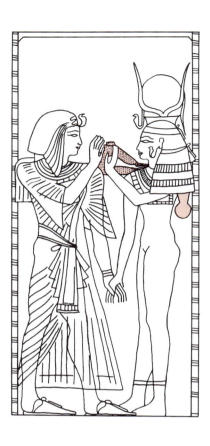

1 *Hathor offering menit necklace to the king, tomb of Seti I, Thebes. Nineteenth Dynasty.*

2 *Ankhesenamun with menit and sistrum, small gilt shrine of Tutankhamun. Eighteenth Dynasty.*

3 *Menit and other gifts before Hathor, Hall of Offerings, temple of Dendera. Greco-Roman Period.*

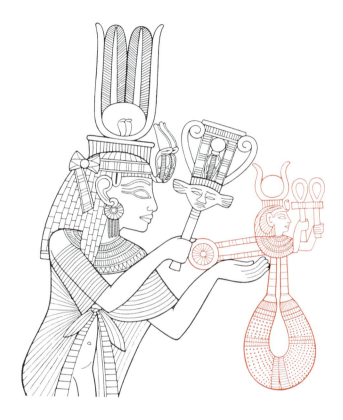

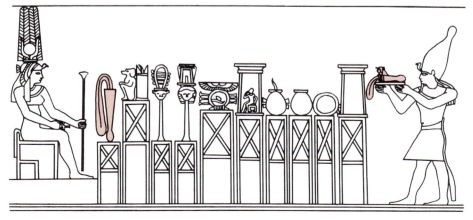

The *menit* consisted of a heavy bead necklace with a crescent frontpiece and a counterpoise attached at the rear. This elaborate necklace, like the sistrum (°Y8), may have functioned as a kind of percussion instrument in certain religious contexts; and it was certainly a symbolic item associated with the goddess Hathor – who bore the epithet "Great Menit" – and with her young son Ihy. As an important attribute of Hathor, the *menit* seems to have functioned as a medium through which the goddess' power was transmitted, and many representations show this deity proffering the *menit* to the king. This action occurs in two forms: the *menit* being worn by Hathor who lifts the front section up toward the king (**ill. 1**), and the object simply held in the hand as it is offered (**ill. 2**). Because the queen herself could function as the high priestess of Hathor, royal wives are sometimes depicted offering the necklace, and the example shown in ill. 2 from the king's small gilt shrine represents Ankhesenamun holding the sistrum and *menit* before Tutankhamun. The particular *menit* in this representation is constructed as a personification of Hathor who holds an *ankh* or life sign (°S34) in each hand, and thus portrays visually the way in which the goddess' power was passed through the necklace. In scenes such as these, the *menit* seems to have been associated with ideas of life, potency, fertility, birth, and renewal.

Appearing first in representations of the Sixth Dynasty, the *menit* is associated with Hathor in all subsequent periods of Egyptian history; and even when it was included with other items of tomb furniture as an amulet in the later dynasties of the New Kingdom, it is still associated with the goddess in her role as a deity of the western necropolis and with her part in the rebirth of the deceased. Many representations of Hathor in her bovine form show the animal wearing the *menit* around its neck and the necklace is thus sometimes associated with other divine cows (°E4). Not surprisingly, the *menit* occurs dozens of times in the reliefs of the Late Period temple of Hathor at Dendera, and **ill. 3** shows an example in which the king presents an elaborate necklace to the goddess along with other gifts displayed on small tables set before her. These gifts include *naos-* and hoop-type sistra and, on the table closest to the goddess, another necklace depicted in the exact form of the *menit* hieroglyph. The necklace is shown in its hieroglyphic form in many similar representations of gifts offered by the king to Hathor and to certain other deities in temple reliefs of the New Kingdom and later periods. Representations of the king offering the *menit* before Hathor probably are meant to equate him symbolically with the goddess' son Ihy. This is because the principle of divine assimilation, where the monarch is made to represent the son of a divine couple, exists in a number of instances – the most common assimilation being the identification of the king with the infant Horus (°B5).

MENIT NECKLACE

menit

S 18

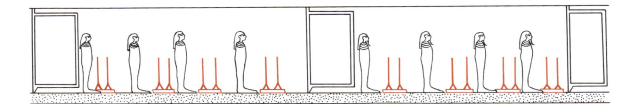

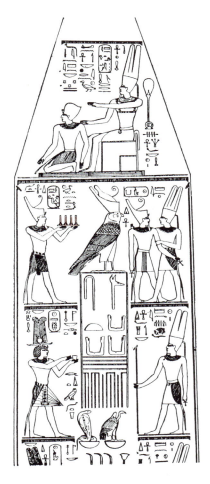

1 *Scene from the eighth "hour" of the Book of That Which Is in the Underworld, tomb of Seti I, Thebes. Nineteenth Dynasty.*

2 *Presentation of linen and other gifts to Amun-Re, obelisk of Hatshepsut, Karnak. Eighteenth Dynasty.*

3 *The queen presenting linen to the god Ptah, tomb of Nefertari, Thebes. Nineteenth Dynasty.*

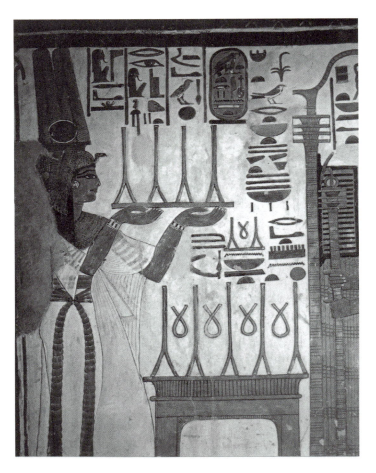

The sign used as an ideogram or determinative in the word *menkhet* – "clothing" – seems to represent either a horizontal strip of linen cloth with two strands of fringe or, perhaps more probably, two vertical strips of folded cloth on some kind of stand. The Egyptians excelled in weaving and produced many varieties of fine linen cloth which was used for garments and for the bandage-like wrappings used in mummification. According to myth, the goddesses Isis and Nephthys spun, wove, and bleached fine cloth for Osiris, and this story illustrates the importance of linen in the funerary context. Fine clothing was considered an important commodity for the afterlife, and linen is commonly included in mortuary offering lists along with "bread, beer, oxen, fowl, and alabaster jars [of oil]." *Menkhet* seems, therefore, to have been regarded as an important staple rather than a luxury offering.

In the Book of That Which Is in the Underworld, scenes from which were painted on the walls of the royal tombs in the Valley of the Kings during the latter part of the New Kingdom, the clothing hieroglyph appears in many scenes and in a number of different ways. In the eighth "hour" it is depicted next to the figures of gods and spirits who have been properly mummified (**ill. 1**) and who are apparently suitably provided with funerary linen. The sign also appears next to the enigmatic symbols of the "followers" (*T18, ill. 2) of the gods and as a kind of seat upon which various deities sit – both here and in other "hours." The prevalence of the sign underscores the importance of proper clothing in these religious ideas.

The importance of linen as an offering for the clothing of the gods is also seen in many royal offering scenes. Egyptian monarchs are shown dressing the images of gods in items of clothing, but usually it is the clothing hieroglyph which is offered. Hatshepsut is depicted offering the *menkhet* sign to Amun-Re on the very uppermost register of her obelisk at Karnak (**ill. 2**), and it may not be coincidental that this representation is placed above those showing the queen presenting other offerings. Clothing certainly seems to be singled out as a special offering in a number of such scenes. **Ill. 3** shows part of a wall painting from the tomb of Nefertari where the queen offers the hieroglyph for clothing to the god Ptah. In this representation the queen is depicted holding a tray with four pieces of cloth, and more linen is presented on the table before her. The hieroglyphic sign for *menkhet* is also clearly seen in the inscription above the table which reads: "The Great Royal Wife...gives clothing to the Lord of Truth [an epithet of Ptah]." The manner in which the queen here presents the hieroglyph for clothing rather than a pictorial representation of actual garments is typical of the depiction of the offering presentation of a number of items and underscores the hieroglyphic nature of Egyptian representational forms in this context.

CLOTHING

menkhet

S 27

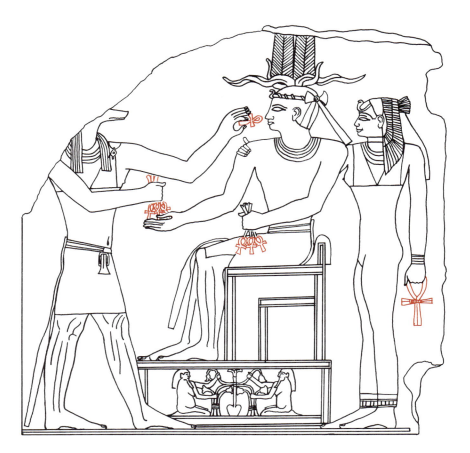

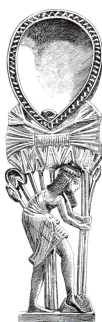

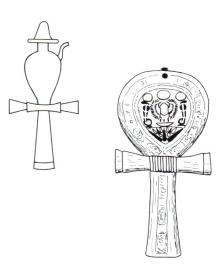

1 *Niuserre receiving ankh signs, relief from Abusir. Fifth Dynasty.*

2 *(Far left) Wooden unguent spoon. Eighteenth Dynasty.*

3 *(Center left) Ankh-shaped vessel, relief in temple of Amun, Karnak. Eighteenth Dynasty.*

4 *(Left) Mirror case, tomb of Tutankhamun, Thebes. Eighteenth Dynasty.*

The origin of this most familiar of hieroglyphs is somewhat obscure, and suggestions for its original identity have ranged from expressions of arcane sexual symbolism to representations of the humble sandal strap. Like the so-called "Isis knot" (*V39) which it closely resembles, however, the *ankh* probably depicts some kind of elaborate bow. Detailed examples (such as those in **ill. 1**) often show that the lower section is actually composed of two parts – the ends of the bow – and these ends are clearly separated in some archaic examples. While the object originally represented by the *ankh* may thus have been a knot with some specific religious or mythical significance, its meaning as a symbol for "life" is clear enough, and it is with this basic significance that the sign appears as an emblem carried in the hands of many Egyptian deities. A floral bouquet, also called *ankh* in Egyptian, is thus sometimes held by a man or woman in funerary representations to form a visual pun which subtly associates the deceased with the gods.

The *ankh* may represent the life-giving elements of air and water, and the sign is thus commonly offered to the king as a symbol of the "breath of life" (ill. 1), and a personified *ankh* sign is sometimes shown holding an ostrich-feather fan (*S35) behind the king in a variant form of this same idea. In the same way, chains of *ankh* signs are also shown being poured over the monarch (and in later periods, over deceased commoners) as a symbol of the regenerating power of water. A related aspect of this symbolism is seen in the fact that the libation vessels (*W15) which held the water used in sacred ceremonies were themselves frequently produced in the shape of the *ankh* hieroglyph (**ill. 3**).

The construction of functional objects in the form of the *ankh* is also seen in examples of the hooped sistrum (*Y8) and certain other items such as unguent spoons of the type shown in **ill. 2** (where the lower parts of the hieroglyph are formed by the body of the girl and the horizontally tied papyrus stems), mirrors (the Egyptian word for mirror was also *ankh*), and mirror-cases – such as the ornate example found in the treasures of Tutankhamun (**ill. 4**). Probably no other hieroglyphic sign appears so ubiquitously in the shape and decoration of small manufactured objects, as well as in the formal adornment of architectural features such as the walls, pillars and shrines of Egyptian temples. Often the *ankh* appears in conjunction with the *djed* (*R11) and *was* (*S40) signs in all of these contexts, and in inscriptions which are sometimes more symbolic or decorative in nature than they are linguistically functional. Nevertheless, the *ankh* remained a potent amulet throughout all periods of Egyptian history and probably as much because of this fact as for its cruciform shape, the *ankh* survived into the Coptic Period when it entered the iconography and symbolism of the Christian Church as the *crux ansata*, the handled or "eyed" cross.

ANKH

ankh

S 34

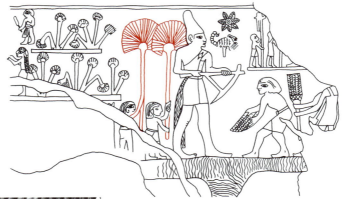

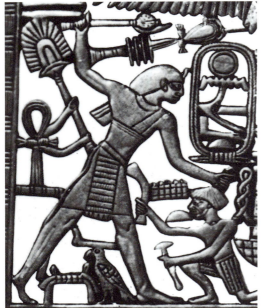

1 *Detail of "Scorpion Macehead", from Hierakonpolis. Predynastic Period.*

2 *Fan-wielding ankh on pectoral, tomb of Mereret, Dahshur. Twelfth Dynasty.*

3 *Human shadows and souls greeting the sun, tomb of Tausert, Thebes. Nineteenth Dynasty.*

Ancient Egyptian fans and sunshades often differed only in size. Large sunshades were doubtless also used as fans, and the hieroglyphic sign acted as a generic determinative used for words representing both items. In all periods, the most common types of fan were lotiform and palmiform, imitating the leaf of the blue lotus or the frond of the date palm. Other, less frequently found types were patterned after the leaves of other plants, bird wings, etc. – objects which were all doubtless used as fans. An actual example of the type of fan represented by the hieroglyph was found in the tomb of Tutankhamun.

The symbolic nature of sunshades and fans was especially important. The double deity Hepui seems to have represented the two fans shown accompanying the king in representations from the earliest times, as in the "Scorpion Macehead" (**ill. 1** – named for the scorpion hieroglyph which appears next to the king, and which may represent his name) where the fan bearers stand directly behind the king in what is evidently a scene depicting an important ritual event. Because the fan represented the air it moved, it was an active, functional symbol of breathing and therefore of life. In fact, several types of fan were known by the term *nefet*: "blower," and the symbolic content of this idea could be represented iconographically in a number of ways. Frequently, the fan is shown held behind the person of the king not by actual attendants, but by partially personified *ankh* signs, whose arms hold the fan aloft. In the gold chest ornament of Amenemhet III (**ill. 2**), the king is shown in the ancient ritual pose of the destruction of enemies or returning from the hunt, and the fan-wielding *ankh* signs in attendance clearly spell out the symbolic message that the "breath of life" (*ankh*) is with the king.

The fan also seems to have suggested the giving of life or life-giving fecundity in a different way. In its function of "blower" the fan could represent the sending forth of the life-giving waters of the Nile; and although this image may have developed as a part of Osirian beliefs in later times, it is possible that even as early as the Scorpion Macehead the fans attending the king represented the sending forth of the waters with which the king's agricultural activity seems to be concerned. By virtue of its shadow the fan or sunshade also represented the "shadow" which, like the soul, heart, and name, was regarded as part of the composite human person. This use of the fan is seen in New Kingdom funerary works such as the Book of Caverns where the hieroglyph appears atop the heads of certain beings and alongside *ba* birds (*G53) which worship the image of the sun (**ill. 3**).

The short-handled *khu* fan (S37) surmounted by a single ostrich feather (*H6) also appears frequently in Egyptian art – carried by the "fan bearer at the king's right side," or by the royal falcon, vulture, or winged *wedjat* eye in attendance on the king or on a deity such as Osiris.

FAN, SUNSHADE

shut

S 35

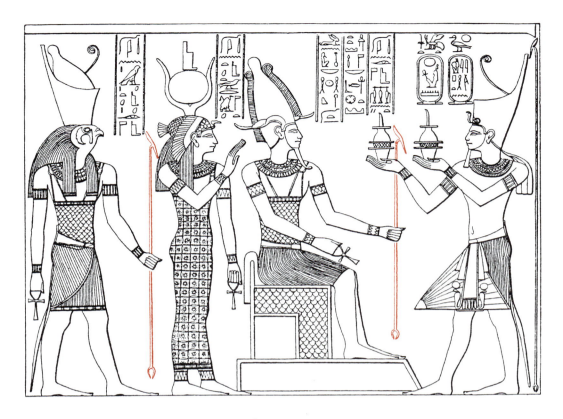

1 *Seti I offering to Osiris, temple of Seti I, Abydos. Nineteenth Dynasty.*

2 *(Right) Personified was sign, temple of Seti I at Abydos. Nineteenth Dynasty.*

3 *(Below) Ankh, djed, was, neb group, Birth House of temple of Dendera. Roman Period.*

4 *(Far right) The goddess Waset, stele of Merneptah, from Thebes. Nineteenth Dynasty.*

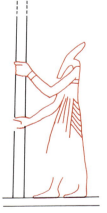

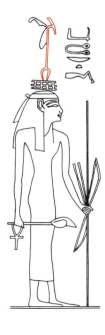

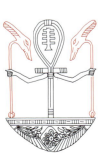

Originally a fetish imbued with the spirit of a revered animal, or perhaps simply a herdsman's staff, or even the generative member of the bull, the *was* scepter consisted of a straight shaft forked at the base and surmounted by an angled transverse section often shaped as the head of some (perhaps fabulous) creature. According to one theory, the forked base of the scepter could represent an animal's legs, and the central shaft might then be understood as the creature's body or elongated giraffe-like neck. The head is the only part of the scepter that is ever shown with detailed zoomorphic features, however, and while this detailing is usually assimilated to the image of the Seth animal (*E20), there is no evidence to show that this association was not a developed one.

Whatever its origins, the meaning of the *was* hieroglyph is nevertheless clear, and the sign is used with the connotation of "power" and "dominion." This conceptual content is clearly present in the iconographic use of the sign as an attribute and an emblem. From early times the *was* scepter is shown carried by deities as a sign of their power, and this use was eventually co-opted in representations of the king and, in later periods, in the mortuary representations of private persons.

Like other hieroglyphs with important amuletic and ritual significance, the *was* sign was used as a decorative element in the borders of reliefs and in the design of small decorated items. Most commonly, the sign occurs as a support for the sky (*N1) hieroglyph in the traditional framing device used around temple reliefs in all periods. This use may be seen in **ill. 1** where one of the framing signs appears behind the figure of Seti I as he presents an offering to the god Osiris – who also holds a *was* as a scepter in his left hand.

Frequently the *was* is grouped with other hieroglyphic signs, especially the *ankh* (*S34) and *djed* (*R11) glyphs. A decorative frieze in the Ptolemaic Temple of Hathor at Dendera (**ill. 3**) characteristically groups these signs on *neb* (*V30) baskets or bowls with the symbolic meaning of "all life, stability, and power." Like the *ankh* sign in this particular example, the *was* is often granted some degree of personification and arms are frequently added to the sign in representational contexts where it holds fans or standards (**ill. 2**), or even performs the gesture of adoration (*A30).

Several variants of the *was* exist. The gods Osiris and Ptah are often depicted holding a *was* scepter which combines the *ankh* and *djed* signs in its design; and decorated with a tall feather (*H6) and a streaming ribbon (R19), the *was* scepter became the emblem of Thebes (the Egyptian name for which was *waset*) and its Upper Egyptian nome (province) of Harmonthis. This emblem is usually worn as an identifying sign on the head of the goddess who personified the city (**ill. 4**). A further variant of the staff is found in the *djam* scepter (S41) which is identical to the *was* except for its sinuously curving shaft.

was

S 40

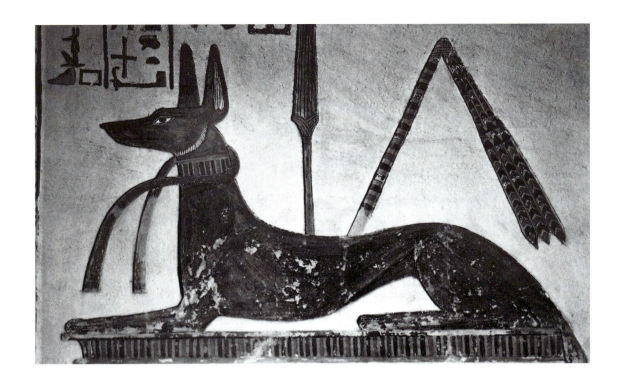

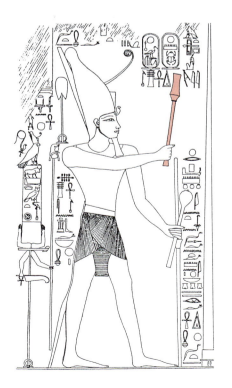

1 *Figure of Anubis with scepter and flail, tomb of Ramesses III, Thebes. Twentieth Dynasty.*

2 *Thutmose III presenting offerings, temple of Amun, Karnak. Eighteenth Dynasty.*

3 *Scepter, tomb of Tutankhamun, Thebes. Eighteenth Dynasty.*

Various types of batons and scepters share this hieroglyphic determinative in written Egyptian, and the sign could also signify related positions of authority such as *kherep*: "controller," *sekhem*: "powerful," and *aba*: "commander." In practice it is often difficult to differentiate between the various scepters and the respective offices, but representationally the sign is usually taken to depict the *sekhem* scepter which denotes the concept of "power" and "might." The word *sekhem* could thus refer to divine beings as "powers," and the name of the warlike lion goddess Sekhmet means, in fact, "She of Might." The god Osiris is frequently given the epithet "Great Sekhem" or "Foremost of Powers," and the *sekhem* is therefore commonly found as an emblem and a fetish in connection with the underworld deity. As a result of this connotation the *sekhem* also became the primary emblem of the mortuary god Anubis and is often depicted behind the reclining canid (*E15) which represented that god (**ill. 1**). In such iconographic usage, the *sekhem* is frequently given two eyes which were carved or painted on its upper part as a symbolic indication that the scepter was the manifestation of divine power.

From the Third Dynasty on, the *sekhem* appears in the royal names of kings, and later in the titles of queens and princesses also. But from the earliest times the *sekhem* was also delegated, as a baton of office, to viziers and others of important rank. Such persons are often shown bearing the scepter in the fulfillment of their duties. The classic Egyptian funerary statue (*A22) thus depicts the tomb owner standing with a staff (itself a sign of authority) in the left hand and a *sekhem* in the right hand in the expression of a motif which signified the successful life and prestigious position of the deceased.

The *sekhem* (or related scepter) was also used in temple and mortuary rituals and was often held by the officiant who presented the offerings. **Ill. 2** shows part of a relief of Thutmose III where the king functions in this manner as he consecrates a pair of obelisks and a rich selection of offerings in the temple of Amun at Karnak. As is usual in such scenes, the king waves the *sekhem* with his raised right hand while grasping his staff and mace in his left hand. Alternatively, the king might hold an incense burner in his left hand while officiating with the *sekhem*, and in either case the scepter was apparently waved four or five times over the items being offered while various recitations were made. A wooden scepter overlaid with sheet gold which was found in the treasures of Tutankhamun (**ill. 3**) shows on one side five registers (perhaps relevant to the number of times the scepter was waved), each containing the embossed image of a trussed and slaughtered bull with a foreleg (*F24) cut off and presented as the very choicest part of the offering.

A somewhat similar staff associated with the cult of Hathor – the *ukh* (R16) – represents a papyrus stem surmounted by feathers.

sekhem

S 42

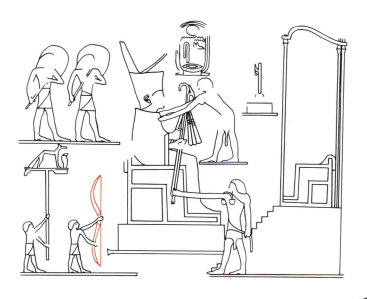

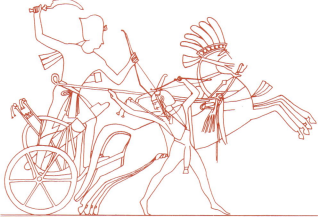

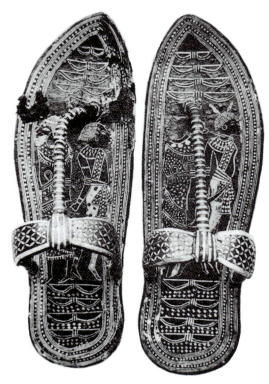

1 (Top left) Sed festival scene, temple of Niuserre at Abu Gurab. Fifth Dynasty.

2 (Above) Archer's arm-guard from Balabish. Second Intermediate Period.

3 (Left) Sandals from the tomb of Tutankhamun, Thebes. Eighteenth Dynasty.

4 (Below) Seti I attacking Libyans, temple of Amun, Karnak. Nineteenth Dynasty.

Because the bow was the most powerful weapon of the ancient world, it held an important place in the iconography of ancient Egypt and was used in a number of contexts. The hieroglyphic representation of the bow shows the weapon – usually aligned horizontally – with the bow string bound to the mid-section of the bow staff to avoid its warping under the string's constant pull when not in use. This simple glyphic representation appears in narrative scenes (**ill. 1**), and as a decorative element on items such as the archer's arm-guard shown in **ill. 2**. This leather guard from the Second Intermediate Period depicts a bow at the base of the projecting tongue, with the shape of the bow perhaps also being mirrored in the tops of the two *djed* (*R11) columns which appear lower on the guard's wrist-band. The juxtaposition of the two symbols recurs frequently on early arm-guards of this period, and it is possible that the combined motif signified the "stability" of the bow, as the arm-guard served to strengthen and support the archer's wrist as well as to protect the arm from the released bowstring.

The bow functioned from early times as a symbol and attribute of the goddess Neith, whose cult center was the ancient site of Sais in the Delta region. Although Neith is frequently represented holding a bow, the weapon's exact significance for the goddess is not fully understood, and it is difficult to know if her image as a warlike deity is the cause or the result of her association with the bow. Certainly, by New Kingdom times, Neith's use of the bow was held to represent her martial power, and the personified capital city of Thebes was also often portrayed as a goddess holding a bow with the same significance of military might (see *S40). As an especially potent weapon the bow could, in fact, symbolize the might of whole nations, and the enemies of Egypt were traditionally referred to as the "Nine Bows," which are frequently depicted as literal bows or personified as ethnically differentiated captives beneath the feet of the king on footstools, statue and throne bases, and even – as **ill. 3** shows – on the soles of Tutankhamun's sandals. Here, as in many other examples, the "Nine Bows" are shown both in the hieroglyphic form of the bow and also as bound captives (*A13) whose bodies are positioned to follow the sinuous curves of the bow's shape.

The bow also appears to be incorporated into many Egyptian artworks as part of the complex, yet fascinating vocabulary of gesture symbolism. The weapon is depicted in a number of representations of Egyptian (and Near Eastern) gods or kings who hold the bow backwards, turned with the string toward captive enemies, in what seems to be a gesture of dominance. **Ill. 4** shows an example of this turned bow motif, and scenes such as this from the period of Eighteenth and Nineteenth Dynasty military expansion also frequently show surrendering enemies holding their bows above themselves as though they are symbolically placing themselves beneath the turned bow, and thus beneath the dominance of the victorious Egyptian king.

BOW

iunet, pedjet

T 10

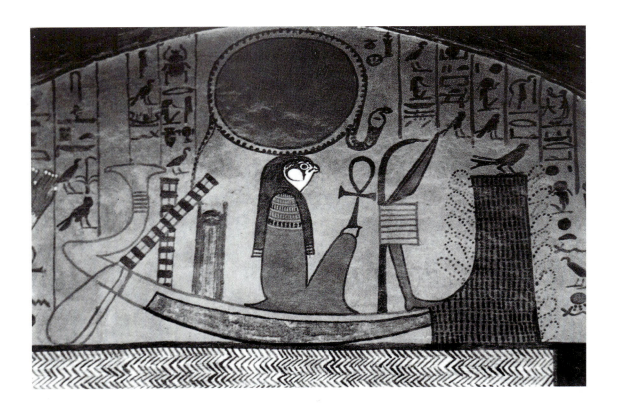

1 *Barque of Re with follower sign, tomb of*
Sennedjem, Thebes. Nineteenth Dynasty.

2 *Scene from the eighth "hour" of the Underworld,*
tomb of Seti I, Thebes. Nineteenth Dynasty.

3 *Mafdet on follower sign, edifice of Taharqa,*
Karnak. Twenty-fifth Dynasty.

The enigmatic object represented by this sign seems to be composed of a staff or crook with a knife (*T30) and some other object lashed to it. The thickness of the area around the knife could represent some kind of package or the addition of a heavy weight. These two possibilities are reflected in the theories concerning the purpose of the *shemset*. While some scholars believe the object depicted was the bundle of equipment carried by early chieftains' attendants – which came to have symbolic importance as a natural sign for "follower" or "attendant" – other Egyptologists believe the *shemset* to be an instrument of execution somewhat like the *fasces* or bundled axe and rods carried before Roman magistrates.

Whatever the origin of this sign may have been, it is certain that from early times it signified "follower" and seems to have been used to designate royal ancestors of the distant past. In mortuary paintings and the illustrations found in funerary papyri, the follower sign is frequently depicted as a mast-like object in the solar barque (*P3). A painting in the Nineteenth Dynasty tomb of Sennedjem at Thebes (**ill. 1**) shows the sun god seated in his barque between a shrine (*O20) at the aft and a follower sign at the fore-end of the boat. In this instance the details of the knife and the rope with which it is lashed to the crook are clear and the artist has included a touch of originality which is sometimes added to the sign. The handle of the knife which protrudes from the lower part of the "package" has been painted in the form of an outstretched human leg with its foot resting on the deck, thus providing a visual pun on the word "follower" which the sign represents.

In certain representations in funerary contexts, gods of the underworld may be represented by the follower sign (**ill. 2**), on which their heads (*S27) are shown. The deceased is also shown in the company of the *shemset*, sometimes with other figures who represent the royal "followers." While many texts allude to the desire of the deceased to join the barque of Re and thus to enter into the eternal cosmic cycle, the exact connection between the deceased and the royal followers in these scenes is not entirely understood. It is possible that the deceased would wish to be associated with the royal figures as a matter of prestige, or that the iconographic association is meant to imply that he has actually become one of these followers, for the follower sign is one of a number of royal emblems which occurs in private funerary contexts.

The goddess Mafdet, who was venerated from the earliest dynasties, was the manifestation of the protective or punitive aspect of the object represented by the follower sign. The goddess is sometimes depicted in this role as a small predator running up the pole of the *shemset* (**ill. 3**). In the Pyramid Texts she is said to protect the god Re from serpents and is sometimes shown filling this role in representations of the solar barque.

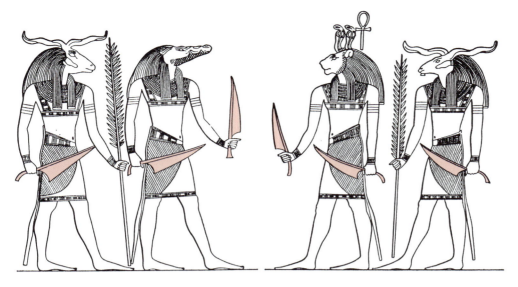

1 (Above) Knife-bearing deities, third funerary shrine of Tutankhamun, from Thebes. Eighteenth Dynasty.

2 (Below) Scene from the sixth "hour" of the Underworld, tomb of Seti I, Thebes. Nineteenth Dynasty.

3 (Below center) Judges of the dead from a funerary papyrus. New Kingdom.

4 (Bottom) Scene from the seventh "hour" of the Underworld, tomb of Seti I, Thebes. Nineteenth Dynasty.

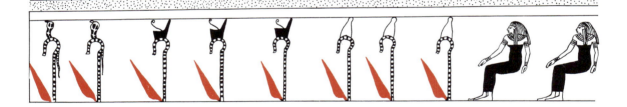

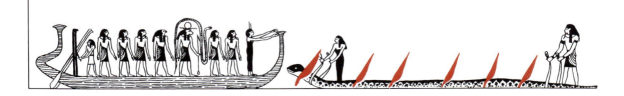

Finely worked flint knives were produced in Egypt from prehistoric times, and even when metal knives were available the ancient flint knife remained the type used in religious rituals. The word *des* which was used for "knife" throughout Egyptian history means, in fact, "flint." The hieroglyph appears as a determinative for different kinds of knives and, by extension, for words such as "cut," "carve," and "slaughter." The knife was therefore a natural symbol of protection and retribution, and the hieroglyphic form appears in a number of representational contexts.

Apotropaic deities such as the lion-man Bes and the hippopotamine Taweret may be shown armed with knives, and many of the beings inhabiting the Egyptian underworld hold knives by which they destroy the enemies of the sun god. These deities are depicted in almost every "hour" or division of the underworld as it appears on the walls of New Kingdom royal tombs and in other, related contexts – such as the doors of the third funerary shrine of Tutankhamun (**ill. 1**) which are guarded by such figures. They bear names such as "Slaughterer" and "He Who Repulses the Wicked," and all hold knives for the fulfillment of their protective work. Knives are also held by emblematic images such as crowned royal scepters (**ill. 2**) and by the guardians of the gates (*O13) of the twelve hours of the underworld to impede the progress of those who should not rightfully pass through. While these guards sometimes resemble the judges who make up the divine tribunal before which the deceased is judged in the afterlife, the judges are usually shown holding or wearing feathers (*H6) of truth as symbols of their office (**ill. 3**).

The knife also played an important part in solar and lunar imagery. A knife is shown as part of the ancient "follower sign" (*T18) which accompanies Re in his daily journey in the solar barques of evening and morning, and the crescent moon is a knife in the hands of lunar deities such as Thoth. Magical knives also functioned in the destruction of the sun's enemies as the solar orb rises each day. This imagery is especially common in relation to the underworld serpent Apophis, the enemy of the sun, and many representations illustrate Chapter 17 of the Book of the Dead, in which the Heliopolitan cat (*E13) cuts off the head of this great serpent as it threatens the sacred Persea tree (*M1) which was symbolic of the sun itself. **Ill. 4** shows a similar scene where a great serpent which threatens the sun god is transfixed by multiple knives. The twin sycamore trees between which the sun was said to rise each day are sometimes referred to as the "two knives," probably because of their knife-like form and also because they symbolized the success of the sun god's struggle with the powers of the underworld every dawn.

Because of the magical power inherent in depictions of the knife, images of malevolent creatures such as serpents and scorpions are often shown cut with knives to render them powerless, both in written texts and in representational scenes.

des

T 30

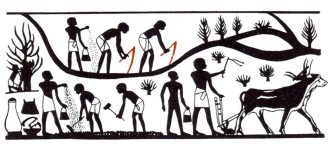

1 *Agricultural scene, tomb of Khnumhotep, Beni Hassan. Twelfth Dynasty.*

2 *(Below) Hoe and obelisks, tomb of Rekhmire, Thebes. Eighteenth Dynasty.*

3 *(Bottom) Hoeing the earth, Papyrus of Nestanebettawy. Twenty-first Dynasty.*

4 *(Right) Ushabty of the scribe Amenemhet. Eighteenth Dynasty.*

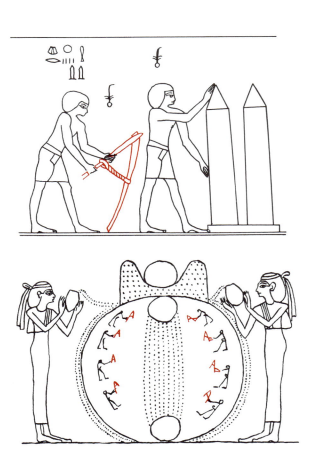

The Egyptian hoe was a simple yet effective agricultural implement with a long wooden handle and a scoop-like blade joined at the top and supported by a rope tied between the two halves in the center. The implement is depicted in normal everyday use in many tomb paintings (**ill. 1**); yet because it was the first part of the agricultural process, hoeing the ground could also take on important symbolic implications. As a symbol of fertility the hoe may be depicted as early as the "Scorpion Macehead" (see *S35); and in the realm of myth and ritual, the rite of hoeing the ground could specifically allude to the death of the god Osiris who was symbolically buried each year in the form of the planted grain. This ritual expression of the death of the god could also apply to the deceased Egyptian who became an "Osiris" at death. It is in this way that the first chapter of the Book of the Dead contains the statement "I have received the hoe on the day of hacking up the earth," followed by the wish "May you cause to enter the perfect soul...into the house of Osiris." Hoeing the ground was thus one of the symbolic rites included in the funerary proceedings. In the tomb of Rekhmire at Thebes the rite is shown along with the setting up of small funerary obelisks before the entrance to the tomb (**ill. 2**).

The mortuary hoeing of the earth seems to be very ancient, as the rite is alluded to in numerous passages in the Old Kingdom Pyramid Texts. There the ritual is repeatedly mentioned in connection with the giving of offerings and libations for the deceased king, as in utterance 1394-5 which states "The earth is hacked up by the hoe, the offering is presented...O Geb [god of the earth], open your mouth for your son Osiris." The ritual probably survived through most of Egyptian history, and several funerary representations from the Late Period show figures with hoes flanked by two goddesses who pour water (libations?) upon the scene (**ill. 3**). Two spheres which seem to be solar disks also appear in these scenes which are thus made to include earth, water, and sun – the three essential elements of Egyptian resurrection symbolism. The motif is almost invariably accompanied by other symbols of the resurrection and afterlife and doubtless illustrates the funerary hoeing of the earth.

The hoe also appears as a regular attribute of the mummy-shaped *ushabty* figurines placed in the tomb to do the work which the deceased might be called upon to perform in the next world (**ill. 4**). These servant figures were intended to protect the deceased from an afterlife corvee which might require the cultivation of the fields or the clearing of silt from the canals, etc. Early in the New Kingdom, the *ushabty* was provided with small model tools and implements such as the hoe to do this work. As time passed, these implements – and especially the hoe – were painted or molded onto the figurine itself, and the classic pose in which the figure holds a hoe – in the position of the hieroglyph – in each hand became almost invariable.

HOE

henen

U 6

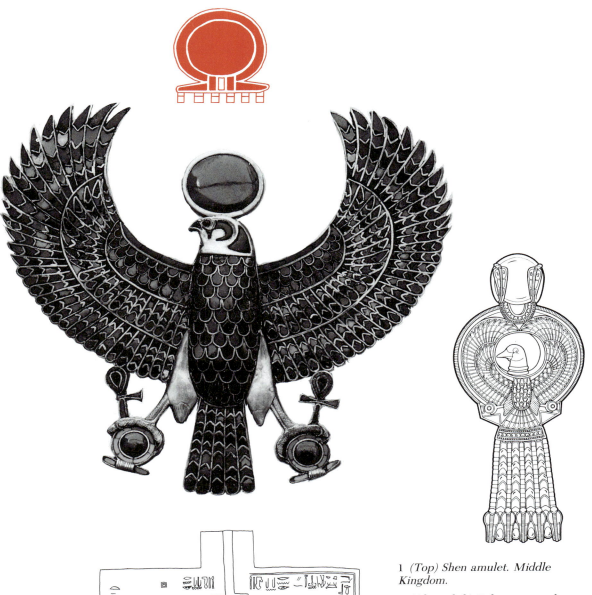

1 *(Top) Shen amulet. Middle Kingdom.*

2 *(Above left) Falcon pectoral, tomb of Tutankhamun, Thebes. Eighteenth Dynasty.*

3 *(Above right) Earring, tomb of Tutankhamun, Thebes. Eighteenth Dynasty.*

4 *(Left) Shen-shaped stands on representation of offering mat. Offering table. New Kingdom.*

Being without beginning or end, the circle evokes the concept of eternity through its form, and its solar aspect is symbolized by the sun disk often depicted in the center of the *shen* sign. These ideas were probably the origin of this hieroglyph which is found in words connected with the verbal root *shenu* meaning "encircle," and which in its later elongated form became the cartouche (*V10) which surrounded the Egyptian king's birth and throne names. Perhaps from this particular context the *shen* sign also took on the connotation of protection – as the device which excluded all inimical elements from the royal name. The *shen* may appear with both of these meanings – "eternity" and "protection" – in Egyptian art. As a sign for the former, the hieroglyph is frequently associated with representations of Heh (*C11), the god of eternity, and often forms the base of the notched palm-branch (*M4), symbolizing "years," which is held by this deity. It is also mirrored in the shape of the *ouroboros* (see *A17), the serpent which bites its own tail. The sign is perhaps most commonly associated with the avian forms of the falcon (*G5) god Horus and the various vulture (*G14) goddesses, however. These divine birds are frequently depicted holding the *shen* in their claws, hovering above the king and guarding him beneath their outstretched wings (*H5). The *shen* signs proffered by these avian deities may be regarded as symbols of eternity, and therefore life, but it is possible that the signs also carry the connotation of protection, and this double significance would certainly seem to be present in many of the small decorative items and amulets which use the sign in their design.

The *shen* was frequently employed in jewelry from Middle Kingdom times, both directly – in the formation of finger-rings and simple amulets such as the pendant in **ill. 1** – and indirectly, at a secondary level of association. The gold falcon-shaped pendant from the tomb of Tutankhamun which grasps a *shen* ring in each of its outstretched feet (**ill. 2**) is an exquisite example of this. Here, the upcurving wings of the bird itself certainly suggest the shape of the *shen*, and the solar disk on the falcon's head – the center of this part of the composition – heightens this effect. In the duck-headed earrings also found in the tomb of Tutankhamun (**ill. 3**), the secondary association is even clearer. The main element of their design consists of composite birds having the wings and bodies of falcons and the heads of ducks. These hybrid birds not only hold *shen* signs in their outstretched claws, in the traditional manner, but also closely mirror the shape of the *shen* sign by virtue of the almost complete circle formed by their wings and the horizontal bar suggested by their outstretched legs. The shape of the *shen* ring is also often mirrored in representations of small stands as in those depicted on the offering mat (*R4) in **ill. 4**; and the hieroglyph is frequently held by the goddesses who kneel on the gold (*S12) hieroglyph at the ends of New Kingdom royal sarcophagi.

SHEN RING

shen

V 9

1 *(Right) Cartouche of king Shabaka, from Memphis. Twenty-fifth Dynasty.*

2 *(Below) Sarcophagus lid, tomb of Merneptah, Thebes. Nineteenth Dynasty.*

3 *(Far right) Chest, tomb of Tutankhamun, Thebes. Eighteenth Dynasty.*

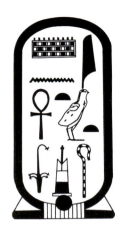

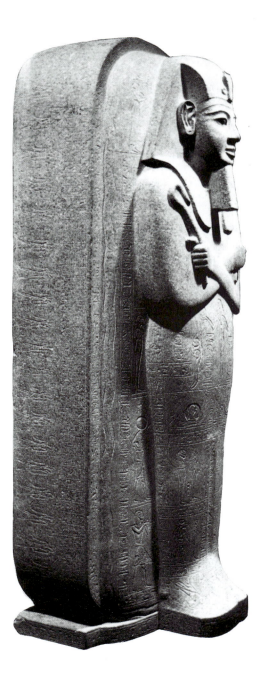

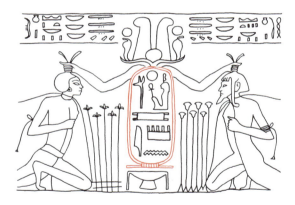

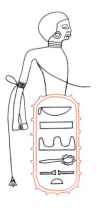

4 *(Above) Partially personified cartouche, temple of Ramesses III, Medinet Habu. Twentieth Dynasty.*

5 *Name ring, temple of Ramesses III, Medinet Habu. Twentieth Dynasty.*

The term "cartouche" is a relatively modern one which was bestowed on this hieroglyph by the soldiers of Napoleon's expedition to Egypt, who saw in the sign the likeness of the cartridges or "cartouches" used in their own guns. The Egyptian name for the cartouche – like that of the *shen* sign (*V9) – was derived from the verb *sheni*: "to encircle," and the earliest forms of the cartouche in which the king's name was written were in fact circular and identical with that sign. Early in Egyptian history, however, the form of the *shen* ring was lengthened in order to hold the increased number of hieroglyphs resulting from longer royal names and fuller orthography. In this way the *shen* continued to be used as a sign with its own meanings while the cartouche became the standard holder of the royal name (**ill. 1**). By the time of the Fifth Dynasty, both the king's prenomen or throne name (Egyptian *nesu-bit*) and his nomen or birth-name (Egyptian *sa-re*) were written within cartouches. These two names were without doubt the most important titles in the developed royal titulary, and the two cartouche names frequently appear with emblematic use in works of art as well as in formal inscriptions.

While one of the connotations of the cartouche seems to have related to solar symbolism (since the device may have originally represented that which was encircled by the sun – the realm of the king), an apotropaic function relating to the protection of the king's name was also extremely important. This protective function may be alluded to in the design of cartouche-shaped royal sarcophagi from the Eighteenth Dynasty on (**ill. 2**). Certainly, it would seem fitting to place the deceased king within a chest signifying his name and person, but the sense that protective imagery is involved is heightened by the inscriptions and representations which were also added to many sarcophagi. In the Tomb of Thutmose III, in the Valley of the Kings, the entire burial chamber – as well as the sarcophagus – was constructed in the form of the cartouche.

The hieroglyph also appears in many decorative contexts such as the finger rings and decorated cartouche-shaped boxes – including the example shown in **ill. 3** – which were found in the tomb of Tutankhamun. Some of these rings and chests were based on the form of the twin cartouches which framed both of the king's most important names, though in these examples the cartouches often encircle small representations of a solar-related deity or the king himself rather than his name. In many instances, solar disks (*N5) with uraei (*I12) and plumes (*H6) surmount cartouches, possibly alluding to the solar connotations of the device as well as the solar element in the names of kings such as Tutankhamun (Nebkheperure) and Ramesses.

A partially personified cartouche may represent the king's role as controller of Egypt's enemies (**ill. 4**), and rings in which the names of subject peoples and defeated cities were inscribed also appear in lists of captives (*A13) placed on temple walls (**ill. 5**).

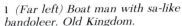

1 (Far left) Boat man with sa-like bandoleer. Old Kingdom.

2 (Above) Sa amulet necklace.

3 (Center left) Combined sa, ankh, and neb amulet.

4 (Below left) Lion figure, from the tomb of Tutankhamun, Thebes. Eighteenth Dynasty.

5 (Below) Tawaret figure with double sa signs, from Karnak. Twenty-sixth Dynasty.

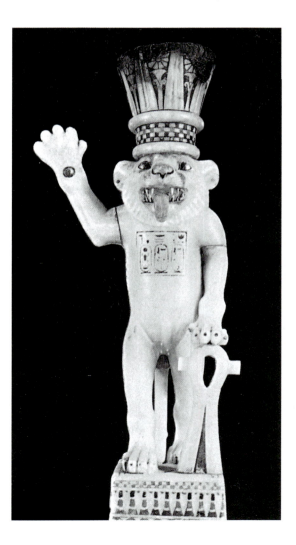

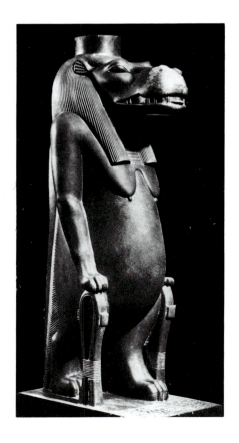

Various theories have been proposed for the origin of this hieroglyph meaning "protection" – ranging from its representation of a rolled-up herdsman's shelter to the bandoleer or papyrus life-preserver used by ancient Nile boatmen (**ill. 1**). The hieroglyph essentially occurs in two forms: in the Old Kingdom it appears to be undivided at its base (V18), whereas from the Middle Kingdom onward its lower section sign is usually clearly divided (V17). Oddly enough, this development parallels, yet is opposite to, the history of the somewhat similar *ankh* sign (*S34), the base of which was originally divided and later undivided. Whatever its origin, the iconographic value of the *sa* sign is clear, however.

As a symbol of protection, the hieroglyph was employed as an amulet and in the design of jewelry from early times. The *sa* sign may thus be found as the principal motif employed in jewelry such as the Middle Kingdom necklace shown in **ill. 2**. In such instances the sign is simply reduplicated throughout the composition – presumably with the effect of strengthening its magical potency. In other instances, the *sa* sign is found in amuletic compositions employing other hieroglyphs, and particularly the *ankh* (*S34), *djed* (*R11) and *was* (*S40) signs. In the example in **ill. 3**, the *sa* is joined with the *ankh* and *neb* (*V30) signs to form the expression "All life and protection." The *sa* hieroglyph is also found used independently on magic wands or batons of the Middle Kingdom Period, probably designed for use in the warding off of evil influences.

A tendency toward greater use of symbols that satisfied the need for support and protection may be observed as Egyptian history progressed, and the sign is especially common on artifacts dating to the latter dynasties of the New Kingdom and the later periods. In the Twenty-sixth Dynasty, the *sa* sign was frequently used as a potent apotropaic device painted on the ends or sides of coffins, either alone or with *djed* (*R11) or *tiet* (*V39) signs. A certain amount of variation also occurs in the iconography of the *sa* in this period, and the hieroglyph is found occasionally as a winged sign or with some other aspect of partial personification.

In two- and three-dimensional representational works the *sa* sign is commonly found as an attribute of a number of zoomorphic, apotropaic deities – especially the god Bes, the lion (*E22,23) in its protective role (**ill. 4**), and the hippopotamus (*E25) deity Taweret (**ill. 5**), who functioned as a goddess of childbirth. In these representations the sign is usually found as a standing amulet upon which the deity rests a paw, with the other paw almost invariably being raised in a gesture of protection, or to hold a flaming torch whereby the forces of evil are dispelled. Only occasionally, as in ill. 5, does the figure rest its hands on double *sa* signs, a fact which is in accordance with the principle that later Egyptian art – from the New Kingdom on – usually prefers the combination of related symbols to the mechanical repetition of a single symbolic sign.

PROTECTION

sa

V 17

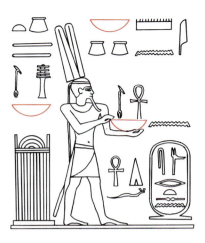

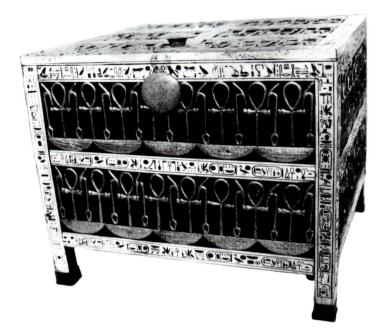

1 *(Above) Amun with neb sign on lintel of Sesostris III, from Naq el-Madamud. Twelfth Dynasty.*

2 *(Left) Decorated chest, tomb of Tutankhamun, Thebes. Eighteenth Dynasty.*

3 *(Below) Scene from the ninth "hour" of the Underworld, tomb of Seti I, Thebes. Nineteenth Dynasty.*

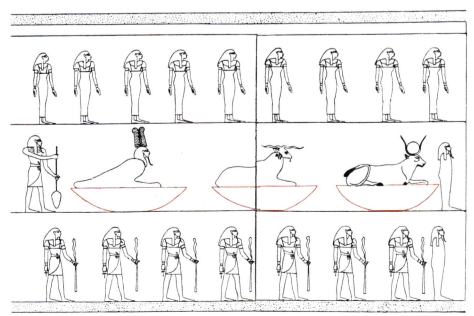

The woven wicker basket in this hieroglyph was termed *nebet* by the Egyptians, and the sign was used in the written language to represent the phonetic group *neb*. This led to the hieroglyph being used in two homophonous words of very different meaning – *neb*: "all," and *neb*: "lord" or "master." Representational use of the basket often involves one of these connotations, therefore. A detail from a carved lintel of the Twelfth Dynasty king Sesostris III which shows the god Amun holding a basket with *was* (°S40) and *ankh* (°S34) signs on it (**ill. 1**) is an excellent example of this double meaning inherent in the *neb* sign. Here, the *neb* sign must be understood as "all," with the significance that the god presents "all life and power" to the king. Corroborating this symbolism, the inscription below and to the right of the basket states "He [Amun] gives life to Sesostris." Above the god, a *neb* basket may be seen in the inscription "Amun, Lord [*neb*] of the Thrones of the Two Lands," and another directly behind him is "All [*neb*] stability and power." In this instance then, the *neb* sign functions with both its respective meanings in the written text, and as "all" in the representational example. This latter meaning is the most common in representational contexts and may be found in many scenes where "all" of a given item or quality is offered to the gods or, with equal hyperbole, given by the gods to the king. This is the usual meaning, too, where the sign is placed in decorative contexts such as the carved wood and ivory chest of Tutankhamun (**ill. 2**) or in architectural (see °G24) and amuletic (see °V17) use.

Used with the connotation of "lord" – or in feminine cases "lady" or "mistress" – the *neb* sign was used from very early times as a kind of stand for the image of a god in order to show its divine nature. The vulture (°G14) and uraeus serpent (°I12) are thus seated on baskets in written Egyptian and in many representations to signify their identity as the tutelary deities of Upper and Lower Egypt. The two goddesses appear together in this way in the royal *nebty* or "Two Ladies" title which was used as the king's throne name, and in many emblematic scenes. In paintings made to illustrate the mortuary Book of That Which Is in the Underworld in the royal tombs of the New Kingdom, the ninth "hour" of the night contains the images of three gods which recline on *neb* baskets (**ill. 3**). These deities were revered as the providers of abundant offerings, and their depiction in this manner probably symbolizes their special importance.

In later times, the *heb* sign – a similar hieroglyph depicting a carved stone bowl (°W3) – was frequently used interchangeably with the *neb* basket in representational contexts, and the two signs may be alternated in friezes and other instances where multiple *neb* baskets might be depicted. Yet another hieroglyph, the *ek* sign (V31), represents a wicker basket with a small handle attached. This sign should not be confused with the previous glyphs and does not bear their symbolic or linguistic meanings.

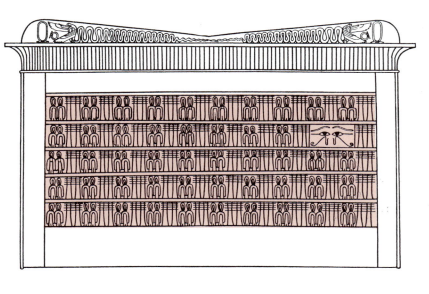

1 *Djed-tiet signs on the first funerary shrine of Tutankhamun, from Thebes. Eighteenth Dynasty.*

2 *Personified tiet knot, coffin of Ankhefenkhonsu. Twenty-fifth Dynasty.*

3 *Hathor-headed tiet amulet, statue of Djedkhonsuiuefankh, from Thebes. Twenty-third Dynasty.*

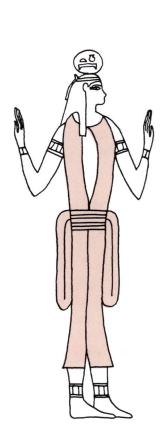

The exact origin of the Isis knot is unknown, though initially this sign was perhaps a variant of the *ankh* (*S34) which it resembles closely, except that its transverse arms are curved downwards. In written sources the meaning and symbolism of the *tiet* seem to be similar to those of the *ankh*, and the sign is often translated as "life" or "welfare." In representational contexts, the *tiet* is found as a decorative symbol as early as the Third Dynasty when it appears with both the *ankh* and the *djed* (*R11) signs, and later with the *was* scepter (*S40).

Perhaps because of its frequent association with the *djed* pillar, the *tiet* came to be connected with Isis, and the two symbols were thus used to allude to Osiris and Isis and to the binary nature of life itself. The association of the sign with Isis leads to it being given the names "the knot of Isis" (as it resembles the knot which secures the garments of the gods in many representations) and "the blood of Isis." Complex mythological stories surround these names, but it is impossible to know whether the stories preserve the original significance of the *tiet* object or if they were merely developed to explain and expand upon the established names. Because of the latter name, "blood of Isis," the sign was often used as a funerary amulet made of a red semi-precious stone such as carnelian or jasper or from red glass.

Due to its symbolic significance, the *tiet* sign is frequently found with the *djed* in decorative bands carved on the walls and columns of temples, and in the decoration of shrines (**ill. 1**), and on other objects such as sarcophagi and beds. Sometimes the sign is personified as a goddess (**ill. 2**), where the knot is used as the form of a dress – with the center part and side-pieces forming the garment's stylized belt. A number of variants of this treatment of the *tiet* sign are found in works of the Late Period, with the sign being associated with the goddesses Nut (as in ill. 2), Hathor, and Nephthys as well as with Isis. All of these variants, however, appear in contexts relating to the idea of resurrection and eternal life.

From Old Kingdom times, the *tiet* knot was also fused with the bovine faces of the goddesses Bat or Hathor as an emblematic motif related to their cults and as a badge of office for the *kherep-ah* (the major *domo*, or "manager" of the palace). Combined with the cow-eared face of the goddess Hathor, the *tiet* is commonly depicted as an amuletic pendant slung low from the belt in statues dating from the Third Intermediate Period on. Block statues including this detail of the suspended amulet often show it dangling rather conspicuously just over the knees of the seated figure – as in the Twenty-third Dynasty statue shown in **ill. 3**. In late examples such as this, however, the emblem usually seems to be present as a protective amulet rather than as a badge of office.

(This hieroglyph was moved from its original position in Gardiner's sign list and placed by him between the signs S34 and S35.)

ISIS KNOT

tiet

V 39

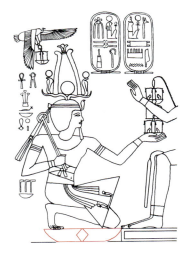

1 (Right) Sed festival scene of Ramesses III, from a temple relief. Twenty-first Dynasty.

2 The deified Seti I, relief in temple of Seti I, Abydos. Nineteenth Dynasty.

3 Emblematic groups with bowl hieroglyphs, temple of Hathor, Dendera. Ptolemaic Period.

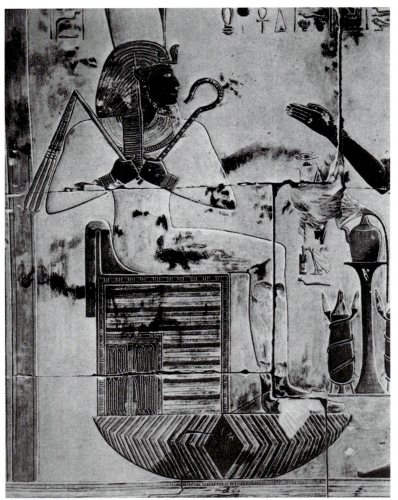

This hieroglyph is distinguished from the similarly shaped *neb* basket (°V30) by the triangular markings on its side which detailed examples show to represent the variegated layers of stone from which the bowl was cut. The use of the hieroglyph as a determinative for vessels of alabaster (*shes*) indicates that it represents a type of basin made of that stone which was used in purificatory rites. More importantly, though probably as a result of the purifications characteristic of religious celebrations, the bowl glyph also came to stand as a determinative for the word *heb*: "feast," or "festival." While the hieroglyph was also used as a determinative for a number of other associated words, its iconographic usage is limited almost exclusively to the festival context and as a representational variant of the *neb* sign.

Most frequently, the hieroglyph is combined with the *sed*, or "jubilee," sign (°O23) to represent the king's jubilee festival, and in the relief of Ramesses III shown in **ill. 1**, the king kneels on a small dais in the shape of the bowl or festival glyph as he receives the symbols of the jubilee from the enthroned Amun-Re. The hieroglyph may also be seen in the jubilee (*heb* + *sed*) sign held by the protective vulture (°G14) above the king, and in the chain of "jubilees" which the king receives from the god. These smaller examples all bear the diagonal patterning characteristic of the fully detailed sign.

On other occasions, the alabaster bowl is used as a virtual substitute for the *neb* basket with that hieroglyph's meanings of "lord" or "all." It is found with the clear former meaning in only a few contexts, although it is certainly possible that royal jubilee representations of the kind mentioned above are also meant to imply the concept of "lord" at least at a secondary level – a subtlety certainly not beyond the range of Egyptian art. The *heb* bowl does appear with the meaning of "lord" beneath the throne of Osiris in a number of depictions of that god, and occasionally the sign is used in the same manner in representations of monarchs. In a relief of Seti I in the king's chapel at Abydos (**ill. 2**), for example, the deified Seti is shown in the guise of Osiris and is seated on a throne which rests on the *heb* glyph in this way.

Like the *nebet* basket (°V30), however, the bowl sign is more commonly used in the sense of "all," where it frequently supports the *ankh* (°S34), *djed* (°R11), or *was* (°S40) signs – as in **ill. 3** which shows this use in a carved frieze from the Ptolemaic Temple of Hathor at Dendera. Here, as in many other examples from the later periods, the hieroglyph simply denotes "All life and dominion," and in representations such as this the *neb* basket and *heb* bowls are sometimes alternated in the same frieze, apparently for no other purpose than graphic variation – a factor which is important in most symmetrical Egyptian compositions.

ALABASTER BOWL

shes, heb

W 3

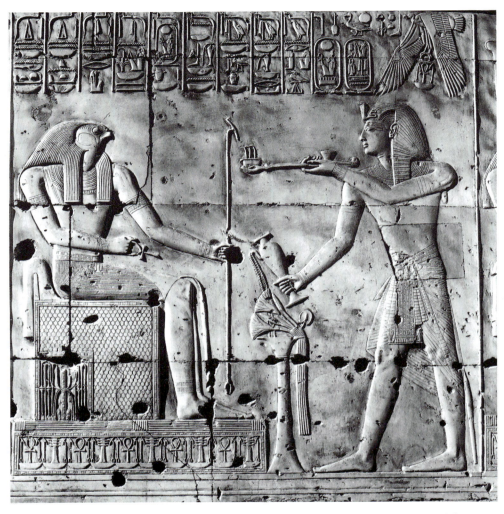

1 *Seti I offering libation, Temple of Seti I, Abydos. Nineteenth Dynasty.*

2 *Offering table of Harsiese with water jar motifs, from Akhmim. Eighteenth Dynasty.*

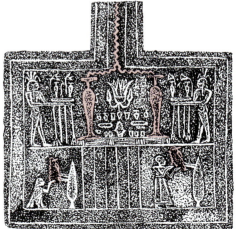

Because water was a natural symbol of life and reanimation as well as of cleansing, it was used in the temple and mortuary cults both as an offering and for purification. Apart from the small jars used for offerings of water, milk or wine (see D39), the vessels used for ritual libations were of a specific form – mirrored by the hieroglyphs W14-18. This type of vessel consisted of a tall narrow jar with a base not normally wider than the shoulder, which might be set in a ring stand (W16) or a specially designed rack (W17) while not in use. Often these vessels were made from precious metals, and variations from the basic design appear in the jar being made in the form of the *ankh* sign (*S34) (signifying the principle of life and reanimation), or the addition of a spout, animal-headed lid or some other minor ornamentation. Funerary models of libation vessels found in numerous tombs – such as the faience water pots found in the tomb of Tutankhamun – are often of less costly materials and may even be solid, their significance and intent being thought to be sufficient to allow them to function magically.

In the hieroglyphic script, in words such as *kebeh*: "to purify," or "to present libations," and in the representations found in temples and tombs, water jars are often shown with the wave-line which signified water (N35) issuing from the neck of the vessel. This may be seen in **ill. 1** where Seti I is shown offering incense and pouring a libation of water before the enthroned god Amun-Re. The inscription before the king affirms that incense and libation are being offered, with the latter being signified by the water jar in its stand. The water vessel is also frequently inscribed, along with various food offerings, on the surfaces of altars or offering tables (*R4); and **ill. 2** – the Ptolemaic Period offering table of Harsiese in the British Museum – shows a particularly clear example of this practice. Here, two large water jars are depicted flanking food offerings at the center of the upper register of the composition. Water lines flow from the necks of the vessels into a unified stream which proceeds into the table's offering projection. Fecundity or "Nile" figures are shown presenting trays with water jars at the sides of the same register and in the lower corners of the table Harsiese and his *ba* or soul bird (*G53) receive libations of cool water from a personified tree (*M1) deity, probably representing the goddess Nut or Hathor.

Water – and thus jars of water – could represent the god Osiris, just as earth could represent his wife Isis, a polarity which found symbolic expression in the inundation of the Nile and the fertile union of water and earth. On the other hand, the symbols could be reversed and in the annual festival of Osiris, a model phallus representing the god was carried at the head of the procession with a jar of water symbolizing his wife. Far from being crude symbols of reproduction, these elements were also a manifestation of deeper cosmogonic imagery.

WATER JAR

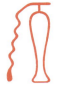

heset

W 15

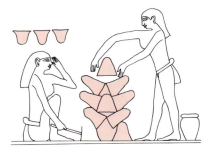

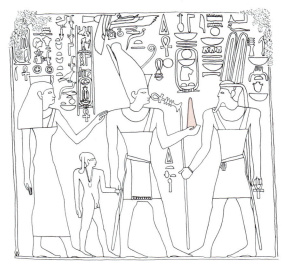

1 *Heating pots for bread baking, tomb of Ti, Saqqara. Fifth Dynasty.*

2 *(Right) Ahmose presenting bread to Amun-Re, stele of Ahmose. Eighteenth Dynasty.*

3 *(Below) Loaves on offering table, stele of Rahotep, from Meidum. Fourth Dynasty.*

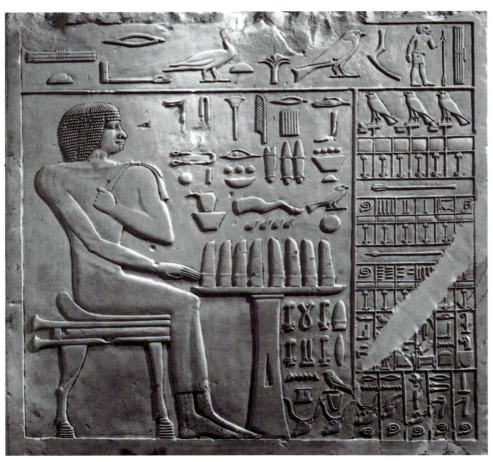

Bread occupied an essential place in the Egyptian diet and New Kingdom texts use some forty terms for different breads and cakes. Representations show loaves of oval, round, and conical shape and a number of hieroglyphs represent these different types of bread (X1-8). The signs selected here are doubtless the most common in representational contexts, however. In both X2 and the alternative simplified form X3, the hieroglyph represents the type of tall bread loaf most often found in offering scenes. These tall loaves were baked in clay pots and are represented in various stages of the baking process in a number of Egyptian reliefs (**ill. 1**). Once produced, the loaves were usually cut in tall, semi-circular sections, and these halved or sliced loaves (X7) are also frequently shown on the offering table placed before the deceased. **Ill. 3** shows a fine example of this motif from the Fourth Dynasty stele of Rahotep in the British Museum. Here the deceased reaches – in the classic gesture of acceptance – toward the sectioned loaves presented before him (in the shape of X7), while the funerary formula below the offering table lists "thousands of loaves" (X2) among the first of its prescribed offerings. The sectioned loaves shown on the offering table are often replaced by hieroglyphic reeds (*M20) which functioned iconographically as a symbol of abundant offerings, and some examples combine the two elements into what might be described as a type of hybrid "reed loaf."

In the written Egyptian language, a stylized conical loaf (X8) held by a hand and arm (*D37) depicted the presentation of an offering, and this hieroglyph was used to write the words *di* and *redi*: "to give," or "to present." Naturally enough, therefore, the bread loaf came to symbolize the process of offering at a number of levels. In the mythological papyri, sacred loaves are said to be found in the "Eye of Horus" (*D10) – which represented a generalized symbol for offerings as well as certain cosmic entities – and the loaf hieroglyph was used as a generic food offering in the decoration of offering tables as well as in the ubiquitous offering formulae found on funerary stelae and in tomb inscriptions. The central position of bread as an offering in the mortuary cult is also mirrored in the temple sacrifices. A large number of reliefs depict kings in the act of presenting loaves of bread to the gods, as in **ill. 2** where Ahmose, the first ruler of the New Kingdom period, makes such a presentation to the god Amun-Re. The inscription beneath the king's outstretched arm (beginning with the hieroglyph X8) specifies the offering as the gift of "white bread." Depictions such as this were made throughout the New Kingdom and continue down to the end of the Pharaonic Period.

Finally, bread could also be used symbolically in ways which are only understandable in terms of its connection with offerings for the deceased. On Middle Kingdom coffins, for example, the bread loaf sometimes appears as a substitute for the names of the gods Thoth, Geb, or Anubis, all of whom were deities closely associated with the afterlife.

BREAD LOAF

te

X 2,3,7,8

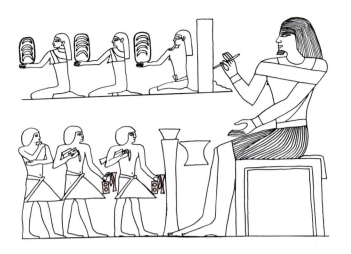

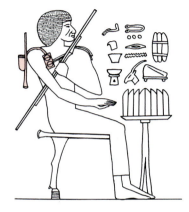

1 *The deceased writing, tomb of Khentika, Saqqara.*
Sixth Dynasty.

2 *(Right) Deceased with scribal outfit, from the tomb*
of Hesyre, Saqqara. Third Dynasty.

3 *Thoth with scribal outfit, Papyrus of Taukherit.*
Twenty-first Dynasty.

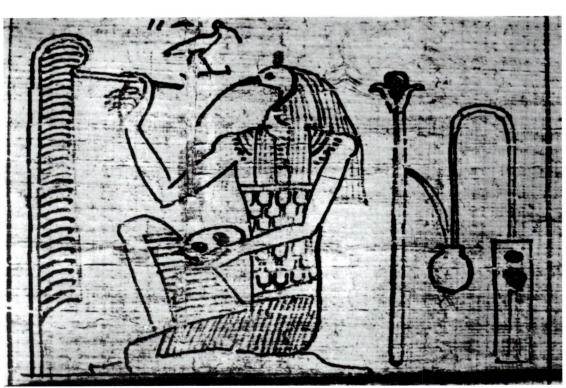

The writing equipment used by the Egyptian scribe consisted of a palette (usually with two depressions to hold black and red pigments), a water jar (or pigment bag), and a pen case. Often the several parts of the outfit were held together – as in the hieroglyph – by a connecting string which facilitated carrying. The central element of the outfit, the scribe's palette, might be made of any of a number of different materials with wood being common, but stone and other non-porous materials doubtless considered preferable.

Because writing was an important skill practiced by an elite group of trained scribes, even kings and nobles were proud of the ability to write and were not uncommonly portrayed with writing equipment in the guise of the scribe. **Ill. 1** shows a relief scene from the tomb of the Sixth Dynasty vizier Khentika, where this noble is shown drawing figures of the three seasons of the Egyptian year (each represented by figures holding four crescent "month" signs). Khentika is seated with an unrealistically enlarged pen case, water pot, and palette before him, in order to heighten the visual emphasis on his writing ability. The two scribes standing before the vizier are drawn in a more traditional manner, each holding his writing outfit in such a way that the presentation to the viewer is exactly that of the *menhed* hieroglyph.

Never shy to find ways to put their best points forward, the Egyptians found an alternative to the exaggeration of the size of the writing outfit in a rather blatant repetition of the sign. Carved wooden panels from the tomb of the Third Dynasty official Hesyre for example, show the deceased in a number of scenes in which his writing equipment is always clearly visible. In one of these scenes (**ill. 2**), Hesyre sits with his palette and water pot slung over his shoulder – by means of the connecting string – in the manner that these items were often carried. Even in this representation the depiction of the scribal outfit departs little from the hieroglyphic form. Book of the Dead vignettes from the New Kingdom and later periods often show a scribal palette or full writing kit among the offering goods beneath the bier on which the deceased rests; and occasionally the deceased is shown receiving writing equipment – for use in the afterlife – from the hands of the god Thoth.

The design of the palette was variable, and some types were made with recesses in which the reed pens or "brushes" were held, rather than in a separate case. This elongated type of combined palette and pen case became fairly standard in the New Kingdom, though the short palette represented in the hieroglyph is the form usually found in earlier representations. **Ill. 3** shows the hieroglyphic form of the outfit in an ink drawing from a Twenty-first Dynasty papyrus in which the ibis-headed Thoth – the god of wisdom and patron of scribes – draws a large *maat* feather (°H6). Although Thoth holds a small oval palette in his hand, the large scribal outfit behind him emphasizes the nature of the god and his work.

SCRIBE'S OUTFIT

menhed

Y 3

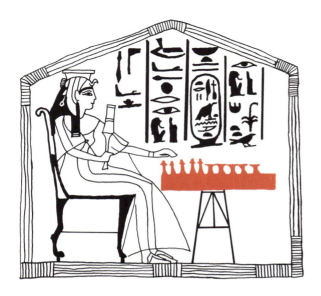

1 (Below) Lion and gazelle playing board game. Satirical Papyrus. Twentieth or Twenty-first Dynasty.

2 Nefertari before game board, tomb of Nefertari, Thebes. Nineteenth Dynasty.

3 Hieroglyph on a chest, from the tomb of Tutankhamun, Thebes. Eighteenth Dynasty.

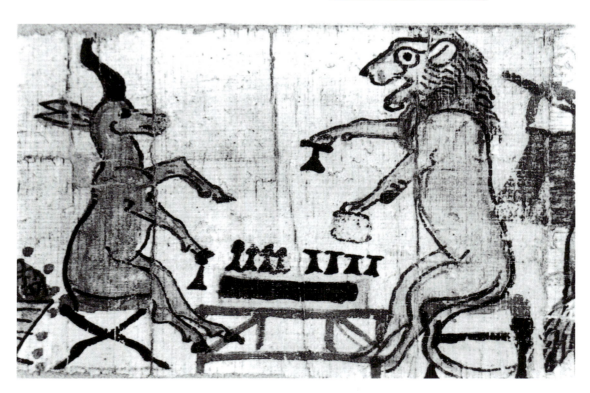

A number of board games were popular in ancient Egypt, but the game of *senet* was probably the most important in its cultural and religious significance. *Senet* is represented in Old Kingdom tomb paintings from as early as the Fifth Dynasty and continued to be popular through most of Egyptian history. The word *senet* signifies "passing" and at least in later times the game seems to have been associated with passage through the underworld.

The *senet* board consisted of thirty squares in three rows of ten, the last five squares generally bearing hieroglyphic symbols connected with the game. The two opponents each had five pawns or playing pieces (seven in the Old Kingdom) which were differentiated by their usually conical or discoid shapes and sometimes by color also. In more elaborate New Kingdom sets, pieces were sometimes made in the form of kneeling, bound captives (°A13) or adorned with the head of the protective god Bes. Often, the playing surface of the *senet* box has on its reverse a shorter – twenty square – game called *tjau* (perhaps meaning "robbers") which originated around the Seventeenth Dynasty. In both games movement of the playing pieces seems to have been determined by the use of dice-like knucklebones or by throwing sticks with differently colored sides. In **ill. 1** such a game is parodied in a satirical composition – where a lion and a gazelle match wits.

Although the rules of play are not known with certainty, the connection of the *senet* game with concepts of the afterlife is clear. In the Old and Middle Kingdoms the game was certainly a secular one, yet it is mentioned in Chapter 17 of the Book of the Dead and in other later New Kingdom religious writings. In fact, although the game continued as a popular diversion, *senet* games were probably placed in the tomb not only as a pastime for the deceased, but also in symbolic connection with the dead person's attainment of the afterlife. This is indicated by the many representations in tombs and in Book of the Dead vignettes which show the deceased playing the game without a visible opponent, as in the painting from the tomb of Queen Nefertari (**ill. 2**). It is assumed that in these cases the scenes represent a game played against the powers of the beyond, with success on the part of the deceased being equivalent to good fortune in the afterlife. In the written script, the *senet* board signified the word *men*: "to endure," and it is possible that this meaning reflects the afterlife concerns of the game.

In most two-dimensional representations of the *senet* game it will be noticed that the board is depicted in exactly the same manner as the hieroglyph – with the playing pieces shown in elevation along the top edge of the board according to the canons of Egyptian "bent" or "composite" perspective. That the pieces are not depicted on the playing surface itself may be seen in the many representations which clearly show the board's squares on what appears – according to modern perspectival systems – to be the side of the game box (**ill. 3**).

senet

Y 5

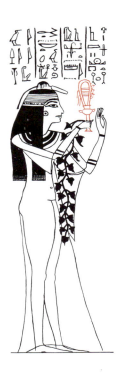

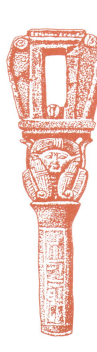

1 *Hoop sistrum, Papyrus of Anhai. Nineteenth Dynasty.*

2 *Naos sistrum. Greco-Roman Period.*

3 *Hathor Columns, Dendera, Roman Period. (From a lithograph by David Roberts.)*

4 *(Below) Block statue of the scribe Rey holding a sistraform shrine. Nineteenth Dynasty.*

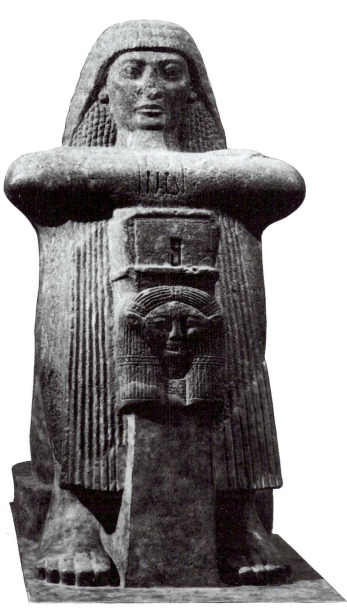

Two forms of this ceremonial instrument may be distinguished. The hooped sistrum (**ill. 1**) consisted of a handle surmounted by a simple metal hoop. Metal rods set in this hoop supported small metal disks or squares which produced a characteristic tinkling sound when the instrument was shaken. Because of its basic form, this type of sistrum was often made in the shape of the *ankh* or "life" sign (*S34), and carried that hieroglyph's significance.

The handle of the *naos* sistrum (**ill. 2**) was usually surmounted by twin heads of Hathor upon which a small shrine or *naos*-shaped box was set. Like the hoop-type instrument, rods were passed through the sides of this *naos* to form the rattle. Carved or affixed spirals framing the sides of the *naos* represented the horns of the cow-eared goddess. Both types of sistrum were associated with Hathor, however, and it is thought that the instrument may have originated in the practice of shaking bundles of papyrus (*M15) flowers (hence the onomatopoeic name *sesheshet*) with which Hathor was associated. The sound of the instrument seems to have been regarded as protective and also symbolic of divine blessing and the concept of rebirth. Another image which is associated with the sistrum – probably in connection with the concept of rebirth – is that of the serpent. *Naos*-type sistra often contain the image of one or more uraei (*I12,13), and the rods of both types of instrument were frequently bent where they projected from the hoop or *naos* in order to mirror the form of the *djet* (*R11) or serpent glyph (I10).

Although the sistrum eventually entered the cults of other deities, and especially those of Amun and Isis, it is with Hathor, her son Ihy (sometimes represented by the king) and her attendants that the instrument is associated in most representational contexts. Apart from the exceptions mentioned, the sistrum appears to have been used only by the priestesses of the cults with which it was associated, and its use – at least in certain circumstances – seems to have carried erotic or fertility connotations probably based on the mythological character of Hathor. The small gilt shrine of Tutankhamun has several scenes showing the use of sistra in this context. On the inner side of the shrine's right-hand door, for example, Queen Ankhesenamun is depicted holding a hoop-type sistrum and wearing the cow horns and solar disk of the goddess. In another scene the queen holds a *naos*-type sistrum and proffers the *menit* necklace (*S18) frequently associated with the use of sistra.

The distinctive shape of the instrument is found in many contexts ranging from minor objects of mortuary significance to the columns of temples such as the Temple of Hathor at Dendera (**ill. 3**). These columns are surmounted not only by images of the cow-eared goddess, but also – above these Hathor Heads – the form of a shrine or *naos*. Thus, in their shafts and capitals, such columns mirror the shape of the *naos* sistrum. A similar application of the motif is found in the shape of many of the small shrines which were offered to the gods by the devout (**ill. 4**).

SISTRUM

sesheshet

Y 8

GARDINER'S SIGN LIST

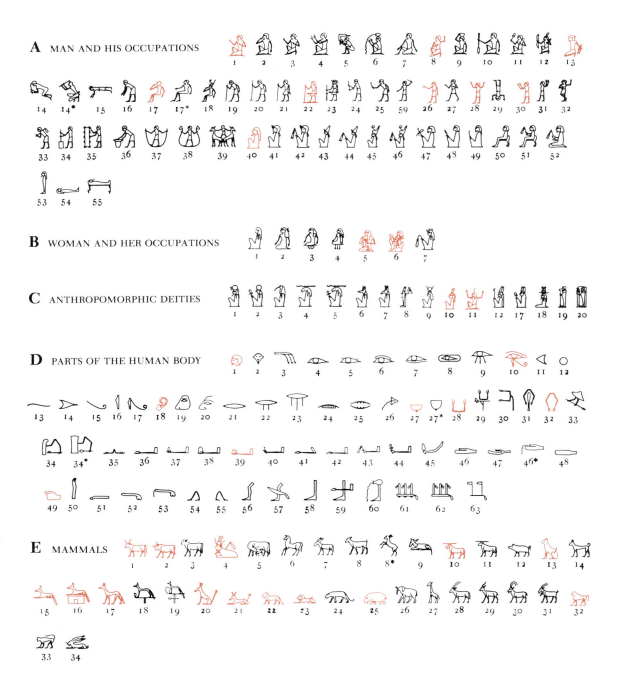

A MAN AND HIS OCCUPATIONS

1 2 3 4 5 6 7 8 9 10 11 12 13

14 14* 15 16 17 17* 18 19 20 21 22 23 24 25 59 26 27 28 29 30 31 32

33 34 35 36 37 38 39 40 41 42 43 44 45 46 47 48 49 50 51 52

53 54 55

B WOMAN AND HER OCCUPATIONS

1 2 3 4 5 6 7

C ANTHROPOMORPHIC DEITIES

1 2 3 4 5 6 7 8 9 10 11 12 17 18 19 20

D PARTS OF THE HUMAN BODY

1 2 3 4 5 6 7 8 9 10 11 12

13 14 15 16 17 18 19 20 21 22 23 24 25 26 27 27* 28 29 30 31 32 33

34 34* 35 36 37 38 39 40 41 42 43 44 45 46 47 46* 48

49 50 51 52 53 54 55 56 57 58 59 60 61 62 63

E MAMMALS

1 2 3 4 5 6 7 8 8* 9 10 11 12 13 14

15 16 17 18 19 20 21 22 23 24 25 26 27 28 29 30 31 32

33 34

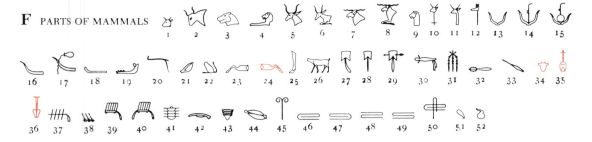

F PARTS OF MAMMALS

1 2 3 4 5 6 7 8 9 10 11 12 13 14 15

16 17 18 19 20 21 22 23 24 25 26 27 28 29 30 31 32 33 34 35

36 37 38 39 40 41 42 43 44 45 46 47 48 49 50 51 52

G BIRDS

1 2 3 4 5 6 7 7* 7** 8 9 10 11 12 13

14 15 16 17 18 19 20 21 22 23 24 25 26 26* 27 28 29 30

31 32 33 34 35 36 37 38 39 40 41 42 43 44 45 46 47 48 49

50 51 52 53 54

H PARTS OF BIRDS

1 2 3 4 5 6 6* 7 8

I AMPHIBIOUS ANIMALS, REPTILES, ETC.

1 2 3 5* 4 5 6 7 8 9

10 11 12 13 14 15

K FISHES AND PARTS OF FISHES

1 2 3 4 5 6 7

L INVERTEBRATA AND LESSER ANIMALS

1 2 3 4 5 6 7

M TREES AND PLANTS

1 2 3 4 5 6 7 8 9 10 11 12 13 14 15 16 17 18 19

20 21 22 23 24 25 26 27 28 29 30 31 32 33 34 35 36 37 38 39 40 41 42 43 44

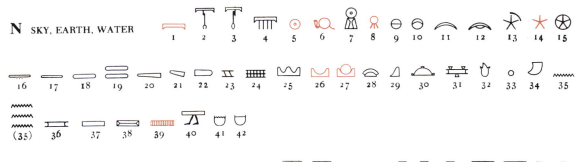

N SKY, EARTH, WATER

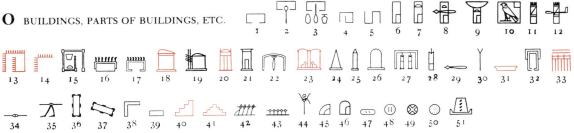

O BUILDINGS, PARTS OF BUILDINGS, ETC.

P SHIPS AND PARTS OF SHIPS

Q DOMESTIC AND FUNERARY FURNITURE

R TEMPLE FURNITURE AND SACRED EMBLEMS

S CROWNS, DRESS, STAVES, ETC.

T WARFARE, HUNTING, BUTCHERY

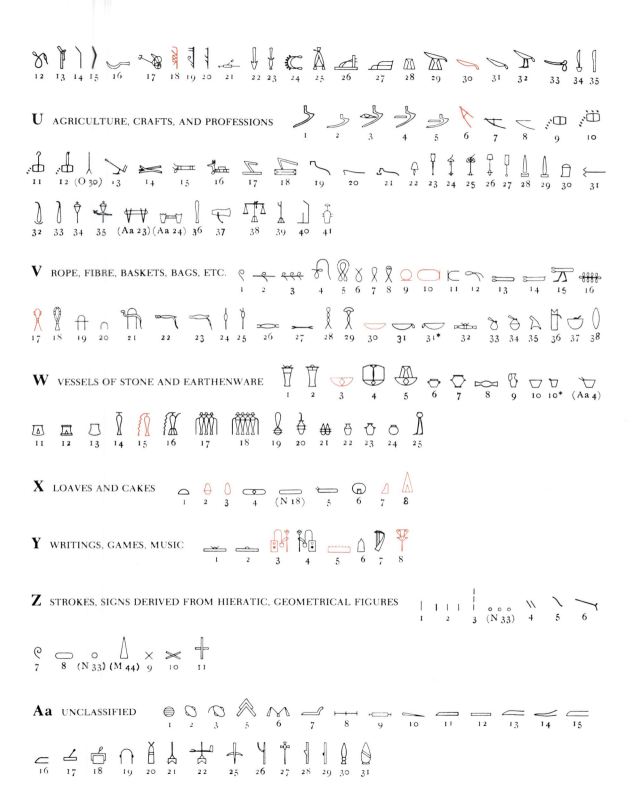

12 13 14 15 16 17 18 19 20 21 22 23 24 25 26 27 28 29 30 31 32 33 34 35

U AGRICULTURE, CRAFTS, AND PROFESSIONS

1 2 3 4 5 6 7 8 9 10

11 12 (O 30) 13 14 15 16 17 18 19 20 21 22 23 24 25 26 27 28 29 30 31

32 33 34 35 (Aa 23) (Aa 24) 36 37 38 39 40 41

V ROPE, FIBRE, BASKETS, BAGS, ETC.

1 2 3 4 5 6 7 8 9 10 11 12 13 14 15 16

17 18 19 20 21 22 23 24 25 26 27 28 29 30 31 31* 32 33 34 35 36 37 38

W VESSELS OF STONE AND EARTHENWARE

1 2 3 4 5 6 7 8 9 10 10* (Aa 4)

11 12 13 14 15 16 17 18 19 20 21 22 23 24 25

X LOAVES AND CAKES

1 2 3 4 (N 18) 5 6 7 8

Y WRITINGS, GAMES, MUSIC

1 2 3 4 5 6 7 8

Z STROKES, SIGNS DERIVED FROM HIERATIC, GEOMETRICAL FIGURES

1 2 3 (N 33) 4 5 6

7 8 (N 33) (M 44) 9 10 11

Aa UNCLASSIFIED

1 2 3 5 6 7 8 9 10 11 12 13 14 15

16 17 18 19 20 21 22 25 26 27 28 29 30 31

GLOSSARY

Afterlife The Egyptian concept of the afterlife was a complex one. While the body remained in its grave, other aspects of the person such as the *ba* moved within the realms of heaven and earth in an afterlife existence. This was not reincarnation, but a concept of the continued afterlife existence of separate aspects of the person.

Amulet A small figure of a god or object of special significance which was worn as a protective charm or placed in the wrappings of the mummy. Amulets were made in the hieroglyphic forms of deities, sacred animals, and parts of the human body, as well as religious and magical symbols.

Amun The chief god of the Theban triad (with Mut and Khonsu), Amun rose to preeminence in New Kingdom times as something close to a state deity. He is usually shown anthropomorphically, wearing a tall feathered crown. He was also depicted as a ram or a goose.

Anubis An ancient mortuary deity, Anubis is represented as a black dog or jackal-like creature, or as a human with canine head. In the New Kingdom, Anubis is frequently depicted leading the deceased to the afterlife judgment. See °E15,16.

Aten The physical disk of the sun appears to have been regarded as a variant form of the sun god in the early New Kingdom, but was briefly elevated to the status of exclusive god by the heretic pharaoh Akhenaten. See °N5,6,8.

Atum A primeval deity held to be the creator of the world according to some branches of Egyptian theology. In later periods Atum was depicted as a ram, a ram-headed hawk or an old, ram-headed man, all of which symbolized the setting sun in its evening manifestation. See °E10.

Ba Usually depicted as a human-headed bird, the *ba* represented one aspect of the human being. It was free to leave the body after death, and to return at will. See °G53.

Bes Usually portrayed as a dwarf with a large, ferocious-looking head (often crowned by feathers or with a lion-like mane), Bes in his various forms actually functioned as a friendly, protective deity associated with music, the household, and especially with the birth of children.

Book of Caverns A royal funerary composition which appears to have originated in the Nineteenth Dynasty. The Book of Caverns divides the underworld into six parts, each with various scenes describing pits or caverns over which the sun passes in its nocturnal journey. The religious focus of the accompanying texts is on the god Osiris.

Book of Gates The modern name for an Egyptian funerary work which appears in royal tombs late in the Eighteenth Dynasty. It contains a more complex and detailed view of the underworld than that of the earlier Book of That Which Is in the Underworld. The name of the composition refers to the twelve gates which divide the hours of the night and which are carefully enumerated in this work.

Book of That Which Is in the Underworld Approximate translation of the name of a royal funerary work known as the *imy-duat* (usually anglicized as "Amduat"). This work was inscribed on the walls of New Kingdom royal tombs and detailed the twelve divisions of the underworld corresponding to the twelve hours of the night. The work's main focus is upon the journey of the sun through these underworld regions and its resultant rebirth.

Book of the Dead In reality, a collection of spells, many descended from the Coffin Texts and Pyramid Texts, which were used by commoners (as well as by some kings) during the New Kingdom. Personally inscribed papyrus rolls contained one of the many versions of this collection of spells with the deceased's name inserted in the text at certain points. The papyrus rolls often include painted vignettes illustrating various mythical and religious concepts. Examples are the Papyri of Ani, Anhai, and Nakht.

Coffin Texts A collection of magic spells, many of which were descended from the Pyramid Texts and which were inscribed on the coffins of nobles and commoners during the Middle Kingdom Period. These texts formed in turn the basis for many of the spells incorporated in the Book of the Dead in the New Kingdom.

Creation legends Rather than one widespread story of creation, differing accounts of creation – such as the Hermopolitan legends – existed in various parts of Egypt. Each account usually gave prominence to the deity of the area of its origin.

First Time The time when the world came into being. The "First Time" represents the Egyptian concept of the primeval age – the details, however, would be envisaged according to the various stories of creation.

Geb Primeval earth deity, viewed as one of the progenitors of the gods togther with his wife Nut, goddess of the heavens. Although Geb was not an important god in the worship of the ancient Egyptians, he frequently appears in Egyptian art, usually in the form of a man with a goose atop his head.

Hathor Ancient mother goddess whose name means "House of Horus," relating to her protective maternal role. Conversely, as the "Eye of Re" she could manifest a violently destructive aspect. Hathor also became associated with the west and was thus an important deity in many scenes relating to the afterlife. Often portrayed as a cow or a cow-headed woman, Hathor merges with Isis in the later periods of Egyptian art. See °E4.

Hermopolitan Legend According to the theologians of Hermopolis, the creation of the world occurred when the young sun god emerged from either an egg on a mound of earth which rose from the primeval waters, or from a lotus blossom which floated upon the water's surface. The latter motif is especially common in Egyptian art.

Horus Originally a falcon god of the sky, Horus became associated with the role of the king in early Egyptian history. Later he was connected with Osiris as the son (by Isis) and avenger of that god, a mythological association which further strengthened his relation to the living king just as Osiris was associated with the

deceased king. After the Old Kingdom, Horus is usually depicted as a hawk-headed man. See °G5.

Horus Name The oldest, and one of the most important, of the Egyptian king's official names or titles. This name associated the king with the god Horus and the mythological basis for the rightful succession to the throne. The Horus name was written in a device called the *serekh*. See °O33.

Isis The wife of Osiris and mother of Horus, Isis is usually depicted as a woman with the hieroglyph for "throne" on her head, though she may appear in other forms and was closely associated with a number of goddesses such as Hathor. In Egyptian art Isis is often depicted mourning her deceased husband Osiris or nursing their son Horus. She is also shown protecting the sun god on his nightly journey through the underworld. See °B5,6 and °B8.

Ka One form or aspect of the human "soul," the *ka*, was viewed by the Egyptians as a kind of spiritual double which continued to exist after death. Intimately related to the concepts of nourishment and strength, the *ka* received the offerings given to the deceased. See °D28.

Khepri The name Khepri is related to the Egyptian word for "to come into being," and the god was regarded as the morning manifestation of the sun. Usually depicted as a scarab beetle, Khepri was also sometimes drawn as a human with scarab head. See °L1.

Litany of Re New Kingdom royal funerary composition originating in the Eighteenth Dynasty, and perhaps contemporaneously with the Book of That Which Is in the Underworld. The Litany of the Sun, as it is sometimes called, acclaims the sun god Re under seventy-five different forms and also praises the king in the form of different deities, especially as the sun god.

Maat Goddess of Order, Truth and Judgment, Maat is almost invariably depicted in Egyptian art as a woman, with her symbol – a tall feather – on her head. See °C10.

Mastaba A type of tomb common in the Old Kingdom, the mastaba (Arabic for "bench") is a flat, rectangular structure built above the actual burial, and often containing a small offering room or chapel.

Neith A primeval (and sometimes androgynous) deity worshipped from very early times, Neith became a goddess of war, and also a protector of the dead. Along with Isis, Nephthys, and Selket she is often depicted guarding New Kingdom burial chests, coffins and sarcophagi.

Nephthys Recognized by a rectangular hieroglyph surmounted by another bowl-shaped sign worn on her head, Nephthys was the sister of Seth and Isis. Her role was largely protective and she is often depicted at the head of the deceased Osiris while Isis guards his feet. With Isis, Neith and Selket she protects the body of the deceased; and like Isis, she is also sometimes shown protecting the sun god Re.

Nut Goddess of the heavens, Nut was an ancient deity who daily gave birth to and reabsorbed the sun. She is portrayed as a woman arching over the body of her husband, the earth god Geb, and also on the underside of the lids of many sarcophagi, for she received the dead into herself just as she received the evening sun. See °N1.

Osiris Supreme underworld god, Osiris was also closely related to the institution of kingship. As the deity who died only to return to life, he represented not only the cycle of nature, but also all who had died, and especially the deceased king who was replaced by his son Horus – the living monarch. Anthropomorphically, Osiris is depicted as a mummiform man with a crown and the crook and flail of kingship. He was also associated with the *djed* pillar (°R11) and was frequently shown in that form.

Papyrus of Anhai Funerary papyrus containing the illustrated Book of the Dead of the chief concubine and chantress of Amun, Anhai. Twentieth Dynasty, *c.* 1100 BC.

Papyrus of Ani Funerary papyrus containing the illustrated Book of the Dead of the royal scribe Ani. Nineteenth Dynasty, *c.* 1250 BC. This papyrus is especially complete.

Papyrus of Nakht Funerary papyrus containing the illustrated Book of the Dead of the royal scribe and military officer Nakht. Eighteenth to Nineteenth Dynasties, *c.* 1350–1300 BC.

Prenomen The first of the Egyptian king's two cartouche names (see °V10). The prenomen was adopted at the time of the king's accession and is often called the "Throne Name." Usually the prenomen includes the name of the god Re.

Primeval Hill This was the first earth which rose from the primeval waters at the time of creation and upon which, in turn, life appeared. Central to Egyptian mythological concepts of creation, the primeval hill was reflected in the design of some Egyptian temples, and symbolically in funerary depictions of burial mounds.

Ptah Worshipped at Memphis as an ancient creator god, Ptah was also the patron deity of craftsmen and in the Later Period became a member of the important composite deity Ptah-Sokar-Osiris. Represented as a mummiform man, Ptah usually holds a composite scepter before him.

Pyramid Texts The oldest body of religious writings in the world, these texts were inscribed on the inner passages and chambers of the royal pyramids of the kings of the Fifth and Sixth Dynasties. They include even older texts which were arranged with newer material for this special use. The purpose of the texts was to ensure the successful passage of the deceased king into the afterlife, a theme which was later continued in the Coffin Texts and the so-called Book of the Dead for other members of society. The Pyramid Texts are conveniently divided into a number of sections known as spells.

Re As the primary manifestation of the sun god, Re was worshipped at Heliopolis and soon rose to national significance. Thus, from the Fourth Dynasty the Egyptian king was regarded as the manifest son of this god. When Amun became the most important god in the Middle Kingdom, Re was fused with him as the composite Amun-Re. Re was usually depicted as a hawk-headed human, though he may also be represented by the disk of the sun itself. See °N5,6,8.

Sed Festival From very early times Egyptian kings held a jubilee festival after thirty years of reign. This event was then repeated at shorter intervals (often about every three years) thereafter. The *sed* festival involved a ritual re-coronation and various other activities aimed at rejuvenating the king and reestablishing his rulership.

Seth God of violence and confusion, Seth personified the harsh desert lands as opposed to the fertile valley of the Nile represented by Osiris, whom he killed. As the relative of Horus, Seth also represented the domain

of Upper Egypt as opposed to the Lower, northern region of the land; and the Egyptian king thus united the offices of Horus and Seth in his own rule. Revered in the Second Intermediate Period, Seth later became unpopular only to rise to importance again as patron of the Ramesside kings (hence the name Seti). Seth is portrayed as a fabulous creature or as a human with the creature's long curved head. See °E20,21.

Stele Inscribed, upright stones were used as boundary markers, to celebrate victories, to honor gods, and for many other purposes. The most common type, however, was the funerary stele which often depicted the deceased in the presence of one or more deities, and which listed offerings and provisions which would provide sustenance in the afterlife.

Throne Name The chief title given to the Egyptian king at his accession as distinct from his birth name. While modern books refer to Egyptian kings by their birth names – e.g., Tutankhamun – the Egyptians themselves referred to their monarchs by means of the throne names – e.g., for Tutankhamun, "Nebkheperure." See °V10.

Underworld The ancient Egyptians imagined the underworld as an area directly beneath the earth which was in many respects a mirror image of the world of day. The sun entered this underworld each night and followed a riverine course until it rose from the eastern horizon at dawn. The underworld was peopled with both the dead and a myriad of divine beings.

Underworld Books Modern name given to the whole genre of royal funerary compositions which were used in the New Kingdom. Unlike the Pyramid and Coffin Texts and the Book of the Dead – which were composed from various sources – these works were produced at specific times. The category includes the Book of That Which Is in the Underworld, the Book of Gates, the Book of Caverns, and another work known as the Book of the Earth.

FURTHER READING

BASIC BIBLIOGRAPHY

The following books are suggested for further reading on Egyptian art and hieroglyphs – mainly at an introductory level.

Egyptian Hieroglyphs

Sir Alan Gardiner, *Egyptian Grammar* (Oxford, 3rd ed. 1982). The standard English work on hieroglyphs, the *Grammar* is technical but contains a number of very readable essays on various aspects of Egyptian culture and language.
W.V. Davies, *Egyptian Hieroglyphs* (London/Berkeley, 1987) gives a brief but excellent introduction to the subject.
B. Watterson, *Introducing Egyptian Hieroglyphs* (Edinburgh, 1986); and *More About Egyptian Hieroglyphs* (Edinburgh, 1987). These books provide a clear and relatively simple introduction to Egyptian writing and grammar.
H. Fisher, *Ancient Egyptian Calligraphy: A Beginner's Guide to Writing Hieroglyphs* (New York, 1983) is an excellent introduction to the origins of many hieroglyphs, as well as providing guidance in drawing them.
W. Schenkel, "The structure of hieroglyphic script," *Royal Anthropological Institute News*, 15 (1976) 4–7. A short formal study which summarizes how the Egyptian system of writing functioned.

Egyptian Art

H. Schäfer, *Principles of Egyptian Art* (Oxford, trans. by John Baines, 1974) is a technical yet fascinating study of how Egyptian art functioned.
The following are less technical:
Cyril Aldred, *Egyptian Art* (London and New York, 1980). An excellent illustrated survey.
T.G.H. James and W.V. Davies, *Egyptian Sculpture* (Cambridge, MA, 1983).
T.G.H. James, *Egyptian Painting* (Cambridge, MA, 1985).

W.S. Smith, *Art and Architecture of Ancient Egypt*, rev. by W.K. Simpson, 2nd ed. (New York, 1981), an excellent historical survey.

SPECIALIZED BIBLIOGRAPHY

This section provides specialized references for further study. *Lexikon der Ägyptologie* (*LÄ*) articles are cited for general bibliographic reference, and where possible, detailed studies are also listed which discuss the use of the specific hieroglyphs in Egyptian art.
 The following abbreviations are utilized for Egyptological journals, series, and works which are frequently cited:

ÄA	*Ägyptologische Abhandlung*, Wiesbaden
ÄF	*Ägyptologische Forschungen*, Glückstadt, Hamburg, New York
BSAE	*British School of Archaeology in Egypt*, London
HÄB	*Hildesheimer Ägyptologische Beitrage*, Hildesheim
JANES	*Journal of the Ancient Near Eastern Society*, New York
JARCE	*Journal of the American Research Center in Egypt*, New York
JEA	*Journal of Egyptian Archaeology*, London
JNES	*Journal of Near Eastern Studies*, Chicago
JSSEA	*Journal of the Society for the Study of Egyptian Antiquities*, Toronto
LÄ	*Lexikon der Ägyptologie*, I–VI (Wiesbaden, 1975–86)
MÄS	*Münchner Ägyptologische Studien*, Munich
MDAIK	*Mittelungen des Deutschen Archäologischen Institutes, Abteilung Kairo*, Cairo
MIE	*Memoires de l'Institut d'Egypte*, Cairo
PÄ	*Probleme der Ägyptologie*, Leiden
Piankoff	*Mythological Papyri* (New York, 1957)
RdE	*Revue d'Égyptologie*, Cairo

SAK *Studien zur Altägyptischen Kultur*, Hamburg
VA *Varia Aegyptiaca*, San Antonio
ZÄS *Zeitschrift für ägyptische Sprache und Altertumskunde*, Leipzig, Berlin

A 1 SEATED MAN G. D. Scott, *The Scribal Statue and Related Statues in Ancient Egyptian Sculpture*. Ph.D. dissertation (New Haven, 1989). **A 8 PRAISE** Jorge R. Ogdon, "Observations on a Ritual Gesture, After Some Old Kingdom Reliefs," *JSSEA* X.1 (1979), 71–6. **A 13 BOUND CAPTIVE** Dieter Wildung, "Feindsymbolik," *LÄ* II, 146–8. **A 17 CHILD** Erika Feucht, "Kind," *LÄ* III, 424–37. **A 22 STATUE** Marianne Eaton-Krauss, "The Representations of Statuary in Private Tombs of the Old Kingdom," *ÄA* 39 (1984). **A 26 SUMMON, A 28 REJOICE, A 30 ADORE** Emma Brunner-Traut, "Gesten," *LÄ* II, 573–585. **A 40 SEATED GOD** B. Hornemann, *Types of Ancient Egyptian Statuary*, I–VII (Copenhagen, 1951–1969). **B 5, 6 WOMAN NURSING CHILD** Reingart Unger, *Die Mutter mit dem Kinde in Ägypten*, Ph.D. dissertation (Leipzig, 1957). Lucia Langener, *Isis lactans-Maria lactans: Untersuchungen zur koptischen Ikonographie*. Ph.D. dissertation (Münster, forthcoming). **B8 MOURNING WOMAN** Erich Lüddeckens, "Untersuchungen über religiösen Gehalt, Sprache und Form der ägyptischen Totenklagen," *MDAIK* 11 (1943). **C 10 MAAT** Emily Teeter, *The Presentation of Maat: The Iconography and Theology of an Ancient Egyptian Offering Ritual*, Ph.D. dissertation (Chicago, 1990). **C 11 HEH** J. F. Bourghouts, "Heh, Darreichen des," (in English) *LÄ* II, 1084–6. **D1 HEAD** E. Russmann, *Egyptian Sculpture: Cairo and Luxor* (Austin, 1989), 19–21, 214 n. 5. **D 10 WEDJAT EYE** C. Müller-Winkler, "Udjatauge," *LÄ* VI, 824–6. **D 18 EAR** Lothar Störk, "Ohr," *LÄ* IV, 562–6. **D 27 BREAST** J. Baines, *Fecundity Figures: Egyptian Personification and the Iconology of a Genre* (Chicago and Warminster, 1985). R. Bianchi, *Cleopatra's Egypt: Age of the Ptolemies* (Brooklyn, 1988), 217. **D 28 KA** P. Kaplony, "Ka," *LÄ* III, 275–82. L. Bell, "Luxor Temple and the Cult of the Royal *Ka*," *JNES* 44 (1985), 251–94. **D 32 EMBRACE** H. Beinlich, "Umarmung," *LÄ* VI, 843–5. **D 39 OFFER** A. Moret, "Du sacrifice en Egypte," in *Revue de l'histoire des religions* 57 (1908), 81ff. **D 49 CLENCHED HAND** C. Sourdive, *La Main dans l'Egypte Pharaonique* (Berne, 1984). **E 1, 2 BULL** L. Störk, "Rind," *LÄ* V, 257–63. **E 4 DIVINE COW** L. Störk, "Rind," *LÄ* V, 257–63. E. Hornung, *Der ägyptische Mythos von der Himmelskuh* (Freiburg and Göttingen, 1982). **E 10 RAM** P. Behrens, "Widder," *LÄ* VI, 1243–9. **E 13 CAT** L. Störk, "Katz," *LÄ* III, 367–70. **E 15, 16 ANUBIS ANIMAL** M. Lurker, "Hund und Wolf in ihrer Beziehung zum Tode," *Antaios* 10 (1969), 199–216. **E20, 21 SETH ANIMAL** Herman te Velde, *Seth, God of Confusion* (Leiden, 2nd ed., 1977) **E 22, 23 LION** Ursula Schweitzer, *Löwe und Sphinx im Alten Ägypten*, AF 15 (1948). Constant de Wit, *Le rôle et le sens du lion dans l'Egypte ancienne* (Leiden, 1951). **E 25 HIPPOPOTAMUS** Torgny Säve-Söderbergh, "On Egyptian Representations of Hippopotamus Hunting as a Religious Motive," *Horae Soederblomianae* 3 (Uppsala, 1953). **E 32 BABOON** L. Störk, "Pavian," *LÄ* IV, 915–20. **F 24 FORELEG OF OX** Craig C. Dochniak, "The *Hps* Hieroglyph as a Module in Egyptian Art and the Subsequent Implications of Its Use," *VA* 5:2–3 (1989), 97–102. **F 34 HEART** H. Brunner, *Das Herz im Umkreis des Glaubens* (Biberach, 1965). **F 35 NEFER** H. G.

Fischer, *Ancient Egyptian Calligraphy* (New York, 1983), 25. **F 36 UNION** E. Feucht, "Vereinigung beider Länder," *LÄ* VI, 974–6. **G5–G48** Patrick F. Houlihan, *The Birds of Ancient Egypt* (Warminster, 1986): **G5 FALCON** 46–9, **G 14 VULTURE** 39–43, **G 24 LAPWING** 93–5, **G 26 IBIS** 26–32, **G 31, 32 HERON** 13–16, **G 36 SWALLOW** 122–3, **G 39, 40, 41 PINTAIL DUCK** 71–3, **G 48 NEST** passim. **G 53 BA** Louis V. Žabkar, *A Study of the Ba Concept in Ancient Egyptian Texts* (Chicago, 1968). **H 5 WING** A. Gardiner, "Horus the Behdetite," *JEA* 30 (1944), 46–53. Dieter Wildung, "Flügelsonne," *LÄ* II, 277–9. **H 6 FEATHER** J. Grumach-Shirun, "Federn und Federkrone," *LÄ* II, 142–5. **I 3, 4, 5 CROCODILE** E. Brunner-Traut, "Krokodil," *LÄ* III, 791–811. L. Kákosy, "Krokodilskulte," *LÄ* III, 781–811. **I 7 FROG** L. Kákosy, "Frosch," *LÄ* II, 334–6. **I 12, 13 COBRA** K. Martin, "Uräus," *LÄ* VI, 864–8. S. B. Johnson, *The Cobra Goddess of Ancient Egypt* (London, 1990). **K1 BULTI FISH** I. Gamer-Wallert, "Fische, religiös," *LÄ* II, 228–234. D. J. Brewer and R. F. Friedman, *Fish and Fishing in Ancient Egypt* (Warminster, 1989), 77–9. **L 1 SCARAB BEETLE** R. Giveon, "Skarabäus," *LÄ* V. 968–81. **L 2 BEE** J. Leclant, "Biene," *LÄ* I, 786–9. **M 1 TREE** M. L. Buhl, "The Goddesses of the Egyptian Tree Cult," *JNES* 6 (1947), 80–97. E. Hermsen, *Lebensbaumsymbolik im alten Ägypten: Eine Untersuchung* (Cologne, 1981). **M 4 PALM BRANCH** I. Wallert, *Die Palmen im Alten Ägypten, Eine Untersuchung ihrer praktischen, symbolischen und religiosen Bedeutung*, *MÄS* 1 (1962). **M 9 LOTUS** H. Schlögl, *Der Sonnengott auf der Blüte*, Aegyptiaca Helvetica 5 (Basel, 1977). J. Dittmar, *Blumen und Blumensträusse als Opfergabe im alten Aegypten*, *MÄS* 43 (1986). W. Harer, "Nymphaea: Sacred Narcotic Lotus of Ancient Egypt," *JSSEA* 14 (1984), 100–2. **M 15, 16 PAPYRUS CLUMP** P. Montet, "Hathor et le papyrus," *Kémi* 14 (1957), 92–101. Rosemarie Drenkhahn, "Papyrus," *LÄ* IV, 667–70. **M20 FIELD** H. Altenmüller, "Feld," *LÄ* II, 148–50. L. Lesko, "The Field of Hetep in Egyptian Coffin Texts," *JARCE* IX (1971–2), 89–101. **N 1 SKY** Erik Hornung, "Himmelsvorstellungen," *LÄ* II, 1215–18. **N 5, 6, 8 SUN** H. Schäfer, "Altägyptische Bilder der auf-und untergehenden Sonne," *ZÄS* 71 (1935), 15ff. D. B. Redford, "The Sun-disc in Akhenaten's Program: Its Worship and Antecedents," I, *JARCE* XIII (1976), 47–61; II, XVII (1980), 21–38. J. Assmann, "Sonnengott," *LÄ* V, 1087–94. **N 14 STAR** O. Neugebauer, R. Parker, *Egyptian Astronomical Texts*, 3 vol., plates (Providence, 1969). H. Beinlich, "Stern," *LÄ* VI, 11–14. **N 26 MOUNTAIN** E. Otto, "Bachu," *LÄ* I, 594. D. Kurth, "Manu," *LÄ* III, 1185–6. **N 27 HORIZON** J. Assmann, "Horizont," *LÄ* III, 3–7. **N 39 POOL** B. Gessler-Löhr, "Die heiligen Seen ägyptischer Tempel," *HÄB* 21 (1983). **O 13, 14 GATEWAY** H. Brunner, "Die Rolle von Tür und Tor im Alten Ägypten," *Symbolen* N.F. 6 (1982), 37–52. —, "Tür und Tor," *LÄ* VI, 778–87. **O 18 UPPER EGYPTIAN SHRINE** A. Piankoff, *The Shrines of Tut-Ankh-Amon* (New York, 1955), 69–91. **O 20 LOWER EGYPTIAN SHRINE** A. Piankoff, *The Shrines of Tut-Ankh-Amon* (New York, 1955), 45–68. **O 23 JUBILEE PAVILION** C. J. Bleeker, "Egyptian Festivals," *Studies in the History of Religions* 13 (Leiden, 1967), 96–123. K. Martin, "Sedfest," *LÄ* V, 782–90. **O 31 DOOR** H. Brunner, "Die Rolle von Tür und Tor im alten Ägypten," *Symbolen* N.F. 6 (1982), 37–52. —, "Tür und Tor," *LÄ* VI, 778–87. **O 33 PALACE WALL** R. Wilkinson, "The

Horus Names and the Form and Significance of the Serekh in the Royal Egyptian Inscriptions," *JSSEA* XV:3 (1987), 98–104. **O 40 STAIRWAY** W. Helck, "Treppe," *LÄ* VI, 757–8. **P 3 BARQUE** S. R. Glanville and R. O. Faulkner, *Wooden Model Boats. Catalogue of Egyptian Antiquities in the British Museum* II (Oxford, 1972). K. A. Kitchen, "Barke," (in English), *LÄ* I, 619–25. **P 5 SAIL** D. Kurth, "Luft," *LÄ* III, 1098–1101. **P 10 STEERING OAR** W. Decker, "Rudern," *LÄ* V, 314–15. **Q 4 HEADREST** W. F. Petrie, *Objects of Daily Use* (London, 1927), 33–6. H. G. Fischer, "Kopfstütze," (in English) *LÄ* III, 686–93. **Q7 FIRE** E. Hornung, "Altägyptische Höllenvorstellungen," *Abhandlungen der Sachsischen Akademie der Wissenschaften zu Leipzig* 59.3 (1968), 21ff. **R 4 LOAF AND OFFERING MAT** H. Altenmüller, "Opfer," *LÄ* IV, 579–84. **R 11 DJED COLUMN** H. Altenmüller, "Djed-Pfeiler," *LÄ* I, 1100–05. J. van der Vliet, "Raising the Djed: A *rite de marge*," *Akten des Vierten Internationalen Ägyptologen Kongresses* (Hamburg, 1985), 405–13. **R 13, 14 THE WEST** K. Sethe, "Die ägyptische Ausdrücke für rechts und links und die Hieroglyphen-zeichen für Westen und Osten," *Nachrichten von der Gesellschaft der Wissenschaften zu Göttingen* (1922), 2ff. **R 17 FETISH OF ABYDOS** E. Otto, "Abydos-Fetisch," *LÄ* I, 47–8. H. E. Winlock, *Bas-Reliefs from the Temple of Ramesses I at Abydos* (New York, 1921), Fig. 1. **S 12 GOLD** Lothar Störk, "Gold," *LÄ* II, 725–31. J. van Lepp, "The Role of Dance in Funerary Ritual in the Old Kingdom," *Akten des Vierten Internationalen Ägyptologen Kongresses* (Hamburg, 1985), 385–94. **S 18 MENIT NECKLACE** E. Staehelin, "Menit," *LÄ* IV, 52–3. **S 27 CLOTHING** E. Strouhal, "Tracht," *LÄ* VI, 726–37. **S 34 ANKH** J. Baines, "*Ankh Sign, Belt and Penis Sheath*," *SAK* 3 (1975), 1–24. P. Derchain, "Anchzeichen," *LÄ* I, 268–

9. **S 35 FAN, SUNSHADE** H. G. Fischer, "Fächer und Wedel," (in English) *LÄ* II, 81–5. **S 40 WAS SCEPTER** K. Martin, "Was-Zepter," *LÄ* VI, 1152–4. **S 42 SEKHEM SCEPTER** W. Barta, "Sechem," *LÄ* V, 772–6. **T 10 BOW** R. Wilkinson, "The Representation of the Bow in the Art of Ancient Egypt and the Near East," *JANES* 20 (1991), 83–100. —, "The Turned Bow in Egyptian Iconography," *VA* 4:2 (1988), 181–7. — "The Turned Bow as a Gesture of Surrender in Egyptian Art," *JSSEA* XVII. 4 (1987), 128–33. **T 18 FOLLOWER SIGN** W. Helck, "Hinrichtungsgerät," *LÄ* II, 1219. **T 30 KNIFE** W. Helck, "Messer," *LÄ* IV, 109–13. **U 6 HOE** E. Eggebrecht, "Hacke," *LÄ* II, 924–5. W. F. Petrie, *Tools and Weapons* BSAE 30 (London, 1917), 18ff. **V 9 SHEN RING** C. Müller-Winkler, "Schen-Ring," *LÄ* V, 577–9. *V 10 CARTOUCHE* P. Kaplony, "Königsring," *LÄ* III, 610–26. **V 17 PROTECTION** H. G. Fischer, *Ancient Egyptian Calligraphy* (New York, 1983), p. 48. **V 30 BASKET** I. Grumach-Shirun, "Korb," *LÄ* III, 740–1. **V 39 ISIS KNOT** W. Westendorf, "Isis Knoten," *LÄ* III, 204. **W 3 ALABASTER BOWL** W. Helck, "Alabaster," *LÄ* I, 129–30. **W 15 WATER JAR** D. Arnold, "Gefässe," *LÄ* II, 483–501. **X 2 BREAD LOAF** R. Drenkhahn, "Brot," *LÄ* I, 871. **Y 3 SCRIBE'S OUTFIT** M. Weber, *Beitrage zür kenntnis des Schrift und Buchwesens der alten Ägypter*, Ph.D. dissertation (Cologne, 1969), 27–58. **Y 5 BOARD GAME** T. Kendall, *Passing Through the Netherworld: The Meaning and Play of Senet* (Belmont, Mass., 1978). E. B. Pusch. *Das Senet Brettspiel im alten Ägypten*, MÄS 38 (Berlin, 1979). P. Piccione. *The Historical Development of the Game of Senet and Its Significance for Egyptian Religion*, Ph.D. dissertation (Chicago, 1990). **Y 8 SISTRUM** C. Ziegler, *Catalogue des instruments de musique égyptiens* (Paris, 1979), 31–40. —, "Sistrum," *LÄ* V, 959–63.

LOCATIONS OF ILLUSTRATED OBJECTS

The following abbreviations have been used in this list: BM = British Museum, London; EC = Egyptian Museum, Cairo; MFA = Museum of Fine Arts, Boston; MMA = Metropolitan Museum of Art, New York.

A 1 SEATED MAN 2 EC, No. JE 30272 = CG36. **3** EC, No. JE53150. **A 13 BOUND CAPTIVE 1** MMA, No. 47.2 **2** EC, Carter No. 90. **A 17 CHILD 2** National Museum of Scotland, Edinburgh, No. A1956.1485. **3** EC, Piankoff No. 133. **4** EC, No. JE64735. **A 22 STATUE 1** MFA, No. 04.1780. **2** MFA, No. 25.659. **A 26 SUMMON 1** MFA, No. 1981.2. **A 28 REJOICE 1** Kunsthistorisches Museum, Vienna, No. 3959. **A 30 ADORE 1** BM, No. 10472. **2** Rijksmuseum van Oudheden, Leiden, No. T2. **3** MMA, No. 38.5. **A 40 SEATED GOD 2** Metropolitan Museum of New York, New York, No. 25.3.31. **3** University Museum, Philadelphia, No. 9217 (neg. no. S8-32891).
B 5, 6 WOMAN NURSING CHILD 1 Ägyptisches Museum, Staatliche Museen Preussischer Kulturbesitz, Berlin. **2** The Brooklyn Museum, Brooklyn, No. 39.119.

B 8 MOURNING WOMAN 1 BM, No. 10554. **3** BM, No. 10470. **4** MFA, No. 72.4127.
C 10 MAAT 1 Louvre, Paris, No. E4436. **4** Louvre, Paris, No. E.17401. **5** BM, No. 10558. **C 11 HEH 2** EC, No. JE 66708.
D 1 HEAD 1 EC, No. JE32169 = CG14716. **2** BM, No. 10470. **3** MFA, No. 72.590-93. **4** EC, No. CG1320. **D 10 WEDJAT EYE 1** EC, Carter No. 256vvv. **2** EC, No. JE61884. **3** MFA, No. 03.1631. **D 18 EAR 4** BM, No. 1466. **D 27 BREAST 3** Greco-Roman Museum, Alexandria, No. 25783. **D 28 KA 1** MMA, No. 19.2.16. **2** EC, No. JE30948 = CG259. **D 32 EMBRACE 1** BM, No. 2292. **2** BM, No. 10009. **D 39 OFFER 1** MMA, No. 1972.125. **3** Petrie Museum, University College, London, No. L82 UC 30132. **D 49 CLENCHED HAND 1** Louvre, Paris, No. E11255.
E 1, 2 BULL 2 Soane's Museum, London. **3** BM, No. 37448. **4** EC, No. JE32169 = CG14716. **E 4 DIVINE COW 1** BM, No. 9901. **2** Louvre, Paris, No. 3287. **E 10 RAM 1** EC, Piankoff No. 11. **3** EC, Provisional No. 23-2-22-1. **E 13 CAT 2** BM, No. 64391. **3** EC, No. CG51113.

E 15, 16 ANUBIS ANIMAL 1 EC, No. CG40017. 3 EC, No. JE61444. E 20, 21 SETH ANIMAL 2 Myers Museum, Eton College, Windsor, No. 832. 3 EC, No. JE6189. 4 EC, No. CG42993. E 22, 23 LION 2 Louvre, Paris, No. A23. 3 MMA, No. 25.3.31. 4 EC, No. JE62020. E 25 HIPPOPOTAMUS 2 MMA, New York, No. 17.9.1. 3 EC, Carter No. 137. E 32 BABOON 1 EC, No. 59291. 2 MMA, No. 30331. 4 BM, No. 10470. 5 Walters Art Gallery, Baltimore, No. 48.475.
F 24 FORELEG OF OX 1 University Museum, Philadelphia, No. 40.19.1 (neg. no. S8-31269). F 34 HEART 1 BM, No. 10470. 2 MFA, No. 72.769. 3 EC. 4EC, No. JE31113. F 35 NEFER 1 EC, No. JE31413 = CG600. F 36 UNION 2 MFA, No. 09.202. 4 EC, No. JE62114.
G 5 FALCON 1 EC, No. JE6189. 3 EC, No. JE10062 = CG14. 4 MMA, No. 34.2.1. G 14 VULTURE 1 EC, No. 14724. G 24 LAPWING 1 EC, No. JE6009. 2 EC, No. JE33968. 4 EC, No. JE61481. G 26 IBIS 2 Seattle Art Museum, Seattle, No. 65.141. 3 Kestener Museum, Hanover, No. 1957.83. G 31, 32 HERON 2 BM, No. 10471. 4 EC, No. JE6189. G 36 SWALLOW 1 EC, Piankoff No. 22. 3 Museo Egizio, Turin, No. 1591. G 39, 40 41 PINTAIL DUCK 1 EC, No. CG14480. G48 NEST 1 EC, No. 61481. 3 EC, No. CG1300. G 53 BA 2 Louvre, Paris, No. N3276.
H 5 WING 1 EC. 2 Seattle Art Museum, Seattle, No. 48.224. 3 EC, No. 11. H 6 FEATHER 2 Kunsthistorisches Museum, Vienna, No. 3859. 3 EC, Piankoff No. 6.
I 3, 4, 5 CROCODILE 1 Ägyptisches Museum, Staatliche Museen Preussischer Kulturbesitz, Berlin. 3 Staatliche Museen zu Berlin, Ägyptisches Museum, Berlin, No. 16953. 4 BM, No. 37450. I 7 FROG 1 MMA, No. 22.1.154. 3 National Museum of Sudan, Khartoum. I 12, 13 COBRA 5 The Brooklyn Museum, Brooklyn, No. 67.68.
K 1 BULTI FISH 1 EC, No. JE38642. 2 EC, No. JE25226. 3 EC, JE63672.
L 1 SCARAB BEETLE 1 EC.
M 1 TREE 3 Kestner Museum, Hanover, No. 2933. M 4 PALM BRANCH 1 EC, No. JE6189. 2 EC, No. 61481. 3 EC, No. 1320. M 9 LOTUS 1 EC, No. JE60723 = CG755. 3 EC, No. 62112. M 15, 16 PAPYRUS CLUMP 1 Louvre, Paris, No. N3663. 2 EC, Carter No. 108. 3 EC, Carter No. 108. 4 EC, No. JE31113. M 20 FIELD 2 EC, No. 22182. 3 MMA, No. 14.2.7.
N 1 SKY 2 BM, No. 10554. 4 EC, Piankoff No. 10. N 5, 6, 8 SUN 1 Kunsthistorisches Museum, Vienna, No. 3959. 2 Louvre, Paris, No. N3663. 3 EC, Piankoff No. 20. N 14 STAR 2 EC, No. JE6337B. N 26 MOUNTAIN 1 EC, No. 6016. 2 MMA, No. 11.150. N 27 HORIZON 1 BM, No. 8300. N 39 POOL 3 BM, No. 9901. 4 EC, Piankoff No. 4,5.
O 18 UPPER EGYPTIAN SHRINE 2 EC, No. JE61481. 3 EC, No. 37406. 4 BM, No. 10470. O 20 LOWER EGYPTIAN SHRINE 1 EC, No. 1319. 2 BM, London, No. 10470. 3 EC, No. 27296. 4 Soane's Museum, London. O 23 JUBILEE PAVILION 1 Ashmolean Museum, Oxford, No. E3632. 2 EC, No. JE6189. O 33 PALACE WALL 1 Louvre, Paris, No. E.11007. 2 EC, No. JE35054. 3 The Brooklyn Museum, Brooklyn, No. 39.120. 4 MMA, No. 15.2.2. O 40 STAIRWAY 1 Rijksmuseum van Oudheden, Leiden, No. T3. 2 Staatliche Museen zu Berlin, Ägyptisches Museum, Berlin, No. P10477. 3 Museo Archeologico, Florence, No. 3708. 4 EC, Piankoff No. 10.
P 3 BARQUE 3 EC, Piankoff No. 133. P 5 SAIL 1 BM, No. 10471. 2 BM, No. 10257. 3 BM, No. 10253. 4 BM, No. 10471. P 10 STEERING OAR 1 EC, Piankoff No. 8. 3 EC, Piankoff No. 7.
Q 4 HEADREST 1 EC, No. JE51901. 2 EC, No. JE62020. 3 BM, No. 10470. 4 BM, No. 10472. Q 7 FIRE 3 Louvre, Paris, No. I3297. 3 MMA, No. 22.1.154.
R 4 LOAF AND OFFERING MAT 1 Luxor Museum, Luxor, No. J63. 3 EC, No. RT.6.12.2419. 4 EC No. CG20564. R 11 DJED COLUMN 2 EC, Piankoff No. 10. R 13, 14 THE WEST 1 MFA, No. MFA95.1407a. 2 Kunsthistorisches Museum, Vienna, No. 3859. 3 MMA, No. 30.3.31. R 17 FETISH OF ABYDOS 2 MFA, No. 95.1407a. 3 EC, No. 6008.
S 12 GOLD 1 EC, No. JE52372. S 18 MENIT NECKLACE 2 EC, No. JE61481. S 34 ANKH 1 Staatliche Museen zu Berlin, Ägyptisches Museum, Berlin, No. 16100. 2 Louvre, Paris, No. N1750. 4 EC No. 62349. S 35 FAN, SUNSHADE 1 Ashmolean Museum, Oxford, No. E3632. 2 EC, No. JE30875 = CG52003. S 42 SEKHEM SCEPTER 3 EC, No. 61759.
T 10 BOW 3 EC, Carter No. 397. T 30 KNIFE 1 EC, No. 1320.
U 6 HOE 3 EC, Piankoff No. 8. 4 The Brooklyn Museum, Brooklyn, No. 50.128.
V 9 SHEN RING 2 EC, No. 61893. 3 EC, No. 61969. V 10 CARTOUCHE 1 Staatliche Museen zu Berlin, Ägyptisches Museum, Berlin. 3 EC, No. JE61490. V 17 PROTECTION 4 EC, No. JE62114. 5 EC, No. CG39194. V 30 BASKET 1 EC, No. JE6189. 2 EC, No. CG397. V 39 ISIS KNOT 1 EC, No. 1322. 2 EC, No. JE41042. 3 EC, No. CG42211.
W 15 WATER JAR 1 EC, No. 38575. 2 BM, No. 1227.
X 2 BREAD LOAF 2 EC, No. CG34001. 3 BM, 1242.
Y 3 SCRIBE'S OUTFIT 2 EC, No. CG1429. 3 Rijksmuseum van Oudheden, Leiden, No. T.3. Y 5 BOARD GAME 1 BM, No. 10016. 3 EC, No. JE61490. Y 8 SISTRUM 1 BM, No. 10472. 2 Louvre, Paris, No. N4314. 4 BM, No. 81.

INDEX

Page numbers in italics refer to illustrations.

Abydos, fetish of *132*, 133, *168*, 169
adore *28*, 29
Aker 69, *134*, 135
Ammit 71, *76*, 77, 105
amulet *76*, *84*, 85, 97, 107, *122*, 123, *134*, 135, 159, 165, *200*, 201, 218
Amun 20, 21, *28*, 45, *48*, 49, 55, 61, 75, 97, 107, 115, 127, 183, *198*, 199, 218
Amun-Re 21, *28*, 129, *144*, 145, *174*, 175, 203, 206, 207
ankh 105, *176*, 177, *178*, 179, 181, 201, 213
Anubis *18*, 19, *28*, 29, *64*, 65, *76*, 163, *182*, 183, 207, 218
arm *48*, 49, *50*, 51, *52*, 53, *54*, 55
Aten *128*, 129, 218
Atum 55, 57, 113, *154*, 155, 218

ba 29, 61, 83, 91, *98*, 99, 131, 147, 153, *178*, 179, *204*, 205, 218
baboon *28*, 29, 41, 43, *50*, 51, *54*, 55, 72, 73, *136*, 137
barque *36*, 37, *56*, 57, 71, 73, *90*, 91, *92*, 93, 109, 127, 139, *152*, 153, *186*, 187
basket *198*, 199
bee 95, *114*, 115
beetle, scarab *112*, 113
ben-ben 90, 91
Bes 101, 159, 189, 197, 211, 214
block statue 30, 31, 201
board game *210*, 211
bow *184*, 185
bowl, alabaster *202*, 203
brazier *160*, 161
bread loaf *206*, 207
breast 33, 35, *46*, 47
bull *54*, 55, *56*, 57, 59, 75, 99, *116*, 117, *156*, 157, 181, 183
bulti fish *110*, 111, *124*, 125

Cackler, the Great 97
canopic jars *40*, 41, 141
captive, bound *18*, 19, 29, *184*, 185, *194*, 195
cartouche *194*, 195
cat *62*, 63, 189
child 20, 21, 135
clothing *174*, 175
coffin 35, *42*, 43, 65, 81, 83, 101, 131, *140*, 141, *142*, 143, *148*, 149, *166*, 167, 197
collar 153, 171
cow, divine *38*, 39, *58*, 59, 123, 131, 137, *156*, 157
crocodile 71, *104*, 105
crown 91, 115

dance, ritual *170*, 171
djed 164, 165, 177, 181, 201
door *146*, 147
duck *94*, 95, 125, 193

ear *44*, 45
egg *96*, 97, 125
Eye of Horus 43, 83, 113, 207
Eye of Re 43, 109
eye, *wedjat 42*, 43, *58*, 63, *72*, 73, 83, 101, 157, 179

falcon 20, 21, 53, 61, 67, *82*, 83, 95, 99, *126*, 127, 129, 135, *148*, 149, 153, *166*, 167, *170*, 171, 179, *192*, 193
fan *178*, 179
feather 61, *102*, 103, 113, 189
fecundity figures 20, 21, *46*, 47, *80*, 81, *106*, 107, *162*, 163, *204*, 205
field *124*, 125, 151
fire 31, 109, *136*, 137, *160*, 161
First Time 59, 137, 218
follower sign 175, *186*, 187, 189
foreleg of ox *74*, 75
frog 39, *106*, 107

gate 117, *138*, 139, 141, 147, 189
Geb 97, 103, 191, 207, 218
gesture symbolism 17, 23, 25, 27, 29, 49, 51
god, seated 30, 31
gold *170*, 171

hand, clenched 53, *54*, 55
Hathor 59, 71, 89, 117, 123, 133, 153, 167, 171, *172*, 173, 183, *200*, 201, 203, *212*, 213
head *40*, 41, *120*, 121
headrest *158*, 159
heart *36*, 37, 65, *76*, 77
heavens 27, 101, *126*, 127, *146*, 147
Heh *38*, 39, 107, 119, 127, 193
heron *90*, 91
hippopotamus *70*, 71, 161, 197
hoe *190*, 191
horizon 20, 21, 57, 69, *116*, 117, *132*, 133, *134*, 135, 139
Horus 21, 43, 45, *66*, 67, 71, 81, *82*, 83, 129, 135, *148*, 149, *168*, 169, 171, 193, 218
Horus the child 20, 21, *32*, 33, 173
Horus name 67, 149, 219
Horus, sons of *40*, 41, 73, 121, 137, *142*, 169

ibis 88, 89
Inundation of the Nile 57, 61, 91
Isis *32*, 33, *34*, 35, 45, *46*, 47, 51, 65, 71, *76*, 77, 83, 93, 97, *100*, 101, 107, 117, 135, *164*, 165, *168*, 169, *170*, 171, 201, 205, 219
Iunmutef priest 24, 25
Isis knot *200*, 201

jackal *64*, 65, 67, *154*, 155
jar, water *176*, 177, *204*, 205
jubilee festival 91, *144*, 145, 161, *202*, 203

ka 32, 33, *48*, 49, 107, 149, 219
Khepri *112*, 113, *128*, 129, 219
Khnum 49, 61, 97, 129
kites 35, 83, *140*
knife *138*, 139, *188*, 189

lamp 107, *110*, 111, *120*, 121
lapwing *16*, 17, 29, *86*, 87
linen 103, *174*, 175
lion 20, 21, *68*, 69, 129
lions of the horizon 20, 21, *68*, 69, *134*, 135, *158*, 159
lotus *14*, 15, *20*, 21, *110*, 111, 121, 129, 169

Maat *36*, 37, 89, 103, *152*, 153, 219
mastaba 17, 65, 71, 143, 219
Mekhweret *58*, 59, 137
menit necklace 59, *172*, 173, 213
meret chest *102*, 103
Meskhenet *40*, 41
mirror *176*, 177
moon 39, *42*, 43, 73, 113
mountain 59, *132*, 133, *134*, 135, 169
mummy 31, *34*, 35, 43, 45, 63, 65, 77, 83, 99

necklace 59, *172*, 173, 213
nefer 78, 79
Nefertem 43, *120*, 121
Neith 85, 115, 123, 125, 171, 185, 219
Nekhbet *84*, 85, 109, 141
nemset vessel 103
Nephthys 35, *76*, 77, 83, 89, 93, *100*, 101, *106*, 107, 135, 171, 201, 219
nest *96*, 97
Nile figures 20, 21, *46*, 47, *80*, 81, *106*, 107, *162*, 163, *204*, 205
Nine Bows *86*, 87, *184*, 185
Nut 27, 51, 71, 117, *126*, 127, *130*, 131, 147, *152*, 153, 201, 205, 219

oar, steering *156*, 157
obelisk 73, *174*, 175, *190*, 191
offering *52*, 53, *96*, 97, *124*, 125, *174*, 175
offering mat *162*, 163
Osiris *50*, 51, 61, *64*, 65, 67, 77, 81, 89, 91, 93, 99, *106*, 107, 113, 117, 125, *136*, 137, *150*, 151, *162*, 163, 165, *166*, 167, 169, 179, *180*, 181, 183, 191, 203, 205, 219

palace wall *148*, 149
palette, scribe's *208*, 209
palm branch 39, *118*, 119, *144*, 145
papyrus *122*, 123
perch, Nile *110*, 111
Persea 117, 189
personification, emblematic 11
personification, formal 11
phoenix *90*, 91, 99
pool *136*, 137, *160*, 161
prenomen 195, 219
Primeval Hill 91, 151, 169, 219
Primeval Waters 21, 57, 59, 111, 137, 151
protection 161, *196*, 197
Ptah *44*, 45, 51, 57, 73, 77, 85, 89, 97, 99, *166*, 167, *174*, 175, 181

ram 60, 61, 153
Re *30*, 31, *36*, 37, 39, 71, 73, *92*, 93, 115, 117, 125, *128*, 129, *152*, 153, 171, *186*, 187, *188*, 189
Re-Herakhty *100*, 101, 117, *128*, 129
rebus 21, 109
reeds *124*, 125, 207
river, celestial 153, 155

sail *154*, 155
sarcophagus 35, 143, *170*, 171
scarab beetle 61, 63, 85, *112*, 113, 129, 153
scepter, *djam* 181
scepter, *sekhem* 65, *182*, 183
scepter, *was 180*, 181
scribe *14*, 15, *72*, 73, *208*, 209
scribe's outfit *208*, 209
Sebek *104*, 105
sed festival 91, 139, *144*, 145, 161, *202*, 203
senet game *210*, 211
serekh 49, *148*, 149
serpent *54*, 55, *62*, 63, 85, *138*, 139, *142*, 143, 161, 187, *188*, 189, 193, 199
Seth *66*, 67, 71, 75, 81, *152*, 153, 181, 219
shen ring 39, 107, *192*, 193
shrine 31, *64*, 65, *84*, 85, *104*, 105, *140*, 141, *142*, 143, 213
shrine, Lower Egyptian *142*, 143, 187
shrine, Upper Egyptian *140*, 141
Shu 27, 55, 59, 69, *102*, 103, 115, 127, 159
sistrum 63, *172*, 173, *212*, 213
situla *46*, 47
sky 101, *122*, *126*, 127, *146*, 147, 181
souls of Nekhen and Pe *16*, 17
sphinx *52*, 53, 61, 67, *68*, 69, 129, *136*, 137
spoon *52*, 53, 95
stairway *150*, 151
star 39, 87, 93, *130*, 131, 159
statue 22, 23, 183
stele *24*, 25, *44*, 45, *92*, 93, *100*, 101, *116*, 117, *124*, 125, *128*, 129, *134*, 135, 155, 219
sun 43, *50*, 51, 59, 61, 91, 93, 101, 109, 111, 113, 121, *128*, 129, *134*, 135, 171
sunshade *130*, 131, *178*, 179
swallow *92*, 93, 153
sycamore 47, 57, *116*, 117, 129, 189

Tatenen *50*, 51, 61
Tawaret 47, 71, 159, 161, 189, *196*, 197
Thoth 45, *72*, 73, *80*, 81, *88*, 89, 153, 189, 207, *208*, 209
throne name 37, 195, 219
tree 57, *116*, 117

Union of the Two Lands *80*, 81, 127, 151
uraeus *108*, 109, 153, 195, 199
ushabty 142, 143, *190*, 191

vulture 81, *84*, 85, 179, 199, 203

Wadjet 109, 143
wedjat eye *42*, 43, 59, *62*, 63, *72*, 73, 83, 101, *156*, 157, 207
west 103, *166*, 167
wing *100*, 101, 193, 197
woman, mourning *34*, 35
woman, nursing *32*, 33, *46*, 47